The Story of
Modern Art

Norbert Lynton

The Story of Modern Art

Second Edition

Prentice-Hall, Inc.
Englewood Cliffs, New Jersey 07632

Dedicated
to my four sons
and to the memory of
my father

North American edition published by
Prentice-Hall, Inc. 1983, 1990
A Division of Simon & Schuster
Englewood Cliffs, New Jersey 07632

© 1980, 1989 Phaidon Press Limited, Oxford

First published 1980
Second impression 1982
Third impression 1986
Second edition 1989

ISBN 0-13-849860-1 PAPER
ISBN 0-13-849902-0 CASE

Printed in Portugal by Printer Portugesa, Lisbon

1 (frontispiece). Robert Delaunay: *The Cardiff
Team.* 1913. Oil on canvas, 77 × 52 in.
Eindhoven, Stedelijk Van Abbe Museum

Contents

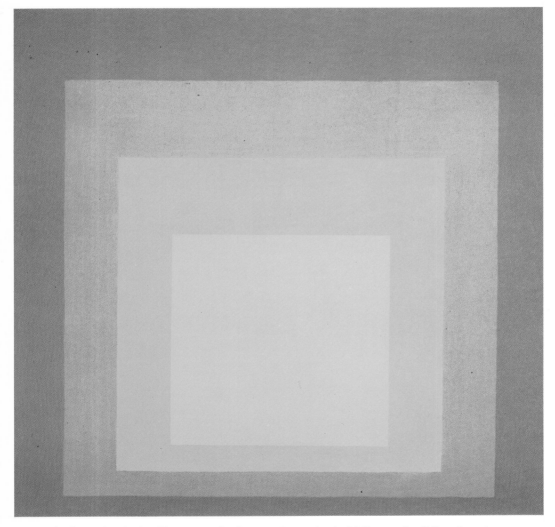

2. Josef Albers: Study for *Homage to the Square: Departing in Yellow*. 1964. Oil on board, 30 × 30 in. London, Tate Gallery

Preface

This book, intended as much to help readers towards a confident relationship with modern art as to offer information about it, is indebted to countless books and articles (not all of them on art) but also, more particularly, to people. I can draw no line between my engagement with modern art and with the art of the past, so that the origins of this book may be traced to the day when I opted for History of Art as one of my subjects for a general degree and found myself studying under a truly great teacher, Professor N.B.L. (now Sir Nikolaus) Pevsner. Further studies launched me into teaching, in art schools at first. Close daily contact with artists enriched and transformed my understanding of art. I had the luck to be teaching at Leeds College of Art during the time that Harry Thubron was head of the painting department there; here was another great teacher, one who infected students with a rare appetite for knowledge and experience, and tempted colleagues into energetic collaboration. Contact with students means perpetual questioning of one's material, and I have been especially conscious of this in my present role at the University of Sussex. Two of my colleagues there have helped me in various specific and general ways—Dr Erika Langmuir, to whose wide wisdom I herewith pay homage, and David Mellor, with whom I have shared courses and whose example I have found profoundly stimulating.

I have been blessed with a thoroughly supportive publisher, and thank Simon Haviland and Anne Bosman of Phaidon Press for combining efficient management with so gentle a touch; both mattered greatly during the later stages of writing. From the start I could count on the energy and optimism of Keith Roberts (through whom I originally proposed this book to the publisher). His sudden death in 1979 deprived art-historical writing and publishing of a tireless constructive force. My wife has had to put up with much over the years as I wrote and re-wrote the pages that follow. She is also the painter I know best and has undoubtedly contributed much to my visual education.

October 1979 N.L.

Preface to the second edition

The broad stream of art flows on. Ten years ago I finished work on the first edition of this book. Much has changed in the art world, much more remains the same or repeats history. For example, one could be thoroughly disturbed by the open conservatism of the arguments now

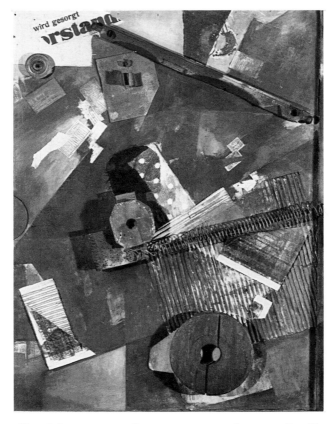

3. Kurt
Schwitters:
*Ausgerenkte
Kräfte
(Dislocated
Forces)*. 1920.
Collage,
$41\frac{1}{2} \times 34\frac{1}{8}$ in.
Bern,
Kunstmuseum

offered in support of new art, were they not familiar from the 1920s and 30s. Artists bend to the wind of publicity, and speak as easily of traditional values as of innovation: they work with both. The Modernism now under attack never existed outside the crudest accounts of modern art. My claim for this book is to have avoided simplistic definitions and asserted art's complexity. My aim is to show an open engagement rather than suggest that anything has been finally dealt with and laid to rest.

For this edition I have been able to make some amendments in the text, convert some black-and-white illustrations into colour plates, trim the last chapter, add a new chapter for the 1980s, and add to and update the biographies and bibliography. The section I was most eager to enlarge was that on Russian Modernism in chapter 3. As that stands the subject gets more prominence than in other general histories. There is a lot more to be said about it, but it will have to wait for another book.

Nikolaus Pevsner and Harry Thubron, to whom I paid brief homage in the preface, have meanwhile died. They live on in many minds. I am tempted to add new names, but one's essential debt is to artists, all artists ancient and modern, famous and obscure. Art would not flow but for all of them. Our epoch insists on individualism, yet the ever-flowing, self-refreshing stream of art is a collective achievement.

January 1989 N.L.

Introduction

The historian of twentieth-century art faces special problems. Their pressure will be felt in the pages that follow, so the reader may as well be warned.

One, perhaps the worst, is that he inherits a ready-made outline account of what happened, and doubts its truth and value. This account, because of its origin, is given in terms of triumphant revolution following upon triumphant revolution. Yet few would claim that there is progress in art. In any case an artist's relationship to his inheritance is as interesting and as relevant as any innovation he may contribute. Another is that, as the historian comes closer to the present day, his terrain changes from being history to being something closer to autobiography. He has witnessed the events he describes, and experienced the polemic which they occasioned at the time. Reflecting on them has certainly affected his view of the historical terrain.

The history of modern art was written as it happened. This means that it was written as the art became public, as part of its becoming public. I should perhaps here be offering a distinction between art criticism and the history of art. If a useful one exists, it does not hold for the twentieth century. In receiving modern art, critics appear as much concerned to test its historical role as to assess its inherent qualities, while the historian who sets out to achieve an objective chronicle will soon find himself either having to accept priorities established by the critics or go by others that he prefers for not strictly historical reasons. I am an art historian who has long worked as critic, and it seems to me that the only kind of critical attitude the historian should avoid is that which is narrowly partisan— where the critic, for honourable or sometimes for dishonourable reasons, makes himself the spokesman or even leader of an art movement, and uses the past in order to justify his option while dismissing other aspects of the present.

Since modern art became my prime interest, a quarter of a century ago, the history of it available to us has of course changed. Mostly in terms of quantity. When I was a student no course of twentieth-century art was on offer (nor, to be honest, would I have chosen one). When, working alongside artists and teaching students who wanted to be guided through the recent past in order to find their feet in the present, I needed to inform myself on the art of this century, what was available in books, magazines, and catalogues was amazingly limited. Paris ruled, of course: almost everything one could get hold of started from that assumption. Gertrude Stein's statement, 'Painting in the nineteenth century was only done in France and by Frenchmen, apart from that, painting did not exist, in the

twentieth century it was done in France but by Spaniards', makes a splendid opening for her little book on Picasso (1938) and is a rampant exaggeration but catches something of the tone of modern art writing. There were other views outside France, of course, but even they tried to gain credit by emphasizing all possible links with the Ecole de Paris. Alfred H. Barr's book on Matisse (1951) was a unique model of fullness and fairness, and next to that stood the same author's book on Picasso (1946), lighter and probably more widely read. Other Museum of Modern Art publications were available, and a study remains to be done of the extent to which these, often associated with exhibitions and thus shaped by the exigencies and the opportunism of exhibition-making, determined or perhaps re-determined (representing a second-generation exercise) our understanding of the first decades of this century. For example, to what extent was our habit of seeing Cubism as a kind of antechamber to abstraction implanted by Barr's *Cubism and Abstract Art* (1936)? My chief point is that we depended on Museum of Modern Art publications and received them as close to Gospel truth. They were, and remain, magnificent, but they were limited in their scope and depth. They offered an invaluable alternative to the often blatantly promotional literature available from Paris, the insularity of which became more obtrusive with every year that passed. There was very little available on German Expressionism and nothing on Italian Futurism or the Russians. As knowledge and understanding of both developed, the map of modern art history became larger and more detailed, and also more confusing.

The story of modern art is usually told in terms of movements: Fauvism, Cubism, Futurism, Expressionism, and so on. It was as group events that developments tended to come before the public, and in some instances (Futurism, Surrealism) it is true that the art and its movement context fittingly went together. But in most cases the movement was a fabrication—a convenient arrangement for artists of some similarity of direction but lacking the support that membership of an academy or well-established society would bring them, or just a cohesiveness imposed from the outside. Thus some artists, most of whom knew each other and whose work shared some characteristics, but who in no way thought of themselves as a group, were bundled together in 1905 and delivered into history as the Fauves by a hostile and witty critic. Thus, largely, they remain, though for several of them 1905 and Fauvism signify neither a cardinal moment in their work nor their mature way of working. It is impossible for the historian to abandon the pattern of movements: the pattern is itself part of history. Moreover, readers will want their reading at least partly shaped by the classifications they find used elsewhere. So one uses the movements and tries to help the reader to see them for what they were, whilst also stressing ideas and work that the emphasis on movements tends to obscure. That often means stressing similarities where the movements speak of oppositions: each movement necessarily announces its difference from what already exists. Yet the differences inside the group are sometimes more substantial than those between groups, and whilst this book offers a narrative of the main events in twentieth-century art my effort has gone into encouraging thoughtful

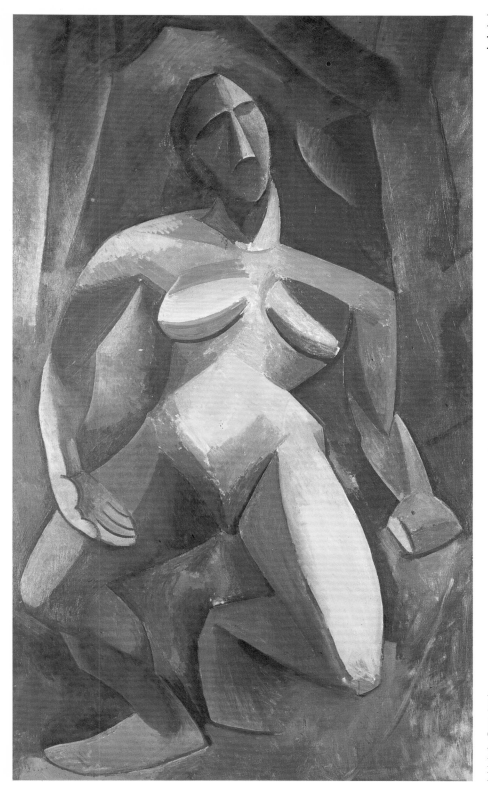

4. Pablo Picasso:
*Nude in a Forest
(The Dryad)*. 1908.
Oil on canvas,
$72\frac{7}{8} \times 42\frac{1}{2}$ in.
Leningrad,
Hermitage

understanding for and of the art that has been produced rather than attempting a blow-by-blow account.

This has meant being very selective. Nobody can tell the whole story, even if he were in a position to know the whole story, within one portable and purchasable book. I decided to omit admired artists in order to be able to discuss a smaller number of artists more fully. I am also aware of omitting whole countries, in one or two cases reluctantly. To have given more information would have meant reducing discussion. My hope is that readers will find my comments on individual works and on their often multivalent implications applicable elsewhere. There is room for more books on modern art—efficient and objective compilations of information, for example, and also more thoughtful surveys proposing better classifications than those provided by the movements and their instant slogans—but I feel very strongly that we do not need any more books that, with good plates or without, are satisfied to run through all the old platitudes yet again. This applies even to the most recent art, though here it is particularly difficult to distance oneself from the definitions offered and their implied priorities. It would certainly not be difficult to suggest some categories by means of which to consider, say, the varying activities today referred to as Concept art or some such term. Perhaps we should be talking about Solitary art and Team art or Quiet art and Loud art; if these not entirely arbitrary categories are found revealing for the discussion of contemporary art, they may also prove illuminating for modern art at large. History must be useful as well as truthful, and I would like to see everyone interested in modern art combining the information available, the historical facts together with knowledge of the works themselves, with his or her experience of modern life and thought in order to build ever more useful versions of it. For me 'useful' tends to mean, in part, inclusive rather than exclusive, catholic rather than dismissive, where twentieth-century art is concerned as much as any other. Perhaps that is a prejudice, though I wonder whether one can be a historian without it. Art is long, life is short, one is told; *ars longa, vita brevis*. What Hippocrates actually said and meant was that life is short compared with the time it takes to learn the art of healing. But, yes, art goes on and we do not. The contrast the historian of modern art becomes most aware of, however, is that between the work of art and the words piled up around it. The work, God willing, survives; the words are washed away. He knows that is how it should be, even if as a writer he has somewhat mixed feelings about it.

1 The New Barbarians

When the means have become so refined, so weakened that their power of expression has gone, we have to return to the essential principles on which human language was formed.

Matisse, speaking about Fauvism, 1936

It was—truly—like an opening world.

Ford Madox Ford, on the years before 1914

The approach of a new century invites thoughts of change, and 'twentieth century' has a millennial sound. What many called 'the new age' would surely come, but what kind of an age would it be? The nineteenth century had invested faith and effort in what it called progress—meaning mostly material, technological advance. From the start there had been those who doubted that man would be capable of handling his new-found powers with wisdom. As the (Western) world progressed there were more and more doubters who saw life becoming more fragmented, cities growing into monstrous displays of arrogance and oppression, man's contact with nature, and with his own deeper nature, perhaps irrecoverably lost. There were others who saw all this as evidence that a better world was coming. Technology would triumph over its own defiling; industry would soon bring plenty, and plenty would end strife between nations as men recognized their interdependence, especially the workers in their membership of one world-wide brotherhood, and, with the help of technology's gifts, turned the globe into one smiling habitation.

The essential change of direction had already happened in the eighteenth century. E. H. Gombrich summarized it in *The Story of Art*, in the chapter he titled 'The Break in Tradition'. Loss of faith in the classical tradition as the guide to excellence, abetted by the passion for historical studies which proved that tradition to be itself a complex of contradictory models; growing self-consciousness about style, compounded by the new idea that art is a matter of self-expression, the artist now being expected to find his own motivation and reveal it in the subject-matter and in the manner of his art. There followed the period we call Romanticism, which includes the French Revolution and the Industrial Revolution, Rousseau's rejection of the values of civilized society, Beethoven's rejection of the framework of inherited forms, harmony and stylistic proprieties, Wordsworth's rejection of idealized language as the material of poetry in favour of the speech of country folk and their children, the recognition by Goethe and others that the unconscious, not any outside agent or impulse, is the true originator of creative work, and so on. Some commentators argue that Romanticism continues to this day. Many of its ideas are certainly still active, and the confusions and antagonisms that surfaced then are ours today.

Until Romanticism art, whatever licence it allowed itself, had been seen in relationship to a great central tradition stemming from what is still sometimes called 'the cradle of civilization', the Mediterranean. Not the tradition but its centrality was lost; it came to be seen as an option, one alliance among other possible ones. There were other traditions to be tried, some of them Western but till now obscured by classicism, such as that of the Middle Ages and of Nordic Europe, some distant and until now thought of as quaint, the civilizations of the Middle and Far East for example, as well as the ways of savages in various parts of the world, now being studied with care as indicative of Western man's own early life. The sudden plurality of traditions to be followed, languages to be used with greater or lesser seriousness, is most apparent in architecture and decoration. In art it is less obvious; the postulates of classicism were being undermined but the language of classicism still held, and alternative forms of art were being exploited that were a challenge to classicism only in the fact of their being received, gradually, as worthy alternatives. Constable brought visual vividness and a moral purpose to the representation of otherwise meaningless stretches of landscape, giving primacy to nature in all its transient appearances in place of man's domination of his world, while Turner attended so closely to the drama of nature as a force infinitely more powerful than man that no one could recognize his paintings: 'pictures of nothing, and very like', said Hazlitt. Goya's reports and nightmare visions of cruelty and madness inverted the orthodox purposes of classical art—to delight and instruct—and so in another way did that great classicist David, using a radically pared-down, archaic-seeming kind of classicism to criticize the art and morality of a society seeking only delight. His pupil Ingres borrowed from archaic forms of classicism as well as from medieval and on occasion Oriental art to build up compositions that sometimes restated classical themes with aplomb and sometimes moved into darker realms of erotic fantasy. Delacroix, whom Ingres feared as a destroyer of art, searched literature and history for subjects that could, through his rich and sensuous treatment of them, convey personal meanings.

One could go on but the chief points are these: that even traditionalists were looking for a wider world of subject-matter and expression than tradition could support, and that there were justifications within Romanticism for this activity as well as for all the others that showed a shrugging-off of tradition. In any case, there was justification for proceeding without justification: genius stands above rules, and the products of genius cannot be measured by previously determined criteria but have to be approached and assessed on their own terms. Before very long there resulted the kind of total misunderstanding and lack of faith as was manifested when the Impressionists were denounced as incompetents and Ruskin accused Whistler of 'flinging a pot of paint in the public's face'.

The case of Impressionism is particularly instructive. Impressionist paintings today are more loved and admired than any others. In the 1870s and 1880s they were scorned by almost everyone. The strength of this antagonism is surprising, even allowing for the repeated ritual of denunciation followed by interest and acclaim that modern art has

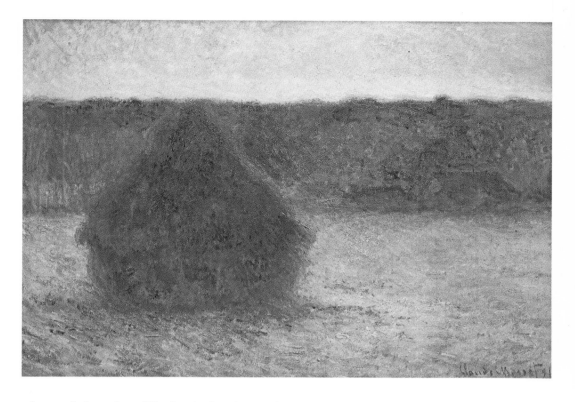

witnessed since then. The fact is that these paintings were very difficult to make out. There seemed to be no drawing in them, no composition, no way of knowing what one was supposed to admire, let alone what to think about. There seemed to be no subject, no content. Patience might, helped by the pictures' titles, determine that some of them were indeed landscapes, but there remained the problem that the coarse, unblended brushstrokes used, defensible possibly as a way of rendering water or foliage, were given also to firm objects such as buildings and people. Representing the human figure convincingly and with comforting grace was known to be the most difficult part of art; these painters seemed unwilling to attempt it, or to construct a convincing space, or use it to present an action worthy of the name of art. In the eighteenth century the category of painting known as history painting, the representation in dignified and significant terms of an important, elevated subject, was still regarded as the sole business of the high-minded artist. The flood of art produced in the nineteenth century included many history paintings, hollow performances often, as well as paintings of other categories— portraits, genre paintings (narrative or descriptive scenes of ordinary life), landscapes, still lifes—that in one way or another borrowed elements of history painting in order to share in its exalted status. But it had been recognized for a long time that not everyone could be an epic artist, and the nineteenth century was able to see genius too in lighter and slighter productions, in lyrical poetry, for example, and in *Lieder*. But these would exhibit rhyme, metre, a felicitous use of words or melody, and some sort of overt or implied message. Where was the message in

5

5. Claude Monet: *Haystacks at Sunset, Frosty Weather*. 1891. Oil on canvas, $25\frac{5}{8} \times 37\frac{3}{4}$ in. Private collection

Impressionist paintings? Zola, to defend them, spoke of 'nature seen through a temperament', but where was the temperament? Not only were these canvases marked with coarse brushstrokes they were also indistinguishable from each other, with only the signatures to indicate that individual temperaments may have been at work. The queues that today form for Impressionist paintings include those members of the public who are thought of as the enemies of modern art because they still ask 'What does it represent?' and those who are seen as converts because they have learned not to ask what a work of art is about. The second sort is in many respects the more troubling, and it may well be that Impressionism and the sort of explication that gradually formed in support of Impressionism produced them.

Artists since Impressionism have often proclaimed a separation of art from literature, the breaking of a relationship that was certainly close to the heart of classicism. A looser affiliation with music has often been offered in exchange. Music, it was said, reaches deeper levels of response than could be reached by an art dependent on learned interpretation. The abstract elements of art—colour, form, scale, their deployment in hard, soft, rhythmically assertive or quiet ways—would strike through man's veneer of house-trained understanding to the instinctive, natural man beneath. Instinctively working artists would communicate directly to instinctively receiving spectators. Perceptual psychology suggested that this sort of communication could indeed take place, and the triumphant history of music in the nineteenth century, and its growing popularity in the twentieth century, thanks to radio and gramophone, offered convincing proof of it. Art abandoned, or seemed to abandon, its duty of instructing, but that did not mean it was willing to yield its high status to books, newspapers, and films. Like music it aimed at an even more exalted plane: that of religion—and in seeking that role it sought also its primordial place at the centre of human existence.

There are several ways of explaining the tendency, especially marked in later nineteenth-century and in twentieth-century art, towards what is broadly called primitivism. One can see it as a Rousseau-ist turning away from the styles and associations of art as recognized in Western society. The folk art and the medieval art of one's own country; exotic art forms (in the 1870s and 1880s particularly Japanese woodcuts, subsequently also tribal art from Africa, the South Seas, and the Americas, then also Persian and Indian painting, and prehistoric cave paintings, discovered in France and Spain just in time to be of influence); the primitives also of one's own time and place, that is the art of children, of unsophisticated amateurs, and of the insane; the art even of the professional artist when he can reduce or remove his control over what he is doing, through the use of drugs for example—all these served to disengage art from the firm hold of 'fine art' and the several institutions formed in its support.

Another way is to see it as a return to the essential and eternal bases of art. The historicism that came to dominate Western self-awareness from the later eighteenth century onwards invited men to consider the origins of things. Just as Rousseau had sought to explain the social system in which he found himself by guessing at the ways in which societies first came about and on what agreements they had been founded, so people

concerned with understanding the arts looked for their earliest instances and imagined earlier ones. The conventions, which to many were the ineluctable forms and methods of the various arts, could thus be shown to be accretions, useful, and even necessary when they were formed but not therefore of permanent value. Dance, for instance (of noticeable interest to writers, artists, and others in the decades lying both sides of 1900): the costumes, positions, movements, and gestures of what is called classical ballet are conventions that gradually separated dance as an art form from courtly and country dancing. Many of those conventions were established in the nineteenth century. It was possible to step aside from them, as did Loie Fuller with great success in the 1890s in Paris, and develop an abstract dance dependent more on the swirling motion of coloured veils than on human motion, or, as did Isadora Duncan to even greater and more international acclaim, from 1900 to the 1920s, develop an art of expressive bodily action, without narrative or props and with the body scarcely veiled, to deal with the great themes of existence—birth and death, love, parenthood, joy, fear, anger. The success of Diaghilev's Russian Ballet Company came from its combination of aspects of traditional ballet with ballet suggestive of peasant dances and even more primitive forms. *The Rite of Spring*, conceived by the Russian painter Nicholas Roerich, composed by Stravinsky, and choreographed by Nijinsky with the help of a girl brought in specially from Dresden, Marie Rambert, told no story but had for its subject a sequence of rituals such as might have been part of the life of pagan Russians long ago. It was an attempt to reinvent the kind of dancing known to prehistoric man, religious in function and of course participatory, not something witnessed in a theatre by passive spectators. Debussy attended the famous first performance of the *Rite*, in 1913, and thought it 'an extraordinarily savage affair... primitive with every modern convenience'. (A fortnight earlier Diaghilev had put on for the first time a short ballet to music composed by Debussy, *Jeux*, on the theme of three persons playing tennis.) Diaghilev's ballets and their decors, by some of the leading modern artists, helped to break down the public's resistance to new art forms but associated these with the make-believe and ephemeral world of the stage.

If historical examination of the arts led one back to their common origin in religion and magic, one could also examine each of them ahistorically for their inherent nature and potentialities. Lessing, in the eighteenth century, asked what sort of communication each of the arts could effectively deliver; a century later people were asking what, essentially, each of the arts was. When Degas complained to Mallarmé that, though he had plenty of ideas for the sonnets he wished to write, he found them painfully difficult to produce, Mallarmé replied: 'Degas, you don't make sonnets with ideas. You make them with words.' Degas told and retold the story with evident pleasure, valuing the implication that, similarly, paintings are made of more rudimentary stuff than famous subjects and valued styles. Maurice Denis, a generation younger than Degas and inspired by the example of Gauguin, spelt it out with memorable firmness in the opening sentence of an essay published in 1890 and often quoted since: 'Remember that a picture—before being a

battle horse, a nude woman or some anecdote—is essentially a flat surface covered with colours arranged in a certain order'. That seemed to announce the end of the Renaissance concept of painting as the art of suggesting three-dimensional bodies placed into space, and sometimes it was quoted to sound like a call for abstract art, but of course it does not exclude the possibility of perspective and modelling, let alone figuration or narrative. Rodin was recorded at about the same time as saying that 'Sculpture is the art of the hollow and the lump'. In 1910 we find Paul Klee, an assured artist with pen, pencil or etching needle, noting a 'revolutionary discovery' in his diary: 'more important than nature and nature study is one's attitude to the contents of one's paint-box.'

6

In developing their concept of an art of delight and instruction, the painters of the Renaissance had combined the Greeks' principles of selective naturalism and mathematical proportions as the means to beauty with a version of Aristotle's dramatic unities—the unities of time, place, and action—as the means to effective instruction. One moment of an action was represented in one coherent space and in one coherent language or style. Often the result was like a stage presentation, but a presentation of one moment only, implying others (a tableau, in other words, which in French means picture); an artist's ability and originality would lie in putting together a yet more telling presentation of an action already known to the spectator. Modernist artists were to reject these unities and the skills which each called for, and modern dramatists theirs. In every case primitive works of art could lend support: their priorities were different, and thus their methods also. The much emphasized divorce of art from literature, never complete, was really a public disclaimer of academic principles formulated to strengthen an art that cherished its literary content. With the discursive subject gone, there was no special need to locate figures on a picture stage in a way that would tell a story, nor to light them in a helpful manner, nor employ a received code of poses and gestures, as in ballet, to show each figure's part in the whole.

6. Auguste
Rodin: *Iris,
Messenger of the
Gods*. 1890 – 1.
Bronze,
$34\frac{1}{4} \times 37\frac{3}{8} \times 15\frac{3}{4}$ in.
Paris, Musée
Rodin

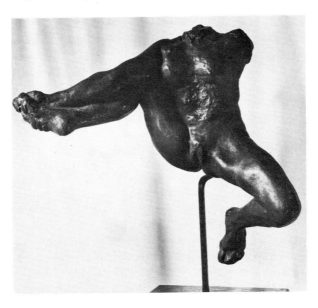

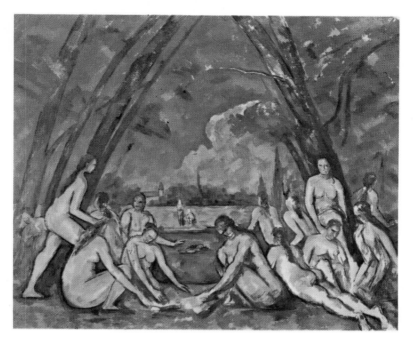

7. Paul Cézanne: *Bathers*. 1898–1905. Oil on canvas, 82 × 99 in. Philadelphia Museum of Art (W. P. Wilstach Collection)

Histories of modern art conventionally stress the road to abstraction as the essential course of modernism—as a race course even, since there is much talk of who 'got there first' to produce the first truly abstract work. In the nineteenth century avant-garde painting proceeded mostly by means of landscape and still-life painting. When it did venture into history painting it preferred a very limited form of it, with generalized and vague meanings delivered by means of symbols, or, as in the case of

7 Cézanne's *Bathers*, finding a theme which, though full of literary undertones, can visually be very succinct. It is the general setting-aside of history painting as the category of art into which the adventurous and ambitious artist would feed his best energies that is the important event. And it meant setting aside the most learned, most thoroughly cultured form of art, the crown of traditional art in the West.

The painters known to history as the Post-Impressionists—they were not a group, but shared the impact of Impressionism and an urge to move beyond its emphatic objectivity to something more obviously constructed and significant—provided many of the starting points of twentieth-century art, at the level of ideas as well as in their practice. Gauguin was the most openly primitivist of them. His life story combined with his stirring paintings and prints to add drama to the attractions of primitivism. He had given up a career at the stock exchange to become a painter, and then his wife and family when he could no longer support them; he had gone to Brittany because life was cheaper there but also because there he could reorientate himself by the simple life and ancient superstitions of the peasants; and then he had abandoned France and Western civilization by going to the South Seas to live among

8 natives, using them and their setting in his art as well as exotic material gathered elsewhere. He claimed to be rejecting Western art—in fact his

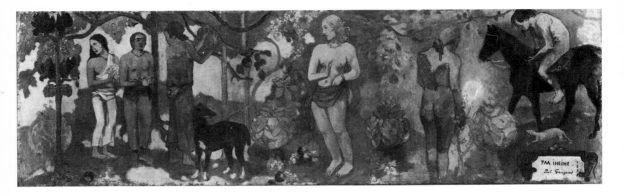

8. Paul Gauguin: *Faa Iheihe (Pastorale)*. 1898. Oil on canvas, $21\frac{1}{4} \times 66\frac{3}{4}$ in. London, Tate Gallery

art proves the strong hold of classicism—but he was able to attack the basis of classicism, its roots in naturalism and good sense. 'Emotion first; understanding afterwards' was his chief message, and that meant expressive rather than accurate drawing, stirring rather than accurate colours, and scenes permitting no rational interpretation. He tended to flatten the forms in his pictures, though rarely more so than a Neo-classicist like Ingres, but his glowing colours on rough canvas give an effect of tapestry, a richly worked surface, not a window on to anything, real or imaginary. 'God does not belong to the scholar or the logician', he wrote; 'he belongs to poets, to the dream.'

In Brittany Gauguin had acquired a small circle of disciples; back in Paris some of them built up a wider circle of artists who explored the fields of suggestion rather than narrative and of decorative display rather than illusionism, all associated with his example. He was in correspondence with a few friends in France, especially with Daniel de Monfreid, and sent work home through him. At times de Monfreid suggested to him that he should return to France. When, not long before his death, Gauguin agreed that it might be right to return, de Monfreid advised against it: Gauguin's work was at last becoming known and needed the support of the Gauguin legend. His rising reputation was part of the call for a fresh start. The novelist Charles-Louis Philippe formulated it well in 1897: 'The time for gentleness and dilettantism is past. What we need now is barbarians. The age of passion begins today.' About ten years later André Gide used the same words in a lecture: 'The time for gentleness and dilettantism is past. What we need now is barbarians.' By that time Gauguin had died and his work had been seen and commemorated in a memorial exhibition within one of the annual unofficial Paris art shows, the Salon d'Automne of 1906. He was beginning to be seen as one of the heroic pioneers of the new age.

His friend Vincent van Gogh had died long before but also rose to art-world fame in the first decade of this century. Close to the Impressionists while in Paris during 1886–8, he had then moved to the South of France and into an art much more intense and personal than theirs. His subjects were around him—landscapes, individual people, interiors and sometimes objects—but he heightened their colour and sharpened their characteristic forms to express his valuation of them and to endow them with a radiance that feels religious. He used colour brilliantly and

9

densely, applying the paint in painstaking, often long and linear strokes. The brightness and the brushstrokes tended to be mistaken for vehemence: his admirers wished to place their hero within the 'age of passion'; again, the artist's personal history, his passionate humanitarianism and also his emotional crises, leading at times into madness, gave additional impact to his work. For some, Vincent van Gogh was a frenzied genius spilling his emotions out with his paint. His letters prove him to have been one of the most observant and thoughtful painters ever. They began to be published in the 1890s but no large number of them was available until 1914 when the six hundred-plus letters he wrote to his brother Théo were published in Holland and in Germany.

Whereas van Gogh's paintings seemed all impetuosity, and Gauguin's all exotic reverie, Seurat's announced themselves by their coolness and calculation. He knew Impressionism through his friend Signac, and, like an Impressionist, he wanted to capture the light of day on his canvases, but his mind was formed on the classical tradition and his paintings demanded the sort of preparatory research and patient constructing that history paintings had called for. Colour theory suggested to him that accuracy and brightness could best be achieved by juxtaposing little spots of unmixed pigment. The technique he developed is known as 'divisionism' when attention is being drawn to his analysis of observed

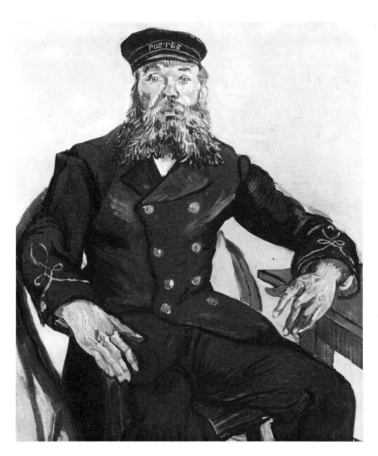

9. Vincent van Gogh: *Portrait of the Postman Roulin*. 1889. Oil on canvas, $31\frac{7}{8} \times 25\frac{5}{8}$ in. Boston, Museum of Fine Arts

colours into their pigmentary constituents, and as 'pointillism' when people speak of the way the paint was applied. But Seurat equally studied the forms he used and their organization on the rectangle of the canvas: these could be deployed to convey meaning and emotion in themselves. Thus every aspect of his paintings was severely controlled, proclaiming their basis in thought and knowledge. This included a knowledge of classical systems of proportion, used in plotting the main elements and divisions of his pictures. In his very large painting, *A Sunday Afternoon on the Island of the Grande Jatte*, he may seem to be mocking classicism in his scrupulous attention to every detail and the grandiose stillness he imposes on his figures when his subject is merely the leisure activity of ordinary Parisians. The effect is at once archaic and modern. Seurat insists on according the ordinary world a dignity once reserved for kings. He was a convinced socialist. It is striking that his picture is without dominant and secondary areas of interest plus background or infilling but offers a surface of equal interest as well as of even visual texture. His last painting, left slightly unfinished, is of a circus performance; other paintings are of nightclub dancers, performers outside a Montmartre music hall, and so on, scenes of urban diversions that complement the more innocent leisure activities of the *Grande Jatte* and other pictures. It may be that he intended his work to form a coherent survey of the everyday life of his time, but always in these hieratic and formal terms. This interest separates him from Signac and his other followers; it also separates him from the other Post-Impressionists. The divisionist technique exercised a great deal of influence on modern painting, partly thanks to Signac's account of the theories and methods of what, by then, was often called Neo-Impressionism (published in 1898 and 1899). The influence of Seurat's rationalist attitude to art as a process of conscious making has a longer history and can be traced through Mondrian and Constructivist art to the present day.

Cézanne was referred to as 'the father of all of us', 'my one and only master', 'my teacher *par excellence*' and other phrases of the same sort by

10

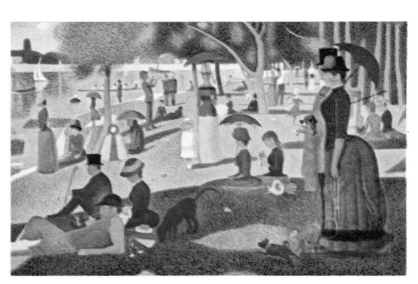

10. Georges Seurat: *A Sunday Afternoon on the Island of the Grande Jatte*. 1883 – 6. Oil on canvas, $81\frac{1}{2} \times 121\frac{1}{4}$ in. Art Institute of Chicago

a remarkably large number of painters in the first decades of this century.

In fact the art of this near-hermit of Aix-en-Provence was stimulus and
model to a variety of descendants. He gathered in himself aims and ideas
proposed by others before him and passed them on, strengthened and
clarified. As this implies, his work was full of contradictions. He was a
classicist, admiring Poussin and classical sculpture, and crowned his
career with a group of large figure paintings, the *Bathers*, that
unmistakably refer back to the great tradition of classical figure painting
and sculpture and to the myths which this tradition was created to
embody. He was also a colourist and a Romantic, admiring the great
Venetian masters, especially Veronese, and also Rubens and Delacroix.
One is tempted to say that he united the classical tradition, which
emphasizes drawing and design (and instruction), with the painterly
tradition of the Venetians and their followers, emphasizing colour and
expressive brushwork (and delight), but in many respects they remain in
conflict in his work, complementary, not fused. Moreover, in spite of this
attachment to the great models of the past, Cézanne painted as though he
was the first to use colour on a flat surface to represent the world. Even his
admirers tended to call him clumsy, and he spoke as though painting were
a desperately difficult matter of catching 'little sensations' and disposing
them on a surface, not to imitate nature so much as to construct an image
that would be 'parallel to nature'. He had passed through an Impres-
sionist phase, but his characteristic art is not concerned with light so
much as with capturing the subjects before him to show their physical
presence and also the spatial relationships and tensions between them,
while also allowing for the tremor of life that the act of seeing imparts on
what is seen. This emphasis on seeing—not the retinal scanning of the
Impressionists, but the complex process by which we relate ourselves to
the world physically and spiritually—makes him the most radical of the
pioneers of modernism. He sensed something of the sort in his last years
and referred to himself in a letter as 'the primitive of a new sensibility'.

Cézanne's work became known in Paris little by little in the 1890s and
then more generously after 1900. The year after his death, in 1907, there
was a large commemorative display of his paintings at the Salon
d'Automne and an exhibition of his watercolours at the Gallery
Bernheim-Jeune. About this time some of his letters were first published.
In them artists found a range of advice and general exhortations, to which
they tended to give meanings the writer may not have intended. Many of
them picked on the reiterated instruction to 'Treat nature according to
the sphere, the cone and the cylinder', unconsciously sometimes added
the missing cube, and quoted it to argue for an art of geometrical forms,
figurative or even abstract. In fact it could also be seen as standard
academic advice to a young artist whose drawing showed little under-
standing of the character of the forms before him. In some of his later oil
paintings, and more obviously in his last watercolours, painters could see
him recording forms by juxtaposing small planes or facets, representing
visually dominant parts of objects and also surfaceless things like the sky,
and setting them down like tesserae in mosaics. These could have a
geometrical character, or stress the geometry of the motif; they could also
serve as pictorial stepping stones to link different parts of the motif into a

serviceable composition. Some of Cézanne's admirers made Cubism out of them and long wrestled with the contradictions they brought with them. But around 1907 the greater number of Cézanne's disciples attached themselves to quite another part of his work, to the *Bathers*. He had done small paintings of groups and single figures for some years but in his last decade produced three large paintings that he saw as his most important productions. Matisse had bought a small *Bathers* picture in 1899, when he could ill afford it: 'it has sustained me morally in critical moments of my venture as an artist; I have drawn from it my faith and my perseverance', he wrote of it many years after. He saw in it not planes or geometry but richness 'in colour and surface', and praised 'the sweep of its lines and exceptional sobriety of its relationships'. Above all, the *Bathers* brought back into the sphere of progressive art a type of picture that had been particularly crudely devalued by academic routine. It could once again be the apogee of artistic ambition; it also, in dealing with the relationship of human beings to each other and to nature, focused on basic concerns of art and existence.

The Swiss painter Ferdinand Hodler is rarely mentioned in this kind of roll-call of the great pioneers. Yet his work was well known in Paris and also outside France, and, especially outside France, he was undoubtedly one of the main stimuli. He too turned from Impressionism to an art which was strikingly archaic in some respects. With it he appalled the Swiss authorities and greatly impressed the art-worlds of Paris (1891 and after), Vienna (1904), and Germany. He sought in his work a 'religious harmony', which he associated with bringing out 'the resemblance between human beings'. He wanted 'large and simple harmonies' and he used large and simple şubjects. He valued the directness of the old masters, the clarity particularly of Dürer, Holbein, and the 'Italian primitives' (artists of the Early Renaissance). He observed very closely, taking great pains to find the right models and poses for his major compositions, and studied also the expressive movements of dancers. Thus he produced a series of large paintings on large symbolical themes: night, day, love, truth, and so on, addressed to people like himself, of simple origin. *The Disillusioned* is typical in its combination of naturalism 11 with compositional firmness. Variety of person and expression submits to a very strict arrangement. A similar arrangement is found in other paintings in the series—five figures set out symmetrically along the picture. Hodler used the word 'parallelism' for this use of repeating forms and lines, derived from Egyptian art and from Byzantine mosaics. Some years after painting *The Disillusioned,* which was shown in Paris in 1892 in an important Symbolist exhibition, Hodler became friendly with Jacques-Dalcroze, a professor of music who had developed a physical method, known as Eurhythmics, of studying the expressive movement of music and words through bodily exercises akin to basic, instinctive dance movements. He taught this in a school near Dresden; young Marie Rambert's role, in going to work with Nijinsky in Paris, was to impart something of the character of these exercises to *The Rite of Spring*. Soon after, Rudolf Steiner adapted Dalcroze's system to the purposes of Anthroposophical art work and teaching. Hodler, like Dalcroze and Steiner, believed that his (in academic terms) unsophisticated pictorial

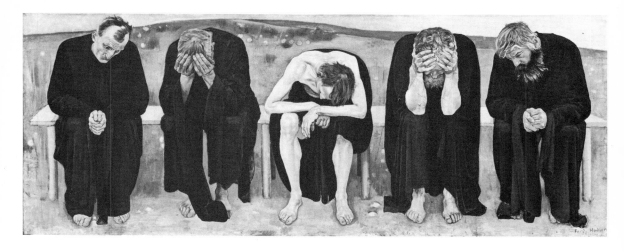

language would reach people defeated by the complexities of most art and release in them basic human qualities suppressed by the false values of modern society. We find echoes of his work in the art of Matisse, Munch, and Mondrian, as well as in German Expressionism and the better end of Soviet Social Realism. Also the brightness of Hodler's paintings, particularly in his landscapes, accustomed central European eyes to the vividness of the Impressionists before they were much seen outside France.

Charles-Louis Philippe's words are heard again in a very different context when Ludwig Hilberseimer, the German architect and town-planner, used them in 1925. He was writing an introduction to a catalogue of a newly-formed collection of mostly abstract and Constructivist art, and looked back on the process of renewal which had led to this thoroughly modern art. 'Our need now is for barbarians. The essential thing is to have lived close to God and not to learn out of books. The time for delicacy and dilettantism is past. The time of passion begins. With these words Charles-Louis Philippe outlined sharply the spiritual physiognomy of emerging Expressionism. The barbaric was a means for the rejuvenation of art.' That rejuvenation, he felt in 1925, had at last been achieved, the barbarians had done their work; perhaps he felt also that that barbaric work had been echoed in the bloodier achievements of the first world war and in the disruptions and reconstruction that followed it in Germany and Russia.

'Expressionism' was first used to imply the reverse of Impressionism, to indicate the rejection of Impressionist priorities in French art. In Germany it was used especially broadly to refer to all art developments since Impressionism, but it was in Germany, too, that it was given a more specific role, though still a broad one. It was associated with an undefined tendency, in music and literature (poetry and the theatre especially) as well as in art, to use subjects and means as forms of personal expression. Expressionism was concerned with moving the spectator emotionally and spiritually through a markedly personal vision of the world, com-municated through anti-naturalistic forms and colours. The first concerted appearance of paintings that had this character was, however,

11. Ferdinand Hodler: *The Disillusioned.* 1892. Oil on canvas, $47\frac{1}{4} \times 117\frac{7}{8}$ in. Berne, Kunstmuseum

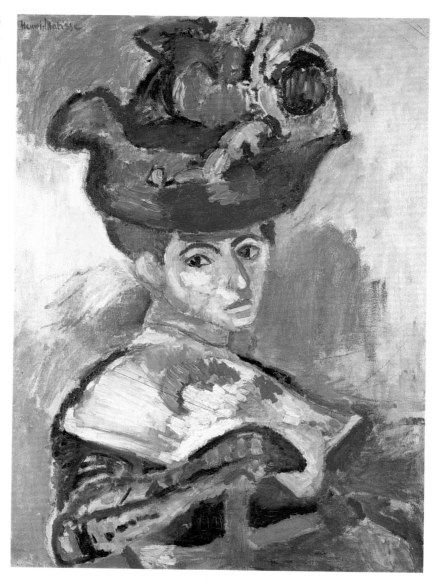

12. Henri
Matisse: *Woman
with the Hat*.
1905. Oil on
canvas,
$31\frac{7}{8} \times 25\frac{5}{8}$ in. San
Francisco, private
collection

in Paris. The Salon d'Automne of 1905 included a roomful of paintings by Matisse, Rouault, Vlaminck, and others. Because of the bright and often unnaturalistic colour they used, and their assertively unrefined manner of putting it on the canvas, one critic called them wild beasts in his review, *fauves*. The name has stuck, and historians speak of Fauvism as the first of the great movements in modern art. The artists embraced by it were not closely interrelated in their ideas or methods, and developed in different ways soon after this public appearance together. As in the case of Impressionism, we must make some effort to understand how their art can have seemed so offensive when it was first shown.

One of the paintings in the exhibition was Matisse's *Woman with the Hat*. The subject had nothing offensive about it: a lady (Matisse's wife, in

12

fact), seated in quite an elegant position (actually posed rather like a fashion model) and wearing a hat that might have seemed a little extravagant in a formal situation but would have done splendidly in the Bois de Boulogne. It was, clearly, the way Matisse represented her that made the painting seem an affront—to the sitter and to the public. His colours looked nonsensical to those who read them for information: was the sitter's hair really red on one side and green on the other, and was her face really streaked with lilac, green and blue? And then the brushstrokes themselves suggested uncaring haste. Today we are less intent on finding a one-to-one relationship between each part of a painted object and its normal appearance; we are also more aware that if we look at things with the care and the analytical eye of a painter, instead of assuming that we know what things look like, we see in them all sorts of colour effects that would otherwise have escaped us; and we have learned that, rather than question the details of a painting on their veracity, we should see the whole painting and let the interrelationship of the brushstrokes, the colours, of figure and background, of the relative scale of the parts, and thus the combined effect of all elements, make their impact on us. What seemed a caricature at the time was for Matisse a means of achieving vividness, and if there was an emotional statement in the work it probably had to do with the painter's love of women, colour, and ornament. The painting is not an affront but an expression of pleasure and visual excitement.

13 Rouault's painting, *Monsieur and Madame Poulot*, was inspired by a novel written by a severe critic of society, Léon Bloy's *The Woman who was Poor* (1897). Rouault knew the author and admired him, and painted

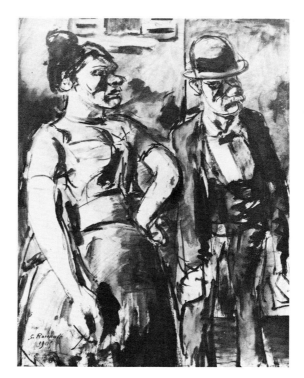

13. Georges Rouault: *Monsieur and Madame Poulot.* 1905. Watercolour and gouache, $27\frac{1}{2} \times 20\frac{1}{2}$ in. France, private collection

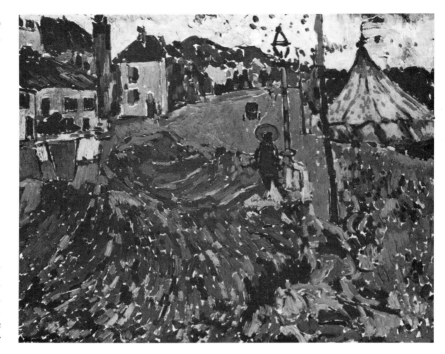

14. Maurice de
Vlaminck: *The
Circus*. 1906. Oil
on canvas,
$23\frac{5}{8} \times 28\frac{3}{4}$ in.
Basle, Galerie
Beyeler

this picture in homage to the book. Bloy hated it. He saw in it nothing but
'atrocious, vengeful caricatures' and later accused the painter—one of
the most deeply sympathetic to human suffering—of being 'attracted
only by what is ugly'. Certainly Rouault's couple is close to caricature in
the sense that he had stressed some of the figures' aspects in order to
characterize them firmly, and it may be that they did not match their
inventor's conception of them. But what Bloy and others hated was again
the rough and apparently cursory manner in which the figures are
presented. The brushwork, the gloomy colours, the entire scene lacks
grace or charm. Yet Bloy's novel too was quite without allure, and behind
it stood of course a considerable tradition of critical, condemnatory
fiction, in which no one would have expected to find the pleasures
associated with more entertaining sorts of writing. Behind Rouault's
picture stood relatively little painting and that not so well known and not
admired (Daumier's and Toulouse-Lautrec's, for example). We have
here an instance of a curious prejudice which still troubles modern
society: that people will grant liberties or, better, opportunities to one
medium that they will not countenance in another. The implication in
this case is that ugliness may be described in words but not shown in an
image.

A third Fauve was Vlaminck. Unlike Matisse and Rouault, he was at
least partly motivated by that desire to shock of which artists are too often
accused. At least, he wanted to make a strong personal statement that
would go against the grain. Yet the typical Vlaminck painting of this time
is a landscape, so that again it must be the manner rather than the subject
that is to carry his statement, and that statement must be a generalized
one. His colours blaze *fortissimo*; his brushstrokes attack the subject

14

rather than build it; his message would seem to be about energy, about being alive and experiencing the world in a very positive way. This makes his work comparable to that of some of the German Expressionists. Like them, he had not bothered with an art training. He was proud not to have had his artistic personality tampered with by an academy, and he (wrongly) recognized in van Gogh a kindred spirit. He even boasted of never having been inside the Louvre.

Vlaminck had, however, been inside the Paris Trocadéro, where the former Museum of Ethnography and Anthropological Gallery (today combined as the Musée de l'Homme) displayed primitive artefacts from Africa and elsewhere that excited him as works of art. He had, about 1904, acquired two or three African statuettes; not long after someone gave him two more figures and a mask. His friend and fellow Fauve, the painter Derain, bought the mask from him, and it was in Derain's studio that, according to Vlaminck, Matisse and Picasso first saw African sculptures. Matisse himself formed a substantial collection of primitive works, perhaps beginning as early as Vlaminck; some contemporary accounts suggest that Picasso first saw such things in Matisse's studio. Perhaps the details do not matter; the Trocadéro was there for anyone to visit. Yet the desire has to be seeded somehow and here a colleague's interest may be decisive. It was at this time still relatively rare for artists to look outside their high art inheritance, and it must be stressed that most African carvings are in sharp contrast to the traditions of European art. Whoever it was who first saw, and made his fellow artists see, the power of this strange, remote and in a sense timeless art opened up a rich vein in the world's goldmine of creative art—to all of us, in due course. And it looks as though Matisse and Vlaminck, two very different men, share the honours in France. In Germany it was the painter Kirchner, also in 1904. (The first book to discuss African carvings as art was *Negerplastik* by the German art critic Carl Einstein, published in 1915. In 1916, in New York, Alfred Stieglitz's magazine *291* printed an essay on 'African Negro Art: its influence on modern art', written by Marius de Zayas. Stieglitz had shown African sculpture at the '291' Gallery in 1914;

15

15

15a (left). Fang mask. 19 in. France, collection of Geneviève Taillade (formerly owned by André Derain)

15b (right). Téké mask, Gabon. $11\frac{7}{8}$ in. Paris, collection of J. C. Bellier (formerly owned by André Derain)

de Zayas was presenting New York's second African exhibition at his recently opened Modern Gallery. From about 1910 on African art could be seen alongside nineteenth- and twentieth-century paintings and sculpture at Paul Guillaume's gallery in Paris; his book, *Sculptures nègres*, was published in 1917.)

It is usual to stress Picasso's debt to African sculpture, but it seems apt that it should have been the 'wild beasts' who first responded to the work of distant tribesmen. They saw these carvings as intensely dramatic objects, forbidding initially because of the distortion of face or figure but soon revealing potent harmonies within their strange idiom and even an attractive and convincing element of naturalism. They learned from them the value of working in direct response to the nature of the material. The European sculptural tradition depended almost entirely on over-coming the limitations of the materials; here was an alternative tradition that seemed innocent of artifice and hence more vigorous in expression.

Matisse did not go on wielding his brush so roughly. While the much criticized portrait of his wife was hanging at the Salon d'Automne he began another, now known as *Madame Matisse: the Green Line*. This is a 16 vehement work too, more powerful even than the first, but now the power results from firm construction. He avoided distorting the forms in both paintings, but in the earlier one the brushstrokes and the intermitting colours seem to work against the forms as they present them. In the second painting the colours, however surprising in themselves, firmly support the forms and so do the brushstrokes: where they are vehement they serve to clarify and confirm. The hair is blue with glimpses of bright red; the background consists of areas of orange, purple, and blue-green; the face is pink one side, yellow and green the other, and a pronounced band of lime-green goes down the middle of it from forehead to chin and on to the neck. This sounds arbitrary yet the effect is convincing: a bold account of the features of a handsome woman. Another painter might have modelled the head with forceful shadows to give it sculptural presence: Matisse achieves it through colour contrasts that produce an optical tension similar to that given by lit areas and shadows. He does not have to lose part of the face in shadow or tone down the vividness of any part of his picture. African sculpture can similarly surprise us with a strong sense of mass and presence, conveyed without imitating the natural form at all closely. Moreover, many African masks propose that a face is to be understood as two broad planes either side of a central ridge. It is possible that Matisse's representation of his wife's face came directly from what he saw—from two sorts of light, perhaps: daylight on her left cheek and reflected light, tinted by whatever surface reflected it, on her right. Knowledge of African masks may have guided his reading of the face.

Woman with the Hat marked an end for Matisse; *Madame Matisse: the Green Line* marked a beginning. Before 1905 his painting, always dynamic and searching, had switched between a personal examination of the art-school tradition of figures posed indoors and modelled in terms of light and dark, and the revolutionary tradition of colour analysis and organization initiated by Seurat in the 1880s and formulated by Signac in his recent account of Neo-Impressionist ideals and methods (1899).

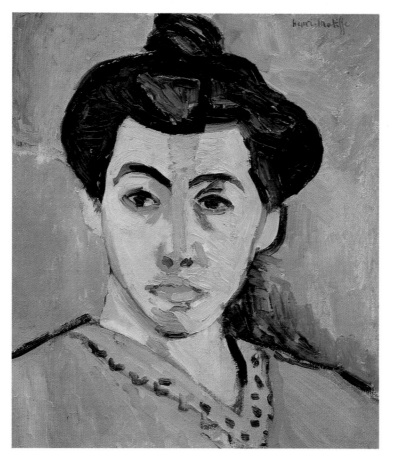

16. Henri
Matisse: *Madame
Matisse: the
Green Line*. 1905.
Oil on canvas,
16 × 12¾ in.
Copenhagen,
Statens Museum
for Kunst (J.
Rump Collection)

Woman with the Hat suggests that Matisse was breaking away from both systems; *Madame Matisse: the Green Line* that he has successfully fused them. When he wrote his first and major statement on art, in 1908, he emphasized his independence of theory: his choice of colours, for instance, is 'based on observation, on feeling, on the very nature of each experience'. His aim is expression, he says, but expression of a harmonious sort. The experience he wants to transmit has to be transformed into a pictorial equivalent for it: 'I want to reach that state of condensation of sensations which constitutes a picture'. This condensation has taken place in *Madame Matisse: the Green Line*, whereas *Woman with the Hat* suggests a fluidity, a chancy spontaneity that still belongs to Impressionism and the tradition of the sketch. Matisse's lifelong aim was to convey the keenness of his experience by giving his work an appearance of immediacy. But this appearance and the architectural strength that he thought every canvas should offer were the result of slow, cunning work and many corrections.

Another time Matisse said that what interested him was 'a clarification of my ideas' and that he had been working 'to put order into my feelings'. These words would fit most of his post-1905 work but on this occasion he was speaking of his sculpture. He frequently modelled figures, sometimes

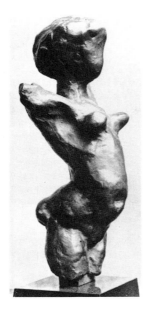

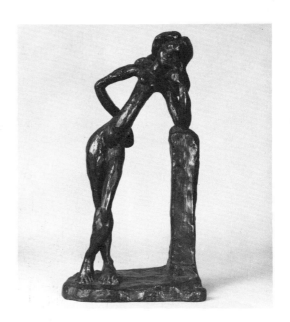

17 (left). Henri
Matisse: *Torso
with Head*.
Bronze,
height 8¾ in.

18 (right). Henri
Matisse: *La
Serpentine*. 1901.
Bronze, height
22¼ in. Baltimore
Museum of Art
(Gift of a Group
of Friends of the
Museum)

on a large scale, and he claimed that doing this helped him to understand painting better. But his sculptures are powerful works as such, not mere aids to painting. In other words, in his sculpture he sought a condensation proper to sculpture. This insistence on bringing out the essential character or needs of each particular medium is as typical of modern art as the diametrically opposed urge that we shall also meet: the urge to combine media and to demolish distinctions usually made between them. Matisse's direct forerunners in this respect were Cézanne the painter (who said it had taken him forty years to learn that painting was not sculpture) and Rodin the sculptor. In 1899, when still very short of money, Matisse bought a Cézanne painting of *Bathers* which was to be of especial importance to him, and also a Rodin bust, a small Gauguin painting and a van Gogh drawing.

Between 1906 and 1909 Matisse turned to sculpture frequently and also reached full maturity as painter. At least twenty-five sculptures date from those years, among them the little *Torso with Head*, which combines 17 Rodin's surprising invention of the incomplete figure with a thrusting, jutting pose that echoes African sculpture, and the larger figure known as *La Serpentine* (the serpentine figure). Her pose is familiar to the classical 18 tradition; in fact Matisse modelled the figure from a photograph made for the use of artists. The photograph shows a decidedly plump young lady ('a little fat but very harmonious in form and movement', said Matisse). In making his sculpture he altered the proportions of every part, attenuating the torso and arms to an extreme degree and thus giving openness and sweep to an otherwise inert form. Unlike Rodin, Matisse did not think that free-standing sculpture should represent motion: here too the end product should have architectural strength. His figure is still, therefore, but its parts are fluent and invite the eye to pass along and around the body and also out into the encompassing space. We are left with a sense not of distortion but of energy.

This is what we feel also in front of the two great mural canvases that mark the climax of Matisse's early career. A Russian businessman, Sergei Shchukin, already the owner of a magnificent collection of late nineteenth-century French paintings, had acquired eight Matisses by 1909 when he commissioned him to make two paintings to hang on the staircase of his Moscow home. These very large canvases were painted in 1909 – 10 and caused a sensation when they were shown at the 1910 Salon d'Automne. The brushwork is firm and the colours glow fiercely (a heavy red for the figures, green and a rich blue for the background). *Dance* is at once still and violent, a ring of ecstatically dancing women held for ever in their dynamic positions. *Music* is still and sonorous: the men are placed like notes on a stave. In both cases we feel that we are lifted out of our

19
20

33
The New Barbarians

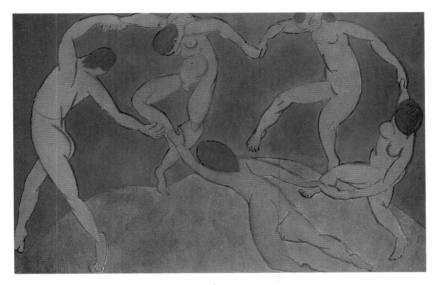

19. Henri Matisse: *Dance*. 1910. Oil on canvas, $102\frac{1}{4} \times 114\frac{1}{2}$ in. Leningrad, Hermitage

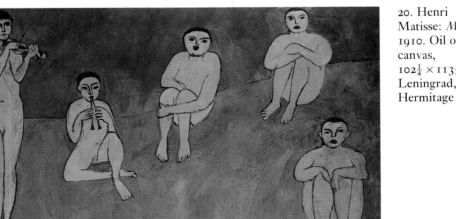

20. Henri Matisse: *Music*. 1910. Oil on canvas, $102\frac{1}{4} \times 113\frac{1}{4}$ in. Leningrad, Hermitage

civilization into some prehistoric age and are witnessing the earliest dancing, the beginnings of music. In 1909 Diaghilev's Russian Ballet took Paris by storm with dances that at times violated the traditions of ballet, and the company returned every year until 1914 to dance to full houses. Their earlier presentations were relatively decorous: it is *The Rite of Spring* that one thinks of in connection with Matisse's *Dance* and that was composed in 1912 (the year in which the Matisse canvases were installed on Shchukin's staircase) and first performed in 1913. Isadora Duncan also first danced in Paris in 1909 to wide acclaim as well as some mockery. She was in her way an expressionist with primitivist ambitions and here, one is tempted to say, was Matisse's inspiration. But a ring of dancers, much smaller but remarkably similar in arrangement to those in *Dance*, can be seen in the background of a large picture called *Joy of Life* that Matisse had painted in 1905–6. He certainly saw Duncan dance, and he later made designs for the Diaghilev company and may have been interested in them from the start, but we are told that he preferred to these stage performances the kind of dance on which both drew for inspiration, real country dancing.

Having stressed the primitive force of *Dance* and *Music*, I must stress also the long process of composing and adjusting that went into them. *Dance* echoes the earlier ring of dancers, yet the size of the mural and its concentration on the one theme meant that Matisse had to reconsider every detail. There are several preparatory drawings and also a full-size oil sketch. *Music* had to be invented almost from scratch, although a much smaller painting of 1907 with the same title provided a partial starting point. Again there is a sequence of drawings and painted sketches that show Matisse abandoning a dog, flowers, and a much more varied landscape setting in favour of the plain and powerful arrangement of the finished painting. If we study that we can see hints even in it of how he shifted his figures around until he was satisfied with them. Thus the primitivism of these two great paintings is the product of, on the one hand, themes that are timeless and common to humanity and, on the other, a process of simplification and elimination, not of a primitive style.

The men who came together as the *Die Brücke* (the bridge) group in Dresden in 1905—Kirchner, Heckel, Schmidt-Rottluff, and for a short time Bleyl—were all abandoning architecture for art. This is curious in itself because there had been something of a fashion for going the other way, leaving the luxury of art for the purposeful activity of designing useful things. Kirchner, alone amongst them, had had a short period of art training. I have already mentioned his enthusiasm for the exhibits he saw in the Dresden ethnographical collection. It is not at all clear what he and his friends knew of modern art in 1905, nor what their intentions were. The manifesto that Kirchner probably drafted and certainly produced in the form of a woodcut did not say much: 'Believing in progress and a new generation of creative as well as receptive people, we call all youth together. As youth, bearers of the future, we want to achieve freedom to live and work in opposition to old, established forces. Everyone belongs with us who, directly and without dissimulation, represents that which drives him to create.' So: youth; everyone who expresses himself openly; opposition to anything established. As an

21

21. Ernst Ludwig
Kirchner: *Brücke
Manifesto*. 1906.
Woodcut

image the woodcut was ambiguous. The left half belongs to the
established decorative fashion of *Jugendstil* and Art Nouveau; the right
half is more assertively primitivist and even hints at South Seas relief
carving. The whole print has something heavy-handed about it: not only
is a woodcut a home-made alternative to more sophisticated forms of
printing (it must have reminded those who saw it of the prints produced
in Germany at the end of the middle ages), but Kirchner was also content
to let the resulting image smack of the actual process involved. It was the
basic act of cutting into a wood block with a knife that he was
demonstrating, not his skill at doing it.

Dresden was not a major art centre then, and had not been one since
the early nineteenth century (except for music: three Richard Strauss
operas had their premières there—*Salome* in 1905, *Elektra* in 1909 and
Der Rosenkavalier in 1911), and this may be one reason why the *Brücke*
artists tried to form some sort of international association. Kirchner's
brief experience of art training had been in Munich, and it was there that
he saw a contemporary art exhibition (in 1903 or 1904) and had the
insight that seems to have provided the basic *Brücke* programme: 'The
paintings were dull in design and execution, their subjects totally
uninteresting, and it was quite evident that the public was bored. Indoors
there hung those anaemic, bloodless and lifeless studio daubs; outside
there was life, loud and cheerful, pulsating in the sunlight.' Neither this

22. Erich Heckel:
Woodland Pool.
1910. Oil on
canvas,
$37\frac{3}{4} \times 47\frac{1}{2}$ in.
Feldafing,
collection of
Mr Lothar-
Günther Buchheim

nor the 1906 manifesto gives any substantial hint of what should be done or how, only a general suggestion that art should have life and be about life.

It took them some years to find their artistic feet, and during that time they became more aware of what other artists were doing and had done: van Gogh; Indian cave painting; Gauguin and Munch; German art of the Reformation period, especially Dürer and Cranach; news of Fauvism but not first-hand sight of Fauve paintings—not systematic study or development but openness to experience. Rather like the so-called Decadents of late nineteenth-century Paris, Kirchner and his friends wanted to be artists, to live like artists, even more than to produce works of art. Hence the formation of the group (which at least partly contradicts the individualism they all believed in); hence also the desire to make contact with other like-minded artists irrespective of what their work actually looked like. Kirchner, Heckel, and Schmidt-Rottluff lived together in a somewhat poverty-stricken way that was probably not forced on them by lack of money. Their paintings decorated their rooms; they made some of the furniture themselves in an emphatically primitive way. Girl friends served as models, and sunshine and youthful energy as inspiration. By 1909 – 10 they had found an idiom that was in fair measure their own and had common characteristics; it is demonstrated most convincingly in the paintings they produced during the summer months when they left Dresden for the countryside and boldly, briskly, celebrated this existence in brightly-coloured, rough-hewn pictures. Kirchner's *Self-Portrait with Model* represents this style at its most sophisticated: vehement colours are juxtaposed (orange and blue, pink and green) and interrupted by areas or flashes of colour of a contradictory sort (the pale turquoise of her underwear, the lilac of his lips, green

22

23

strokes in both their faces). And, although this painting has obviously been constructed with greater care than usual, no doubt under the influence of Matisse, it looks as though it had been painted energetically rather than carefully, with intentional roughness and with more attention to filling the surface than to delineating forms. Kirchner shows himself holding a very broad brush.

Yet it is clear that Kirchner, Heckel, and Schmidt-Rottluff were very different artists. Kirchner was the most intense and perhaps the most gifted; certainly the most vulnerable. He suffered a physical and mental breakdown in the war and never fully recovered. Until then his art had dealt almost exclusively with the present, gaily or grimly but always vividly; after 1915 it became much more introspective and also retrospective. One of his most interesting later works is the door he

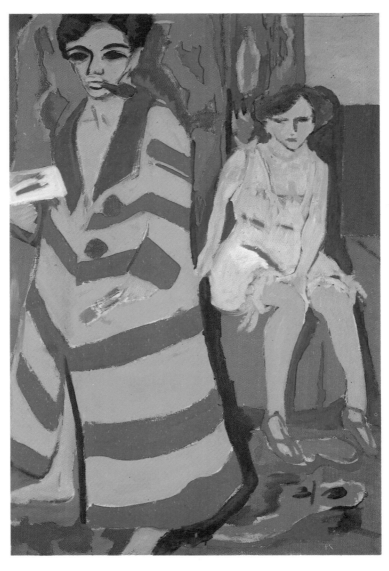

23. Ernst Ludwig Kirchner: *Self-Portrait with Model. c.* 1910. Oil on canvas, 59 × 39⅜ in. Hamburg, Kunsthalle

carved for a studio he intended to have built. One side shows a man
dancing between two women, and there is reason for thinking that it
represents himself as a young man and thus perhaps a critical review of
his own past. The other side shows the rustic life of Switzerland, where
Kirchner lived from 1918 on. The door serves as a symbol of past and
present, of the artist's hectic earlier life and the benign influence of his
present surroundings. As a carving it recalls Gauguin as well as the South
Seas, as well as European folk art and Romanesque stone carving. In any
case it shows (as in Gauguin) an adaptation of religious or ritual imagery
to personal, private-made-public purposes.

Here we touch on one of the key problems in Expressionism.
Expressionist art valued—one could almost say, demanded—strong
personal statements: 'this is what I saw, imagined, experienced; this is
how it was for me; this is how I felt about it. I, the artist, offer you this
experience because as artist I am sensitized to a special degree and devote
my life to this thin-skinned experiencing and to finding ways of capturing
it for you, the public. I am one, unique, though a part of mankind. You
are many; most of your time, your education and your work, if not your
leisure too, is designed to restrain your experiencing, to thicken your
skin. How shall I address you? Not through the conventions of European
art, worn smooth with endless use; they no longer connect with life and
do not permit me to set down my personal apprehension of it. Strong
colours, emphatic rather than accurate representation and especially
distortion in my delineation of figures will catch your attention but may
also numb your responses by making too strong an assault. I handle these
colours daily and they don't frighten me; the drawing that strikes you as
incompetent is how I want it. Yet can you learn to read it, respond to it,
especially since I have to adapt my manner continually to changes in my
situation and myself? I want you to use my art, to counter with it the
deadening weight of urban life. Indeed my insistence on a self-centred art
is only justified if it helps you to discover your true self, but, in order to
reveal myself, I have had to abandon what shared visual language there
was as a link between us.'

The nineteenth century had seen rapid developments in psychology,
and especially in the psychology of perception. What sensory and thus
also emotional effect different colours and structures have on us, or
contrasts of light and dark, open space or cluttered closeness, and so on,
can be studied and measured in a more or less scientific manner. It can
also be considered on a more tentative and imaginative level by the
psychologist who notes what roles such experiences play in our sleeping
and waking life. Both sorts of study were particularly well advanced in
Germany and Austria. Some artists were aware of this research, informed
themselves of it and even sought to develop it further; others knew of it
only through that indistinct, osmotic process whereby ideas and
knowledge percolate through the world, half understood or possibly
misunderstood but nonetheless with effect. The other development that
supported expressive aims in art was that of music: the rise of music to
being the dominant art form in central Europe and, in the process, its
increasingly informal and emotional character, and also the establish-
ment of music—that immaterial, undescriptive, directly affecting art—

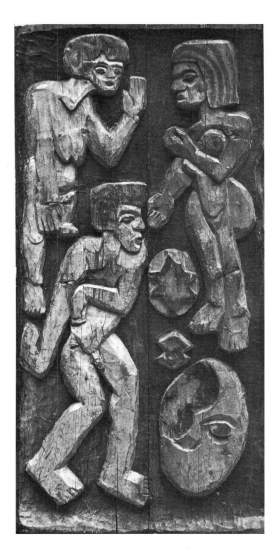

as the ideal towards which the arts should strive. This obviously implied a new role for visual art, or at least the exclusion of roles that had been considered central: it was no longer to give perceptible shape to the mysteries of religion or of kingship, nor to celebrate humanity's grandeur by illustrating fictional or occasionally factual stories in powerful and memorable form, but now it was to move, to excite, to offer models of experience at a time when true human experience and the daily life offered by civilization no longer matched or complemented each other. There is no need to make too close a comparison of the opportunities for expression offered by music and painting; pitch and quality of sound, discord, rhythm, and the relative scale of whole and parts are elements of music that have strong affective force and for which the visual arts could find some equivalents.

Support also came from something more easily hinted at than defined and of deep and wide effect (though we shall see that by no means all

24. Ernst Ludwig Kirchner: *Man Dancing between Women* and *Ascent of the Alps*. 1918. Wood, studio door carved on both sides, $70\frac{1}{4} \times 34\frac{1}{4} \times 4\frac{1}{8}$ in. West Germany, private collection

modern art relied on it). Perhaps it is best referred to by naming names: Dostoevsky, Nietzsche, Freud. Each of these stands—among many other things—for the recognition that mankind is motivated by needs and fears that have little to do with ideals of beauty and harmony or of reason. This is not the place for a fuller account of the work of each. I want merely to stress that the apparently negative preference of much modern art— substituting disorder for order, ugliness or distortion for beauty and proportion, obscurity often for predetermined clarity of meaning— represents a productive engagement with aspects of experience previously considered abnormal and not art-worthy but now recognized philosophically, creatively, and scientifically as central to humanity. The image of the modern artist is so much that of the rebel and the destroyer, and the popular image of modern art is so much that of a campaign to shock and to affront—partly, I admit, as a result of the words put out and the attitudes struck by and on behalf of the artists concerned—that it is essential to establish this point. Neither modern art at large, nor Expressionism in particular, denies the attractions of peace, order, beauty, but there were around 1900 and continue to be today forces that make for their questioning and replacing as the only goals of art. It would be possible to survey modern art in terms of a debate between those who see it as a means for offering images and models of beauty (a new beauty, possibly) and those who see it as a means for dynamizing (and sometimes dynamiting) everything that offers stability and security.

Within Expressionism itself, as we shall see, there was a comparable duality of intentions. In addition, I believe that every artist would like to refine and develop his work towards an ideal of finality and completeness, yet at the same time feels the urge to disrupt his own habits and to break his tried methods in order to see what lies outside and beyond them. The process is common to mankind and is responsible both for material progress and for the non-progressive change which is natural to art. And if, nonetheless, this seems difficult to grasp except as a negative process, that must be in part due to the fact that language itself has oddly few words to offer for the 'negative' side that are not negative words: disorder, distortion, obscurity, irrationality and so on. Oddly? Perhaps not: it is just that language too is on the side of order, of a limited experience. That is why the visual arts, once so closely intertwined with poetry and prose, have tried to break away from literature, and also why modern writers often seem to violate language in their desire to report on the chaos of life.

Dostoevsky, Nietzsche, Freud, and others provided verbal introductions and justifications for much that the Expressionists were attempting to do in art; the music of Wagner, Strauss, Mahler, and others provided a sensory analogy for their art in the privileged and reassuringly social situation of a performance in an opera house or a concert hall. In art too, of course, the ground had been prepared for many years, especially by Gauguin, van Gogh, Munch, and Ensor, but their work was still relatively unknown and inaccessible. It took some time for a public to connect with the work of the *Brücke* artists; their following grew gradually from a few, mostly local, admirers in and around Dresden, to a more extensive specialist public when the artists moved to Berlin, the capital of the recently unified Germany and increasingly its cultural

25

25. James Ensor:
*The Entry of Christ
into Brussels in
1889.* 1888. Oil on
canvas,
101 × 149 in.
Malibu, California,
The J. Paul Getty
Museum

centre. They achieved something approaching popularity after the first world war which had done much to shake people's faith in the value of conventional order, but the totalitarianism of the 1930s denounced all Expressionism as communist-inspired and monstrous. Kirchner committed suicide in 1938, a year after the Nazis confiscated or removed from German museums no fewer than 639 of his works.

That curiously negative development in the name of national order contradicted a belief to which some of the Expressionists subscribed passionately: that in casting off traditions associated predominantly with Greece, Rome, Italy and France they were uncovering and propagating elements and qualities that could be seen as Germanic or Nordic. The *Brücke* men hoped for international fellowship but also looked for leadership to a man who identified himself closely with the North and used primitive material, wherever it came from, as a means with which to counter Mediterranean classicism. Emil Nolde belonged to the borderlands of Germany and Denmark. He studied art in Munich and Paris but rapidly shed what traditional skills he had there acquired in order to evolve a primitive manner of painting, an art of the people which, he claimed, the peasants of Schleswig could readily understand. He was formally a member of the *Brücke* group for a few months only. Like his colleagues, he valued the art of primitive people above that of the old masters, with the exception only of the German artists of the age of Dürer. He felt especial admiration for the Isenheim altarpiece by Matthias Grünewald, attracted perhaps by its forceful combination of sharp realism of detail and visionary intensity. In 1911–12 Nolde painted a nine-part polyptych of the *Life of Christ*, a large uncom-

26
31

26. Emile Nolde:
Life of Christ.
1911 – 12. Oil on
canvas, left and
right panels
$39\frac{3}{8} \times 33\frac{7}{8}$ in.,
centre panel
$86\frac{1}{8} \times 75$ in.
Seebüll, Nolde
Foundation

missioned altarpiece that appalled the clergy on account of its insistent crudity and harshness. It remains an acrid work to this day, a compilation of sharp colours and grim forms, spaceless and airless, a discord resolved only by the symmetry necessitated by the format. What stylistic quotations it may contain connect it with late medieval German art rather than with the art of primitive peoples. Nolde was not a devout Christian; it was spiritual fervour of any sort that he was after, and he found it convenient to use biblical subjects, which not only brought spiritual values with them and also linked him to a long European tradition of belief, but could also be taken as a major source of all mankind's manifold and varied yet typical spiritual expressions, transcending any particular time or culture. In 1912 he began work on a book on primitive art (which seems never to have progressed beyond a few declamatory sentences). In 1913 he travelled through Siberia and China to the South Seas, recording much of what he saw in quick sketches, some of which he later developed in paintings. But his sense of one-ness with the primitives of all times and places does not seem to have conflicted with his desire to create, or rather to rediscover and to develop, a specifically German art. 'We in Germany must now create . . . a great German art, a second period—the first was in the days of Grünewald, Holbein and Dürer—the big struggle forward. I feel that I am part of this struggle and hope that the second great period of German art will come.' He joined the Nazi party very early, in 1920, hoping no doubt for a great Germany, but when that came (if it did) it rejected his art, forbade him to paint, and lampooned his great altarpiece.

Lacking an understood language, and indeed adapting its language to the emotions of a moment rather than to more stable data, Expressionism is not suited to delivering messages or information of a very particular kind. Given established subjects—bathers by a lake, the life of Christ— an Expressionist painter can show his attitude to such themes and their implications. Since his intentions are not primarily descriptive, we might assume also that he is not the ideal portraitist. Yet here we would be wrong, and perhaps this is partly because, thanks to the ubiquitous camera, we need not look to the painter for superficial verisimilitude. Kirchner's *Erna with Cigarette* is an outstanding portrait, unmitigatedly Expressionist in its use of sharp colours (yellow, green, and black), edgy

forms and assertive brushstrokes, and at the same time a convincing portrayal of a particular person in a particular setting. So strong is the painting that I find the question of truth does not arise (did Erna really look or feel like that, or are we given an emphatically personal and possibly distorted version?).

But the question of truth does arise with Kokoschka's much praised portraits of around 1909 – 10, mostly because they form, retrospectively, a series that diminishes his sitters' uniqueness. Writing about these portraits later, Kokoschka claimed he had revealed in his sitters an underlying fear which their apparent security could not assuage: 'I painted them in their anxiety and their pain.' Or were the anxiety and the pain his own? Certainly the young Kokoschka's work has cataclysmic characteristics beside which the bravura of his mature paintings seems lighthearted. The famous drawing he did to illustrate his own Expressionist play, *Murderer, Hope of Women*, is constructed of lines almost every one of which looks like a stab or a cut and feels like it too. Contradicting and sometimes parodying the conventions of academic drawing, Kokoschka gives an expressive function to each line, so that the means of the drawing carry the same affecting message as does its content. Something of this applies also to the famous portraits that came soon after—portraits of scholars and other professionals rather than of public figures. The best is that of Herwarth Walden. Its delineation is fairly naturalistic; the Expressionism resides in its scrubbed, rubbed, almost poverty-stricken manner and the sudden flashes of red marks and yellow hair in an otherwise almost monochrome and gloomy setting. In his drawings—as also in his early writings—Kokoschka set out to create his own idiom, starting from the possibilities that black ink and white

29

28

27 (left). Ernst Ludwig Kirchner: *Erna with Cigarette*. 1915. Oil on canvas, $27\frac{3}{4} \times 23$ in. Munich, Staatsgalerie Moderner Kunst

28 (right). Oskar Kokoschka: *Portrait of Herwarth Walden*. 1910. Oil on canvas, $39\frac{3}{8} \times 26\frac{3}{4}$ in. Stuttgart, Staatsgalerie

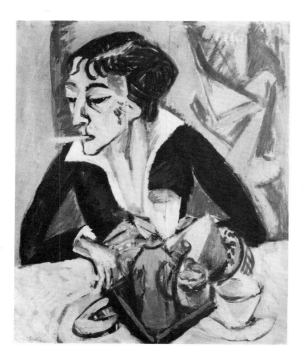

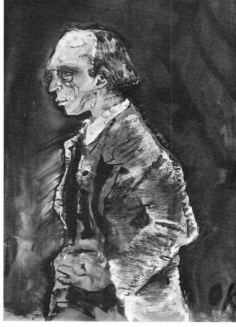

44
The New Barbarians

29 (left). Oskar Kokoschka: *Murderer, Hope of Women.* 1911 –12. Pen and brush with ink, $10\frac{1}{8} \times 7\frac{1}{8}$ in. Stuttgart, Staatsgalerie

30 (right). Oskar Kokoschka: *Portrait of Herwarth Walden.* 1910. Pen and ink on graph paper, $11\frac{1}{8} \times 8\frac{5}{8}$ in. Cambridge, Massachusetts, Fogg Art Museum, Havard University (purchase, Friends of Art and Music at Harvard)

paper—or words—offered. Compared with that, the painting has something of the character of a photograph worked up with dexterous touches of a somewhat disconcerting sort: Walden seems to appear through the marks rather than to be them. A small portrait drawing of Walden has the best of both worlds. The same marks with which Kokoschka notes down the appearance of the head also serve as notation for its tense, hyper-active character. 30

Walden was a composer and a writer who ran in Berlin, under the name *Der Sturm* (Storm), a publishing house, a cultural journal, an art gallery and art centre (with music and drama as well as lectures and readings) and an art school. He presented through these various channels the widest range of Expressionism and of modern creative work generally. Because of him, particularly because of his journal and gallery, Germans had better access to the new art of Europe than anyone else. He also found collectors for much of the art he showed. Kokoschka's *Murderer, Hope of Women* drawing appeared prominently in *Der Sturm* magazine and so did other drawings by him subsequently. Walden's first exhibition in Der Sturm gallery in March 1912 juxtaposed works by Kokoschka and by the *Blaue Reiter* painters of Munich.

Der Blaue Reiter was the name Kandinsky and Marc chose for an almanac they produced in 1912, a collection of essays and illustrations mostly about and of art but including also music. (They planned a second volume but the war put paid to that.) It gave prominence to a quotation from Goethe: he had said in 1807 that painting lacked what supported music, an established and generally agreed underlying theory. This suggests the general trend of the almanac. The academies stood for a 32

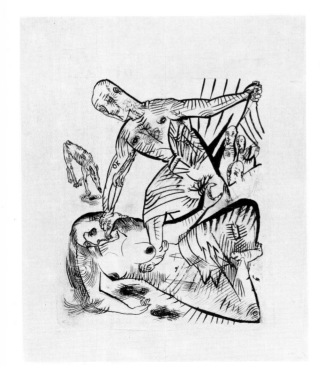

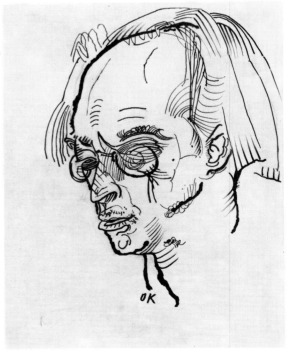

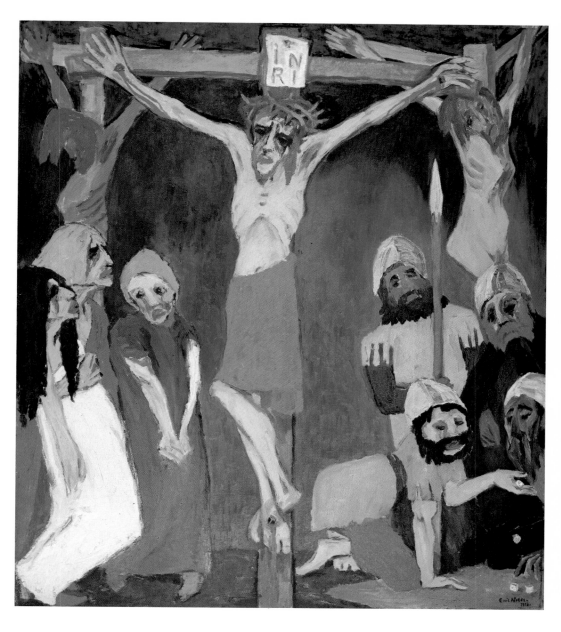

body of knowledge and beliefs from which the most adventurous artists of the nineteenth century had dissociated themselves. What basis for action did that leave? The answer, the almanac implied, lay in taking a broad survey of all sorts of art and noting what was essential and permanent to it as art and what resulted from its temporary, worldly role. What must have astonished most people who opened the book was the profusion of illustrations of things they were not in the habit of counting as art at all. Fifty of the illustrations are of European folk art, mostly Bavarian paintings on glass with religious subjects and Russian secular and religious prints. There are several pages of children's drawings.

31. Emil Nolde: *Crucifixion* (detail of Fig. 26)

32. Frontispiece
and title-page
from *Der Blaue
Reiter*, Munich,
May 1912.
Bavarian mirror
painting (redrawn
from the
original).
Woodcut by
Kandinsky.
Munich,
Städtische
Galerie im
Lenbachhaus
(formerly owned
by Kandinsky or
his companion,
Gabriele Münter)

Otherwise art of the past is represented by an archaic bronze relief, juxtaposed with part of a Gauguin painted wood relief, a Byzantine mosaic, a number of German and French medieval items, a woodcut by Baldung Grien (a German artist of the Dürer period), and an El Greco painting. Over fifty illustrations survey modern art from the Post-Impressionists on; these include a fair representation of Kandinsky, Marc, and their associates but also a rich selection of new art in France (Matisse's *Dance* and *Music*, Picasso, Delaunay etc.), elsewhere in Germany (Kirchner, Heckel, Nolde, and others) and in Russia. In addition there are sixteen illustrations of masks, figures and other objects made by primitive peoples around the globe. The fact that these illustrations were jumbled up together must have added to the strangeness of the book and perhaps to the readers' excitement.

This is our world, the almanac seems to say (and one notices the almost total absence of European art from the end of the middle ages to the Post-Impressionists). The articles include reports on new art in Germany, France, and Russia. Music makes a very substantial appearance with two articles on new ideas in music, one on Scriabin's complex recent composition for music and projected colours, *Prometheus*, and, by Schönberg, an essay on the relationship of music to texts and also, in a wider sense, to verbally describable content. It opens: 'Relatively few people have the ability to understand in a purely musical way what music has to say', and goes on to stress that the language of music cannot be

DER BLAUE REITER

HERAUSGEBER: KANDINSKY
FRANZ MARC

MÜNCHEN, R. PIPER & CO. VERLAG, 1912

Deutsch

Benin

given verbal form because it cannot be grasped rationally. Songs by Schönberg, Berg, and Webern are printed at the back. Articles by Kandinsky and Marc, and also some of the others, attempt to shift intellectual emphasis from questions of style and from celebratory accounts of individual artists such as one would find in the magazines of the period, on to questioning the nature of art. They emphasize its detachment from the real, material world and its value as spiritual, quasi-religious communication. In the same year, 1912, Kandinsky published his thoughts on this also in his book *Concerning the Spiritual in Art*. Almost instantly translated into English and Russian, the book was widely read and quoted, which suggests that its insistence on art's role as revealing the inner life of man fitted an inclination that others had felt and wished to see defined and supported. It became one of the basic texts of abstract art, and indeed Kandinsky's own painting moved into abstraction about this time, yet he argued that spiritual meaning in art could be reached equally through abstract compositions and through a poetically expressive, rather than a strictly imitative, treatment of the visible world.

The *Blaue Reiter* phenomenon contradicts what the example of the *Brücke* artists and of Gauguin may have suggested, that turning away from the high art traditions of the West and attaching oneself to primitive models means abandoning sophistication for gutsy simplicity. Kandinsky was a highly educated man, qualified in law and political economy and with a deep love of music, literature, and art. In Russia he had researched into folk art traditions, and it may have been that experience and also his contact with modern art in Moscow that led him at the age of thirty to

33. Two pages from *Der Blaue Reiter*. Tombstone from the tomb of Rudolf von Sachsenhausen (died 1371). Frankfurt am Main Cathedral. Bronze relief from Benin, then in Munich, Staatliches Museum für Völkerkunde, present whereabouts unknown

34. Constantin
Brancusi; *Magic
Bird (Pasarea
Maiastra)*, version
1. 1910. White
marble, height
22 in. Collection,
The Museum of
Modern Art, New
York (Katherine S.
Dreier Bequest)

35. Constantin
Brancusi: *Yellow
Bird*. After 1912.
Marble with
limestone base,
height $64\frac{1}{4}$ in. New
Haven, Yale
University Art
Gallery (bequest of
Katherine S.
Dreier to the
collection Société
Anonyme)

move to Munich and devote himself to painting. It is clear that he valued
primitive works not for any superficial toughness or even for their visual
energy (though he responded with gratitude to the rich and colourful
interiors of the peasant homes he visited in Vologda province), so much as
for the contact they offered with human constants: awareness of the
supernatural, the need to express joys and fears. Marc, who immersed
himself in landscape and the life of animals, came to believe that 'art in its
essence was and is at once the boldest withdrawal from nature and a
bridge into the world of the spirit'. The primitive was untainted by the
materialist values, the false and fragile glamour of Western society. There
was no need to borrow characteristics from such objects; what mattered
was that one should seek to be as unworldly and as unliterary as the
primitive artist and to use the expressive means of art directly and fully.
If there were relatively few people now who would be able to understand
painting in a purely visual and pictorial way (to adapt Schönberg's
words), primitive example showed that such people did exist in the past.

The sculptor Brancusi had similar hopes. Born into a peasant family in
Rumania but trained in the basic academic skills of modelling exact
anatomies, he came to rebel against the unquestioned domination of the
human body in sculpture. *Biftek*, steak, was his word for all those
centuries-worth of figure sculpture which the nineteenth century had
indeed brought to a lavish and laboured anticlimax. 'Don't look for
obscure formulas or mysteries. It is pure joy that I am giving to you. Look
at my sculptures until you see them. Those nearest to God have seen
them.' His mature work, from about 1910, is in several different manners
and in various materials but is marked by great concentration and a
simplicity that feels inclusive rather than merely the product of
reduction. The *Magic Bird* of 1910 is the first of a series of similar 34

34 35 36 37 38

39. Constantin
Brancusi: *Endless
Column*. 1937. Iron
and steel, 96 ft.
$2\frac{7}{8}$ in. × $35\frac{3}{8}$ in. ×
$35\frac{3}{8}$ in. Rumania,
Tirgu Jiu Public
Park

36. Constantin
Brancusi: *Bird in
Space*. c. 1924.
Bronze, height
$49\frac{3}{4}$ in.
Philadelphia
Museum of Art
(Louise and Walter
Arensberg
Collection)

37. Constantin
Brancusi: *Bird in
Space*. 1925.
Marble, stone and
wood, height
$136\frac{1}{2}$ in.
Washington,
National Gallery of
Art (gift of Eugene
and Agnes Meyer,
1967)

38. Constantin
Brancusi: *The
Prodigal Son*.
c. 1915. Oak on
stone base, height
$17\frac{1}{2}$ in.
Philadelphia
Museum of Art
(Louise and Walter
Arensberg
Collection)

sculptures, in marble and in matt and highly polished bronze, sub-
sequently further extended in a series of slimmer, aspiring *Birds* which
become ever swifter and less material. His wood carvings sometimes
suggest his native region's functional and also decorative use of timber,
and sometimes appear to have been inspired by African examples. *The
Prodigal Son* is of the latter kind. It is in no way a transcription of an
African figure—in fact it is very difficult to read it as any sort of figure—
but Brancusi's disposition of masses and voids, his incisive use of cut
planes and edges, all point to a full appreciation of the African carvings he
was able to study in Paris. The Rumanian peasants' use of timber is
monumentalized in his *Endless Column*, a metal version of a work he had
first developed in wood. Nearly a hundred feet high, it consists of fifteen
identical elements, bead-like modules square in plan but in elevation
ambiguously almost straight-edged, almost curved; at the top is half such
a module, and that at the bottom becomes a square post in order to
function as a foot. Clearly, it was not mechanical repetition that Brancusi

35
36
37

38

39

was after but rather a rich visual presence achieved by apparently simple means. According to one's angle of vision the column and its parts take on a surprisingly varying character. The shape of the modules has the effect of counteracting the perspectival diminution that looking upwards at them would otherwise produce: as the eye rises the modules seem more squat, which also means more angular and active; at the same time the total silhouette is likely to seem more zig-zag and thus more positively dynamic. The twentieth century has heard much argument about public sculpture, in answer both to man's need for monuments (lately mocked rather than met by the Victorian plethora of aldermen in bronze), and to that other, troubling need, for art to make contact with ordinary people. Brancusi's column, at once primitive and the product of sophistication and refinement, remains the only totally successful and unregretted solution.

The desire to appeal to the people at large appears to have stimulated Russian artists in their experimentation with primitive idioms—in addition, that is, to the general desire to revitalize art. Like the Germans, the Russians felt that Western traditions had covered up native traditions of art with an international veneer that was mostly of Italian and French origin and character. To rediscover the beauty and expressive power of Russian icons, and also to strengthen one's art by drawing on folk art traditions (which were current, not defunct), was to be a Russian and a liberal as well as a creatively searching artist. At the same time, as we have

40. Mikhail Larionov: *Officer at the Hairdresser's*. 1909. Oil on canvas, 46 × 35 in. Lausanne, private collection

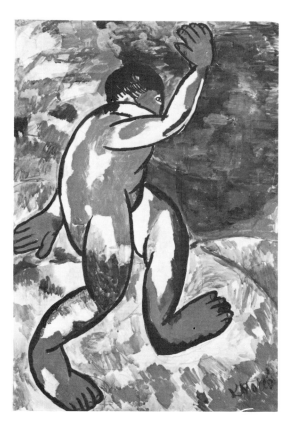

41. Kasimir
Malevich: *The
Bather*. 1910.
Gouache on
paper,
$41\frac{3}{8} \times 27\frac{1}{8}$ in.
Amsterdam,
Stedelijk
Museum

seen, Moscow and St Petersburg (the present Leningrad) were art centres with their eyes on what was new further west. Primitivist tendencies in Russia were thus both national in inspiration and

40 international in stimulus. The paintings, for example, of Larionov show for a time a self-conscious naivety of manner derived from popular broadsheets and painted shop signs and even from blunt graffiti; they must have jarred sensibilities accustomed even to Impressionist and Post-Impressionist novelties. In 1913 Larionov presented an exhibition in which his own paintings and his friends' were shown alongside icons, shop signs, folk art and child art, and popular Russian as well as Oriental prints. As in the *Blaue Reiter* almanac, a new sort of allegiance between professional art and the rest of the world was being demonstrated.

41 Malevich's *Bather* could be described as second-hand primitivism in that it appears to be based on suggestions in the work of Gauguin and of Matisse rather than on primitive material. It was one of a series of paintings in which Malevich represented urban and, more often, peasant workers; in this respect, as also in the vehement clumsiness of his manner, he was working outside Gauguin's and Matisse's range. We shall see that he was ready to drop this clumsy manner when he found an equally energetic idiom, more modern in feeling but still rudimentary in its formal character, in which to represent his workers.

I emphasized Brancusi's indirect use of some of the formal characteris-

tics of African carving. The opposite sort of use is demonstrated by Picasso, who quoted African masks more or less directly in his famous painting *Les Demoiselles d'Avignon*. Picasso's career shows that appropriating visual themes or devices from the work of others was repeatedly his way out of an impasse. Romanticism's insistence on originality would seem to forbid this kind of borrowing, but art has always thrived on art, and artists have always used and also abused ideas they got from other artists; it is of course the use to which such borrowings are put that justifies them. In the *Demoiselles* Picasso had set out to produce a major work. He had enjoyed increasing success with his earlier, poetic and pessimistic, paintings, but he now wanted to assert himself *vis-à-vis* the Paris avant garde—which meant primarily Matisse—and also to find his place among the epic figure painters of the time. Cézanne's large figure paintings were becoming known and seemed a challenge to young artists to find new solutions to the age-old problem of the large-scale figure painting. Matisse had caused a great stir at the 1906 Salon des Indépendants with a single exhibit, his large *Joy of Life*, upsetting even his former admirers. The *Demoiselles* would be Picasso's counter to both painters: female nudes, too, but in an interior; not timeless symbols of human existence in nature but prostitutes. His first sketches for the painting had made this obvious by including male figures dressed as sailors but these he cut out, perhaps in order to reduce the symbolical and anecdotal character of the scheme and also to force the spectator to find his own relationship to the damsels rather than receive it spelled out. He

43

42. Henri Matisse: *Joy of Life*. 1905–6. Oil on canvas, $68\frac{1}{2} \times 93\frac{3}{4}$ in. Merion, Pennsylvania, © The Barnes Foundation

42

had already made his idiom weightier by imitating elsewhere the forms of archaic Spanish stone sculpture, but his drawing of the women in the centre of the painting looks more like an inelegant version of Matisse's delineations in the *Joy of Life* and lacks the sculptural emphasis that he had briefly used. We do not know why he then introduced those heads on the right; we can only speculate about it. Obviously he was not satisfied with what he had done, and it looks as though he was not satisfied with it when he put it aside in 1907; his friends hated it too. Try to imagine all five figures painted in the manner of the middle two: linear rather than modelled, outlined in swift curves and sharp angles, and with faces that strike us as both ghastly and funny. I think failure stared Picasso in the face. Having set out to produce a monumental, tough figure painting, he

43. Pablo Picasso: *Les Demoiselles d'Avignon.* 1907. Oil on canvas, 96 × 92 in. Collection, The Museum of Modern Art, New York (Lillie P. Bliss Bequest)

seemed to have made a large poster of uncertain seriousness. He became, pictorially speaking, violent. He pulled about the figure on the left to give her a harsher outline and jutting planes, reworked her face to give it a primitive and partly sculptural character, roughly enlarged her raised left hand and subsequently began to do the same for her left foot. He repainted the seated figure as a frighteningly transformed version of the seated woman in Cézanne's *Bathers* (in Matisse's collection), and perhaps intended to give her and the standing figure behind her heads akin to that of the girl on the left. But he went further. He gave the standing figure, top right, a mask-like face which is clearly a free transcription of an African mask (and used similar masks to give ambiguous angular form to her chest), and then gave a flat, grossly distorted version of that to the seated woman. I cannot believe he intended to leave the painting like that. Perhaps his friends' detestation of the work drained his courage and made him decide not to rework the whole canvas in this way.

He left it unfinished and rolled it up, and thus it remained for many years. Yet in some ways it bore early fruit. Picasso had been excited by African sculpture and this excitement was to show in his next paintings as a gruffer and also more sculptural figuration, without the bitter-sweetness of his earlier work. His large *Nude in a Forest* shows how he could use the simplified, often sharp forms of African sculpture to produce a somewhat appalling addition to a traditional image associated with pleasure; the painting was in Shchukin's collection and will have been known to Malevich and his colleagues. But the *Demoiselles*, in the drapery between the figures as much as in the figures themselves, had also shown that it was possible to suggest a flickering, unstable kind of space and volume by suggesting planes by means of light and dark but not carrying them through logically. This discovery was to become one of the chief means and visual characteristics of Cubism, though it seems that Picasso had to work the African influence out of his system before he could perfect that important new pictorial language. The *Demoiselles* may also have sown the thought (once the initial shock had worn off) that perhaps it was after all not essential for every part of a painting to be in the same idiom. Coherence is a useful thing, making for clarity and calm in any kind of work of art. But, if the whole of man's wide-ranging art lies before the artist, must he always choose one narrow sector of it for his own activity to the exclusion of all others? Human experience is not as one-stream as that, as psychologists and philosophers were pointing out. In our heads the disagreeable mingles with the agreeable, the clear with the unclear, the new with the ancient. Might not art reflect this variousness and instability? A planned confusion of tongues, it could be argued, might be closer to experience than the use of one consistent language.

4

2 Reality Questioned and Answered

> The close of the past century was full of a strange desire to get out of form . . . I now feel an impulse to create form.
>
> Yeats, 1903

Primitivism implies a reaching out to sources at once new and ancient, the quest for a timeless world in order to redress the cultural balance. It also implies a reassessment of first principles. What is art for? In what ways does it affect us? What must art's mode of communication be? The Greeks had posed these questions, and their answers had been fruitful enough to serve until now. Art, they said, is a method of instruction through delight, and its mode is imitation and idealization of the visible world. The exotic and primitive artefacts now studied testified to other principles; in particular, they ignored, in varying degrees, the law of imitation. If one admired an African carving it was in most cases in response to its dramatic reformulation of the natural object, to the expressive, often rhythmic action of its forms as such. The evident communicative power of shapes and colours, with or without references to the visible world, suggests that all men share a submerged language, primitive and essentially poetic, that is in the long term more powerful than the contingent language of current discourse, and of which art can avail itself much more whole-heartedly than it had done in the past. To compromise this power of sensory communication by making a work of art function also as a description or a narrative now came to seem like pulling one's punches. Had not photography and the film been developed to fulfil those functions more efficiently than painting had ever done?

Yet to this day most people still demand that a picture or a sculpture should be of something, and preferably of something likeable. To abandon this function seemed a dereliction of duty. Many, artists included, felt that representation must always remain the basis of art. Even Picasso, endlessly experimental and challenging as he was to be, rejected an art of pure abstract form. A barrier arose between representational and abstract or non-representational art, a barrier that still remains. Voices were and are still raised on both sides; there continues to be much heart-searching in both camps. Each prophesied the collapse of the other. Both survive, possibly strengthened by the test. Yet the opposition was and is false, tending to draw attention away from issues that are more pressing.

Photography's role was much more complex than is usually allowed. When photography was invented, around 1840, some were convinced that it would rapidly usurp the role of painting. Instead, painters used photographs as aids and also found in them exciting new effects of composition, light, and space. But if photography did not kill painting, it

did devalue those kinds of painting whose primary function was that of accurately recording appearances. Portrait painting is an obvious example: it survives, but with much diminished vigour. The press photographer serves us better than the 'artist' whose 'impressions' would have appeared in the illustrated papers of the mid-nineteenth century. Similarly, the cinema and television convey narrative so effectively that the history painting, the highest achievement of Renaissance art and long the apex of academic ambitions, has almost entirely disappeared. Perhaps another way of saying all this is to suggest that the creative talent and intellectual aspirations that once went into history painting today go into film and that film, too, is where the public for narrative art is to be found.

Photography has also changed our way of seeing, our use of the stimuli that reach the brain from the retina. The flood of photographic images that now surrounds us has largely removed the ancient sense of the image as an inherently valuable thing, possibly charged with supernatural powers. At the same time these images have become our unconscious yardstick of visual truth, even though we all know that human sight is binocular and selective whereas the camera is monocular and unselective. Moreover, that unselective monocular seeing is purely visual. Human sight mingles all sorts of foreknowledge with what the eyes perceive: we see far and near, hard and soft, cold and hot, comforting and threatening, beautiful and ugly, fast, slow and static objects, without pausing to distinguish between visual data and conceptual interpretation. Human sight is especially closely associated with the sense of touch, and the artist's seeing-and-making involves a particularly close unison of eye and hand. Such associations have been weakened in us by our continual reliance on photography—a particular instance of a general tendency to interpose contrivances between direct experience and ourselves: not just camera and cine-camera but also record and tape, the invisible energy we use for light, heat, transportation etc., perhaps even gunpowder and printing. Whatever we have gained and lost, these aids have left a special role to art as directly expressed experience, and while they have encouraged some artists to use art to create objects not indebted to the visible world, they have led others into representing the visible world more forcefully and also at times more accurately than the machines can manage.

It is not possible to delineate the emergence of abstract art satisfactorily. Too many factors were involved in it, too many definitions have to be found. But in the work of Picasso and Braque, especially their paintings of about 1909 to 1911, the issue of figuration versus abstraction first becomes a conscious matter. This work is called Analytical Cubism, and though the term like most such shorthand labels is misleading it permits us to refer to that phase or kind of work quickly. (The term implies methods of dissection and rational enquiry not evidenced by the works.)

The *Demoiselles d'Avignon* had produced a kind of partnership between Braque and Picasso. For a time they lived in the same building and saw a lot of each other and each other's work. They were very different men yet it can be difficult even today to attribute their paintings of those years to one or the other of them on appearance alone. Braque

44. Georges Braque: *Guitar and Accordion*. 1908. Oil on canvas, 19¾ × 24 in. France, private collection

said later that they were 'like two mountaineers roped together'. The subjects of their Analytical Cubist paintings were almost always studio subjects: still lifes mostly, sometimes sitters with objects. The titles we know the paintings by were provided by the dealer, for reference purposes and to help us look at them. The same or similar objects and groupings occur again and again. An early example is Braque's *Guitar and Accordion* (1908), probably the first of their series of musical still lifes. Both men owned musical instruments, but the picture suggests that Braque painted it from imagination and not from a group of objects set up on a table for the purpose. Out of knowledge rather than seeing, then, and that knowledge would have included a familiarity with eighteenth-century French still-life painting and its echo in the carved or moulded decorative reliefs which served as accents in fashionable Rococo interiors.

It is generally true to say that Picasso and Braque's Cubist paintings were done without reference to models. This has to be stressed because Cubism is said to have sprung from the art of Cézanne and to involve the representing of objects from several different viewpoints. Cubist paintings do at times remind us of those Cézanne paintings and watercolours in which objects seem to be faceted by his broad, juxtaposed brush-strokes. But Cézanne sought to represent his subjects unambiguously, giving proper value to their physical existence and to the spaces between them. With rare exceptions he spent long hours studying his motif in order to fit it to his canvas. Picasso and Braque had no comparable concern for the subjects of their paintings. Their regard for them seems to have been playful rather than passionate; their attention centred on their pictorial language.

The instruments in *Guitar and Accordion* are recognizable enough (but

44

would not *Mandolin and Accordion* be a more accurate title?). We see also the sheet music and can guess at a table top and a curtain or corner closing the scene on the left. Not many months later Braque painted *Violin and Palette*. Here the violin has been sharply transformed. It has something of the wholeness still felt in the mandolin of the earlier picture, but now this wholeness has been disturbed as though invaded by the corners and pleats of the accordion. To right and left of the violin are zigzagging planes that represent nothing specific but recall the flickering curtains of the *Demoiselles d'Avignon*. Higher up there is the music—some of the staves seem to be detaching themselves from the paper they are printed on—and the palette hanging on a nail. That nail belongs to a different kind of picture. It is the only object here that is stated unambiguously. We can tell what it is, where it is, its angle to the wall, and also its size, and we can see that light is falling on it from somewhere higher up and to the right. Thus the nail asserts a kind of reality that is intentionally withheld in the rest of the painting.

Picasso's *Man Smoking a Pipe* (1911) represents a further step in what

45

46

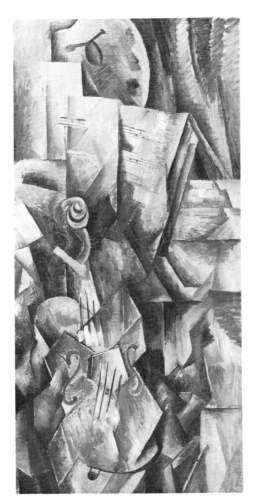

45. Georges
Braque: *Violin
and Palette*.
1909 – 10. Oil on
canvas,
$36\frac{1}{4} \times 16\frac{7}{8}$ in. New
York, Solomon
R. Guggenheim
Museum

is beginning to look like an argument between art and reality. It is difficult to find the man (at the time, without the practice we have all had, consciously or not, it must have been almost impossible). When we have found his head and pipe we can start deciphering the rest. He is seated; his hands are holding some paper near the bottom of the canvas. Some of the shapes that surround his interrupted triangular silhouette could belong to his chair. To his left there seems to be a square bottle and also a piece of paper with letters on it that may be part of the word JOURNAL; the letters *est* (east) suggest that there may be posters or notices on a wall behind them. Those letters, like Braque's nail, are quotations from everyday reality. The rest, in contrast, is a fairly loose compilation of signs and signals that belong to a system only remotely connected with representing reality. Or should we say *systems*? The man's pipe and moustache are shown quite clearly though summarily; they have some physical presence in the painting. The square bottle is indicated by linear signs that tell us something about the bottle but do not represent it physically. Other signs of the same sort occur elsewhere to suggest parts of the face, arms, chair, and so on. They are clearly visible, though we may not be certain to what they refer. The rest of the painting consists largely of sharp-edged planes painted to look as though they tilt this way or that according to their light and dark tones. Line and tone often go together, but there are places where tone is left to suggest a tilted surface by itself, and others where lines ignore tonal change and resemble a wire-like structure hanging in space. The effect of the painting taken as a whole is that of an unstable, flickering arrangement of shapes and hieroglyphs that attract our eye more on account of their inherent qualities than because of any relationship with the visible world. As long as we worry about the subject-matter that painting is little more than a conundrum.

But did Picasso set out to paint a man with a pipe, a newspaper, and a bottle? Or did he perhaps start building a composition from his mental kit of planes, lines, signs, and quotations and only gradually arrive at the subject that becomes a title? Where did his and Braque's own interest lie? What they said about Cubism is far from conclusive except on one point: they were working within the tradition of painting and they were doing something new—'seeking a new expression', as Picasso put it retro-spectively in 1932. What the recent tradition of painting offered them was roughly this. Courbet, Manet and the Impressionists had in their different ways asserted that it was the job of painters to represent the real world directly and exclusively. Seurat and Cézanne had found it necessary to process reality through a controlling method or through an intuitive process of integration in order to arrive at a pictorial wholeness they found essential. Other painters of the 1880s and 1890s had taken a lead from poetry and turned against reality: art's business was with dream and fantasy, not with the everyday world, and it progressed by refining its means of expression. Gauguin is the best known artist associated with this tendency, which is called Symbolism, but he is not typical of it: most Symbolist painting aimed at hyper-sophistication, not primitivism. As Cubists, Picasso and Braque belong to the Courbet-Manet-Impressionism tradition of taking the ordinary world as subject. Yet they also felt, following Seurat and Cézanne, that objects and their settings

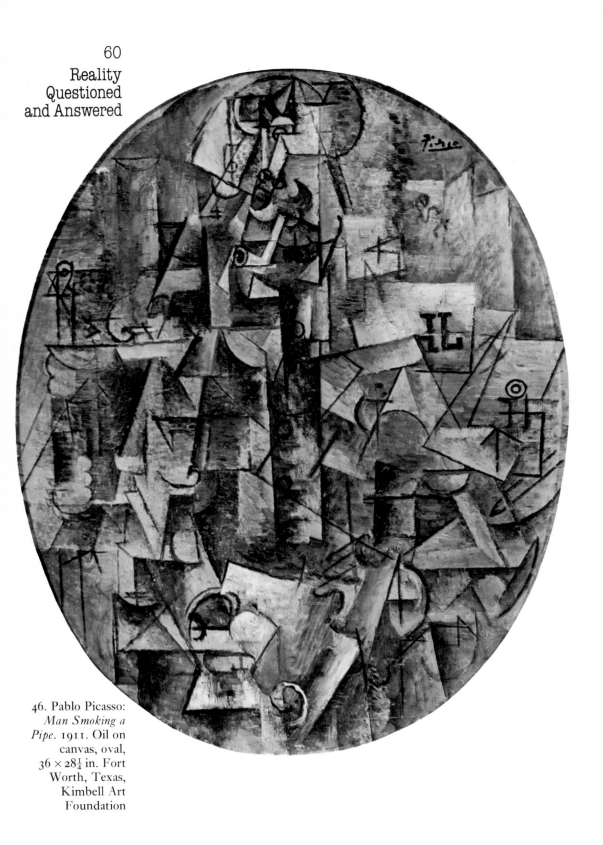

46. Pablo Picasso:
*Man Smoking a
Pipe*. 1911. Oil on
canvas, oval,
$36 \times 28\frac{1}{4}$ in. Fort
Worth, Texas,
Kimbell Art
Foundation

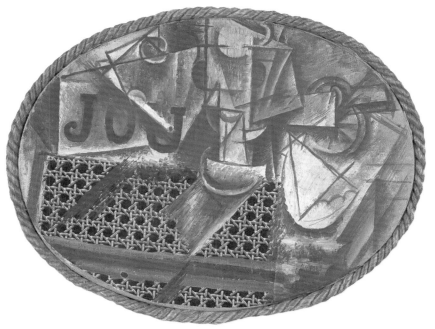

47. Pablo Picasso:
*Still Life with
Chair Caning*. May
1912. Oilcloth and
oil on canvas, oval,
$11\frac{3}{8} \times 14\frac{5}{8}$ in. Paris,
Musée Picasso

had to be restructured on the canvas if a picture was to have character and
strength as a painting. Their acceptance of only a very small part of the
world, their limiting of their subject-matter (with rare exceptions) to a
studio-centred, almost agoraphobic, smallness of range recalls Sym-
bolism, as does their concentration on language at the expense of subject.
In Symbolist poetry in particular we find comparable combinations of
mysterious and enticing structures that afford only glimpses of external
reality.

The 'new expression' that Picasso and Braque had achieved very
quickly became a springboard for a variety of developments in
international art and design. We can point to some of the reasons for this
effectiveness: the importance of Paris as a centre for artists and patrons,
the existence of an inner circle of young artists close to Picasso and
Braque who were eager to make their own contribution to this new idiom,
the existence of writers (poets mostly) who supported it with useful
(memorable and adaptable, but not necessarily accurate) explanations.
The world, one is tempted to say, was ready for Cubism, and Cubism was
what it was ready for because Cubism was strikingly new yet brought
together divergent strands from the recent past. The remarkable
collaboration of Picasso and Braque is itself illustration and symbol of
that; the vigorous and ambitious Spaniard much of whose previous work
had been Symbolist in character, and the Frenchman, gentler and quieter
and with much of the craftsman about him, whose earlier work had been
more or less realistic. Much of this effectiveness also stemmed from the
fact that Cubism offered a range of freedoms: the freedom to abandon the
ancient duty of imitating reality more or less directly, and the freedom to
find new languages or combinations of languages in order to present

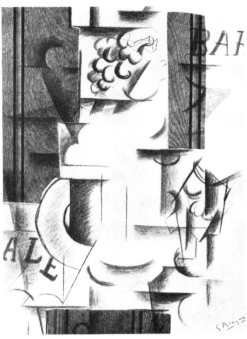

novel views of the world. It is typical of those years that these freedoms tended to be seen as a discipline.

In 1912 the work of Picasso and Braque changed fundamentally. The name given to their second kind of Cubism, Synthetic Cubism, implies that the works are created through a building up of separate elements originating in art or artifice and not in nature. The art of painting is, conventionally (in English and French, for example, also literally), the art of putting paint on a surface. When Picasso did his famous *Still Life with Chair Caning* (May 1912) he used a piece of printed oilcloth for a third of the picture, as the surface on which his Cubist objects, newspaper, pipe, glass, and so forth appear to be placed. Braque, in his *Man with a Pipe* (September 1912), used charcoal for the man and wallpaper printed to look like wood panelling for the background. At the same time he produced *Fruit Dish and Glass* with the same materials and in much the same idiom except that the naturalistically sketched grapes suggest a conflicting reality. The printed paper, like Picasso's oilcloth, asserts itself as the most realistic and reliable part of the picture, yet we know it to be a lie. This game with languages can be taken even further. Braque's *Still Life with Playing Cards* (1913) looks like a more elaborate version of the last picture, and in a sense it is. But everything in it is paint or charcoal. The areas of wood are not printed paper but have been painted and grained with a decorator's comb to look like imitation wood. A lie about a lie—as though to remind us that all representation in painting is a lie, as Plato had warned the world long ago. Picasso took the game further still. The violin in his *Bottle, Glass and Violin* (1912−13) is made partly of charcoal lines, on a piece of newspaper and on the sheet of paper which is the picture surface, and partly of a shaped and stuck-on piece of imitation

47

48

49

50

51

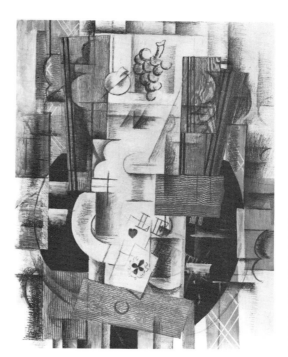

51 (below). Pablo
Picasso: *Bottle,
Glass and Violin*.
Winter 1912–13.
Pasted and
pinned paper
with charcoal,
$18\frac{1}{2} \times 24\frac{3}{8}$ in.
Stockholm,
Moderna Museet

50. Georges Braque: *Still
Life with Playing Cards*.
1913. Oil and charcoal on
canvas, $32 \times 23\frac{5}{8}$ in. Paris,
Musée d'Art Moderne

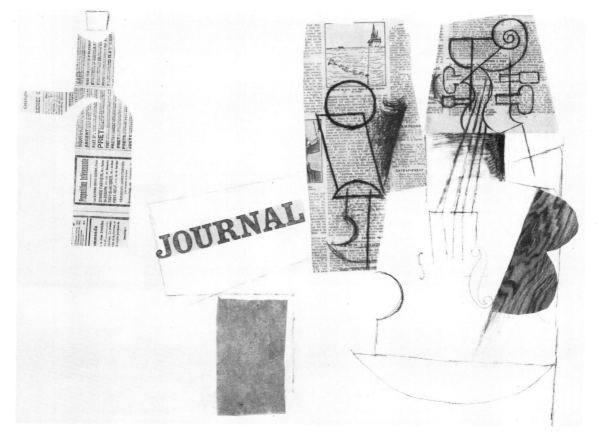

wood. Next to it, on another piece of newspaper, which also helps to outline the violin with its cut edge, is a sign for a glass. The bottle on the left is cut out of newspaper. The letters JOURNAL are pasted on but the newspaper they belong to is indicated merely by an outline. Where is reality now? The physical presence of each object in the picture is roughly the opposite to that which each has in life (transparent glass, wooden violin, folded newspaper), and everything is spread out so as to leave us ignorant of their interrelationship.

Faced by such a work one has the option of stressing its novelty, with delight or disdain according to taste, or its deep involvement in tradition. Perhaps the novelty is more obvious. The use of materials from outside art's conventional store and also from what one would tend to think of as inferior realms; playing fast and loose with reality not in order to attain idealized beauty but for the game's sake; using conflicting kinds of information in one picture; generally repudiating all notions of painterly skill by the use of collage (from the French *coller*, to glue, to stick together); the now complete dismissal of the convention that the picture surface should appear to the viewer like a window pane through which he looks into an illusory space. But of course there had been sorts of painting, such as medieval art and stained-glass, that showed little interest in creating illusions of space. The later nineteenth century shows repeated instances of painters—Gauguin, Puvis de Chavannes, Rossetti, Seurat, and Cézanne—who sought to reduce or cancel out spatial effects. Art has always toyed with reality, and has often felt it its duty to transcend nature and also to reorganize nature for the sake of pictorial wholeness. The realism represented by Courbet, Manet, and Impressionism was as exceptional as the nineteenth century's liking for an art rooted in naturalism of treatment if not of subject-matter. Mixing different sorts of visual information in a painting is certainly against Renaissance tradition (though we can find instances of it there too), but not against the conventions of medieval or, say, Egyptian art. There is precedent for a multiplicity of materials in the old practice of enhancing the value and effect of a painting by affixing jewels or by cladding it in gold or silver. For the use of common materials such as newspaper there is another kind of precedent: the painter's trick of trying a piece of paper on his canvas as a way of testing the effect of a particular shape or colour. Picasso and Braque may well have used paper shapes in plotting the larger forms in their Analytical Cubist paintings. To leave such a piece of paper permanently in place would have seemed only a small step that fitted in well with their playful attitude to representation.

The poet Apollinaire welcomed collage as a technique particularly suited to conveying the life experience of a modern city dweller. Until his death in 1918, he was an ardent and vocal champion of new art, but this particular enthusiasm suggests something more specific. All the arts were looking for new methods, 'new expression'. Collage, in the wider sense of composing a work by bringing together disparate elements and accepting the discontinuous texture that results, can be found in one guise or another in all the arts. Apollinaire collected bits of overheard speech in order to juxtapose them with his own formulations in his poetry. Pound and Eliot used direct and indirect quotation from a great range of sources

in their poems. Joyce's *Ulysses* is a vast composition in which this sort of collage is combined with significant changes in language. In music composers experimented with adding alternative sources of noise to the time-honoured but not especially ancient instruments of the orchestra. They invented noise machines and also introduced specific, recognizable sounds such as those made by typewriters, telephones, police whistles and those splendid new electric car horns, klaxons (launched by a firm of that name in 1914). The film, a new kind of entertainment, was ambitious to establish itself as an art form at least equal to the theatre (on which it had depended all too closely) and was beginning to find its essential means as an assembled work, free to ignore limitations of space, time, and sight. People to whom Cubism seemed a dereliction of duty rapidly learnt the language of montage (French for putting together) and accepted as perfectly comprehensible an art that combined photographic realism of parts with firmly anti-naturalistic composition. In short, discontinuity and the conscious use of disparate idioms (often reached by introducing elements from everyday reality directly into a work) become conventions of modern artistic expression, and here Cubism led the way.

These new conventions are often associated with developments in physics, especially with the recognition that the atom is not the irreducible unit of matter after all but is itself a bundle of electrons, protons, and neutrons moving in space, and with Einstein's theory of relativity and equation of mass with energy. Few men outside the world of science can have had more than the most general notion of what these discoveries and hypotheses meant. Today we are reconciled to the fact that the sciences are out of reach of most of us. In the nineteenth century, however, scientific progress was often the work of people with only a broad and largely classical education for their platform, and their findings were shared with many similar people through journals, lectures and demonstrations. By about 1900 science, as that wise man Henry Adams noted, was becoming a mystery dedicated to replacing the concept of an ordered universe with one of disorder and incessant change. In his *Reminiscences* (1913) Kandinsky wrote that 'the disintegration of the atom was to me like the disintegration of the whole world'. The French philosopher Bergson reached a wide international public with his anti-mechanistic view of our understanding of the world in which reason played little or no part, and intuition responded creatively to the stream of information and ideas fed to it by consciousness and the memory. Mass, location, space, and time could no longer be received as the absolutes they had once seemed to be. The artist could respond to this in a variety of ways: he could try to find images for this discontinuity and complexity; he could seek to build models of man-made order and offer them as metaphors for the new social order that was needed in this much-changed world; he could turn inward to explore unconscious areas that are permanent and inalienable; he could ignore change and continue to give his attention to natural beauty, making truer and possibly more energetic representations than before; and he could attach himself to the comforts of past art, offering his public a sense of security by upholding time-honoured values and screening it against the new.

One would like to be able to say that this new world was what Cubism

was about. But so absolute a statement would be inept. Whatever Picasso and Braque may have gathered about new insights into physics and phenomenology, it was art they were making and what they made was a response first of all to the art that already existed, their own and others'. It is striking that the objects symbolic of the new world, such as cars, aeroplanes, the Eiffel Tower and other familiar engineering structures, do not appear in their work. None the less the discontinuity and complexity of their paintings, their ambiguous play with material fact on the one hand and their liking for straight lines and geometrical forms on the other, served to make Cubism a style (or range of styles) generally associated with a positive response to the new world.

The word itself, which Picasso and Braque did nothing to promote, became the label of a movement in 1911, when a group of artists (not including Picasso and Braque) exhibited together at the Salon des Indépendants and were written about as Cubists. Two of them, Gleizes and Metzinger, the following year published the first book on Cubism. That year also Cubist paintings from Paris were exhibited all over Europe, in London, Barcelona, Cologne, Zurich, Munich, Berlin, Prague, and Moscow. In 1913 Apollinaire's collection of essays on avant-garde art was published as *The Cubist Painters*, and a large New York exhibition of contemporary art, the Armory Show, made Cubism notorious in America. The label, Cubism, itself prompted interpretations, so that Cubism was often described as an art of simplification, and painters whose work contained a lot of geometrical forms or solids were taken to be truer representatives of the movement than painters with a subtler aim. Works of art that offer a conventional vision behind a veneer of novelty make friends and find emulators more rapidly than

52. Juan Gris: *Book, Pipe and Glasses*. 1915. Oil on canvas, $28\frac{3}{4} \times 36$ in. New York, collection of Mr and Mrs Ralph F. Colin

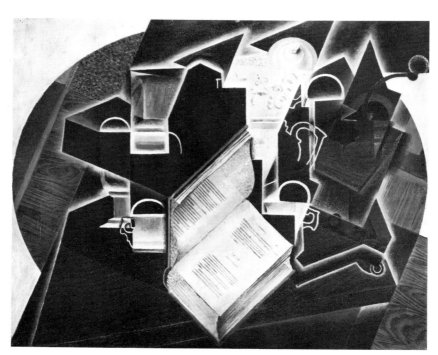

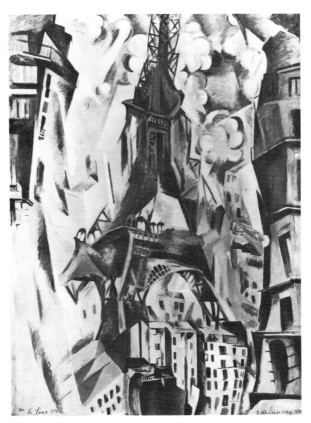

53. Robert
Delaunay: *Eiffel
Tower*. 1911. Oil
on canvas,
$79\frac{1}{2} \times 54\frac{1}{2}$ in. New
York, Solomon
R. Guggenheim
Museum

more thoroughly radical works. In the case of Cubism this veneer was provided by geometric planes. Retrospectively we can say that the Cubism of Picasso and Braque served to release a wide, latent taste for geometry and crispness, for which technology and the city provided encouragement and context. Because of this, in spite of the violence it did to inherited notions of beauty and harmony, Cubism was generally received, where it was received at all, as a positive, outgoing art. Its influence was soon to be recognized in design and culminated in the *Art Déco* styles of the 1920s and 1930s.

A few examples of work by the best of international Cubists can illustrate what was a broad trend with many levels of quality. In Paris painters such as Gris, Delaunay, and Léger were variously affected by what they knew of the work of Picasso and Braque and used it for differing ends. Gris made of Synthetic Cubism a firmly geometrical, almost heraldic art. His compositions originated in linear designs which he then developed to represent still lifes and occasionally harlequins. The large tilting planes in his paintings oppose and compensate for each other, each suggestion of space and movement being countered by another. This, together with his all-over neatness and decorative interest, gives them a cool perfection. Delaunay borrowed the loose geometry of Analytical Cubism as a way of bringing strength and drama into paintings otherwise largely concerned with expression through dynamic colour.

52

54. Robert Delaunay: *Window on the City (1st part, 3rd motif)*. 1912. Oil on canvas, 18 × 14¾ in. London, Tate Gallery

His *Eiffel Tower* series (1910–11) shows how colour and form express his personal enthusiasm and at the same time deliver a convincing representation of his chosen subject. In the *Window* series that followed (1912), the drama and the excitement are diminished along with the size of the paintings. These are delicate, lyrical compositions of softly geometrical colour patches that retain hints of the tower and of other

53
54

buildings; they belong among the most beautiful as well as the most influential paintings of their time. Their spirit, and to a surprising extent Delaunay's method, suggest Impressionism. Once we accept the colour patches just as admirers of Impressionism had to accept separate brushstrokes of luminous colour, we can read these paintings as fairly naturalistic accounts of what the painter saw from his window (the series was actually based on a postcard showing the view towards the Eiffel Tower from the top of the Arc de Triomphe). Delaunay went on to develop this poetic vein. A series of paintings done in 1912 – 13 depends for their expression on colour and curved form without recognizable subject-matter. Thus, they are abstract paintings without theme other than the sensations and associations triggered by themselves. Delaunay repeatedly used the words *Sun*, *Moon* in their titles to make the paintings more accessible and to guard against other, possibly more prosaic

Reality
Questioned
and Answered

55. Robert
Delaunay:
*Circular Forms:
Sun and Moon.*
1912 – 13. Oil on
canvas,
$98\frac{3}{4} \times 97\frac{5}{8}$ in.
Zurich,
Kunsthaus

55

56. Fernand
Léger: *Smokers.*
1911. Oil on
canvas,
51 × 37⅞ in. New
York, Solomon
R. Guggenheim
Museum

interpretations. His desire for a musically expressive art was countered by an urge to connect with the everyday world, and we shall see how he adapted his art accordingly.

A very different man, Léger was drawn by similar ambitions. His *Smokers* (1911) echoes Delaunay's *Eiffel Towers* in the vertical structure 56 and the use of planes. Even more than Delaunay, Léger paints clouds, light, and smoke as visible, almost solid substances. Unlike Delaunay at this stage, he gives prominence to people. The problem of how to represent figures convincingly in the new idiom of colour planes led him to use curved planes, suggesting volume, in a setting of two-dimensional planes. The figures that result from this suggest robots (Karel Čapek's play *R.U.R.*, which popularized the notion of robots and gave them their name, was written in 1920); we shall see Léger moving closer and then also away from such machine-like forms in his subsequent work.

Man Ray's portrait of Alfred Stieglitz (1913) shows how a Cubist 57 flavour could be given to what remained a legible rendering of a particular face, and also how Cubism's polyglot ways made it easy for him to indicate the sitter's interests. Stieglitz was a photographer and he ran a gallery, known as '291', at 291 Fifth Avenue, New York, where he introduced America to the work of Cézanne, Matisse, Picasso, Braque, and Brancusi among other leading contemporaries. He also published a magazine, *Camera Work*, which promoted new art and writing as well as photography. The outbreak of the 1914–18 war coincided with Man Ray's completing a painting of soldiers, and so he dated it, Roman

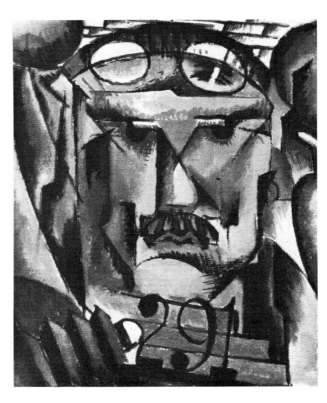

57. Man Ray: *Portrait of Alfred Stieglitz.* 1912–13. Oil on canvas, $10\frac{1}{2} \times 8\frac{1}{2}$ in. New Haven, Yale University Art Gallery (gift of Georgia O'Keeffe to the collection of American Literature)

58. Man Ray: *AD MCMXIV*. 1914. Oil on canvas, $37 \times 69\frac{1}{2}$ in. Philadelphia Museum of Art (A. E. Gallatin Collection)

58

fashion, to link it in perpetuity to that moment. In it a battle rages between geometricized figures, red against blue. The composition they make is of that ancient type used in all ages, the horizontal frieze, so that one is led to read Ray's Cubist-inspired abstraction as merely an updated version of a classical model. A similar sort of geometrical abstraction,

59. David
Bomberg: *The
Mud Bath*.
9I2 – I3. Oil on
canvas,
69 × 88¼ in.
London, Tate
Gallery

much more intelligently developed, is found in Bomberg's *The Mud Bath* 59
(1913). Its angular forms and poster-like colours give little hint that the
painting is based on studies made at a London swimming pool over
several months. Bathers at a public pool become dancing shapes in a flat
composition. The pool itself gives at best an ambiguous hint of recession
because of the axonometric projection in place of perspective. More

60. Paul Klee:
*Homage to
Picasso*. 1914. Oil
on board,
irregular oval,
13¾ × 11½ in.
Connecticut,
private collection

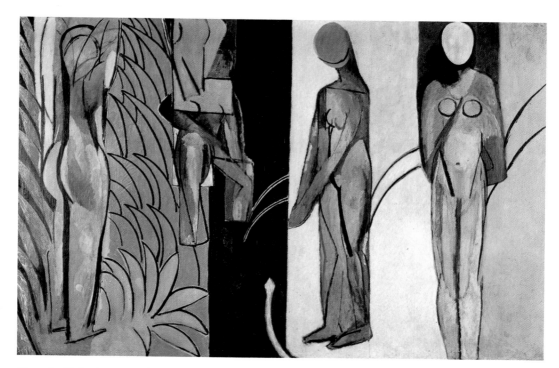

61. Henri
Matisse: *Bathers
by a River*.
1916 – 17. Oil on
canvas,
103 × 154 in. Art
Institute of
Chicago

60 directly linked to specific Paris examples is the abstraction shown in
Klee's *Homage to Picasso* (1914). Its oval format echoes Picasso and
Braque but in all other respects it looks more like a homage to Delaunay
(it is a thickly worked painting and may have been closer to Picasso at an
earlier stage). Klee was to go on to make many paintings as patchworks of
colour areas, often freehand, sometimes strictly geometrical, but always
intuitive in their colour disposition. Such works formed one stream
among others in his large and varied output.

 Matisse never became a Cubist of any kind, but he responded to the
Cubist style. He and Picasso were rival leaders of avant-garde art in Paris
and he could not but be aware of what the other man was doing. Matisse's
independent development had led him into clear but fluently organized
flat colour compositions and it required no major change of direction for
him to adopt some of the architectonic tendencies of Cubism. The
immediate stimulus seems to have come from Gris, whom Matisse saw a
good deal during the war. It is likely too that the war brought out in
Matisse a tendency towards austerity as innate and as personal as his

61 more evident taste for the good things of life. His *Bathers by a River*
(1916 – 17) originated in studies he made for a third large painting to go
on Shchukin's staircase in Moscow. We can see its kinship to *Dance* and
Music in spite of the structure of vertical rectangles. What is exceptional
for Matisse is that he has here made the figures subservient to the
composition and not its source.

 For some painters Cubism was self-evidently the road to complete
abstraction. To them it seemed that anyone unwilling to follow that road
to the end was merely afraid to shed the tradition of representational art.
The Dutch painter, Mondrian, had worked for many years as a

Reality Questioned and Answered

62. Piet Mondrian: *Still Life with Ginger-Pot II*. 1911–12. Oil on canvas, $36 \times 47\frac{1}{4}$ in. The Hague, Gemeentemuseum

naturalistic painter before he came into contact with Cubism. The landscape of Holland inspired him to accentuate verticals and horizontals and to exploit the tension this brought between the flat structure thus provided and the swift recession that was the landscape's other chief characteristic. More and more he became attuned to the dynamic interaction of these elements, and he read into them a mystical

63. Piet Mondrian: *Colour Composition A*. 1917. Oil on canvas, $19\frac{5}{8} \times 17\frac{3}{8}$ in. Otterlo, Rijksmuseum Kröller-Müller

64. Piet
Mondrian:
*Diamond with
Grey Lines*. 1918.
Oil on canvas,
diagonal $47\frac{5}{8}$ in.
The Hague,
Gemeentemuseum

significance reflecting his studies as a member of the Theosophical
Society. For a while he experimented with Fauvist colour as a way of
giving an other-worldly character to otherwise stark images of towers and
trees. In 1910 and 1911 he was able to study Cubist paintings in the
Netherlands. He reduced his colour range and tried to organize his
paintings as primarily linear structures that would convey the character
of each subject whilst also embracing the whole surface in a rhythmical
62 network of lines. *Still Life with Ginger-Pot II* (1911), the second of two
paintings of the same motif, retains the curved shape of the ginger-pot
and allows it to strike echoes elsewhere in the composition, but otherwise
is organized as an almost entirely flat arrangement of lines that suggest
Analytical Cubism. Mondrian worked in Paris during the period
1912–14. The paintings he made there, of trees and buildings, take the
65 process of abstraction further. *Colour Planes in Oval* (about 1914) is the
product of studies that began with charcoal drawings of particular
buildings, gradually transformed, through further drawings and through
slow, intuitive painting and repainting on the canvas, into the thoroughly
generalized arrangement of lines and colours seen here. The original
motif provided Mondrian with some of the main lines of his final
composition, and also with an aesthetic experience of which the accents
and transitions of the painting had to be a counterpart—the painting now
serving not as a representation but as a formulation whereby an emotion
in the artist is evoked in the beholder through a situation offered to his
senses, not through an account of the emotion itself. Back in Holland
Mondrian produced paintings some of which do not seem to have
63 originated in any specific visual subject. *Colour Composition A* (1917) and
64 *Diamond with Grey Lines* (1918) are fine examples. In the earlier painting
colour rectangles and black lines coexist in what is read as a shallow space;

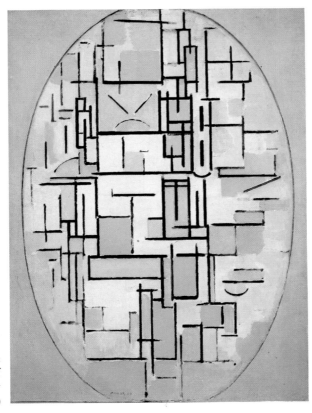

65. Piet Mondrian:
*Colour Planes in
Oval.* 1914? Oil on
canvas, $42\frac{3}{8} \times 31$ in.
Collection, The
Museum of
Modern Art, New
York (purchase)

overlapping and the discreteness of the elements suggest weightlessness
and the possibility of motion. The later painting is based on a regular
trellis of grey lines, some of them accentuated by thickening. The
diamond format suggests that we are seeing only a part of a larger trellis.
Thus the basis of the picture and of its visual impact is the regularity and
stability of the grid which is associated with the wall to which the painting
is fixed; its second aspect, in importance and in the sequence of
awareness, is the irregularity and unsystematic structure of the thicker
lines, a dynamic disturbance of what was, and half remains, a stable
organization. Space is here sensed not as depth but laterally, as an
extension of the plane of the picture. In 1920–1 Mondrian attained a
combination of elements from both types of painting in the works he
called Neo-Plasticism, which he went on producing, without altering his
severely limited pictorial language, into the 1940s. Until 1925 he was one
of the leading members of an association of artists and designers, formed
by him and van Doesburg in 1917 under the name *De Stijl* (style). We
shall refer to its ideals and its international role below.

66

Until 1914 and the beginning of hostilities Russian artists tended to
travel in the West. Some of them had long working periods in Paris and
thus served as a communication system for others. Moreover, the modern
collections being formed by Shchukin and others in Russia, the
exhibitions that were organized and magazines that were published, gave
artists in Russia remarkably good access to developments in the West.

But their awareness of what was new, particularly in France, Germany and Italy, was complemented by the awareness of what was old and closer to home. We have already seen some of the results of this. Here we are concerned with the impact of Cubism on Russian artists.

68 Malevich's *The Woodcutter* (1912) shows the outlines of his *Bather* transformed into curved planes made emphatic by glowing colours and contrasting tones. The feeling of volume these produce is counteracted by placing the planes into contradictory relationships: the highlights and the dark areas lie now this way, now that, so that there is no sense of consistent modelling or of light. This method echoes Analytical Cubism, probably as transmitted by some paintings of Léger. The *Woodcutter* is one of a series portraying the life of peasants in these simplified but also stately terms. Part of the series was exhibited in Moscow in 1912, in an exhibition organized by Larionov as a primitivist manifestation and largely consisting of emphatically anti-elegant paintings that exaggerated folk-art and child-art devices. In that context the Malevich must have seemed reverent and calm. It is said that after the exhibition he ended his association with Larionov.

66. Piet Mondrian: *Composition in Red, Yellow and Blue.* 1920. Oil on canvas, $20\frac{1}{2} \times 23\frac{5}{8}$ in. Amsterdam, Stedelijk Museum

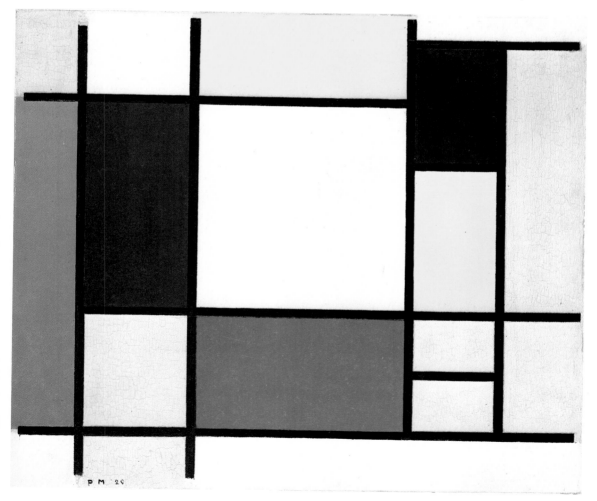

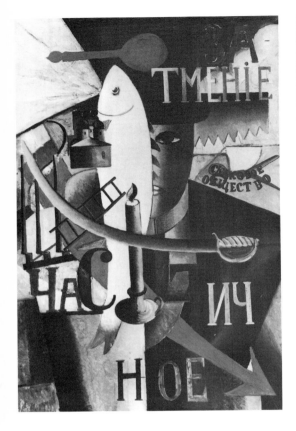

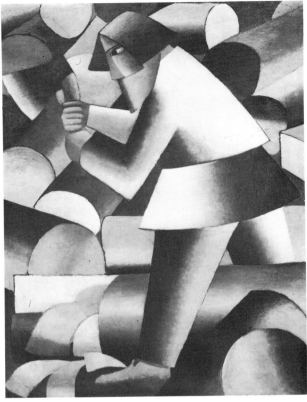

67 (left).
Kasimir
Malevich: *An
Englishman in
Moscow*.
1913–14. Oil on
canvas,
34⅝ × 22⅜ in.
Amsterdam,
Stedelijk
Museum

68 (right). Kasimir
Malevich: *The
Woodcutter*. 1912.
Oil on canvas,
37 × 28⅛ in.
Amsterdam,
Stedelijk
Museum

Soon afterwards the tone of Malevich's work suddenly became much
more modern and also less popular. It looks as though this change was
stimulated by avant-garde poetry. Mayakovsky, Kruchenykh, and other
Russian writers, somewhat younger than Malevich, were seeking new
effects and meaning through an illogical, playful use of words, or alogism.
Not only did they juxtapose words without evident sense so that
unexpected meanings might emerge, but they also cut up words and re-
arranged them as though they were pieces of anonymous matter. In 1913
Malevich collaborated with Kruchenykh and a young composer,
Matyushin, on an opera, *Victory over the Sun*. It was produced in St
Petersburg that December and caused more than the usual scandal.
During that year Malevich's paintings took on a marked alogist character;
the means for this he found in Synthetic Cubism. In *An Englishman in
Moscow* (1913–14) the figure is represented in much the same terms as 67
The Woodcutter, but is half hidden behind a shower of broken-up words 68
and incongruous representations: fish, burning candle, ladder, bayonets,
sword, church, and so on. Presumably these refer to an Englishman's
experience of the city. By himself he would have seemed like an icon.
Accompanied by his swarm of objects, which recall the attributes that
would accompany and identify a saint in an icon, he becomes a symbol of
experiencing. The red spoon painted near the top of the picture replaces a
painted wooden spoon originally stuck on to the canvas: Mayakovsky and

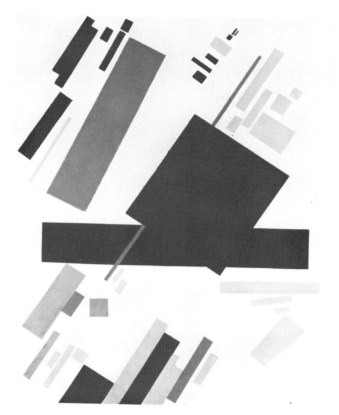

69. Kasimir
Malevich:
*Suprematist
Painting.* 1916.
Oil on canvas,
$34\frac{5}{8} \times 27\frac{3}{4}$ in.
Amsterdam,
Stedelijk
Museum

his friends wore such painted spoons in their buttonholes as a public
demonstration of their alogism. Other Malevich paintings of this period
made use of a good deal of collage. One of them sports a thermometer.

This phase too turned out to be no more than an interlude in
Malevich's development. *Victory over the Sun*, an opera of quarter-tone
music and alogistic sound poems, had for its theme the triumph of
technology over nature, of modern man over the sun. Malevich's designs
for the costumes and sets were generally Cubist in character, but one of
his backcloths showed merely a large square divided diagonally into a
black and a white area. He said himself that it was his work on this opera
that led him into the art he was to call Suprematism, and it may well be
that its theme was the seed from which his philosophy of art, expressed in
several essays, was to spring. The first mature product of his Suprematist
phase was a painting of a black square in the centre of a white square
roughly twice its area. A sign perhaps more than an image, it was
certainly not an abstraction from anything visible. He exhibited this and
other paintings for the first time in St Petersburg during December 1915
to January 1916. It was the simplest and the most assertive of them.
Subsequent paintings had involved a growing number of elements and
also colours, and from the static finality of the first painting Malevich had
gone on to more fluid arrangements and a more marked sense of space.
Contrasting colours, the overlapping of elements and also their differing

69

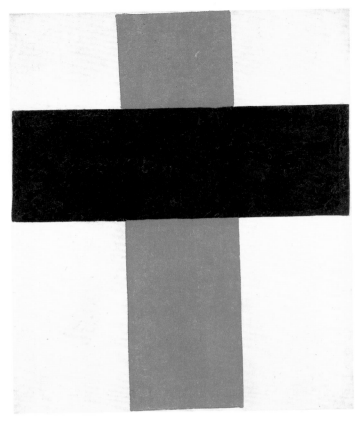

70. Kasimir
Malevich:
*Suprematist
Painting (Large
Cross on White)*.
After 1920. Oil
on canvas,
$33\frac{1}{8} \times 27\frac{3}{8}$ in.
Amsterdam,
Stedelijk
Museum

sizes, all seen against a white ground, produce a sense of floating forms in
an endless space filled with light.

These paintings, like Mondrian's Neo-Plasticist works, were from the
first intended to be shown without frames. But Mondrian's were to be
held flat against the wall whereas Malevich's were hung in the traditional
way, tilting forward. Mondrian implied that the space of his painting was
also the space of the wall; Malevich that his referred to an infinite space
elsewhere, a cosmic space not part of the immediate environment. *Black
Square on a White Ground* was actually hung tilted across a corner of the
room in the 1915 exhibition, like an icon in the devotional corner of
every Russian's house. After Malevich's death in 1935 his corpse lay in
state in the Artists' Union in Leningrad (the former St Petersburg or
Petrograd) with a neater version of the *Black Square* on the wall above his
head. A few days later his ashes were buried in a grave marked by a square
white headstone bearing a black square on its main face. For the painter
and his friends the work clearly had an iconic character. This probably
applied also to some of the paintings he did in the early 1920s. *Large Cross
on White* is one of them: a black rectangle lying over a red rectangle to
form a massive cross, all painted rather heavily. Another painting of the
same time shows an even broader cross, but painted in white on a white
ground. The cross is an unmistakable symbol. Malevich may not have
wished to invoke Christianity exclusively, but it is clear that his art was

70

mystical in intention. His writings show that it was rooted in a fusion of
religious and philosophical thought. Some of his earlier Suprematist
compositions had titles such as *An Aeroplane Flying* and *House in
Construction*, but he had come to regret these references to the material
world. The reality he wished to endow with visible form was
immaterial—'the sensation of non-objectivity'—and this distinction
became more pressing to him as the new society created by the Russian
Revolution based itself more and more firmly on materialist principles.
After 1922 Malevich did not exhibit Suprematist works in Russia, but
their fame spread in the West. They were seen in large Russian art
exhibitions in Berlin in 1922 and 1923, in Venice in 1924 and in a

71. Vassily
Kandinsky:
Improvisation 13.
1910. Oil on
canvas,
$47\frac{1}{8} \times 55\frac{3}{8}$ in.
Munich, Neue
Pinakothek

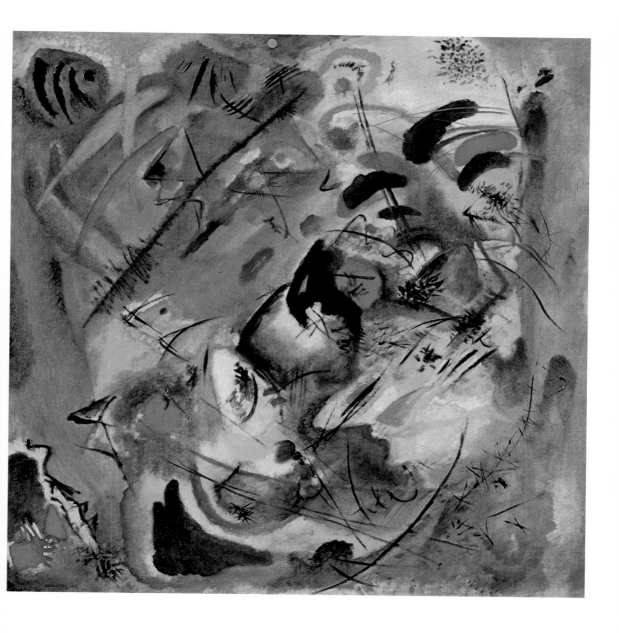

Malevich one-man exhibition in Berlin in 1927. That year also saw the publication of a section of his theoretical writings entitled *The Non-Objective World*.

Thus three of the most influential pioneers of abstract art, Delaunay, Mondrian, and Malevich, had used Cubism as a guide towards total non-representation. Delaunay's art was concerned with lyrical sensations of light, colour, and movement and does not seem to have been burdened by a general philosophy. Mondrian's was an expression of a quasi-Oriental concern with universals and with existence as a meeting of opposites (as in the joining of *yin* and *yang*); the dynamic but harmonious structures he painted were, he said, to be seen as models for the spiritual and physical world that had yet to be achieved and in which no paintings would be needed. Malevich's offered images of universal sensations, not strictly religious but certainly implying aversion from the technological world. Picasso and Braque had had no comparable intentions, and must be seen as firmly on the side of figuration in the subsequent figuration versus abstraction debate. Yet they had unwittingly proposed an art of geometry and of assembled forms, and those who availed themselves of that were free to use it to carry other kinds of content. There was, moreover, another road to abstraction—to abstraction as the art of improvisation. This was the exploitation of what Delacroix had called 'the musical in painting' and what we have referred to as the communicative power of shapes and colours. The geometrical, constructed nature of Cubism puts it into the constructive tradition represented by such deliberate picture builders as Piero della Francesca, Raphael, Poussin, Vermeer, Ingres, and Seurat. 'The musical in painting' points to the tradition of painterly painting which goes back via Monet, Delacroix, Velásquez, Rembrandt, and Rubens to Titian and his colleagues in the Venetian school of the sixteenth century. It can obviously be misleading to line up artists into successions of this kind, which stress one aspect of their work and ignore others, yet this is how artists have often seen them. (Cézanne has the distinction of clearly belonging to both traditions but his admirers in the early twentieth century tended to see only the constructor in him). In the painterly tradition the emotive effects of colour and tone, and of the brushstroke as expressive gesture and as texture, are directly associated with emotional communication between the painter and the spectator. Representation could here come to seem both unnecessary and un-welcome, a screen between one and the other. Thus within the broad trend of Expressionism there developed what since the 1950s (and the rise of American abstract painting) we have come to call Abstract Expressionism. Its champion and leading apologist was Kandinsky.

We can summarily say that Kandinsky's art is a growth out of Fauvism and folk art, but it seems essential to add music if we want to understand it; music both as experience and as idea. Kandinsky greatly admired Wagner and saw his fusing of music, text and stage into a seamless *Gesamtkunstwerk* as the spiritualization of the too worldly art of opera. We saw that the *Blaue Reiter* almanac, edited by Kandinsky and Marc, included an essay on Scriabin's *Prometheus* and an essay by Schönberg (both men were a few years younger than Kandinsky). The last text in the almanac is Kandinsky's stage composition (*Bühnenkomposition*) *Yellow*

Sounds. This consists mostly of instructions for the six short scenes: Kandinsky describes the effects of light, colour, and darkness he wants and the kind of music that is to go with them, and also the simple motions to be performed by individuals and groups (man, child, five giants, mysterious beings, etc.). The words to be sung or spoken are few. The last word comes in Scene IV, and is to be spoken by the man ('very loud, commandingly; beautiful voice'): 'Silence'.

Painting, wrote Kandinsky, 'can develop the same energies as music'. He sought for resonance: forms and colours should penetrate the beholder, reverberate in him and move him in his depths, as music does the listener. During the years leading up to the publication of the almanac and of *Concerning the Spiritual in Art*, his paintings had become ever richer in colour and less precise in their representation of landscape and sometimes of cryptic scenes involving figures and horses. From 1909 on he called some of his paintings *Improvisations*. We can still find references to figures, buildings, mountains and so forth in them, but these now function as signs rather than representations; they refer us not to the object but to his own earlier simplified representations of these things. The effect is visionary and dream-like. The title implies that Kandinsky created these images by acting as spontaneously as possible and minimizing the role of conscious control. His *Compositions* (from 1910 on) are planned, more extended works based on the *Improvisations*. By 1913–14 many paintings seem to be devoid of references to particular objects. Some of them look as though they were built up slowly and deliberately, like the *Compositions*, but others are self-evidently improvisations.

These are the first substantial examples of an abstract art that is distinct from and in many ways complementary to geometrical abstract art, yet we should be wrong to put geometric and informal abstract art into separate camps as antagonistic modes. The abstract art of Mondrian and Malevich appears impersonal as well as assertively modern because

71

72

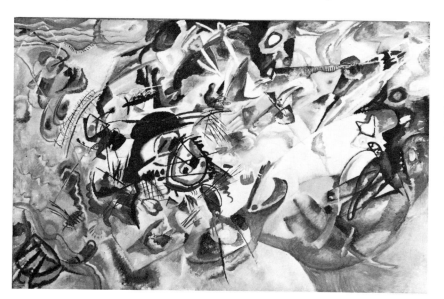

72. Vassily Kandinsky: *Composition VII*. 1913. Oil on canvas, $78\frac{3}{4} \times 118\frac{1}{8}$ in. Moscow, Tretyakov Gallery

73. Vassily Kandinsky: *Shrill-Peaceful Pink*. 1924. Oil on cardboard, 25 × 19 in. Cologne, Wallraf-Richartz Museum

of its reliance on basic forms. Nevertheless both artists were impelled by mystical speculations and intended an answer to the material world rather than a celebration of it. There is support in classical philosophy for their belief that visible reality is a mask for a deeper reality that can only be reached through the imagination. In addition, Mondrian's insistence that art should go beyond the accidentals of natural appearances in order to create a pure beauty by means of abstract forms set into dynamic relationships can be seen as an extension of the Greek doctrine that art should aspire to a perfection beyond nature's reach. Yet the particular quality of both Mondrian's and Malevich's thought comes from the mingling of such ideals with Oriental forms of mysticism that swept through the Western world during the last decades of the nineteenth century and the first years of the twentieth (and again after the first and second world wars). Kandinsky's art, on the surface so unlike Mondrian's and Malevich's, stands on much the same ground. All three were deeply interested in theosophical ideas; Kandinsky like Malevich came to see art as the communication of sensations through form and colour. Mondrian's insistence on an impersonal idiom and technique distinguishes his work from theirs more fundamentally than the use of geometric forms links it to Malevich's. Artists were at liberty to adopt and adapt Mondrian's and Malevich's pictorial languages, and several did with varying degrees of success, but while Kandinsky's admirers could benefit from the master's teaching they could not appropriate his personal language of this time.

Kandinsky returned to Moscow after the war started. Following the 1917 Revolution he was given a leading role under the Commissariat for Education. He was especially concerned with devising the programme of instruction for the new Soviet art workshops. It may have been the need to find a teachable extension of his markedly personal art that led him to reconsider his methods. Certainly he was influenced by the example of Malevich, then facing similar tasks in Vitebsk and in Petrograd. Kandinsky's paintings lost their appearance of spontaneity. Geometrical forms took the place of freely invented shapes, and a fairly smooth surface replaced the varied marks and textures of the previous decade. His compositions became if anything even richer and more seductive—he never attempted the economy of Malevich or the severity of Mondrian—but now there was clarity where there had been fluidity and sometimes vagueness. His art was still generated by his subconscious rather than by conscious programmes or references, but this was much less obvious from the appearance of his paintings. Precision would not diminish the subjective principle that guided his work, the 'inner necessity' which his art obeyed, but now he was using a controlled formal language which everyone could understand. In 1914 he had begun work on, in effect, a combined dictionary and grammar of the language of forms and colours, based on an analysis of his own responses as well as a systematic study of the responses of others. A summary of the results was published in 1926 in celebration of his sixtieth birthday under the title *Point and Line to Plane*. In 1921 Kandinsky again left Russia for Germany, and the following year he joined the staff of the influential design school in Weimar known as the Bauhaus.

73

3 Images of Progress

> This belief in an uninterrupted, inexorable 'progress' had for that era in truth the force of a religion; indeed, people believed in 'progress' even more than in the Bible, and this belief appeared justified by the daily wonders of mechanics and science.
>
> Stefan Zweig, *The World of Yesterday*, 1943

It is not difficult, even now, to sympathize with the believers of 1900. Think of the benefits to which they could point. Running water in the home, electric light and power, central heating, lifts, the telephone; in the street the horseless carriage, the tram and the bus, electric street lighting and, beneath the streets, an electrified subway system: the gramophone, radio, telegraph, and cheap newspapers and magazines illustrated with half-tone pictures made from photographs; from 1903 onwards the rapid development of the aeroplane, with Blériot's cross-Channel flight of 1909 evoking especial enthusiasm in Europe; dramatic developments in medical science, for which the invention of the X-ray in 1895 will serve as instance; the rapid advances made in industry, undoubtedly improving the material well-being of the majority of people in the Western world. The machine, with its gleaming, rhythmically moving, geometrical limbs and organs, could not fail to impress as a symbol of all these achievements. Another symbol, but to be visualized only in its effects, was electricity. Armed with such powers man would not fail to make a better world for all—if only he could cast off the chains of now unwanted traditions.

Not everyone was a believer, of course. Goethe had guessed a century before that scientific knowledge would outgrow normal human capacity. Why should mankind change its ways? The arts contributed to both sides of the argument. Those who wanted to celebrate the new could find new shapes, new expressions, a new pulse with which to work. Their campaign was international. A poetic tradition of appetite for the new and the powerful stemmed from the American Walt Whitman and was upheld by the Belgian Verhaeren, the Frenchman Romains and the Russian Mayakovsky. An allied tradition developed in fiction: science fiction, stemming largely from the American Edgar Allan Poe and growing through the contributions of the Frenchman Jules Verne, the Englishman H. G. Wells, the Russian Zamyatin and the Czech Karel Čapek. Stravinsky's *The Rite of Spring*, composed for the Russian Ballet and first performed in Paris in 1913, had a primitivist theme, presented through sharp discords and pounding rhythms that were instantly associated with the hard world of technology. The new and the primitive were eager bedfellows. Jazz, for example, which became popular in western Europe around the time of the first world war, represented both

America and Africa. Africa stood for primordial energies; America for devil-may-care progress.

Until 1909 the word 'futurism' belonged to theology and referred to the belief that biblical prophecies were yet to be fulfilled. That year it became the name of a cultural movement. Soon afterwards 'futuristic' was born as journalistic jargon for anything in the way of art and design that would seem advanced to the man in the street. The movement, Futurism, was launched by a manifesto, published 20 February 1909 on the front page of the Paris newspaper, *Le Figaro*, and written by the Italian poet and playwright, Marinetti. In ringing, romantic tones he hailed the new world of mechanical forces and denounced all attachment to the past. He glorified speed and aggression, patriotism and war ('the only true hygiene of the world'—an opinion shared by a surprisingly large number of people up to about 1917), and he promised to destroy museums and libraries as reliquaries of the past. Among all the rhetoric, the words that were remembered most readily were those he used to exemplify that 'new form of beauty, the beauty of speed': 'A racing car, its bonnet adorned with pipes like serpents with explosive breath ... a racing car which seems to run on gunpowder is more beautiful than the *Victory of Samothrace*'. Thus he put into memorable opposition an industrial product, created to unprecedented standards of efficiency and power, with a work of art created in emulation of an established standard of beauty, the famous Hellenistic sculpture admired by visitors to the Louvre.

Marinetti's home was in Milan, the business and industrial capital of Italy. Nearby Turin was and is the home of the great Italian motor company, Fiat. (Motor racing began as early as 1887.) Italy carried a stifling burden of past greatness. If the nineteenth century had brought political unification to the peninsula (still incomplete, since some northern areas remained under Austro-Hungarian rule and the Vatican did not accept unification until 1929), it had done little or nothing for the arts in Italy. Marinetti was avid to put himself and his country into the forefront of modern European culture in all the arts. Futurism became a movement that embraced poetry, novels and plays, painting and sculpture, music, photography, film, typography, and architecture.

The general message of the movement and its name preceded Futurist art. Young Italian artists who responded to Marinetti's call to action had some trouble in translating his general exhortations into a practical programme. Clearly, their subject-matter would have to come from the urban and industrial environment. Then there was the new ideal of speed, which they could interpret as movement. From Bergson they learned that experience had to be represented as multiplicity and fragmentation. This would demand overlapping and transparent representations, a mingling of near, far, moving, stationary, seen and recollected. In addition their art had to be vital, aggressive: 'our pictorial sensations must not be murmured; we shall make them sing and shout upon our canvases in deafening and triumphant fanfares' *(Futurist Painting: Technical Manifesto*, 1910). They seized on the Neo-Impressionist technique of divisionism as a way of obtaining vividness with transparency, but they did not feel confident of their work until they

had learnt also the dividing or fragmentation of form. In October 1911 two or three of them—Boccioni, Carrà, and perhaps Russolo—travelled from Milan to Paris to study the new art developing there, and specifically to look at Cubism, whose public debut had been reported on in Italian journals.

The following February they presented in Paris their first major exhibition. It went on to London that March, to the Der Sturm gallery in Berlin in April-May, and to Brussels in May-June. Thereafter two exhibitions were formed. One, consisting of 24 paintings bought by a German banker, toured through several central European cities, including Munich and Vienna, and in 1913 reached Chicago. The other, the rest of the original exhibition plus new work, went to Amsterdam, Rotterdam, The Hague, and Munich. Futurist manifestos and lectures accompanied the exhibitions and indeed went even further (for example, Marinetti lectured in St Petersburg and Moscow in 1914). Thus Futurism rapidly made itself known all over the Western world. It tended to be seen as a branch of Cubism, and certainly made aspects of Cubism even more widely known than before, thus further confusing the question of what Cubism actually was. Futurism linked visual art to literature and to the other arts, and went on to express extreme views on politics and society. In Italy the Futurists presented soirées that were a mixture of cabaret and harangues. In theatres and halls in all the main cities they showed their work and read out their manifestos. Marinetti and other Futurist poets would declaim their verse and pepper it with insults hurled at the audience. Futurist composers would assault the public's ears with new music, much of it made by means of noise machines. All this plus abusive political slogans guaranteed that the performance would end in uproar.

That art should instruct and persuade has usually been part of its purpose, and there have been times when its propagandist role was particularly prominent. During the French Revolution art had played a great part in propagating republican ideals while under Napoleon it served to glorify autocracy and empire. During the nineteenth century, especially in France, some artists used their art to support the socialist and anarchist movements. But Futurism introduced not only an even more immediate headlong engagement of art with politics but also a new kind of artist, a performer whose studio work may well be noticed less than his personal appearances.

The art of the Futurists was, in fact, very varied and tentative. There was no agreed way of putting all their ideas and excitement into works of art, and perhaps they never achieved an art that measured up to their swaggering announcements. But their attempt was valid and the results are fascinating even if they never seem to match their expressed ambitions. Boccioni was undoubtedly the finest artist in the group as well as its leading art theoretician. His *States of Mind: The Farewells* (1911) is 74 the central painting of a triptych whose theme is the sensations of people taking leave of each other in a railway station and being carried off in the train or wending their way home. The concept of the triptych (a form familiar from Renaissance altarpieces) has something of a scenario about it, dramatic or even operatic. Hard, visible facts and sweeping emotions

had somehow to be fused into an image informative enough to be understood and open enough to attract our empathetic elaboration of it. That hero of Victorian engineering, the steam locomotive, lords it over the painting. Its forms are dispersed in a more or less Cubist manner; its lifelike, eye-catching number echoes the letters and figures in Picasso and Braque. Lines and some shading to the right of the locomotive indicate railway carriages; lines to its left represent electricity pylons and also suggest landscape and power. Swirling lines, softly painted, represent steam coming from beneath the engine but also suggest the emotions of the embracing couples, who seem to be swept off by them as in a dream. The figures, not easily read, also suggest Cubism but we notice that the forms Boccioni uses for them are curved, shell-like, not rectilinear. As a whole the painting is almost as complex as the experiences it embodies. Its visual means range from diagrammatic lines that can only hint at meaning to abstracted forms that echo natural appearances, and also to direct transcription in the case of the number. As for the assertive modernism we have been led to expect by Futurist statements, Boccioni both satisfies and transcends it. The locomotive (mentioned alongside racing cars, steamers, aeroplanes, and bridges in Marinetti's foundation manifesto) stands as instance and symbol of mechanical power. In *States of Mind: Those who Go* glimpses of travellers seated in their compart-

74. Umberto Boccioni: *States of Mind: The Farewells*. 1911. Oil on canvas, $27\frac{7}{8} \times 37\frac{7}{8}$ in. Collection, The Museum of Modern Art, New York (gift of Nelson A. Rockefeller)

ments are mingled with fragments of the urban landscape flashing by. In *States of Mind: Those who Stay* we see figures, again suggested by hollow curving forms, moving slowly through a forest of curtain-like lines that represent nothing but convey sadness. *Those who Stay* is dominated by mood; *Those who Go* by speed; in *The Farewells* mood and mechanical energy meet. The whole adds up to a much more subtly, even indulgently human account—of a familiar human event but in a relatively novel setting—than the aggressive words of the manifestos would lead one to expect.

The less narrative and symbolical side of Boccioni's work can be represented by a pencil study related to two paintings, *The Forces of a Street* and *Simultaneous Visions*. The drawing shows, and both paintings include, a tram careering towards us down a city street, past and through pedestrians and a cab. The houses seem to bend and reform as the tram advances, while overhead electric street lamps add beams of light to the rocking play of geometric forms. The sides of the tram are raised as though to insist on the mingling of all experiences. All objects are transparent; alone the light, coming also from the houses and the tram, is given some solidity. The whole composition is aimed at us: in another moment we shall become part of the tumultuous, ordinary scene. The *States of Mind* triptych did not involve the spectator in this way. The action and emotions presented there are at some distance from us, like a stage performance. The difference is partly compositional: the action of *States of Mind* proceeds across the canvases, not towards us. But it is also a matter of language. The visual metaphors Boccioni uses to create mood—which he derives from Symbolism, from early Munch for example—demand from us a more purely spiritual response than do dislocated and semi-abstracted portions of the visible world. In effect, the triptych becomes a meditation on all leave-taking while the drawing and its related paintings, without metaphors but full of expressive distortion, appeal directly to our experience of similar daily events.

The kind of distortion Boccioni used here came from Delaunay and Léger, both of whom stood out amongst the Paris Cubists for adapting Cubism in order to take it out into the streets. Delaunay's *Eiffel Tower* paintings were certainly known to Boccioni, in one or more examples, and it is possible that he knew Léger's *Smokers* or other Légers of that year. The Delaunay series centres on a heroic symbol, rather like the locomotive in *States of Mind*; in *Smokers* Léger shows us an ordinary village landscape seen through and beyond the smokers (or one smoker repeated), the smoke and a curtain. (In *Simultaneous Visions* Boccioni combined the street scene with a foreground still life of jug and bowl to suggest that he and the beholder are looking out of a bedroom window on to the street below.) The same influences appear in the work of Carrà, but modified in the direction of Analytical Cubism. In his *Woman at a Window (Simultaneity)* hints of window, curtain, and houses recall Delaunay; the incomplete but generously and emphatically stated forms of the nude, solid and transparent at once, suggest knowledge of Léger's recent work. But Carrà's colouring tends to monochrome, as in Analytical Cubism, though it includes some very seductive mother-of-pearl hues in the figure. At first the nude is the real presence in the

75

76

75 (opposite).
Umberto Boccioni:
Study related to
The Forces of a Street and
Simultaneous Visions. 1911.
Pencil on paper,
$17\frac{1}{4} \times 14\frac{5}{8}$ in.
Milan, Civica
Raccolta delle
Stampe Achille
Bertarelli

painting, standing between the painter (or us) and an imagined
townscape; then the townscape becomes the real scene and the assertive,
plastic forms of the body become an intrusion, a voluptuous irritant
interposed by the imagination. Seen and felt experience seem to coexist
and to switch roles.

76. Carlo Carrà:
*Woman at a
Window
(Simultaneity)*.
1912. Oil on
canvas,
$57\frac{7}{8} \times 52\frac{3}{8}$ in.
Milan, collection
of Dr Riccardo
Jucker

The work of Giacomo Balla focused more on the purely perceptual aspects of an action. Long interested in photography, he was willing to benefit openly from the analyses of motion made by chronophotography in which successive stages of an action are recorded as one image. In *The Hand of the Violinist* (1912) the violinist's left hand, the violin itself and the bow are shown in several positions while the architrave in the background is constant, all as in a chronophotograph. Nothing in the painting suggests an emotional response that modifies the visual experience. We are not made to feel the music. In subsequent paintings Balla explored action in more radically pictorial terms. *Speed of an Automobile + Lights* (1913) is almost purely abstract, a diagram to suggest the motion of an object rather than a representation. He ranged beyond the visual in other paintings in the series (*Automobile and Noise*, for instance) but his matter is still perceptual rather than conceptual, and a series of paintings of 1913–14, under the general title *Iridescent Interpenetrations*, consists of simple geometrical patterns filled with gentle colours that appear to overlap or pass through each other and change hue at each meeting.

Our brief look at a few works by only three of the Futurist painters has hinted at what a fuller survey would prove—that Futurist art reflects diverse goals and influences. The unity of ideals and methods promised in the manifestos was not realized by the artists in their work. But some aims they did clearly share. They rejected the tradition of painting as an

art of representing objects discretely and in stable relationships. Their subjects almost always came from the contemporary world and represented real experiences. To some extent they were able to make their art brilliant and energetic. Beyond this we cannot go without coming upon major differences and disagreements between them. So even Futurism, of all modern art movements the one that most warrants the name of

77. Giacomo Balla: *The Hand of the Violinist*. 1912. Oil on canvas, $20\frac{1}{2} \times 29\frac{1}{4}$ in. London, collection of Mr and Mrs E. Estorick

78. Giacomo Balla: *Speed of an Automobile + Lights*. 1913. Oil and paper on cardboard, $19\frac{1}{2} \times 27\frac{1}{2}$ in. Chicago, collection of Mr and Mrs Morton Neumann

movement, must not be thought of as a single-minded campaign.

Its influence was general, not specific. One can notice some response to Futurist art among the Paris Cubists, though not with any certainty in the work of Braque or Picasso. Delaunay, recently engaged on his *Sun-and-Moon* series, formally abstract and cosmic in theme and feeling, may have been brought back to earth by the example of the Italians. His next major painting, begun in 1912 and finished in time to be included in his Berlin exhibition in January-February 1913, had all the exultation of the previous series but linked it to a popular and worldly subject. Delaunay's source for *The Cardiff Team* was nothing more exalted than a newspaper photograph of a rugby football match in Paris. It is worth considering how he turned this material into rhapsody. In the half-tone illustration the figures are fairly clearly silhouetted against the sky. This clarity Delaunay weakens, without losing the expressive effect of the leaping player. What firmness there is he gives to the hoardings he invents as setting: 'Astra Construction' *(astra* is Latin for stars), and 'Magic Paris'. Above the hoardings, in the realm into which the player seems to be soaring, are sufficiently legible hints of the Eiffel Tower, of the big wheel that stood a little way to the south of the Eiffel Tower and was Paris's second greatest popular attraction, and an aeroplane symbolizing Blériot's triumphant flight over the Channel. It is all popular material: sport, entertainment, heroic achievements—all very modern and marvellously vivid—a brilliant answer, one feels, to the forceful but relatively joyless drama of Boccioni's *Forces of a Street*. The Vorticist group in London shared many of the Futurists' priorities but, like Delaunay and others, felt that their emphasis on motion had led to an art that ineptly challenged the cinema. The best Vorticist works stayed within the general urban experience (rather than attempting particular human dramas as did Boccioni in the *States of Mind* triptych, or quasi-scientific investigations like those of Balla) and presented these in firmly abstracted terms, as in Wyndham Lewis's *Red Duet* (1914) and Lawrence Atkinson's *Painting*. There is evidence that the work of the Vorticists was known in Russia—which further complicates the question of what influence the Italian movement had there.

Nevertheless, Futurist art (thanks largely to the Futurists' promotional efforts) charged like a tidal bore along the international channel opened up by Cubism and confronted the modern artist with certain options in a particularly challenging way. He could remain within the conventional limits offered by tradition and thus be relatively certain of a sympathetic public, or he could help to renew art and reflect in it the character and the problems of the modern world. If he chose the second option he had to decide whether to focus on internal or external themes. The distinction is crude but it will serve: should art, or for that matter any art form, deal with personal matters or with impersonal generalities? Art cannot be totally impersonal as long as it is the work of individuals, and even the most personal expression attains some objectivity in being embodied in a material object, but the artist can decide to focus his attention inwards and offer what he finds there to the world in the well justified belief that there is much common ground between men, or outwards on forms and rhythms perceivable in the external world. This is

79. Lawrence
Atkinson:
Painting.
c. 1914 – 18. Oil
on panel,
$51\frac{5}{8} \times 17\frac{7}{8}$ in.
London, Arts
Council of Great
Britain

the old opposition of classical and romantic in another guise. Those modernists who thought that the arts had to become firm and clear, without slop or sentimentality, and were perhaps excited by the Futurist statements, saw in Futurist art what Matthew Arnold protested against in Romanticism: 'confused multitudinousness' and 'exuberance of expression'.

A similar disappointment could be felt with Cubism. Again words gave notice of a radicalism that the works could rarely live up to and which the originators of Cubism never intended. This kind of reaction was shown by Mondrian when he accused the Cubists of not developing their art to its logical conclusion. It was shown by Malevich's disciple, Lissitzky, when in 1922 he said of Cubism, once a disturbing newcomer, that 'now even the myopics are beginning to recognize its resemblance to its father—the Louvre'. Hilberseimer, in the essay quoted earlier à propos primitivism, summarized Cubism as an art of 'plane construction' that consciously and necessarily turned to 'the basic elements of all design: the geometric-cubic', and then went on to accuse Cubism of falling, like Expressionism, into 'subjective speculation' and of remaining 'too much concerned with the problem of anthropomorphic figuration'.

80. Wyndham Lewis: *Red Duet*. 1914. Pastel and gouache, 15⅛ × 22 in. Private collection

Those who wished to take the idea of art linked to the technological world further saw two ways of proceeding. These turned out to be mutually inimical. One, put at its simplest, was to reflect in art the beauty of that world not merely by representing it but by finding forms, colours,

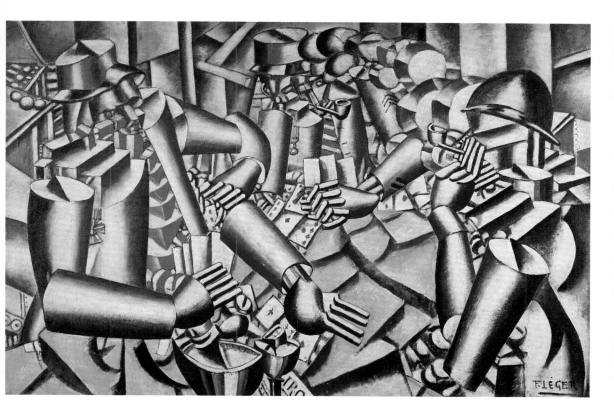

81. Fernand Léger:
The Card Players.
1917. Oil on
canvas, $50\frac{3}{4} \times 76$ in.
Otterlo,
Rijksmuseum
Kröller-Müller

and rhythms that would serve as analogies for technology. The other was to adopt processes that were themselves analogous to those that serve technology. Those who chose the first looked most of all to the machine as the new ideal of beauty (not at the racing car but at its engine); the others looked to construction, as method and principle. Neither way was a sudden discovery. Some Victorians had expressed their admiration for machines and engineering structures and opposed these to the showy, style-burdened productions of architects and applied artists. The machine and machine production, especially as systematized by Taylor in the United States, could serve as a model for an efficiently interacting human society, and the marvels of technology were seen as the fruit of anonymous collaboration in the accumulation of knowledge. The history of science and technology showed the need to abandon old methods and ideas; unceasing advance in these fields had become a man-made parallel to natural evolution. For the classical tradition the human body had served as model and the mathematical relationships ascribed to the universe as system of harmony and proportion. Now the machine was adopted as the model, and the modernists had the satisfaction of being able to quote Plato's words on the absolute beauty of forms made by mechanical means, such as the circle, the square, and the triangle. Construction itself, as word and ideal method, also had the support of history. We have referred to a 'constructive tradition' in painting, using the term loosely. Cézanne had referred to his paintings as 'constructions after nature', and had repeatedly advised painters to 'treat nature in terms

of the cylinder, the sphere, the cone'—the forms that Plato praised and the machine provided. Philosophers from Descartes to Kant had demonstrated the value of systems of thought erected out of components assembled functionally, and that too was, quite visibly, the method for erecting such marvels of engineering as the Eiffel Tower. Braque and Picasso had brought constructive methods into the studio.

Léger's abstracted figures of 1914 have something mechanistic about them but may owe this to Cézanne's advice to bring out the basic solid forms inherent in objects: advice which reflects Cézanne's desire to assert the physicality of objects and give coherence to their interrelationships in the picture rather than any affection for the machine. Léger used similar forms for landscapes, still lifes, and abstracts at this time, and the way he paints them suggests neatly turned solids but also reminds us that we are looking at paint on canvas because his brisk brushwork leaves the canvas visible between patches of colour. The war changed his manner and his view of art. He served in the trenches, was gassed in 1917 and returned to art with a new feeling both for form and for society. He had lived in a world of guns, shells, aeroplanes, lorries, and in close interdependence with other soldiers, individual men united by costume and purpose. His period in hospital combined with his life at the front to provide the experience formulated in *The Card Players* (1917), his largest painting 81 since 1911. The soldiers, their helmets and limbs, the smoke from their pipes, the blanket on which they play—all speak the same emphatic language of machine-made forms. Where forms repeat we seem to sense the staccato pulse of the aircraft motor and the machine gun.

The war had brought a marked slackening of effort within the Paris avant garde. Instead of the swift, heroic, invigorating exercise that many had expected, the war had turned out to be slow, stupid, and degrading; it had shown the bankruptcy of Western political systems and of the nationalism they professed to serve. Aggression had failed to bring any sort of liberation, and international socialism had failed to keep the proletariat out of a mutually destructive war from which only big business benefited. Technology had contributed much to the vileness of modern war. Would the machine ever serve peace as energetically? If it took a deep-rooted belief in man to carry pre-war optimisms through into the post-war years of exhaustion, halting reconstruction and economic crises, it required a touch of Messianic conviction for anyone to develop his art as statements about material and social progress. Yet in the years 1918 to 1921 Léger painted a series of pictures, culminating in *The Discs in the* 83 *City*, that splendidly express such a conviction. His method is synthetic. Shapes that signal façades, roofs, girders, steps, street signs, posters, people, and—in the discs themselves, crisp, factual cousins of Delaunay's softer and more romantic invention—the brilliance of arc lamps, are assembled in juxtaposition. Their main effect is poster-like; the shapes lie flat on the canvas. Vertical and horizontal elements dominate to give the composition firmness, while the discs give greatest visual force to the middle of the composition. At the same time there is a sense of movement (mainly because of the incompleteness of shapes, so that the eye moves on from one to the next) and also of space. Shapes have the same vividness in every part of the canvas, bringing a hint of human

equality. This painting, and the series as a whole, offers a composite image of the city as a place of work and leisure, as man's now normal environment. Cézanne was the last great painter to draw strength from intimate, continuing contact with landscape. Léger, a farmer's son from Normandy, is the first great painter whose art focuses on modern urban life, and it is of course a positive view of the city he offers us as a counter to the nineteenth century's view of the industrialized, crowded city as an inevitably monstrous growth. His view echoes the seventeenth and eighteenth centuries' pride in the city as man's finest achievement. The experience he offers us, through a fragmentation carried out with classical firmness, reaches far beyond the romantic aspirations of the Futurists. Only in film has it been possible to go further in constructing dynamic, optimistic images of city life.

In the twenties Léger turned to much the same vivid idiom for more conventional subjects such as nudes, still lifes, and landscapes. There is less fragmentation and thus less dynamism in these paintings. Bodies, trees, fruit are represented with the same firmness as man-made objects. The idiom Léger had developed to assert the values of shared life in the city now serves to celebrate the less public sector—sex and family, domesticity—as well as rural life. He also painted more or less abstract pictures of two kinds. Some, with titles like *Mechanical Element*, are visual poems about the beauty of machines; others show arrangements of

82

82. Fernand Léger: *Mechanical Element*. 1924. Oil on canvas, $38\frac{1}{8} \times 51\frac{1}{8}$ in. Zurich, Kunsthaus

83. Fernand
Léger: *The Discs
in the City*.
1920–1. Oil on
canvas,
$38\frac{1}{8} \times 51\frac{1}{8}$ in.
Paris, Galerie
Louise Leiris

84 (opposite
above). Fernand
Léger: *The
Baluster*. 1925. Oil
on canvas,
$51 \times 38\frac{1}{4}$ in.
Collection, The
Museum of
Modern Art, New
York (Mrs Simon
Guggenheim
Fund)

flat geometric forms, which at times include a recognizable object, as in *The Baluster* (1925). Léger knew the work of Mondrian, who from 1919 on was back in Paris, and also the work of Mondrian's colleagues in the *De Stijl* group. He was also close to the architect Le Corbusier; *The Baluster* was shown in Le Corbusier's *Pavillon de l'Esprit Nouveau* at the 1925 International Exhibition of Decorative Arts in Paris. In 1923–4 Léger had made a film, *Ballet mécanique*, in which such things as a straw hat, numerals, wine bottles, a pendulum, smiling lips, circle and triangle, cog-wheels, eyes, pie dishes, dummy legs and human legs make brief but reiterated appearances. His emphasis was on rhythmic movement and also on a rhythmic succession of images. As a whole, the film insists on the homogeneity of man-made and natural, inert and living things. This should warn us against seeing his moves across the frontier between figuration and abstract art as any sort of crisis. He was drawn to the universality of geometrical abstract art and he saw its aptness as a complement to architecture. But he shared neither Mondrian's interest in the symbolism attributable to geometric structures nor the *De Stijl* group's growing tendency to adapt their pictorial style to three-dimensional roles in architecture and furniture. Léger's attachment to the realities of daily life was total. His abstract compositions should be seen as contributions to an environment to be used, fulfilled, by people. 'Against these big, calm areas, the human face assumes its proper status. A nose, eye, foot, hand or jacket button will become a precise reality.'

In Russia, where civil strife and foreign invasions added gravely to the problems left by war and by the upheavals brought by the Revolution of 1917, there had to be a sharp emphasis on practical realities. Avant-garde artists suddenly found themselves in leading positions in the nation's art and design institutes at a time when it was particularly necessary to know

85 (below).
Fernand Léger:
Frames from the
film *Ballet
mécanique*.
1923–4. New
York, Museum of
Modern Art,
Film Stills
Archive

and to demonstrate the utility of one's professional life. What could an artist offer to a society rebuilding itself amid grave economic gloom? Three answers presented themselves. One was to reconsider and rebuild art itself so that it represented universal truths by means of signs that (in theory at least) could be read by everyone everywhere. Another was to adapt to new messages the academic art that had entertained the bourgeoisie; soon to become the only form of art permitted by the state, Social Realism, as it is called (Social Idealism would be more appropriate), served to provide the vast conglomerate nation with unifying and encouraging images of its leaders and itself. The third was to apply the intuitions and intelligence of the artist to the practical needs of the time—for the artist to become a worker among workers.

In 1913 a young Russian painter, Tatlin, visited Picasso in Paris. We

86. Pablo Picasso:
Guitar. Early1912.
Sheet metal and
wire,
$30\frac{1}{2} \times 13\frac{1}{8} \times 7\frac{5}{8}$ in.
Collection, The
Museum of
Modern Art, New
York (gift of the
artist)

do not know what Picasso showed him, but from 1912 to 1914 Picasso made several constructed sculptures, some of them evidently playful, others more severe, out of a variety of materials, as well as painting his Synthetic, constructed, Cubist pictures. Among the works Tatlin may have seen is the *Guitar* which Picasso made out of sheet steel and wire, 86 perhaps early in 1912. It is the most severe of them, a dramatic composition of planes, edges, lines, and voids that combines a convincing presentation of a particular object with an extraordinary degree of anti-naturalism. It was made to be hung on a wall, a relief the base of which is the wall itself, but Picasso also liked to show it on a chair, away from the limiting surface of a wall. His idea of constructing sculpture out of available materials of many sorts instead of carving it out of stone or wood or modelling it in clay or plaster for subsequent casting in bronze—an idea which obviously parallels that of using non-art materials in painting—is the starting point of a rich history of constructed sculpture that continues to the present. The history of Russian Constructivism is almost entirely different from that, except for the initial impulse Picasso's example gave to it, and is fundamentally distinct in its ideology.

Tatlin's own first reliefs were assemblages of various materials. They suggested still lifes. By 1915 he was making entirely abstract sculptures out of metal, some of them to hang across corners in rooms, fixed to walls and ceiling but in effect hanging in space. Their forms echo those of Synthetic Cubism but do not hint at still-life motifs or at any descriptive intentions. They were first shown in the St Petersburg exhibition (December 1915–January 1916) at which Malevich launched

his Suprematism. It is said that Tatlin and the somewhat older Malevich came to blows in the gallery. Certainly it would be difficult to imagine a deeper difference of intention than that between these two pioneers of abstract art. In the years that followed this difference became clearer, though it existed before the Revolution. Tatlin sought reality in terms of materials and also, more and more, of practical problems. He became the leading figure in Russian Constructivism as well as one of the key figures charged with reorganizing art institutions under the new Soviet state. For some years his ideas had the support of government, though not its exclusive support, and he, in his turn, strove to make his work and his theories useful to the new-born society.

Weakened by international war, by the effects of revolution and civil war, and then also by the war against foreign troops sent to undo the Revolution, Soviet Russia could not but assess every activity by asking whether it secured the Revolution and strengthened the state. In his sculpture Tatlin had emphasized the reality of materials and of construction as a process. From shallow reliefs of a pictorial sort he had turned to deeper reliefs without framing backgrounds and then to the hanging *Counter Relief*, asserting its existence in actual space and its nature as a compilation of metal sheet, rod and wire. In the twenties Tatlin and his circle found even this kind of work insufficiently close to the needs of the day—a metaphorical approach to reality rather than a direct contribution. They decided that they must bring their inventiveness and experience as artists to bear on everyday problems. They could teach apprentices the nature and use of materials, and they could also

87

87. Vladimir Tatlin: *Counter Relief (Corner)*. 1915. Reconstruction made from photographs by Martyn Chalk, 1966–70. Iron, zinc and aluminium, 31 × 60 × 30 in. London, Annely Juda Fine Art

themselves go into the factories to develop new designs in conjunction
with new processes. As their champion, the poet Osip Brik wrote in an
article of 1923: 'In teaching the workers, learn from the workers'.
Another commentator, Dmitriev, had already announced, in 1919, the
underlying change of role: 'The artist is now simply a constructor and
technician, a leader and a foreman.' Tatlin designed and produced the
prototypes for, amongst other things, a cheap and efficient heating stove
and winter clothing. We also know of similarly practical problems tackled
in his classes: a baby's bottle in china, for example, and a chair with a
bent-wood frame and a seat not unlike a tractor's. What is particularly
striking about these designs, done in the late twenties, is that they do not,
unlike most new designs in the Western world, aim at an appearance of
modern efficiency by using basic geometrical forms. Instead, the design
arises from the purpose of the object and the potential of the material
available. The bottle is like a small breast: the child sucks at an opening
like a nipple, and the bottle can easily be held or stood on a flat surface;
the bent-wood chair exploits the springiness of its curved members.
During 1929 – 31 Tatlin worked on developing a man-powered flying
machine, hoping that one day people would be able to own them like
bicycles. With guidance from a surgeon and a pilot, he developed a
structure of bent wood, whalebone, silk, and other materials, within
which a person would lie, flapping and tilting the wings with his elbows
and forearms. Again he evaded the stylistic pull of modernism but
fashioned his structure in the manner of bones and sinews, an organically
conceived extension of the human body. A truly functional programme;
yet one senses in it also the ancient dream of human flight and all that
that implies in the way of mobility, freedom, and spiritual aspirations.
Tatlin felt that machine-powered flight, with all that it entails, was more
likely to kill that dream than to realize it.

88

Tatlin's most famous work was ambiguous in a similar way, only more
so. During 1919 – 20 he planned a vast structure to stand across the river
Neva in Petrograd (the renamed St Petersburg). Commissioned as a
Monument to the Third International, an organization established in

March 1919 to bring international socialism back into one co-operative brotherhood after the enmities required by war, Tatlin's Tower was to be a sort of answer to the Eiffel Tower in Paris. That was built for advertisement and pleasure and rose to 300 metres. Tatlin's, rising to 400 metres, would symbolize the energy and aspirations of the world-wide association but also serve as the Comintern's headquarters. The spiral structure, in part supported by a vast lattice girder rising at about sixty degrees to the horizontal, would in turn support three cells—a cubic one housing the assembly or debating chamber, a pyramidal one (lying on one side) housing the secretariat, and a cylindrical one with a hemisphere above it serving as information centre and broadcasting station. This fusion of symbol and functional building was to be built of steel and glass. Lifts would move up and down its girder spine; its two spiral, or strictly helical, ramps would afford vehicle and pedestrian access. The structure as a whole would look a little like an astronomical observatory, and it has recently been suggested that its slanting axis would have been aimed at the pole-star. The whole structure was to spring out of the earth, and it is

89

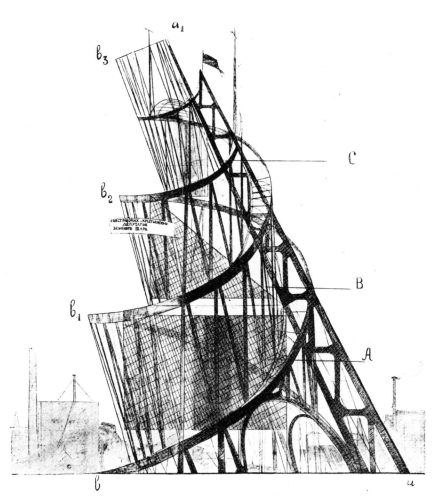

89. Vladimir Tatlin: Elevation of the *Monument to the Third International*. 1919. Photograph courtesy Moderna Museet, Stockholm

by no means fanciful to see it as part of a project global, indeed cosmic, in its function and meaning. Like the bridge on a ship, or the command module of a spacecraft, Tatlin's Tower would have served to steer the course of humanity on earth. Flags and radio masts at the top, as well as the proposed site, suggest ships. The mouth of the Neva at Petrograd was and is a major port; Petrograd was also a centre for astronomical studies. The cells within the structure would rotate in harmony with the cosmos: the assembly would rotate once a year, echoing the earth's annual movement round the sun; the secretariat once in 28 days, like the moon around the earth; the information centre once a day, with and like the earth. Thus the Tower served also as an annual clock, symbolizing and also representing man's existence in time. The whole structure would also have resembled an ancient ziggurat, one of those built on a circular plan and in elevation formed like a tall cone with one or two helical ramps leading to the top. And this association suggests also that biblical ziggurat, the Tower of Babel of *Genesis*, the occasion of mankind's loss 'of one language and of one speech'. The Comintern Tower would be its answer, bringing mankind together again. Tatlin's friend, the poet Khlebnikov, was analysing language to discover its common roots, and it is possible they envisaged the imminent formulation of a global language, more truly international than the Latin-based Esperanto.

Tatlin and his assistants built a model of the tower, which was shown 90 in Petrograd and Moscow in 1920. A simplified version of it toured Russia during the following years, carried in procession almost like the statue of a saint. A stamp was designed with the tower as motif. The critic Punin wrote a pamphlet, published in 1920, which emphasized that Tatlin's concept could not have come into existence without the support of a 'many-millioned proletarian consciousness', and described it as 'the ideal, living and classical expression, in a pure and creative form, of the international alliance of the workers of the world'. The Tower aroused great enthusiasm and was soon known outside Russia, but soon too people criticized its idealism and mocked its ambitions. Could it have been built? Perhaps not; Tatlin certainly did not attempt to cope with all the practical problems raised by the design, but then he never claimed to be an engineer. Wars prove man's resourcefulness again and again. Perhaps Tatlin relied on a collaborative endeavour such as we fail to achieve in times of peace, and believed that international Communism could or should aspire to it. Lenin thought the design a typical example of artistic folly. Trotsky, who valued creative endeavour, thought that Tatlin had gone too far with his rotating cells. The Soviet situation could not allow for such visionary schemes. Lenin's New Economic Policy of 1921 modified communist practice to permit private commerce and property in the hope of energizing trade and production, and art was soon to lose its freedom to explore new means of expression in association with new themes.

Outside Russia Tatlin's work was simplemindedly associated with technology, but then the idealism it might have represented had ebbed from post-war western Europe even more quickly than from Soviet Communism. George Grosz and John Heartfield, photographed at the Berlin Dada exhibition of 1920, present themselves holding a card (taken

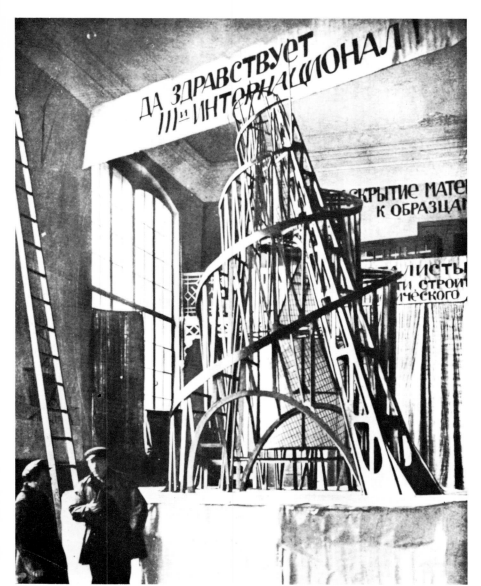

ДА ЗДРАВСТВУЕТ
///ⁿ ИНТЕРНАЦИОНАЛ

КРЫТИЕ МАТЕ
К ОБРАЗЦА

ЛИСТЫ
И СТРОИ
ЧЕСКОГО

90. Vladimir
Tatlin: Model of
the *Monument to
the Third
International*.
1919. Photograph
courtesy
Moderna Museet,
Stockholm

down from the display for the photograph) which bears in large poster
type the message: 'Art is dead/Long live the new/machine art/of Tatlin.'
Lissitzky praised the Tatlin Tower, in his account of Soviet architecture,
published in Vienna in 1928, as a building to be associated with 'lifts,
cranes, conveyor belts'; his suite of lithographs, published in Hanover in
1923, entitled *Victory over the Sun* is a remarkable synthesis of ideas from
the opera on which Malevich had collaborated in 1913 and from the
Tatlin Tower. A small model of the Tower was shown in the Russian
pavilion at the Paris Decorative Arts Exhibition in 1925. Together with
the pavilion (by Melnikov) and other Constructivist manifestations
within, such as Rodchenko's Reading Room for a Workers' Club, it

91. Alexander Rodchenko: *Hanging Construction.* 1920. Reconstruction from measurements and drawings provided by Varvara Rodchenko and put together by John Milner and Stephen Taylor, 1972. Plywood

supported Soviet Russia's image as a boldly progressive country, where art and technology were together creating a new environment, but in Russia itself that dream was rapidly fading.

The group of Constructivists around Tatlin, like Tatlin himself, turned more and more to bread-and-butter goals. A Moscow exhibition of September 1921, entitled '5 × 5 = 25' and consisting of five paintings each by five of Tatlin's followers, included three paintings by Rodchenko that probably ceased to exist many years ago but have become historic. Malevich had painted some white-on-white canvases to convey his intuitive blend of philosophy, religion, and science. Rodchenko showed three monochrome paintings, *Pure Red Colour*, *Pure Blue Colour* and *Pure Yellow Colour*; together he named them 'The Last Painting' and announced the death of abstract art. Rodchenko and other artists, and students in their care in Moscow, soon gave priority to the practical needs of the time and place, adopting the name Productivists to

92. Lyubov Popova: Set for *The Magnanimous Cuckold*, produced by Meyerhold in 1922 at the Actor's Theatre, Moscow. Collage

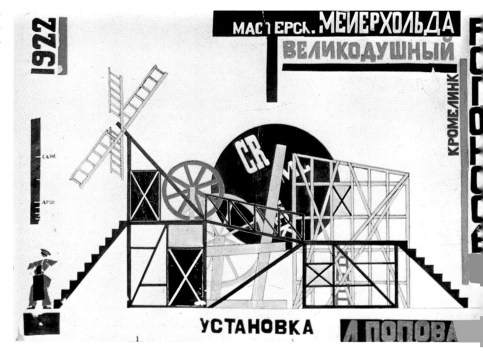
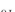

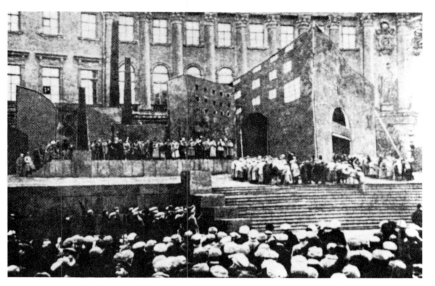

93. *The Storming
of the Winter
Palace*, re-
enactment
organized by
Dmitri Temkin
and designed by
Yury Annenkov,
1920

distinguish them from those who developed Constructivism as an art form. Their studios became workshops and studies. Art itself, under any guise, they denounced as an anachronism embodying bourgeois values and inviting capitalist exploitation. They turned to design. Rodchenko worked busily as photographer, as typographer and, with Mayakovsky often, as a designer of posters and advertisements. Vesnin designed Constructivist stage sets for Tairov's productions and worked with his architect brothers on particularly influential projects, notably the Palace of Labour for Moscow and the Pravda offices for Petrograd (both 1923).
92 Stepanova and Popova created sets and Constructivist stage props for Meyerhold productions (1922–3) and designed and to some extent produced textiles and clothes. Exter, too, turned from painting to theatre design. This tendency was accompanied by comparable moves in other fields. Writers abandoned fiction for reportage, and the fine flow of prose associated with good novels for the blunter, apparently more objective manner of reportage. Film makers made documentaries instead of dramas. Theatrical producers, Meyerhold especially, turned drama back into a popular art form full of movement and bearing clear messages, remote from the narrative and illusionistic conventions of the recent past. Not only did Meyerhold enlist Constructivist artists as his designers, he also trained his artistes to perform not as highly individual star interpreters of psychologically complex Chekhovian characters, but as all-purpose speakers, singers, dancers, clowns, acrobats, and music-hall comedians. On occasion, again often with help from Constructivist artists, dramatic events were staged in the streets and squares of Petrograd and Moscow, and the crowds and detachments of troops were enrolled as performers. The most famous instance of this was on 7 November 1920, when the historic event that took place exactly three
93 years earlier—the storming of the Winter Palace in St Petersburg by a combined crowd of civilians and insurgent troops—was re-enacted in precisely the same place by crowds that must have included some of the

original participants. Lots of writers, directors, designers, and technicians collaborated to prepare the scenario and setting. The action was presented in a sequence of tableaux and group movements, cued in by means of telephone calls from an adjacent tower. Six thousand people performed before the eyes of 100,000 spectators, we are told; the cruiser Aurora, from which the mutiny of 1917 had spread, was moored close by on the river Neva. To much the same purpose, if less spectacularly, railway carriages were adapted as propaganda centres, carrying books, posters, gramophones, and films around the vast country that needed to be welded into one nation, of one mind.

In the hands of Dziga Vertov and others film became the Constructivist art *par excellence*. The cine-camera records the world; the director shapes this objective material into a dynamic, purposeful presentation. Real material, not romance, processed constructively for a specific function. In Vertov's famous documentary films—*Kino-Pravda* of 1922–5 and *Kino-Glas* ('film truth' and 'film eye'), and especially in *The Man with a Movie Camera* (1929)—the illusionistic power of film is constantly neutralized by references to what we are watching and how it was put together. For example, Vertov shows himself in the cutting-room, constructing his film, and includes shots of his brother, the camera man, filming the shot that has just been shown, or shots of his own film as projected in a cinema, so that we see the screen itself and at times the audience watching it. Like Brecht, the German playwright of the same years, and like Meyerhold, Vertov wanted the spectator to be a conscious, mentally active collaborator. In his manifesto *We* (1922), Vertov wrote: 'We discover the souls of the machine, we are in love with the worker at his bench, we are in love with the farmer on his tractor, the engineer on his locomotive. We bring creative joy into every mechanical activity. We make peace between man and the machine. We educate the new man.' Ruskin and Morris, in Victorian England, had pressed for a renaissance in the crafts in order once more to associate work with pleasure and satisfaction; the Productivist dream was to bring man and machine into such a positive relationship. Like Vertov, Eisenstein, who had worked with Meyerhold in the theatre and won international fame with films such as *Strike* (1924) and *The Battleship Potemkin* (1925)—both films are re-enactments of recent historical events—stressed the central role of montage in the art of the film and the need to consider the implicit meaning of every image put before the public. Both men denounced the filmed romances that were then honoured as serious cinema in the West. Like Léger and other artists, they found more stimulus in American adventure films and slapstick comedies.

As an international movement, Constructivism has remained a development within art. It is usually thought of as a branch of sculpture associated with simple geometric forms and industrial materials. It spread in the West, stealthily rather than *con brio*, during the twenties and thirties, principally through the activity of Russian artists in the West, some of them emigrants from the Soviet state, others its emissaries. Several of them worked in central Europe during the twenties. Gabo, for instance, left Russia in 1922 and lived in Berlin until 1932. His first one-man exhibition was at the Kestner Gesellschaft gallery in Hanover under

94

the title 'Constructivist Sculpture'. That was in 1930, by which time this private art association, set up after the war in the regional capital city, had already established itself as a major centre for the support of abstract and Constructivist art. The list of the Kestner Gesellschaft's activities makes very impressive reading, comparable to that provided by Herwarth Walden and Der Sturm in Berlin before the war, but in the Hanover case without the slightest commercial incentive. And the range of dominant interests was now suitably different: not Paris plus Expressionism but now Mondrian and the Dutch *De Stijl* movement, Russian Constructivism, plus German reflections of their influence as well as new music and literature. Other centres shared this interest. A sort of fusion of *De Stijl* with Constructivism is as characteristic of the Weimar Republic that lasted from 1918 until Hitler's accession to power in 1933 as is the stylistically more reactionary 'New Objectivity'.

The marriage of *De Stijl* and Constructivism was arranged by the Dutchman van Doesburg and the Russian Lissitzky. Van Doesburg had been co-founder with Mondrian of *De Stijl* and edited its journal. He was a self-taught painter, a writer (under several names), a designer, and an indefatigable roving polemicist. Lissitzky had been trained as an engineer and worked as architect and painter. He had taught beside Malevich in Vitebsk, and the paintings resulting from this contact strike one as the secularized offspring of Malevich's visionary icons. Lissitzky described them as an 'interchange station between painting and architecture'. This image from the world of travel, meant to suggest their

role in embracing two modes of formal invention, fits also Lissitzky's way of life. One would call it frenzied in a different man. Energetically but also with good humour, Lissitzky (who arrived in Germany in 1921) organized exhibitions and produced his own work for them, wrote and lectured, edited and contributed to several magazines in Germany (most notably the trilingual magazine *Veshch/Gegenstand/Objet*, with the poet Ehrenburg), contributed texts and designs to magazines in Holland, America, and Switzerland, designed the layout and typography for Mayakovsky's poetry, and, after he returned to Russia in 1925, still appeared internationally as a writer and exhibition designer.

For both van Doesburg and Lissitzky paintings and other works of art were only one way of stating their aims. Both were capable of fine individual works, but one always feels that each work is part of a campaign. Their ambition was not to shine as artists or as specialists in any other field, but to lead art and culture at large into a new direction. 'Every piece of work I did', Lissitzky wrote in 1932, 'was an invitation, not to make eyes at it but to take it as a spur to action, to urge our feelings to follow the broad aim of forming a classless society.' Technology was of course the general guide, but Lissitzky's understanding of it was a good deal deeper than most of his colleagues' and went beyond simple dreams of machines and bridges. In 1928 he set down what his art had proposed

95. El Lissitzky:
Proun R.V.N.2.
1923. Tempera
and silver paint
on canvas,
39 × 39 in.
Hanover,
Kunstmuseum
mit Sammlung
Sprengel

for some time: 'My cradle was rocked by the steam engine. Since then that has steamed off to join the ichthyosaurus. Machines have ceased to have fat bellies full of entrails. Now is the time of the crammed skull of the dynamo with its electronic brain. Matter and spirit are transmitted direct into crankshafts which provide immediate motive power. Gravity and inertia are being overcome.' His vision embraced, and his art hinted at, a subtler world of physics, less earth-bound in feeling, yet still deriving its inspiration from the forces of the material world, and also the metaphysical world of modern spiritualist thought.

95 The firm but immaterial character of his *Proun* paintings expresses that vision. (*Proun* is an acronym he invented for himself, signifying 'for the new art'.) Clear forms of an architectural nature, three-dimensional versions of Malevich's massless rectangles, hover in an unidentified space. Their three-dimensionality is both shown and rendered non-illusionistic by the use of axonometric projection which allows no perspectival diminution or recession. The forms seem to float free, scaleless in a space without limits. Such paintings were seen during 1922 and 1923 in mixed exhibitions in Berlin, Düsseldorf, Hanover, and Amsterdam and also in his 1923 one-man exhibition at the gallery of the Kestner Gesellschaft in Hanover. For a Berlin exhibition of 1923,
96 Lissitzky designed and constructed a small square cell as a *Proun Room*. This room, lit from above, its walls, floor, and ceiling and the forms painted on them or built up in relief (in black, grey, and natural wood colour on white), formed an artistic environment, constricted in size but expansive in effect. The *Proun* forms worked with and against the architectural data, each surface presenting a different configuration and

96. El Lissitzky: Design for *Proun Room*. 1923. Lithograph

some elements ignoring corners to continue on the next wall. As in the paintings, the walls were sensed both as support and as space. Standing in this room, with his back to the entrance, a visitor would for the first time be able to imagine himself in a world of pure construction, clear-cut and calm but filled with energy.

The year 1923 also saw the publication of two sets of Lissitzky prints. One, published by the Kestner Gesellschaft, was of lithographic versions of *Prouns* he had worked on in Moscow and Berlin. The other was the *Victory over the Sun* suite. The alogist opera is turned into a Constructivist spectacle intended for a public place. Lissitzky's designs refer to a large 'display machine', a spiral structure that is a homage to Tatlin but also suggests a circus tent, with lights, an amplification system and mobile puppets, all controlled by a 'spectacle director'. The puppets represent types: 'Announcer', 'Globetrotter (in time)' using the American word, 'Troublemaker', 'Sportsmen', 'Old Man (head two paces back)', and others. The last of the images in the set is the 'New Man' striding forward, a living Tatlin Tower, with stars for eyes and a red square on his breast.

Van Doesburg's paintings of 1924–5 abandoned the vertical-horizontal formula characteristic of *De Stijl* painting in its early, Mondrian-dominated phase. Influenced by Lissitzky, van Doesburg now sought a more dynamic and expansive organization; unlike Lissitzky's, his paintings are all-over compositions whose now diagonal grids come into conflict with the canvas edges. (In response to this change, which van Doesburg justified in terms of its dynamism, Mondrian resigned from the *De Stijl* movement.) Halfway between these *Counter-Compositions* and Lissitzky's *Prouns* come the studies in which

97

98

99
100
101

van Doesburg experimented with rectangular planes in an axonometric space as a sort of abstract architecture.

In 1922 van Doesburg and Lissitzky had helped to organize a Congress of Progressive Artists in Düsseldorf. In their debates there, they promoted specifically Constructivist ideas at the expense of less explicit modernist attitudes. *De Stijl* doctrines of pure as opposed to individualist expression and of universal forms representing the human spirit as opposed to the transient, contingent forms of nature, were now linked emphatically to science and technology. The immediate result was the formation of an International Faction of Constructivists headed by Lissitzky, van Doesburg, and the Berlin artist Hans Richter. The manifesto they published included these words by van Doesburg: 'We today—who have hymned and exalted the suggestive powers of the machine as inspiration and fixed our sensations and plastic emotions in pioneer plastic works—we see the first outlines of the new machine aesthetic sketched on the glowing horizon . . . the first plastic expression vouchsafed by a mechanical cosmogony.' A new word emerged for the new art: Elementarism. It stems probably from the word 'element', which Malevich used to refer to his pictorial forms, echoing the nineteenth-century term for basic substances in chemistry. Even without further definition—the words tend to be rather vague, on this and other occasions—Elementarism and Elementarist encourages the notion of art and design as processes of bringing together discrete forms or pieces of matter in space. It also implies the use of succinct geometrical forms and primary colours as a universal language and the rejection of sophisticated complexities. This distinguishes Elementarist art sharply from the art of Léger and others in the Paris sphere of influence.

99. Theo van Doesburg: *Counter-Composition of Dissonants XVI.* 1925. Oil on canvas, $39\frac{3}{8} \times 70\frac{7}{8}$ in. The Hague, Gemeentemuseum

100 (below).
Theo van
Doesburg:
*Counter-
Composition V.*
1924. Oil on
canvas,
$39\frac{3}{8} \times 39\frac{3}{8}$ in.
Amsterdam,
Stedelijk
Museum

101 (right). Theo
van Doesburg:
*Counter-
Composition
(Maison
Particulière).*
1923. Collotype
and gouache on
paper,
$22\frac{1}{2} \times 22\frac{1}{2}$ in.
Detail. Private
collection

The difference becomes clear if we compare *Opus 47* (1923) by the
Belgian painter Servranckx with *A II* (1924) by the Hungarian painter
Moholy-Nagy, who attended the Düsseldorf Congress and was working
in Berlin. Servranckx was a restless avant-gardist, whose work shows a
quick response to a variety of stimuli from opposed tendencies in abstract
art. *Opus 47* is the most handsome in a remarkable series of machine-form
compositions made between 1922 and 1924. Painted mostly in greys, its
strong design echoes Léger's use of machine shapes but ends in stability
rather than dynamism. It asserts its material source in suggesting a firm,
metallic low relief. The Moholy resists such an interpretation. Trans-
lucent planes hover in measureless space. They are parallelograms and
circles, but we read the former as rectangles tilted this way and that. As in
the *Prouns*, there is no way to determine their size or their location in
space, and Moholy's characteristic play with transparency even leads one
to doubt one's first reading of their relative positions. Moholy too had
earlier painted pictures that directly celebrated the technical wonders of
the modern world—railway, electric light, and so on. Then, in 1921, he
had produced a series of three paintings by telephoning instructions to a

102
103

signwriter and letting him execute them to three different sizes. This demonstrated that the new art had nothing to do with personal expression or old-master skills; the use of the telephone (still a rare piece of equipment in those days) added a romantic dimension by distancing conception from execution. In the paintings of 1922 and after, these gestures were no longer felt to be necessary. Retrospectively we can conclude that all Moholy's work is characterized by a passion for light. It links his otherwise astonishingly multifarious activities. He was one of the first makers of photograms, which are prints done on photographic paper by exposing it to light without interposing a negative but blocking or manipulating the impact of the light by placing a variety of objects on

102. Victor Servranckx: *Opus 47*. 1923. Oil on canvas, $44\frac{1}{2} \times 82\frac{5}{8}$ in. Brussels, Musées Royaux des Beaux-Arts de Belgique

103. Laszlo Moholy-Nagy: *A II*. 1924. Oil on canvas, $44\frac{1}{2} \times 52\frac{3}{4}$ in. New York, Solomon R. Guggenheim Museum

104. Laszlo
Moholy-Nagy:
*Light-Space
Modulator*.
1923 – 30. Steel,
plastic and wood,
height 59½ in.
Cambridge,
Massachusetts,
Busch-Reisinger
Museum,
Harvard
University (gift
of Mrs Sibyl
Moholy-Nagy)

or above the paper. Many of Moholy's later paintings, from 1926
onwards, were done on various sorts of plastic, flat or moulded, so that
light could enter into the physical space of the object. His most famous
work is a kinetic sculpture developed over several years and exhibited in
1930. Now known as the *Light-Space Modulator*, it was originally called 104
Light Prop. As both titles imply, this motorized construction in metal,
glass, plastic, and wood is to be seen not merely as a work of art with
patent mechanistic qualities, but as an aid to a performance by light.
Moholy planned a film in six parts that would display all sorts of light
experiences, from lightning and fireworks to stage lighting and neon
signs. He filmed only the last section, in 1930 – 2, which is devoted to the
Light Prop and combines shots of the moving construction with extended
studies of its shadows and reflections. At the Bauhaus Moholy played
many parts, all of them linked by his promotion of an experimental use of
forms and materials thoroughly imbued with, and also limited by, the
machine aesthetic and the Elementarist faith in basic shapes and primary
colours. He was deeply involved in most of the Bauhaus ventures into
industrial design. The most impressive and successful of these was the
large range of light fittings designed and made in prototype at the
Bauhaus (mostly between 1926 and 1928) and quickly mass-produced
and marketed.

That film should take part in this optimistic exploration of a new range

of forms and methods was to be expected. Time is a fourth dimension more easily grasped than the fourth dimension of post-Euclidean geometry which had taken on mystical colouring in the thought of Malevich and others. Also, film, experienced as a changing pattern of projected light, is the least material of visual media, a product of man + machine that is as evanescent as sound. Historically, the impetus that led to the production of the first abstract films seems to have come from music and painting rather than from within cinematography. Stimulated perhaps by the *Blaue Reiter* almanac's call for a theory of painting, the Swedish painter Eggeling, whose father ran a music shop, embarked on a study of visual counterpoint comparable to the analyses of counterpoint that are a well-established part of musical theory. On separate pieces of paper he made successive drawings of one formal theme developed through many stages. From the end of 1919 on, he and Richter worked side by side on these studies, which they now drew in sequence on long paper scrolls. Many had musical titles, such as *Diagonal Symphony* (Eggeling, 1920), *Preludium* and *Fugue* (Richter, 1919 and 1920). In 1921 they began to make films. The same year van Doesburg reported on their work in *De Stijl* magazine, welcoming their contribution to 'conquering the static character of painting by the dynamic character of film'—an intention 'already existing in the minds of many modern artists'. According to Richter, the scroll drawings and Eggeling's earlier single-sheet drawings should not be seen as conscious essays towards film. The notion of continuity emerged gradually and the scrolls were thought of as self-sufficient works. Some of them were repeated in paint on long canvases before the idea of realizing them as films came up. The gap between their purely aesthetic play of forms in visual space and actual time and the reality-rooted films of Vertov reflects the gap between true Russian Constructivism and Western geometrical abstraction. But then Russian Constructivism was a short-lived movement, melting away around 1928–30 and only now becoming part again of Western awareness as knowledge becomes available. 'Bliss was it in that dawn to be alive!' Wordsworth's line, written in recollection of his enthusiasm for the French Revolution, expresses something of the impulse behind Russian Constructivism: optimism in expectation of the good that the rebuilding of society would bring and of the opportunities already offered by the Revolution to an avant garde that, without it, must have remained on the margins of society, and then optimism still in the bleaker days after the New Economic Policy, when long-term idealism had to make way for short-term solutions.

In the West there was no comparable dream, though post-1918 and post-Kaiser Germany seemed to share it briefly. The word 'utopian' is used disparagingly, even though it is obvious that the ability to think in a utopian way—to envisage better worlds and better systems and their rationale, logically and convincingly, without letting practicalities relating to the present occlude the vision—is one of man's inalienable faculties. Utopian thought is valid and makes progress possible. The Constructivist art that spread from Russia in the twenties carried this message with it, but left behind the insistence on abandoning art for production. In this sense it is an extension of Malevich's programme

105. Hans Richter: Frames from *Rhythm 21*. 1923. Film. New York, Museum of Modern Art, Film Stills Archive

rather than Tatlin's. Malevich always insisted on art as a self-justifying activity, spiritual rather than practical in its aspirations, general rather than particular in the problems it handled and, for those very reasons, of the highest value to mankind like other 'pure' pursuits such as philosophy, pure mathematics, etc. In the twenties Malevich made three-dimensional objects, some of which, called Architectons, suggest essays in abstract architectural form. This was as close to utilitarian design as he was willing to go. In 1926 a group of these objects was shown in Leningrad (as Petrograd was renamed in 1924) and firmly criticized for their distance from the actualities of life; Malevich conversely accused architects of never considering architectural form as such.

Gabo shared Malevich's valuation of art as an independent activity. Like Lissitzky, he brought to art the training of an engineer. He turned to art under the influence of what he had seen in the West and of his brother Antoine Pevsner, the sculptor. The brothers returned to Russia when the Revolution started and worked in Moscow in close touch with other avant-garde artists, the institutions they were forming and the debates going on in and around them. Gabo's first sculptures were abstracted representations of heads constructed by means of planes of iron or celluloid arranged so that the edges of the planes delineate the form and there is no barrier between internal and external space. Stimulated by Tatlin's example he too made architectural projects in response to specific needs. His *Project for a Radio Station* for the town of Serpuchov 106 (1919–20) quotes the Eiffel Tower as seen by Delaunay as well as the scale and the directional slant of Tatlin's. Gabo himself soon became critical of this kind of work and devoted his life to inventing pure

106 (left). Naum Gabo: *Project for a Radio Station*. 1919–20. Pen and ink. Whereabouts unknown

107 (right). Naum Gabo: *Model for 'Column'*. 1920–1. Plastic, height 5⅝ in. London, Tate Gallery

108. Naum Gabo:
Spiral Theme.
1941. Plastic,
$5\frac{1}{4} \times 9\frac{5}{8} \times 9\frac{5}{8}$ in.
London, Tate
Gallery

107 sculptural forms, many of which could be developed as large-scale public monuments. In 1920 he and Pevsner exhibited their work in the open air, on a boulevard in Moscow. At the same time they produced their *Realistic Manifesto*, publishing it by means of bill-posting it in the form of a poster. Gabo wrote it. In it he mocked the Italian Futurists for their reactionary patriotism and militarism, and for their enthusiasm for 'frenzied automobiles, rattling railway depots, snarled wires, the clank and the noise and the clang of carouselling streets' that they so eagerly mistook for the dynamism of modern life. 'Look at a ray of the sun', he wrote: '... the stillest of still forces, it speeds more than 300 kilometres a second ... behold our starry firmament ... what are our depots to those depots of the universe?' He made an electrically powered kinetic sculpture in 1920 but found that too limited a process. His sensitivity to space and time as 'the only forms of which life is built' led him into a poetic rather than a literal concern with motion. His characteristic sculp-

108 tures of the twenties and later are transparent structures, often made of transparent materials that seem to grow outwards from a formal nucleus or rise upwards like a plant or a fountain. They are delicate structures usually, revealed by the way they catch light more than by their material presence. They are microcosmic metaphors for the macrocosm and the forces that command it; Gabo warned us not to look for more specific symbolism in his work. It should therefore not surprise us to see one of his public sculptures, the 80-feet-high structure set up outside the Bijenkorf store in Rotterdam in 1957, but conceived in 1954, resemble closely the model with which he won the second prize in the 'Unknown Political Prisoner' sculpture competition the previous year.

Gabo remained in Berlin until 1932, when he moved to Paris and joined the *Abstraction-Création* group, which offered abstract and Constructivist artists a haven and a platform in a generally uninterested or even hostile world. In 1935 he moved to London, where he contributed to exhibitions and collaborated with Ben Nicholson and the architect J. L. Martin on the book *Circle*. During the war he worked near Nicholson in Cornwall, and in 1946 he emigrated to the United States. This westward drift has wider significance and is paralleled in the careers of other abstract artists, notable among them Mondrian and Moholy-

Nagy. It represents the progress of abstract art as a well-founded and shared (as opposed to eccentric) activity, and more particularly also of Constructivist art, from the melting pot of central Europe in the twenties to France, England, and America. In that progress Constructivism has served as a stabilizer and a conscience. It was Gabo's example primarily that kept alive a tradition of Constructivist sculpture, though in Vantongerloo the *De Stijl* movement could also offer a sculptor who constructed abstract sculptures. Vantongerloo's use of simple geometrical forms plotted according to mathematical formulae associates him more specifically with Elementarism than Constructivism but there is no clear distinction that can be drawn at the level of theory. Where the ex-engineer Gabo worked intuitively, the art-trained Vantongerloo based his art on mathematics, and Constructivism has continued in both modes. A rallying call rather than a movement, Elementarism disappeared with the outlawing of modernist art in central Europe. As geometrical abstraction it took root in England and America in the thirties and has survived antagonistic trends and fashions there to this day, returning also to the Continent of Europe as a vital, if not markedly glamorous, tradition. What makes this Constructivist/Elementarist tradition of special importance is its insistence on art as a process combining poetry with rationality (which Expressionism and Surrealism proclaimed to be irreconcilable), and total abstractness, i.e. a basis in geometry or number or other concrete data, with a kind of realism. Here 'realism', as in the title 'Realistic Manifesto', must be understood to refer to the realism implied in the absence of symbolism and in the actuality of the materials employed. They may be industrial materials such as plastic or aluminium; they may be older materials such as wood or paint. In no case do they stand for anything other than themselves. And the processes by which works of Constructivist art are conceived and executed are implicitly offered as models of reasonable and beneficial creative activity.

109

109. Georges Vantongerloo: *Group y = ax²* *+ bx + c*. 1931. Wood painted grey, $26\frac{3}{8} \times 20\frac{7}{8} \times 20\frac{1}{8}$ in. Estate of the artist

4 Art is Dead: Long Live Art

Our heads are round so that thoughts can change direction.

Picabia

If there is such a thing as undying art then demolishing the art cult won't kill it.

Wieland Herzfelde

The big hit of 1914 was the war. On all sides men rushed gaily to arms, sent into battle by their parents and their women. Few doubted that war would be a refreshing, confirming national experience. But there were some and, as the short, sharp contest turned into years of inglorious carnage, there came to be many more, who saw the internecine struggle as proof that the capitalist system and the governments and social structures dependent on it had failed.

Neutral Switzerland offered sanctuary to those who could escape. Zurich became the gathering point for German-speaking émigrés. There, in February 1916, Hugo Ball opened a night-club, the Cabaret Voltaire. Ball was poet, dramatist, and left-wing political writer; he was also something of a musician. His friend Emmy Hennings was an actress, and could sing and dance. His other collaborators at the start included the Rumanian painter and architect Marcel Janco, Hans Arp the painter and poet from Alsace-Lorraine who had contributed vignettes to the *Blaue*

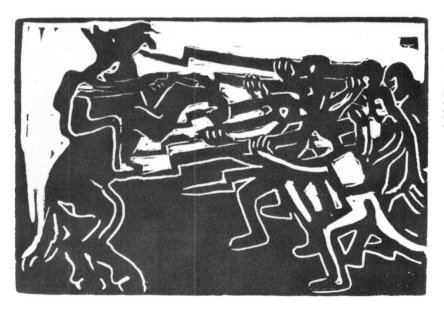

110. Arthur Segal: Anti-war woodcut. *c.* 1915 – 16. $5\frac{7}{8} \times 8\frac{5}{8}$ in. Courtesy Richard Nathanson, London

Reiter almanac, and Tristan Tzara the Rumanian poet. Others were invited to contribute. The first evening featured a Russian balalaika band, readings from Voltaire, Frank Wedekind and Ball, and songs by Rachmaninov and Saint-Saëns. Ball played classical music on the piano, then switched to dance music; people pushed the tables aside and danced. On the walls was a variety of work, much of it from Arp's collection (some Picasso etchings, for example), some of it by artists now in Switzerland, like Arp himself and Arthur Segal from Berlin. An entertaining evening, one imagines, for anyone happy to mingle high and low-brow stuff with chat, drink, and dancing. The progressive note of some of the offerings may have been a little challenging to Swiss habits but their context was not especially outrageous. Anyone who had sampled the more intellectual end of Berlin night-life before the war would have recognized the mixture.

Within a week Ball had been joined by another German writer, Richard Huelsenbeck. Huelsenbeck had abandoned a career in medicine to fight for social progress through words. His arrival brought a much more aggressive tone to the Cabaret. Ball was to describe what they now offered as 'at once buffoonery and mass for the dead'. He and his friends shared Huelsenbeck's view that the war had been primarily of Germany's making, proving the hollowness of her pretensions to intellectual and cultural grandeur. But this reflected also on the other so-called civilized nations hell-bent on mutual destruction. The Cabaret became a loud and public act of dissociation from that world by means of acts and objects created in opposition to Western civilization as a whole. All art, even the avant garde of yesterday and especially Expressionism, stood condemned as part of the war machine. Performances now included the latest music of Satie and Schönberg but also 'bruitist' music made with unmusical instruments. Literature was represented by tribal poetry from Africa and by nonsense poems made by members of the group: poems consisting of words in random sequence, sound poems comprising meaningless syllables, and 'simultaneous poems' made up of two or more poems declaimed concurrently. Manifestos against Symbolism, Futurism, and Expressionism added attacks on specific targets. By the summer of 1916 the group was referring to its work and aim as 'Dada', substituting baby-talk for the name of Voltaire, the great moralist and satirist.

In 1917 Dada became known internationally. The Dadaists opened a gallery and began to publish a Dada journal. There was personal contact with like-minded writers and artists, with the French painter Francis Picabia, for example, and with the French poet Pierre Reverdy, the friend of Picasso and Apollinaire. Dada became an international activity and the Zurich group began to split up. Huelsenbeck, impatient of their safe position on the touchlines, left early in 1917 to return to Berlin, a Berlin that had changed during his absence from the capital of a warlike and war-liking Empire into the capital of a disillusioned nation facing defeat and ready now to question the leaders and institutions that had brought this about. Ball, troubled by what he had come to see as a negative and unconstructive role, left the Dada group and moved to Berne, where he wrote a fierce attack on the now fashionable iconoclasm of German

111
112

intellectuals. Subsequently he joined the Catholic Church. Tzara, already writing in French, developed ever closer contacts with Paris. In 1920 he settled there and worked in close association with the writers and artists who were shortly to launch the Surrealist movement. Arp went to Cologne in 1919 and joined Max Ernst in promoting a Dada group there. In Russia there had already been a similar movement: earlier, in discussing Malevich, I referred to the alogical trend in Russian writing and to associated developments in music and art and shall have to say more about it below. In New York, where the large modern exhibition of 1913 known as the Armory Show had challenged the American art world and infuriated press and public, something like a Dada movement had grown up around the figures of Marcel Duchamp and Picabia, both visitors from Paris arriving in 1915. (Picabia travelled a great deal between America and Europe during the next years, publishing Dada journals and contributing to the journals and exhibitions of others.)

The spirit that we call Dada was clearly not Ball's or Huelsenbeck's or Zurich's creation. It was inherent in a war that forced people either to accept the most appalling events as being justified by the demands of patriotism or to denounce them as proof that progress, technological, educational and political, had been illusory. Was art, then, an illusion too? Had modernism achieved anything? Did not the best of Cubism in the end serve the same function as the art of the academies, to entertain

Art is Dead: Long Live Art

111 (left). Francis Picabia: *Réveil Matin*. Cover of *Dada 4–5*, published in Zurich, 15 May 1919

112 (right). Francis Picabia: *Tableau Dada*. Illustration from *Canibale*, published in Paris, 25 April 1920

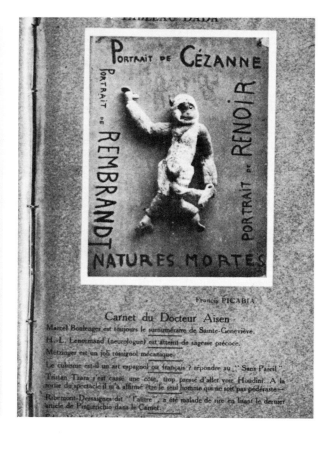

the bourgeoisie and enhance its self-regard? Had not the Futurists actually made propaganda for this war and helped to push their country into it? Had not some of Expressionism's most noticeable manifestations been loudly nationalistic? These movements had attacked some of the criteria by which art was traditionally evaluated—such as the skills of eye and hand required to make a convincing representation—yet they had not asked whether art itself could still be valuable and was worth pursuing. Dadaists could look to occasional forerunners in literature and sometimes in the other arts: men whose partly humorous diverting or inverting of the priorities and processes of their art implied some doubt of its value. Laurence Sterne and Lewis Carroll in English literature, Christian Morgenstern in German; particularly important for modern times the schoolboy wit and smut concentrated by the young French writer Alfred Jarry into his nonsense play *Ubu Roi*, first performed in Paris in 1896, and his posthumous book *Dr Faustroll*, published in 1911 and containing speculations towards a science of imaginary solutions called 'pataphysics'. Such works and actions could be seen as marginal to the arts and perhaps as a beneficial purging of a self-indulgent cultural system, but also as a frontal attack on all that was held sacred in civilization—an attack as serious and as high-minded as anything civilization itself could offer in self-defence.

In international Dada we see the first concerted and unambiguous attack. This is why in this chapter we have been referring so far not to individual artists and selected works of art but to events, publications, performances. Dada was not an art movement. It expressed itself primarily through words, often through the several journals that issued from Zurich, Berlin, New York, Cologne, Moscow, and other places. These journals often had a disruptive visual character through wild or nonsensical typography and aggressive or puzzling illustrations but were nonetheless composed largely of verbal matter and addressed to a reading public. The various Dada evenings and other occasions were secondary since they could only make limited local contact; they were also trial runs for some of the material that would subsequently be sent around the world in printed form. Art itself was, in this sense, tertiary. Here I am referring to the works of art that have survived and were intended to survive, and it could be argued that art objects are counter to the spirit of Dada. Even the bitterest work of art represents a constructive moment, not an anarchistic one. That Dada gave rise to art, indeed to major works of art, is evidence of the persistence of this constructive impulse. Or of the existence of artists. 'There really is no such thing as Art. There are only artists', E. H. Gombrich wrote in *The Story of Art*. Dada, then, was the creation of men of letters and of artists. Both sorts were impelled to give lasting form to at least some of their activity. In the spirit of Dada a writer might be satisfied on occasion by throwing a handful of slogans and rude messages on to a page, though even here the typographical end-product is likely to have a lasting interest that the deliberately crude verbal act does not have, but the visual artist cannot totally evade the need to make his offering, however nihilistic in intention, effective and compelling. He has to give form and material presence to his action, even if that action is merely a rude gesture.

But the Dada experience also showed something else: performances or other events can themselves be art. The term art is here stretched to embrace elements of cabaret, theatre, recital, exhibition, parade, music hall, circus, and so forth—it was stretched then and has never been its old slim shape since. There is a continuing tradition of outrageous or in other ways argumentative exhibitions that has continued since Dada days. There is also a more intermittent tradition of actions or performances carried out as works of art, often as ephemeral works that exist only for the one occasion. There is of course a long tradition of ephemeral art. One thinks of the ceremonial gateways designed by such artists as Dürer and the symbolical actions that went with such structures to celebrate the arrival of the emperor, or of Jacques-Louis David's role in designing the new religious festivals ordered by Robespierre for the enlightenment of post-Revolutionary France. Because of their impermanence these creations have left behind only a vague impression; we have to rely on old prints and reports to gain an impression. In the twentieth century, impermanence has sometimes seemed a positive virtue to artists who questioned the social function of private art collecting and the commerce that goes with it and hated to see art corralled into hygienic and impregnable museums. Art events became a means of evading the system, and that meant evading also its limitations of politeness and of practicality. The last decades, which have seen dizzying increases in the money value of much commercially promoted art, have also seen an explosion of activity in this area of art events, and we shall have to return to it later. In considering Dada from the point of view of art history we have to take our bearings from what verbal productions survive and examine some of the visual works, remembering that there were also these other occasions, of which we know little, when the writers and the artists confronted their public in person to deliver their condemnations of the world through a variety of means, sometimes in the guise of entertainment, sometimes more directly.

Characteristically, Dada art is very diverse. What the Dada artists had in common was a heritage of modernism and the intention of challenging established notions of what art should be. On the face of it, at least, they were questioning rather than establishing anything, so that we need not be surprised to find them giving new meaning and purpose to methods and styles already at hand rather than promulgating new ones. 'Everything the artist spits is art', said Kurt Schwitters. It is not the form, the matter, the content, the category, the skill that make a product art but that the artist knows it as art. This attitude had been prepared for, perhaps, in Cubism and Futurism and in Russian art of the pre-Revolutionary years, but now it is openly announced. The artist as painter, sculptor or whatever continues, and we may think his activity still central to the decades that follow, but he is increasingly conscious that the option he has taken is one amongst others. The stream of art widens, bursting its banks. Each call for redefinition leads to another widening, so that definitions can serve only retrospectively. For anyone drawing the map of modern art this is the main discovery. He has to map something like a river delta but he is not hovering over it in a helicopter, he is in the river himself, unable to see what land formations lie ahead or

113 (opposite).
Jean Arp:
*Portrait of
Tristan Tzara.*
1916. Relief of
painted wood,
$20\frac{1}{8} \times 19\frac{3}{4} \times 4$ in.
Estate of the
artist: on loan to
the Musée d'Art
et d'Histoire,
Geneva

114. Jean Arp:
*Rectangles
Arranged
According to the
Laws of Chance.*
1916. Collage,
$9\frac{7}{8} \times 4\frac{7}{8}$ in. Basle,
Kunstmuseum,
Kupferstich-
kabinett

whether, indeed, as some prophesy, what lies ahead is the sea in which art
will lose its distinctness and surrender its special status, becoming once
again the ordinary human behaviour it must once have been.

Each Dada artist had his particular way of bending the modes of
modern art to Dada purposes. Arp, who had worked in Paris as well as in
Munich before coming to Zurich and who was by birth ambiguously
Franco-German (he is Jean Arp as well as Hans Arp), was by 1916
distancing himself from what he had come to see as the dishonest rhetoric
of much Expressionism and working with abstract forms only. His
113 *Portrait of Tzara* does not tempt us to find the poet's appearance in it the
way a Cubist portrait might. It is evidently a compilation of abstract
shapes and if they make any reference to the poet it is very oblique.
Perhaps it is not a visual one at all. The wooden shapes are placed in front
of one another like the elements of a Cubist collage, but they suggest
natural forms, the forms of living, growing things. In other works of the
114 same period Arp preferred to use shapes from the man-made world, more
or less neat squares, but invited the participation of nature by composing
them, as he put it, 'according to the laws of chance'—according, that is,
not to the artist's plan or preference but to a sequence or an arrangement
determined by the complex of forces (gravity, the motion of the air, etc.)

Art is Dead: Long Live Art

we call chance. Again the method derives from Cubist collage, but what is questioned here is not the relationship of the result to visual reality so much as the artist's role as artificer. To make a work of art by surrendering not only traditional skills but even much of one's controlling function was to be a characteristic Dada element. These particular works hover curiously between asserting man and his world (as in Constructivism) and submitting happily to nature.

This pointed relinquishing of control had already provided the basis for certain works by Marcel Duchamp. Until 1912 he had been a searching, restless painter, given to extending the new idioms available to him in poetic and paradoxical directions. In 1913 he dropped three pieces of sewing thread, each one metre in length, on to a canvas from a height of one metre and fixed them in the irregular, unpredictable position in which they arrived. He called the result *3 Stoppages Étalons*. Thus 115 man-determined measures, useful only to man—and decreed by the French Legislative Assembly, establishing the metric system in 1799, to equal the ten millionth part of one quarter of the earth's circumference— are interfered with by nature's forces and rendered useless. Useless? Duchamp mounts the Standard Stoppages carefully and has a strong case carpentered for them, treating them with the care elsewhere accorded the paradigmatic metal metre measure. He wrote later: 'This experiment was made in 1913 to imprison and preserve forms obtained through chance, through my chance. At the same time, the unit of length—one metre— was changed from a straight line to a curved line without actually losing its identity as the metre, and yet casting a pataphysical doubt on the concept of a straight line as being the shortest route from one point to another.' In 1914 Duchamp used an old canvas, still offering glimpses of an unfinished figurative painting and of early plans for his monumental *Large Glass*, to paint his *Network of Stoppages*. It is a sort of railway map, 116

created by using each of the Standard Stoppages three times. This map, in perspective projection, was later used to determine the location of each member of a troupe of performers contributing to the *Large Glass*, the Nine Malic Moulds. Thus the 'accidentally' achieved becomes the controlling element for subsequent work.

But control can also be relinquished more thoroughly. In 1914 Duchamp began to make works of art by designating as art already existing objects. Acting from 'visual indifference', as he put it, he bought a circular bottle-rack from a Paris store and wrote an inscription on it. In 1915, in New York, he similarly acquired a snow shovel and called it *In Advance of the Broken Arm*. Also in New York, in 1917, he sent a urinal (made by Mott Works) to an exhibition with the signature 'R.Mutt'. The exhibition was supposed to be open to anyone who cared to exhibit, but the hanging committee could not countenance this piece: it stayed in the exhibition space but was screened from view. We know it from a contemporary photograph taken by Duchamp's friend, the photographer and gallery-owner Alfred Stieglitz. The urinal's new title, *Fountain*, and also its position demonstrate an inversion of the object's intended function. More important is the inversion Duchamp was proposing in the artist/art-object/public relationship. Instead of conceiving a work, on the basis of whatever external and internal motivation, and employing his

117

Art is Dead: Long Live Art

116. Marcel Duchamp: *Network of Stoppages*. 1914. Oil and pencil on canvas, $58\frac{5}{8} \times 77\frac{5}{8}$ in. Collection, The Museum of Modern Art, New York (Abby Aldrich Rockefeller Fund and gift of Mrs William Sisler)

Art is Dead:
Long Live Art

117. Marcel
Duchamp:
Fountain. 1917.
Sanitary ware
and enamel paint.
Photograph by
Alfred Stieglitz.
Courtesy Sidney
Janis Gallery,
New York

inventiveness and skill in order to fashion it as an object bearing some specific significance, the artist merely selects—and selects, Duchamp stresses, uncaringly. Instead of the object being something new and unique, it is commonplace and mass-produced. It is new only in its situation and in any apparent change in significance produced by this displacement (and by any signature or other matter the artist may add to it; there is something particularly pointed in the painterly 'R.Mutt' brushed on to that anonymous cold object). The public finds itself deprived of the usual satisfactions it thinks it has a right to expect from art. Instead of playing its habitual game of accepting or rejecting a work of art, the public is forced to ask itself whether the exhibit is a work of art at all and thus what a work of art is. The artist's input is minimal, if we can call such an imperious act minimal, while the public is faced with a problem that threatens to shatter all cultural values.

Duchamp was to add further twists to his philosophical pressurizing of art. From 1923 on he rested. He played a lot of chess. On occasion he would help to mount an exhibition, or consent to reissuing his own earlier work in some publishable form, but there was little or no artistic output. The artist, instead of doing, existed. A benign presence in American and French avant-garde circles, he remained part of the world of art without contributing to it much more than his presence. As the decades passed the former prankster and odd-man-out had the satisfaction of seeing himself become a central figure in modern art history, much discussed, much interviewed, much lionized. When he died, in 1968, it was found that he had in fact been working for two decades on a major new piece.

Now set up in Philadelphia, it is a tableau comprising a reclining nude holding up a gas lamp and a landscape background with a moving waterfall, all shut away behind an old pair of farmyard doors through which we peer, voyeurs all. Its title is *Given: 1.the Waterfall, 2.the Illuminating Gas.*

Between 1912 and 1915 Duchamp planned, and from 1915 to 1923 executed (and left unfinished), what will surely continue to be regarded as his chief work. This is *The Bride Stripped Bare by her Bachelors, Even,* often referred to for brevity's sake as the *Large Glass.* It was planned and wrought with all the care and skill a devout art lover could wish for. Duchamp later published—in facsimile but in random order—some of the sketches, notes, and plans that were its preparation. Through them we can glimpse some of the stimuli and influences that contributed to it: recent thinking in mathematics, technology, alchemy even, the visual and verbal heritage of Symbolism, formal and conceptual elements from his own earlier work. The introspection implied by this is as important as all the cleverness, the wit, the dandyish air of detached superiority that strike us first and tend to dazzle us. Never has so much deliberation of an apparently nonsensical sort gone into the planning of a picture; never has such care in the making been employed to transmit decisions arrived at by chance. The ideal of permanence occasioned Duchamp to turn from canvas to glass, and he achieved it by sealing the pigment between two impervious transparent panes. The bride, in the upper half of the diptych, is a distillation from a long series of paintings and drawings of his sister and of other women, queens, and brides. The 'blossoming' cloud beside her contains three 'draught pistons', vaguely rectangular, whose precise forms were determined in 1914 by photographing three times a square of net curtain as it moved in a draught. Holes ('shots') drilled through one sheet of glass, to the right of and below the cloud, were located by firing match sticks dipped in paint from a toy cannon. In the lower half partly invented, partly transcribed machines—both of them rotatory, the mill wheel ('glider') passive, receiving and transmitting motion, the chocolate grinder active ('the bachelor grinds his own chocolate' is a French saying)—are accompanied by other turned and turning forms, the Nine Malic Moulds clustered on the left as directed by the Standard Stoppages, the conical 'sieves' in the centre, not tinted with pigment but with New York dust, the Oculist Witnesses (from French opticians' charts) on the right. This lower half appears to be terrestrial, with expertly handled perspectival construction implying a horizontal ground plane and measurable space at a height that we can easily relate to. Yet this stabilizing and in many ways reassuring structuring is rendered invalid by being applied to a transparent surface. The perspective, unshakeable on paper, strong in a photograph, is nonsensical in visual fact because there is no ground or background and because of the visual interference provided by whatever static or moving objects its setting in the Arensberg home, in Katherine S. Dreier's library, in exhibitions and now in the Philadelphia Museum of Art offers.

The theme of the *Large Glass* is sex: dream, inspiration and longing, motivating energy and, as for many a mystic through the ages, symbol for spiritual aspirations. In alchemy, for example, stripping the bride on her

wedding night symbolizes purifying matter and also clearing the mind of distractions. But sex, in the end, as failure. The bride and the bachelors do not come together. They are forever bride and bachelors. The union they dreamed of is a solitary obsession. The separateness of the two glass panels confirms this failure and isolates their meditations. In transit from their first public showing, in 1926, the two panels were carelessly packed together and they shattered. Duchamp enrolled the disaster as the work's completion, but worked painstakingly later to piece the fragments together. A sub-theme, obviously, is the machine. We must remind ourselves of the period of the *Large Glass*'s conception and creation, from before the first world war until 1923. Others were celebrating technology in word, image, and sound; a few were using the machine as an ironic image of humanity; some were expressing their fear of the machine. The *Large Glass* can be seen as an answer to that optimistic science-fiction imagery and to the technologically inspired abstract imagery best represented by Lissitzky's paintings. Duchamp's friend Picabia was one of those who used machine images to parody human behaviour. In Duchamp's hands this ironic programme, charged with his formidable curiosity and intelligence, and also with the melancholy of a profoundly solitary man, takes on sacral status. He was a deeply cultured, deeply thoughtful man, member of a family steeped in the arts. Radical in his assault on art's accepted basis, he was also conscious of the history of art. This iconoclast knew his icons. *The Bride Stripped Bare by her Bachelors, Even* is a painting in the tradition of Botticelli's *Birth of Venus* and of Titian's *Assumption of the Virgin*. A note among Duchamp's published documents says: 'The Bachelors serving as an architectonic base for the Bride, the latter becomes a sort of apotheosis of Virginity'. The tradition is celebratory. Duchamp's painting is sad as well as cryptic.

For others Dada was a vehicle for political statements, a way of engaging art in direct political action. The Berlin Dada group, launched by Huelsenbeck in March 1918, was openly left-wing and combined anti-art activities with propaganda. Its leading members, Richard Huelsenbeck, George Grosz, John Heartfield, Raoul Hausmann and Johannes Baader, joined in denouncing Expressionism as a nationalist and romantic phenomenon of no relevance to the post-war world. They published journals and contributed to the publications of others. They held exhibitions and presented afternoon and evening events at which they harangued their audiences about culture and politics as well as performing nonsense poems and the like. Twelve such sessions are recorded during the years 1918 to 1920, mostly in Berlin but also in Dresden, Leipzig, and Prague. Each member had his specialities; what they shared was an express desire to reform the world. Thus Baader's public attack on Jesus Christ achieves Dada quality by being delivered in Berlin Cathedral in the middle of a service, as does his action of scattering flysheets proposing himself as first president of the German Republic at its ceremonial inauguration in Weimar in 1919. At some moments Baader and his friends seemed to be playing the fool; in fact they were engaged in a life and death struggle. Germany was in turmoil; Berlin pre-eminently so. The Kaiser had been driven from power at the end of 1918, and with him many an illusion, but the liberalism embodied in the Weimar

118 (opposite) Marcel Duchamp: *The Bride Stripped Bare by her Bachelors, Even (Large Glass)*. 1915–23. Oil and lead wire on glass, $109\frac{1}{4} \times 69$ in. Philadelphia Museum of Art (Katherine S. Dreier Bequest)

Republic, offensive to the nationalistic right, was nothing but ineffectual idealism to the left. Attitudes polarized. Soon there was civil war. Those who felt it their duty to defend law and order inevitably found themselves backing the right. There was real hatred and much bloodshed, and we know the outcome. For the moment, Russia's example gave hope of success to the socialists.

Russia had had something very like a Dada movement some years earlier, and had called it Futurism. In April 1910 an almanac entitled, approximately, *A Trap for Judges* appeared in St Petersburg. It was primarily a literary miscellany but one of its editors was the painter and poet Matyushin, whom we have already encountered as the composer involved in the opera *Victory over the Sun* for which Malevich did sets and costumes. Matyushin played first violin in the St Petersburg Philharmonic, had a particular interest in quarter-tone music, and translated Gleizes and Metzinger's book on Cubism into Russian. One of his busiest collaborators on the almanac was David Burliuk, painter and poet too as well as publisher and all-round stimulator of avant-garde activities. In 1912 Burliuk published another 'Futurist' volume, which announced its general drift fairly unambiguously in its title, *A Slap in the Face of Public Taste*. The 1910 almanac had pointed in the same direction. It had been meant to shock, 'to throw a bombshell into the joyless provincial street of generally joyless existence' as a contributor said later. It was correspondingly received. The modernist poet Bryusov, for example, dismissed the book as 'beyond the limits of literature', finding it 'full of boyish pranks in bad taste'. The Russian Dadaists also displayed boyish pranks, as when Burliuk, Mayakovsky, and others wandered about the streets of Russian cities wearing ridiculous clothes, with words and symbols painted on their faces, and sporting wooden spoons or radishes in their buttonholes. They were guying the pretensions of high culture, as the Western Dadaists were to do, but, like only some of these, they did so publicly, before a wide, everyday world.

We find here the same duality as in Western Dada activity: impudent antics to draw attention and signal a general attitude but also work which has lasted and borne fruit, however nihilistic it seemed at the time. Many artists, Malevich amongst them, found themselves stimulated by the challenges thus issued to old restrictions and came to evaluate the new art of the West accordingly. Burliuk himself was especially active on the buffoonery front, but also wrote, painted, and contributed in serious vein to the *Blaue Reiter* almanac and exhibitions. For none of them could there be any clear division between their life as 'Futurists' and their constructive work as cultural avant-gardists. When the revolution came they recognized it as their Revolution; almost all of them were eager to serve the Soviet state. Outside Russia too there was no occasion to distinguish between Russian Dada and the artistic events and developments that followed the Russian Revolution. Those in the West who were opposed to cultural change soon learned to denounce it as 'cultural bolshevism'. In Berlin, where the war between left and right was waged particularly openly, there was keen awareness of events in Russia. A large exhibition of Russian art from traditional painting to Constructivism was shown in Berlin in 1922. By that time there was already a lot of

information from Russia through books and magazines, through reports from returning travellers and from the increasing number of Russian émigrés. Once Russia's altered policy towards art began to show its teeth, from 1921 on, the émigrés included artists who had been at the centre of the Russian art world and instrumental in modernizing its institutions. Kandinsky and Gabo are the best known; Lissitzky, as we have seen, came not as émigré but as some kind of cultural emissary and returned to Russia after three extraordinarily fruitful years in the West. The wave of Russian influence was not of course limited to art but touched areas of design, especially architecture and typography, and also in other public arts, notably film and theatre. Alexander Tairoff, for example, brought his company to Berlin in 1922 and demonstrated his revolutionary ideas on the theatre. These were formulated in his book, *The Theatre Unchained*, published in 1923 with a cover by Lissitzky. Conversely the German producer Erwin Piscator modelled some of his work of the early twenties on Russian 'Agitprop' productions designed to rally the masses to the class struggle.

Piscator joined the new German Communist party in 1918, and so did his friends the artists George Grosz and John Heartfield and the writer Wieland Herzfelde (the brother of Heartfield, who had anglicized his name from Helmut Herzfelde in disgust at Germany's wartime hate campaign against Britain). These three represented the left wing of Berlin Dada. Their activities, collaborative and solo, were as much aimed at political change as at cultural protest. All three had fought in the war, and had soon been sickened by it: the war that needed fighting, they decided, was to be fought at home. Grosz's friendship with the Herzfeldes dates from 1915. Almost at once he and John Heartfield began

119. John Heartfield: *Ten Years Later: Father and Sons.* 1924. Photomontage. East Berlin, Academy of Arts (John Heartfield Archive)

120. Alexander
Rodchenko:
Photomontages
for *Pro Eto*, a poem
by Mayakovsky.
1923.

to collaborate on collages. Soon Wieland Herzfelde was publishing periodicals and books, often with illustrations and covers by Grosz or Heartfield. His publishing house, Malik Verlag, also issued most of the Grosz albums, and ran a bookshop whose three large windows could serve for exhibitions as well as for window displays of books.

The Grosz-Heartfield collages sometimes included photographic 119 images. After the war Heartfield, who also worked for the UFA film company and helped Piscator stage his often complex productions, became best known for his use of photographs as a means of propaganda. Like the Russian film makers, he seized on the product of the camera as the raw material for his didactic art. Images juxtaposed or superimposed could deliver a message with peculiar sharpness because of the apparent reality of their constituents. The process is now known internationally as photomontage, a word that originated with Heartfield.

The Russian Constructivists admired the work of Grosz and Heart-field. Having announced the death of painting in September 1921, Rodchenko turned to photomontage when he wanted to make visual images, and subsequently to photography itself. Mayakovsky's poem *Pro Eto* (About This) was written and published in 1923, and the same year Rodchenko produced a suite of photomontages to accompany the text. 120 The poem centres on Mayakovsky's love for Lily Brik, the wife of his

friend Osip. Rodchenko's intimate engagement with the theme suggests a
similar triangular relationship. Mayakovsky and Lily appear repeatedly
in his images, she as girl and child as well as woman. Rodchenko must
have rifled the family album to achieve this visual echo of the poem's
obsession, just as he rifled the wider world of photographic sources to
build up a kaleidoscopic context as rich and pressing as Mayakovsky's.
The political situation in Russia did not at this time invite a polemical use
of photomontage comparable to Grosz's and Heartfield's; the *Pro Eto*
suite is intentionally garrulous where Heartfield, particularly, makes
sharp, epigrammatic points. Looking at the image reproduced here, we
may wonder how far Rodchenko has distanced himself from bourgeois
painting. Delaunay's *The Cardiff Team*, at least, does not seem far away.
The difference, of course, is that Rodchenko was openly displaying his
use of photographic material, whereas few will have guessed at
Delaunay's use of a newspaper illustration, and his image was created to
be as infinitely reprintable as Mayakovsky's poem and not to exist as a
unique, and thus uniquely possessible, art object. Rodchenko's own
painting had been almost exclusively abstract, the known exceptions
being some figurative inventions constructed, so to speak, from simple
geometrical shapes. In these photomontages he does not reach stylisti-
cally beyond the idiom of Cubo-Futurism and of the Grosz-and-
121 Heartfield image of 1919, *Dada-merika*, which belongs to the same area of
modernism. In other words, he has turned to a tradition that predates

121. George
Grosz and John
Heartfield: *Dada-
merika*. 1920.
Collage. East
Berlin, Academy
of Arts (John
Heartfield
Archive)

Suprematism; his constructions of the period go beyond Suprematism in their exploration of very economical means and a calculated system.

Cubism and Italian Futurism are the bases also of Grosz's art. He had spent some time in Paris before the war and was as aware of avant-garde developments as of the academic methods in which he had been trained. His first substantial drawings and paintings show the fragmentation of Cubism and the multiple interaction of Futurism combined to effect a remarkably powerful form of visual narrative. His hatred of injustice and cupidity, which came close to being a general disgust with humanity, gave his visual memory a sharpness, and his imaginings a hallucinatory firmness, that are quite appalling in themselves but which he is able to control, compose and at times tellingly juxtapose to great rhetorical effect. The man who had once chosen to be the sole student of an academic altarpiece painter was able to draw on the past as well as the present. Even the often magnificent drawings and prints of Grosz's like-minded contemporary in Berlin, Käthe Kollwitz, cannot hold us with the same power: their monumentality is too harmonious, too much its own reward. Kollwitz worked out of sympathy for the downtrodden and out of sadness. Grosz worked out of anger. Significantly, Kollwitz had nothing to do with Dada.

Kurt Schwitters of Hanover, equally significantly, wanted to join the Berlin Dada group and was turned away. Too unpolitical, they said, and Huelsenbeck thought him too solidly bourgeois. There was truth in both

122

123

124

views, but what really sets Schwitters apart from most Dadaists (the obvious exception being Arp) is his ceaseless making of art. His image now is that of the humorist. Certainly nonsense and anti-sense were often his chosen medium, but much of his work was humorous neither in aim nor in effect. He wrote nonsense poems of several kinds: poems consisting of numbers, of actual words nonsensically following each other, of whole phrases inconsequentially arranged, of single letters, and, the most famous, his *Ursonate* or primitive sonata, of oral sounds, elaborately scored and developed over the years. He published his own magazine, in which nonsense and pointed sense coexisted disruptively. The name he gave it and most of his work was *Merz*, a word not made but found. It was part of the word 'Kommerzbank' from a letterhead that surfaced when Schwitters was working on a collage. Perhaps the echo from the French word *merde* pleased him, contrasting with its top-hatted origin. No doubt it embodied puns on other words, as for instance *Merzschaf* (a cast-off sheep). The educated German likes to demonstrate his learned wit by juggling with his language. In the poet Christian Morgenstern, translator of Ibsen and Strindberg, disciple of Nietzsche and of Rudolf Steiner, Schwitters and the other German Dadaists had a forerunner who has since become part of the national literary heritage. In Morgenstern and Schwitters, perhaps in all obsessive builders of nonsense structures, the incessant picking at fragments of meaning and at the meaning of fragments is evidence of a desperate, last hold on reality and an inability to rely on the world around them.

124. Käthe Kollwitz: *Bread.* 1924. Lithograph. West Berlin, Kupferstich-kabinett (Staatliche Museen Preussischer Kulturbesitz)

125. Jean Arp:
*Human
Concretion on
Oval Bowl.* 1935.
Bronze,
26 × 29 × 21 in.
Estate of the
artist

Schwitters' response to the world ultimately sets him apart also from
Arp. Arp, increasingly intent on three-dimensional sculpture—on a
process, that is, involving much shaping, making, setting up, protecting
against material failure—evolved for himself an easy relationship with
nature in place of an uneasy one with culture. 'Art is a fruit that grows in
man', he wrote, short-circuiting both the problem of abstract art and the
broader questions Dada had raised, and his work took on a fullness and an
ease that one could welcome as reflecting the benign face of nature
(breasts, clouds, bodies, growing forms generally) without looking for
specific illustration or for more particular or urgent messages. In his
public work, his collages, Schwitters offered an extension of the licence
inherited from Cubism and from Expressionism of the *Blaue Reiter* sort:
he made beautiful art out of rubbish, but he also tested the expressive
potentialities of this art. Some of his collages are highly dramatic, even
threatening objects; had they been created before 1914 we might have
claimed that he prophesied the holocaust. Others have the delicacy and
refinement of great lyrical poetry. The fact that they are fashioned from
the flotsam and jetsam of the world soon loses its pressing interest, even
though some of the bits, particularly the scraps of printed paper, insist on
their individual identities and purposes. Privately Schwitters constructed

125

126

3

126. Kurt Schwitters:
As You Like It.
1946. Collage, $17\frac{1}{4} \times 13$ in. Basle, Galerie Beyeler

Merz environments, first in his house in Hanover, where it came to spread through rooms on three floors, then in Norway and finally also in England, both times on a much smaller scale. Here too rubbish, or indeed any material at all, served: plaster, bits of wood, this or that illustration or other referential material that had held his attention. Anything and everything was fixed together and built up. That one part of the Hanover *Merz* building was called the 'cathedral of erotic misery' should help us to understand that this work was no caprice. Indeed *Merz* also echoes *Schmerz*, pain. Schwitters was shoring up these fragments as a bulwark against the demands of life; his need was nostalgic and defensive. Yet Schwitters was no hermit. It must have taken great social courage, not to say effrontery, for an incorrigible bourgeois to perform his *Ursonate* to an unprepared public, and to go with Theo van Doesburg (who would then exchange his usual pseudonym for 'I. K. Bonset') on their Dada tour of Holland. He was a ready collaborator. Arp, Lissitzky, and others worked with him on particular issues of *Merz* magazine. Schwitters also worked with Moholy-Nagy and others to promote modern typography, based on Constructivist principles, even while mocking it in his *Merz* work.

In Cologne a concurrent Dada movement was dominated by the strange figure of Max Ernst. He had studied philosophy in near-by Bonn, not art. He had been in touch with *Blaue Reiter* work and ideas through contact with Marc in 1911 and with Arp in 1914; he also knew Macke, who lived in Bonn. All Cologne had been offered an exceptionally thorough survey of modern art in the 'Sonderbund' exhibition held in 1912. Then came the war. 'Max Ernst died on 1 August 1914. He returned to life on 11 November 1918, a young man who wanted to become a magician and find the central myth of his age', Ernst wrote of himself. He met Grosz and Wieland Herzfelde in the Sturm gallery in Berlin in 1916. Arp moved to Cologne in 1919, and stayed there almost continually until 1921, when he transferred to Paris. In 1919 Ernst, Arp, and the pro-communist poet and painter Johannes Baargeld (a pseudonym: *Bargeld* means change, ready cash) collaborated to produce aggressive, shortlived periodicals and to disrupt reactionary cultural events. The events were local but the periodicals were international, with Berlin and Paris writers contributing to them frequently—and the British army of occupation demanding their cessation.

Cologne is at the French end of Germany, Roman Catholic and licensed to behave outrageously once a year during the pre-Lent carnival. Something of this is reflected in the activities of Cologne's Dada group. They presented an exhibition, in 1920, in the courtyard of a beer hall reached through a door politely marked 'Gentlemen'. It was a great success. The public were invited to destroy the exhibits with tools provided and the police closed the exhibition on grounds of obscenity, only to find that the offending image was Dürer's print of *Adam and Eve*. The same year Ernst contributed to the Berlin Dada exhibition and had a one-man exhibition in Paris. In 1922 he abandoned Cologne and Germany for Paris. 'Thirty years of Germany were enough', he said. His father had cursed him for dishonouring the family name. Cologne critics had played on that name (*Ernst* means seriousness, earnestness) to contrast it with his work and to present him as an incorrigible playboy. In

Paris there were Tristan Tzara, André Breton, and Paul Eluard (all of them writers), who had for some time now shown keen interest in his work.

 Ernst was to become one of the first and most fecund of Surrealist artists, yet that involved no marked change in the character or direction of his work. Much of it took the form of collage, and one is tempted to explain this preference by pointing to his lack of art training. But between 1909 and 1919 Ernst had done many paintings in a variety of styles, reflecting a growing familiarity with modern art. Some of these, notably the fish and bird watercolours of 1917, prefigure his mature Surrealist productions surprisingly directly. Yet some sort of manipulation of ready-made visual data was to be typical of him. This shows already in the 'mechanical drawings' he did in 1919, taking prints from line blocks lying around at the printer's, adding to them with pen or brush and inscribing them. The impulse for this particular series may have come from Picabia's humorous machine images, but Ernst's are less beguiling and derive their expression more from the process involved than from jokey references to human actions. He also took rubbings from large wooden printing type. By 1920 he had hit upon what was to be one of his favourite means of working, assembling and transforming images selected from printed advertisements, sales catalogues and other such illustrations. Not only did these enable him to produce surprising effect and meanings when he combined heterogeneous material; they also introduced a dizzying sense of temporal dislocation and with that an intense identity and visual presence. He has been quoted as describing

128 (left).
Francis Picabia:
Voilà Elle!, from
291, edited by
Alfred Stieglitz,
published in New
York, Nov. 1915

129 (right). Max
Ernst: 'Let there
be Fashion, Down
with Art,' from
*Fiat Modes, pereat
ars*, a portfolio of 8
lithographs
published by
Schlomilch Verlag,
Cologne, *c.* 1919.
$17\frac{1}{8} \times 12$ in.
Collection, The
Museum of
Modern Art, New
York (purchase)

these collages as 'the systematic exploitation of the fortuitous or engineered encounter of two or more intrinsically incompatible realities on a surface which is markedly inappropriate for the purpose', and of the effect as 'the spark of poetry which leaps across the gap as these two realities are brought together'. It is this spark of poetry that distinguishes Ernst's best work in whatever medium and by whatever method from that of most of the other Dada and then also Surrealist collagists.

With Dada modern art acquires a new range of communication and thus a new range of functions. Setting aside Dada in the form of political action (and perhaps only this aspect of the movement actually warrants a label), we are left with works of art that tease or threaten our awareness of all art, all visual communication including what we now call the mass media, and, in the end, all propositions about what is and is not reality. The process by which this is reached is not that of inventing or transforming but rather that of juxtaposing pieces stolen from the world. At heart the method has little in common with Cubism, though Braque's and Picasso's inventions led to it. It is rather that of the modern poet who collects snippets of common speech in the streets or of journalism in the newspapers and joins them in his own formulations or indeed replaces his with theirs. Apollinaire was pre-eminently that poet. Dadaists tended to write poetry of the same sort (Schwitters' poem 'To Anna Blume' of 1919 is a brilliant, quite untranslatable example). In their art we see this process proved viable on the visual level too—viable, moreover, equally in the figurative and the abstract modes which the rest of the world seemed intent on seeing as opposed, mutually exclusive art languages.

VOILÀ ELLE

F_1

Everything done by the Egyptians, the Greeks
and the Italians of the Renaissance *is*. A great
many modern works *are not*.
André Derain, as reported by André Breton, 1924

Kandinsky defined the stylistic range available to the modern artist in his
essay 'On the Question of Form', published in the *Blaue Reiter* almanac.
Its two poles, he said, are '1. total abstraction, 2. total realism. These two
poles offer *two ways* that lead in the end to *one goal*.' Unlike Malevich,
Kandinsky did not need to insist on a threshold between abstraction and
near–abstraction. He sought to communicate on a spiritual plane where
the objective as well as the non–objective could serve. His conviction that
this was possible must have come from his study of primitive, Oriental
and pre–Renaissance art. Renaissance art too, of course, could be given its
place between his two poles, but the mechanics of Renaissance idealism
and post–Renaissance naturalism had become mindless and oppressive.
Instead, Kandinsky found his perfect realist in Henri Rousseau, the
retired customs clerk untrammelled by academic practices, whose
ambitious paintings had entertained and excited the Paris avant garde for
some years. Here was a modern primitive aspiring to the highest levels of
art, an individualist whose work had an intensity Kandinsky did not find
in Russian and Bavarian folk productions. In 1911 he acquired a

130

130. Henri
Rousseau:
Flowers of Poetry.
1890 – 1. Oil on
canvas,
$15 \times 18\frac{1}{8}$ in.
Virginia,
collection of Mr
and Mrs Paul
Mellon

131. André
Derain: *The
Table*. 1921. Oil
on canvas,
38 × 51⅛ in. New
York,
Metropolitan
Museum of Art
(Wolfe Fund,
1954)

Rousseau landscape. Together with six other Rousseaus it is illustrated in
the almanac, making him the most reproduced artist in the book.

Other painters, too, were giving their attention to the appearance of
things. In some cases these were painters returning from modernist
explorations. Derain, for instance, had been one of the first and finest of
the Fauves and had for a while practised a personal sort of Cubism, closer
to Cézanne than to the fragmentations of Picasso and Braque. A propos
Derain's first one-man exhibition in 1916, Apollinaire described him as
rediscovering 'with simplicity and freshness, the principles of art and the
disciplines derived from them'. A still life of 1921, *The Table*, shows what 131
Apollinaire meant. It is a strong picture, formal in an almost sacramental
way, and more indebted to the Italian primitives than to any exotic or
avant-garde idiom. The objects in it are presented with individual dignity
and fullness. The hieratic arrangement, and the anti-perspective of the
table-top (echoing Sienese painting of the fourteenth century) strike un-
modern notes in a painting that otherwise proclaims its post Post-
Impressionist origin. Another painter reconsidering the world of objects
was Giorgio de Chirico, who was in Paris from 1911 to 1915 but kept
aloof from Cubism and Futurism. His paintings of those years were
openly visionary, but they achieved this character through fairly banal
and totally recognizable things and situations. The objects staged in *The
Philosopher's Conquest* are in themselves not necessarily disturbing: the 132
cannon even does not threaten us or the scene as a cannon, but looks out
of date compared with the train, the factory chimneys and the clock in the
background, and the artichokes in the foreground. But artichokes and the
barrel of a cannon make a strange still-life combination, and a stranger
foreground still for the townscape beyond them where the clock looms
dramatically. Does the clock still work? If not, then the only 'living' thing
in the painting (leaving aside the artichokes) is the train—we accept that

puff of steam gratefully as a signal that normality, even if suspended for the moment, is still in reach. But what is the meaning of those human shadows that alone people the awesome and not quite legible space between foreground and distance? We might be able to find logical or poetic explanations for such a scene, but even then we are left with a combination of empty space and oppressively clustered objects, with actual calm but implications of drama, and a perspective that is both wrong and terribly familiar, at once clear and confusing, and these would continue to keep us on edge. The Italian critic Soffici said of this kind of painting that it 'could be defined as a language of dreams', and Apollinaire repeated it. The heavy clarity of de Chirico's technique, combined with perilous spaces and the unknown events they seem to await, recall disquieting dreams and the visions we are liable to have in the hypnagogic state between wakefulness and sleeping. We may find such paintings agreeably melancholic or thoroughly frightening; in either

149
Calls to Order

132. Giorgio de Chirico: *The Philosopher's Conquest*. 1914. Oil on canvas, $49\frac{1}{2} \times 39\frac{1}{2}$ in. Art Institute of Chicago

case the sensation arises not from monsters or from violent actions but from our creative exploration of the scene. They depend for their effectiveness on a response prepared for us by unconscious experiences and by our addiction to the conventions of Renaissance space description. The Russian painter Marc Chagall, in Paris from 1910 to 1914 and again from 1923 onwards, and well known also in Berlin, demonstrated another sort of imaginative realism. *I and the Village* is a bouquet of memories arranged like a Delaunay disc. Conventional matters of scale and positioning yield to another sort of truth; the dotted line linking the man's eye to the cow's reminds us that we can make the invisible visible too. When Apollinaire visited Chagall's studio he was first nonplussed, then, it is said, muttered 'Supernatural!' Later André Breton said of Chagall: 'His full, lyrical eruption dates from 1911. It was then, in his work alone, that metaphor made its triumphant entry into modern painting.'

Works of art, in inviting us to respond to delineated objects, act metaphorically. In addition modernism's tendency to abstraction and to

133

133. Marc Chagall:
I and the Village.
1911. Oil on
canvas,
75⅝ × 59⅝ in.
Collection, The
Museum of
Modern Art, New
York (Mrs Simon
Guggenheim
Fund)

using conflicting modes of delineation has made us aware by visual means of what many philosophers have proposed since Plato—that the reality we experience is a conventional and variable system. Such considerations became dominant after the first world war. The immediate post-war years witnessed a widespread abandoning of avant-garde positions. Many artists' faith in the modern world had been shattered. It was tempting to return to the rewarding pleasures of making entertaining and beguiling objects for which there would be a grateful public, rather than continue the struggle to remake art and to find a new public. Picasso's use of Cubism as a playful, decorative mode whilst creating a neo-classical style for his more personal and poetic works implies a major change of attitude. It is echoed in the neo-classicism of Stravinsky and other composers. Matisse, whose wartime painting had been so severe, worked after the war in a more seductive manner that hides its stringencies behind attractive subjects, suave colours and soft touches of paint. The radical abstract art, created in Holland and Russia during the war and merging in Germany after the war as Elementarism, made little impact on Paris in the twenties and had only a marginal role there in the thirties. The centre of the Paris cultural stage was held in those decades by Surrealism, of which more below, while a lot of talent and patronage went to amusing and charming forms of art that lay closer to the world of fashion and entertainment than to any continuing concerns of art.

The various activities of Jean Cocteau, poet and playwright, painter and film maker, represent the most glamorous and intelligent end of this culture; the music of *Les Six* (Poulenc, Milhaud, Honegger, Auric, Durey, and Tailleferre) typifies its wit and also its desire to achieve a markedly French product. It is surprising to find Paris, the supranational capital of art for a hundred years, erecting chauvinistic culture barriers. Their foundations were laid during the first world war. Their effect was noticeably to constrict the development of modern art in its many forms—especially regrettable at a time when more specifically constricting programmes were being imposed by politicians elsewhere. In Russia, during the twenties, modernist art yielded its place at the head of the cultural revolution to increasingly lifeless forms of idealized naturalism which, it was argued, would serve the communist cause better. Neither Malevich nor Tatlin was represented in the 1927 jubilee exhibition in Moscow, 'Ten Years of Soviet Art'. In 1932 the Soviet Central Committee decreed the abolition of all artist groups and associations and established the Union of Soviet Artists. That year's jubilee exhibition, shown in Leningrad and Moscow, included a section of 'Socialist Realism' to show the didactic, unquestioningly propagandistic art supported by the state, and also a 'Degenerate Art' section displaying Russian Futurist, Suprematist and Constructivist works. In 1934 Socialist Realism was announced as the only permitted mode by the first congress of the Union of Soviet Writers. What the left achieved in Russia the right established in Germany during the thirties. The triumph of National Socialism in 1933 brought with it instant repressive legislation. First, all modernist artists were deprived of their teaching posts, and adventurous directors of public galleries were dismissed. Then many artists were forbidden to pursue their profession in Germany; many left

134. Franz
Seiwert:
*Feierabend (After
Work)*. 1925. Oil
on hessian,
$78\frac{3}{4} \times 55\frac{1}{8}$ in.
Hamburg,
Kunsthalle

the country. Third, unconventional works were removed from public collections. In 1937 an exhibition of Degenerate Art was formed from them and shown in Munich and toured around the country. It demonstrated, to the satisfaction of the Nazis, the thoroughly Jewish, bolshevic and anti-Aryan nature of modern art from Gauguin onwards. A more open Paris would have served as an invaluable cultural reserve during those years of destruction and oppression. As it was, the displaced energies went further west, some to Britain but most to the United States of America. Others followed them with the outbreak of the second world

war in 1939. Paris has not yet been able to recapture its pre-1914 role in Western art.

Thus political events reinforced a post-war inclination to look to the past and to revive its pleasures with an admixture of modern thrills. Writing in 1933, the English composer Constant Lambert designated this period 'the Age of Pastiche'; the leading figures in it he called time travellers for their habit of reworking admired idioms of the old masters. He was writing about music, but it applies to art as well. Moreover, the inventions of the modernist movements themselves were part of the available past. While Cubism, for example, reappears as a form of decoration in *Art Déco*, its fragmentation or repetitions could also serve to give a modern flavour to neo-classical compositions or be mingled with elements of distortion from Expressionism or colour from Fauvism in a sort of visual Esperanto. The kind of development pioneered by Léger, whereby Cubism was amplified into a monumental and communicative art expressing a broadly optimistic view of industrial society, was paralleled at a less exalted level elsewhere—for example in the art of Franz Seiwert and the Group of Progressive Artists he belonged to in Cologne at the end of the twenties, and in the work of the former Vorticist, William Roberts. In such finely weighed and strongly constructed compositions, Cubism merges with abstraction to become part of the long tradition of monumental art that goes back through Seurat, Jacques-Louis David, and Poussin to Greek relief sculpture and the Egyptians. This represents a true attachment to the great classical

134

135

135. William Roberts: *The Paddock*. 1928. Oil on canvas, $48\frac{1}{4} \times 36\frac{3}{8}$ in. Bradford Art Galleries and Museums

tradition which others raided as a toy cupboard and yet others, in the totalitarian states, as an armoury for megalomaniacal gestures of a thoroughly anti-classical sort.

The charge sometimes laid against the modern movements of the pre-war years was that they had ignored art's role as educator, the old duty to instruct. Cubism, abstraction, Expressionism even, seemed interested only in style, in the 'how' rather than the 'what' of art, and committed to a vague or content-less art that had begun with Impressionism. If some artists in the twenties were content to exploit their heritage as a form of polite entertainment, others were urgently seeking viable forms of art that would contribute to political action. Thus Ernst's, Grosz's, and Heartfield's art was openly and specifically purposeful in a way that Lissitzky's and Mondrian's was not; Lissitzky, after his return to Russia in 1925, was limited to designing and teaching and Mondrian's art was long misrepresented in the West as the most extreme form of art-for-art's-sake mandarinism. Both impulses, towards trifling and towards propaganda, reflected also a craving for order.

It was as though the modernist movements had achieved too much. Colour and form had been freed from descriptive roles, and art as such from its long-borne duty to imitate the visible world. The artist as a professional man was no longer required to show recognizable skills. Awash with freedoms, and lacking the optimism that had fuelled pre-war experiment, many post-war artists looked for ways of stabilizing their activities in relation to a public, for some sort of extra-personal rule. For the neo-classicist that could come from an old master: Corot or Ingres or Raphael, like Bach and Mozart in music. For the Social Realist it was doubly provided by the clear indication of preferred subjects and the agreed need for an undemanding style derived from nineteenth-century naturalism and history painting.

Abstract artists looked to mathematics; not just to geometry but increasingly to numerical systems derived from nature or from pure mathematics. In 'Hamlet and his Problems' (1919) T. S. Eliot usefully defined his way of giving personal feelings valid and thus communicative forms: 'The only way of expressing emotions in the form of art is by finding an "objective correlative"; in other words, a set of objects, a situation, a chain of events which shall be the formula of that *particular* emotion; such that when the external facts, which must terminate in sensory experience, are given, the emotion is immediately evoked'. This echoes the French Symbolists' conviction that emotions must be induced, not represented, and adds to it Eliot's conviction that emotion needs an impersonal vehicle. Similar views are reflected in all sorts of creative work.

The composer Arnold Schönberg had already detached his music from the tonality to which music had been anchored for centuries, and had even—in his use of the *Sprechstimme* (the half speaking, half singing voice)—abandoned the role of precise pitch in sound. In the early twenties he invented the method of serialism as a means of structuring extended compositions. Kandinsky's shift from soft to precisely delineated shapes as the vocabulary of his expressive art implied a similar objectification of emotional content. In *Point and Line to Plane*,

136. Paul Klee: *A Garden for Orpheus.* 1926. Pen and ink over yellow wash, $18\frac{3}{8} \times 12\frac{5}{8}$ in. Berne, Kunstmuseum (Paul Klee-Stiftung)

136

published as a Bauhaus Book in 1926, he offered a summary of his research into the affective meaning of forms as a universal dictionary for art and design. Klee, most mobile of painters, based some of his twenties' work on easily discernible systems, without claiming any universal validity for them. He was more concerned with the genesis of forms than with interpreting their meaning; there was an infinity of possibilities before the artist that should be explored. These words by Charles Rosen à propos Schönberg can also be used to describe one of Klee's favourite painting techniques: 'The limits of small forms could be determined in

various ways, the technique of the nuclear motif being the simplest: when the various permutations and combinations of the motif had been sufficiently displayed, when they had made a musical or expressive point, the piece was over.' A significant number of Schönberg's works and almost all of Klee's can be called miniatures. The aim of the Bauhaus, where Kandinsky and Klee taught for most of the twenties, was to avoid style in the name of rationalism and functionalism. The result was a recognizable Bauhaus style of primary forms and colours that in fact had little relevance to the industrial techniques they were intended to serve but protected their designers against an appearance of arbitrariness. One of the most eminent of former Bauhaus students, Josef Albers, was to crown his career as teacher with an elaborate treatise on colour (*Interaction of Color*, 1963) and his career as painter with a long series of paintings and prints entitled *Homage to the Square*, begun in 1949. His exquisitely controlled use of the basic formula of squares, thoroughly varied by its presentation in ever-changing colours, offers an answer to Malevich's historic *Black Square*—not a clearing out of the temple of art but the richest possible synthesis of formal, colouristic and spatial complexities within self-imposed limits.

2

Neat, unemotional, and thus apparently objective, paintings representing aspects of the present world could meanwhile satisfy the search for firmness and relevance. Most Western countries produced this type of art in the twenties and thirties, though its implications varied. In 1925 G. F. Hartlaub, director of the municipal gallery in Mannheim, presented an exhibition which he called 'New Objectivity' (Neue Sachlichkeit). During the preceding two years he had gathered together artists and works that seemed to share an inclination towards realism. The exhibition attracted a great deal of notice and its title became the label for a new trend. This is probably the first clear case of a 'movement' being formed, named, and defined from the outside: the critic/curator claims to have observed a tendency in individual and possibly quite independent instances and demonstrates their coherence by publicizing them and defining what they have in common. The differences between the artists involved were many and became patent in the exhibition. No true movement emerged but painters inclined to some form of realism could find support in the exhibition and take comfort from its success. Traditional skills of eye and hand were once again manifested under a label that included the word 'new'.

Grosz, who was in the exhibition, that same year wrote a pamphlet with Herzfelde, *Art is in Danger*, in which they defined the options they saw before the artist: to join the exploiters of society or to join the ranks of the exploited and fight for a new society 'by representing and criticizing the lineaments of our time, and by promoting and defending the revolutionary idea and its partisans'. Verism was the name given to the propagandistic realism they called for. Arp and Lissitzky, in their retrospective survey of modern art from 1924 to 1914, *Art-isms (Kunstismen)*, also published that year, defined the Verist as one who 'holds a mirror up to the ugly mugs of his contemporaries'. Grosz now had a contract with a leading Berlin dealer and was painting more and producing less graphic work. Characteristic of this period is his *Pillars of*

137. George
Grosz: *Pillars of
Society*. 1926. Oil
on canvas,
$78\frac{3}{4} \times 42\frac{1}{2}$ in.
West Berlin,
Nationalgalerie
(Staatliche
Museen
Preussischer
Kulturbesitz)

137 *Society*, a painting developed from a plate in the 1921 series of
lithographs, *The Face of the Ruling Class*. His ambition, Grosz said, was
to paint 'modern history paintings'; he pointed to Hogarth as his model.
A few other contributors to the exhibition were also classed as Verists,
notably Otto Dix, but most of the artists in it saw another sort of reality
altogether: not a world to be challenged and changed but a world
observed more passively for its strangeness, its mystery. These became
known as Magical Realists. Some of them came close to Rousseau and
were self-taught or scarcely taught as painters. Others had steeped
themselves, like Derain, in Italian early-Renaissance art in order to create
a strong and objective style capable of expressing wonderment without
confusing the beholder. Georg Schrimpf of Munich is a good example.
He had come to painting gradually, after all sorts of jobs, and had taught

himself by painting from nature and from the old masters. In 1922 he was in Italy; in 1924 Carrà published a small, admiring book about him. *On the Balcony* (1927) is clear, simple and ordinary; at the same time the simplified forms, the shadows, the figures' backs, lead us to wonder at the human meaning of the scene. Carl Grossberg, who had studied architecture and did not turn to painting until after the war, specialized in factory pictures, which he usually managed to sell to the directors for their offices: exact accounts of monumental spaces and machines, sometimes with rather heroicized workers. For himself he turned such subjects into pictures of a very different sort. Their perspectives made steeper, their spaces thus dramatized, the now depopulated factories became ominous. He added bats or monkeys and called the results 'dream pictures'. By rather similar means Oskar Schlemmer transformed neo-classical clarity into mystery in his paintings of stereotyped figures in exact spaces. The desire to find an elegant but adaptable formula for the human body is essentially classical; to set such figures into a vertiginous space and into relationships that are left unexplained is an anti-classical process that recalls the Mannerism of sixteenth-century Italy. That Schlemmer, a Bauhaus teacher, did not participate in the Mannheim exhibition suggests that he and Hartlaub were conscious of the essential unreality of his work. As early as 1915 Schlemmer had noted in his diary that he was looking for 'mystical objectivity'. His master and guide towards this, as indeed Schrimpf's, was pre-eminently Philipp Otto Runge (1777–1810), that remarkable figure in German Romantic painting whose work, then being rediscovered after a century of neglect, gave a visionary cast to every observation of nature.

138

139

140

138 (left). Georg Schrimpf: *On the Balcony*. 1927. Oil on canvas, 37 × 28¾ in. Basle, Kunstmuseum

139 (right). Carl Grossberg: *Machine Hall*. 1925. Oil on canvas, 27½ × 23⅝ in. Wuppertal, Van der Heydt Museum

Thus art's ancient mimetic function was subverted—or returned to its original purpose, perhaps. One effect of our 'loss of belief in the significance and reality of sensory phenomena' (to use W. H. Auden's words) was the enrichment of the visible world and its replicas. Full objectivity was no longer a theoretical possibility; therefore objectivity becomes poetry. The more intense the objective attempt, the more intense the poetry is likely to be. In the Metaphysical Painting movement, led for a few months in 1917 by de Chirico and the former

140. Oskar Schlemmer: *Figures in Space.* 1925. Oil on canvas, $43\frac{3}{4} \times 35\frac{3}{8}$ in. Stuttgart, Staatsgalerie

Futurist Carrà, this was quite explicit: paint objects simply and with dignity and they will reveal their enigmatic, even pathetic character. De Chirico and Carrà chose objects that were in themselves unusual, and set them into puzzling relationships, but even so one is surprised by the 141 poignancy of the result, considering the lack of action and the muteness of the style. Giorgio Morandi briefly adhered to Metaphysical Painting during 1917–18. From the early 1920s on, for the remaining twenty years of a steady career, he painted almost exclusively still lifes, usually of 142 bottles, jugs, and jars. Seeing them in any quantity makes us realize that still life is not a subject of painting but a form of painting (as Kenneth Clark has said about the nude): the content of the painting is conveyed not by the objects but by their grouping and regrouping, their place and weight on the canvas, their colouration and tone, their calming or nervous silhouettes. The imaginative value of what we call reality has nowhere been shown more convincingly. And if we no longer believe in objectively represented facts, we believe even less in the pictorial devices created to make these facts visible. The best instance of this is perspective. For the Renaissance artist perspective was a means of establishing a legible, logical space on a picture surface and locating objects coherently within it. For the modern artist perspective becomes consciously what for the Renaissance artist it had been only secondarily or unconsciously, a means of poetic expression. De Chirico's abrupt perspectives are disconcerting and sometimes nauseating; Schlemmer's more steadily receding spaces threaten us with their excessive clarity. The order both artists affirm is

141. Carlo Carrà:
*Still Life with
Triangle.* 1917.
Oil on canvas,
$18\frac{1}{8} \times 24$ in. Milan,
collection of Dr
Riccardo Jucker

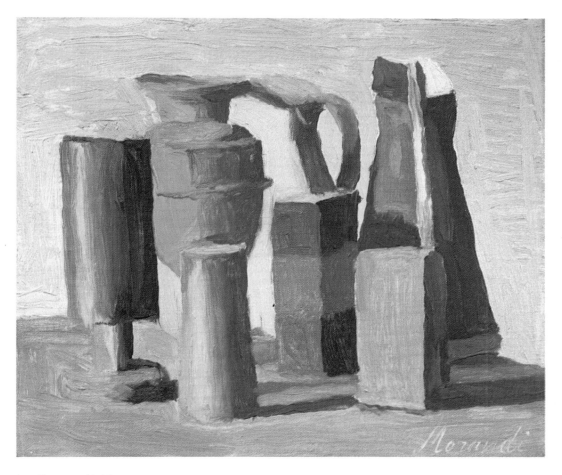

fragile, unreliable; what action there is within their spaces is without apparent motive or purpose.

Some quality of magic will almost inevitably be sensed in any modern painting rooted in close observation of appearances. Only a thick layer of stylization, such as that with which generations of Russian Social Realists coat their happy images of communist society at work and play, can deprive us of it. A metaphysical intention is not essential: the translation of the real on to the unreality of the canvas is itself a sufficient transformation. Paradoxically, perhaps, this observation survives that great fact in modern visual consciousness, the omnipresence of photography. The true paradox is that, amid all our doubts about the phenomenological world, we tend to invest the photographic image with the mantle of truth. We know the photograph to be a highly artificial product, involving certain mechanical and chemical processes: it contributes its own process of transformation before the result confronts our eyes. The photographer, of course, is one of us. He responds to the scene he photographs; he also responds to qualities his process gives to that scene; and he will tend to evaluate the result according to responses developed elsewhere (on art, for instance). It is likely that the metaphysical, transcendental quality we often find in good photography

142. Giorgio Morandi: *Still Life*. 1942. Oil on canvas, $11\frac{7}{8} \times 13\frac{3}{4}$ in. Milan, private collection

owes something to art as well as to the sometimes unexpected modifications photography imposes on the world as our eyes see it.

The shadows that follow the pedestrians in Paul Strand's 1915 photograph, *Wall Street, New York*, and the monstrous architecture that 143 looms over them, add to an inherently dramatic image a sense of conflict between man and man-made systems. It is a Futurist image, like an early Boccioni, but it bred also another kind of image, hard-edged and direct like itself but celebratory. An apt example is Georgia O'Keeffe's *White Canadian Barn No. 2*. O'Keeffe, wife of Stieglitz the dealer and 144 photographer, has zeroed in on her subject like a photographer with a telephoto lens, and has excluded unwanted detail for the sake of a nakedness we know from contrasty photographic prints. Most of her work strikes one at first as more abstract than this picture, but much of it depends on a comparable process of dramatizing the visible world by quasi-photographic means, as when she vastly enlarges part of a flower, giving it monumental presence. Observation + photography + abstraction: this formula underlies much of twenties and thirties painting of the environment, especially in America. The Ashcan School, formed before 1914, had insisted on American subjects but had tended to see them through the eyes of Manet; the post-war years saw several American painters using a clearer, firmer style that owed something to European abstraction but could look very American. Charles Sheeler's *Church*

143. Paul Strand:
*Wall Street, New
York*. 1915.
Photograph. ©
1971 by the estate
of Paul Strand

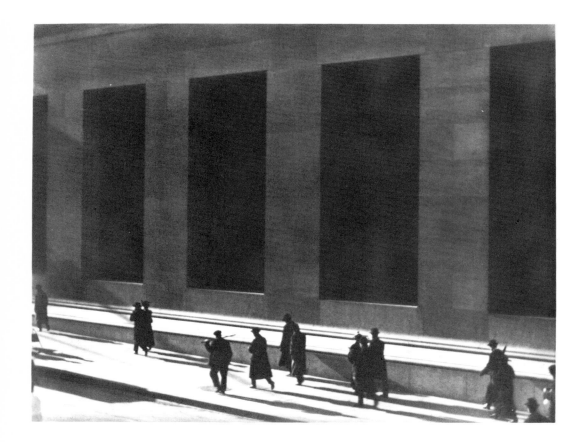

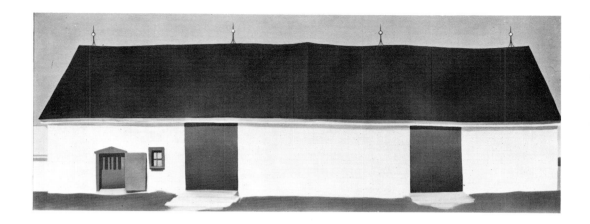

144. Georgia O'Keeffe: *White Canadian Barn No. 2*. 1932. Oil on canvas, 12 × 30 in. New York, Metropolitan Museum of Art (Alfred Stieglitz Collection, 1949)

146 *Street El* owes its angle of vision and its peculiar perspective to the camera; also perhaps its sharpness of focus. Sheeler in fact worked as a photographer as well as a painter. We have to remind ourselves that sharp focus is a stylistic choice for a photographer too, that there had been a taste for soft-focus photographs, and that photography does not normally produce images that are equally sharply focused all over. Charles Demuth had been part of the New York Dada circle around Duchamp and Picabia, where technology served as an at least partly ironic metaphor for human behaviour. Demuth's friend Morton Schamberg had produced one of the most memorable examples in his 'adjusted readymade'

145 (as Duchamp would have called it), *God*, a plumbing trap upended in a

145. Morton Schamberg: *God.* *c.* 1918. Assemblage, height 10½ in. Philadelphia Museum of Art (Louise and Walter Arensberg Collection)

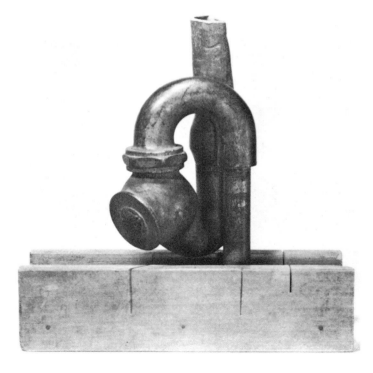

146. Charles
Sheeler: *Church
Street El.* 1920.
Oil on canvas,
$16\frac{1}{8} \times 19\frac{1}{8}$ in.
Cleveland
Museum of Art
(purchase, Mr
and Mrs William
H. Marlatt Fund)

mitre box. This echoes Mr Mutt's *Fountain*; more often Schamberg's and Demuth's attitude to technology was dominated by admiration for its powers and for its handsome forms. In *My Egypt* Demuth sang of 148 precisely that anonymous American architecture which Frank Lloyd Wright, Gropius, and others proposed as models for a new type of beauty and in terms which echo Le Corbusier's bracketing of modern functional design with the highest achievements of Greek classical architecture. The basis of Demuth's painting is again photographic: across that image fall Cubist dislocating rays and colour patches that glorify and spiritualize the motif. Again, fact and magic appear in harness. This applies even more persuasively to his famous painting, *I saw the Figure 5 in Gold*, a 147 Futurist image that embodies his response to his friend William Carlos Williams' poem 'The Great Figure': 'Among the rain/and lights/I saw the figure 5/in gold/on a red/firetruck/moving/tense/unheeded/to gong clangs/siren howls/and wheels rumbling/through the dark city.' The abstract picture represents a very particular experience, partly through direct visual paraphrase (the figure 5 in gold moving) and partly by signs

147. Charles Demuth: *I Saw the Figure 5 in Gold.* 1928.
Oil on board, 36 × 29¾ in. New York, Metropolitan Museum of Art
(Alfred Stieglitz Collection)

148. Charles
Demuth: *My
Egypt*. 1927. Oil
on composition
board, 30 × 35¾ in.
New York,
Whitney Museum
of American Art

and references (names and initials) that are accounted for in the poem.
Demuth's proud use of banal signs, in terms that owe as much to the
signwriter and the layout man as to the artist, is peculiarly American even
if it has been prepared for in Cubism and Futurism. The Depression that
followed the great Wall Street crash of 1929 was to put new emphasis on
an art presenting American scenes in comprehensible terms, but none of
these had the continuing impact of this enthusiastic, not obviously
artistic exploitation of commonplace material.

It remained exceptional in the work of Demuth, but was not entirely
unique to him. Stuart Davis had earlier made even more direct use of
similar material when he portrayed a flattened cigarette packet, enlarging
it to perhaps seven times its actual size. Fact or abstract image? The

multitude of familiar details offered by lettering and by colours, designed to identify the product, yields a succession of sociable encounters, but the whole is something much more. A few years later Davis was to practise transforming seen objects into abstract configurations, in his *Eggbeater* series of 1927. Thereafter he painted large and small pictures that combine signs and names and other recognizable parts of the American scene with ambiguous suggestions of space and vividly unambiguous colour. These cheerful, bustling images form a reassuring link between post-1945 American painting and the *trompe l'oeil* tradition that flourished in America in the last decades of the nineteenth century.

The hard years that followed 1929 gave prominence to social themes and led to the commissioning of mural paintings for public buildings. Artists charged with these were liable to look back to the frescos of the Italian Renaissance for guidance and on occasion to the monumentalized Cubism of Léger. But there was also a non-European (and therefore at this time additionally attractive) source of inspiration. The establishment of a socialist government in Mexico had brought opportunities for large-scale propaganda art. Here was a form that would close the gap between the creator and his compatriots whilst freeing the artist from a merchandising system that kept his work out of reach of the man in the street. It involved repudiating modernism. One of the three leaders of what is often called the Mexican Renaissance made his disavowal from within its stronghold. Diego Rivera spent about fourteen years in Europe, most of them in Paris. There he painted like a Cubist, was personally close to Picasso, and had a contract with the Rosenberg gallery that also handled Picasso, Braque, and Gris. Before returning to Mexico in 1921 he spent some months in Italy, studying fourteenth- and fifteenth-century fresco painting as well as the ancient murals at Pompeii. David Siqueiros, who arrived in Paris in 1919 and became intimate with Rivera there, also went to Italy and immersed himself especially in the paintings of Mantegna, Uccello and Masaccio. The third, José Orozco, did not visit Europe. In his murals the admixture of local elements—the folk traditions seen in popular prints and house decorations, and the relics of Aztec and Mayan civilizations—is stronger than in the others' but it pervades them all.

Not that style was their primary concern. From 1922 on they worked on large walls in buildings such as ministries, hospitals, colleges, and schools, covering them with historical and allegorical scenes that spelled out Mexico's oppressed past and radiant future. The work was commissioned by the Secretary for Education, Vasconcelos. The painters worked for very little reward but could regard themselves as working with and for their society; like famous writers, they were seen as important shapers of the national spirit. Vasconcelos consulted them on all sorts of matters. Siqueiros, conversely, set aside painting during the second half of the twenties in order to devote himself directly to the political struggle. Thus the Mexican artist realized what had been the hope of the avant garde in Russia, to find an effective role in a reformed society. The Russians had hoped to achieve this by pursuing specialized research into form and meaning (Malevich and his followers) and by applying artistic invention to immediate and practical problems (Tatlin

149. Stuart Davis: *Lucky Strike*. 1921. Oil on canvas, 33¼ × 18 in. Collection, The Museum of Modern Art, New York (gift of the American Tobacco Company, Inc.)

and the Constructivists); the Soviet state rejected both in favour of an artistically unambitious picture-making that owed little or nothing to local traditions of icon painting or narrative print-making but adhered to outdated international conventions. Rivera, Siqueiros and Orozco had to abandon avant-gardism for didactic painting but were able to infuse this with artistic as well as humanitarian ideals. Their work became exemplary around the globe; it may even have contributed something to

150

the one art form in Soviet Russia that was able to advance artistically while satisfying the state as to its social efficacy, the film.

During the thirties Mexican muralists worked in the United States. As well as their work, their personalities, particularly their impatience with the theoretical garnish that accompanies much European and Europe-inspired art, made a deep impression. American artists were increasingly eager to find an American kind of art, free from the apron strings of European modernism as well as of European traditions. They sought it mostly through self-evidently American subject-matter, as before. In 1936 the American Abstract Artists group was formed in New York, largely by artists not born in America, in order to counter this isolationist and sentimental tendency. The same year saw the publication, by the New York Museum of Modern Art (founded in 1929), of two particularly influential books, *Cubism and Abstract Art* and *Fantastic Art, Dada and Surrealism*, both compiled by its director, Alfred Barr. The museum, its exhibitions and the publications associated with them, played a major role in establishing an agreed, almost official history of modern art. Its collections, formed at a time when much of Europe was backing away from modernism and even suppressing it, provided Americans with a permanent display of modern masterpieces. This, as well as other developments in public and private galleries and collections, plus the influx of Europeans during the thirties, enabled New York gradually to replace Paris as the headquarters of modern art.

150. Diego Rivera: *Workers of the Revolution*. 1929. Mural. Mexico City, Palacio Nacional

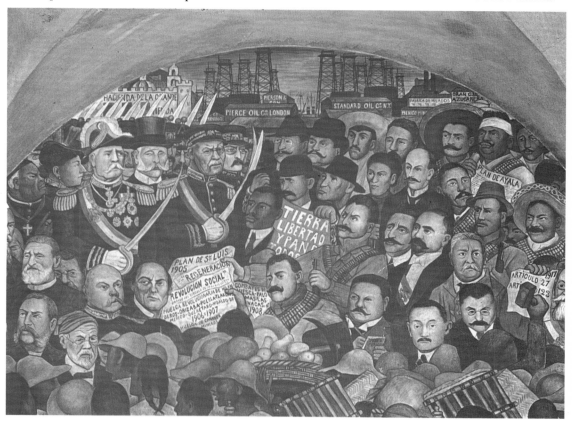

In Paris the movement that replaced Cubism as the spearhead of the new was one that in some respects considered itself anti-modernistic. The Surrealist movement, like its immediate parent, Dada, rejected all the 'isms that had formed the story of modern art as artificial pursuits of no relevance to human existence at any time. The Surrealists' aim was to use the arts as a counter to the ordered and restricted ways of civilization by opening up the super-reality of fantasy, dream and imagination which, they claimed, is man's true habitat. More than Cubism, more obviously than Futurism, more specifically than Expressionism, the Surrealists were concerned with subject-matter and with the effects that subject-matter can have. Their aim being to subvert citizens from their good behaviour, they bombarded them with impolite and impolitic messages but also taught them the joys of anti-rational speculation. They were writers primarily, and their main focus was on literary problems. How, in writing, could they hope to capture true gobbets of irrationality? Merely to describe a dream would not be enough: conscious control would intervene. They experimented with drugs and hypnosis, partly to make themselves more at home in the unconscious. They adopted the Dadaists' game of using words in random sequence, exploiting their value as discrete and multivalent objects and also letting them send sparks of meaning to each other by imposing no intentional meaning on them. This could also be done with images, and they quoted repeatedly some words from the nineteenth-century poet, Lautréamont: 'Beautiful as the accidental meeting of a sewing machine with an umbrella on an operating table'. Both methods—verbal and visual—invited the reader's creative participation by stimulating his imagination to discover significance; the essential thing is to present him with data that will permit no commonsensical interpretations. To assist this process it would help to weaken the hold of logic on the spectator. Short of drugging him before submitting him to the Surrealist experience, the effective thing would be to disorientate him with shock. Thus Dadaists' tricks invented to show their rejection of civilized standards became essential strategies. Surrealism would liberate man by teaching him to live on a superior plane of natural freedom. Material constraints would become irrelevant as man shrugged off the bonds of rational order forged by the Greeks.

Poetry had always had this role. Its imagery had always been free to transcend the limits of practical discourse. In this sense Surrealism was merely asserting the primacy of the poetical faculty. But the Surrealists wrote in order to change society, overcoming their reluctance to risk losing their hold on what they found in the unconscious in putting pen to cold paper. In 1923 André Breton, poet and leader of the Surrealist movement, considered giving up writing altogether; instead he and his colleagues pinned their faith on the shareability of irrational material and tended to disagree about how the sharing should be done. Egocentricity—the angler's intense gaze now fixed on to his own inner life—was the essential method of any Surrealist, but there would be no point in bringing one's catch to table unless it was nutritious to others. *The Surrealist Revolution*, the name they gave to the journal they published from 1924 to 1929 (it was succeeded by a journal with the even more pointed title, *Surrealism in the Service of the Revolution*), could not

be confined to literature or the arts but would have to involve itself in the social struggle. For some years the Surrealists sought to ally themselves with international Communism but the alliance was uncomfortable and not wholeheartedly sustained on either side. The rise of Stalin, his triumph over Trotsky in 1928 and over Bukharin in 1929, brought an end to all tolerance of avant-gardism under Communism. As the doctrines of scientific materialism were pressed with growing dogmatism, Surrealists had to recognize the unbridgeable chasm that lay between those and their necessary belief in total freedom of thought and imagining. The artists associated with Surrealism participated little in the political work. Their names appear only rarely among the signatories of the several manifestos, statements and open letters that were issued from the Surrealist Research Office or printed in the Surrealist journals. Their relationship to the theoretical and literary core of the movement depended mostly on friendship with one or another of its members and did not necessarily imply more than a general sympathy with the Surrealist campaign. Some of the writers argued that Surrealist art was an impossibility; visual formulation of the irrational would destroy its authenticity. Others could not deny their interest in art and artists, and chief among them was Breton himself. Like his mentor, Apollinaire, Breton was stimulated by artists and responsive to their work, and he worked hard to prove that important contributions were to be made to Surrealism by visual means. In a series of articles that began in 1925 and were brought together in 1928 in the book *Surrealism and Painting* he defined some of these contributions and pointed to other artists as stimulating forerunners of Surrealist art.

On the whole he was to find artists unreliable colleagues. The automatism he proposed, in the first Surrealist Manifesto of 1924, as the essential means of exploring the unconscious regions was only of short-term interest to them. Instead, they departed on diverging, independent adventures; though Breton was often willing to give these public support, he was frequently disappointed by the result. Artists were also liable to accept involvement in activities Breton could not approve of. For example, he saw Ernst's and Miró's readiness to design the decor for *Roméo et Juliette* (music by Constant Lambert; choreographed by Nijinska) for Diaghilev's Russian Ballet company in 1926 as a major betrayal of Surrealist ideals, the company being a counter-revolutionary bourgeois institution. In a movement the history of which is full of resignations and expulsions, the artists tended to be the least constant elements. Yet the Surrealist spirit prospered in art: art notably enlarged its range of subject-matter, methods, and functions. We may wonder whether such growth would have occurred without Breton and Surrealism. The evidence suggests that much of it would have occurred independently in similar ways, but the fact remains that it did occur in and around Surrealism and came before the public mainly through Surrealist manifestations. There were major Surrealist exhibitions in Paris in 1925, 1933, 1936, 1938, and 1947. A Surrealist Gallery opened in Paris in 1926; the Gradiva Gallery, run by Breton himself, opened in 1937; other galleries were sympathetic to Surrealism at various times. Individual artists involved in the movement had one-man exhibitions,

and on several occasions Breton, Aragon or another of the Surrealist writers would produce supporting texts for the catalogues. Their own volumes, conversely, often appeared with illustrations done by the artists. Illustrations of recent work, as well as drawings or prints done specially for the occasion, appeared frequently in the Surrealist journals and gained international currency through them. In the thirties particularly Surrealism became an international phenomenon, with exhibitions in New York, London, Brussels, and elsewhere, and with local branches of the Surrealist movement.

Then the second world war came to outbid its often macabre findings. Much that was honoured by the movement turned out to have been not so different from the clever but too charming confections with which Paris and the West had beguiled themselves while the storm clouds gathered. Hardly any of the major Surrealist artists whose work transcends the limits of the movement were French or thought of Paris as their home: in art at least, Surrealism seems to have been an incursion of non-Gallic forces upon the headquarters of French civilization.

Max Ernst, as we have seen, came to Paris fully fledged in 1922. His work combined two elements that particularly appealed to Breton. It sprang from a positive response to the dream world of de Chirico and it relied for its essential method on what Breton had rightly isolated as modernism's chief gift to Surrealism, collage. Collage was an invitation to such stimulating juxtapositioning as Lautréamont had exemplified with words. De Chirico, in Breton's eyes, had recently lost his true path in confining himself increasingly to classical themes. In the young man from Cologne (only three years younger than de Chirico, but perennially youthful as well as highly articulate and gratifyingly untrammelled by any art training), Breton could see his ideal artist. Their relationship was not untroubled but Breton's regard for Ernst remained high. In 1929 he wrote of him that Ernst possessed 'the most magnificently haunted brain at work today'; Ernst in return, was able to provide not only visual equivalents of automatism and productively unlinked images comparable to those of Surrealist writing, but also on occasion to paint detailed dream pictures and generally to retain remarkable mobility, constantly extending his own range and that of visual Surrealism.

His early interpretation of de Chirico was itself remarkable. Part of the pull of the Italian's characteristic paintings came from their pervading nostalgia. De Chirico's paintings exist in the past; we receive them as poignant recollections. In the early suite of lithographs *Fiat Modes* Ernst 129 used de Chirico spaces and figures but turned his period effects into a tussle between yesterday and today whilst using references to dressmaking as mocking metaphors for art. In one of the prints Chirico-esque perspective lines turn ambiguously into the wires or cables of a construction while an illogically inserted smaller image hints at the inverted scene offered by a plate camera. Ernst countermanded the bittersweet obsessiveness of de Chirico; the prints are critical where the Italian's paintings seem indulgent. By 1921 – 2 Ernst was experimenting with frottage—taking rubbings from floorboards and other surfaces in order to let the texture stimulate the imagination into discovering new images. He was to exploit this over some years, gradually adding other

151. Max Ernst:
*Two Children are
threatened by a
Nightingale.* 1924.
Oil on wood with
wood construction,
$27\frac{1}{2} \times 22\frac{1}{2} \times 4\frac{1}{2}$ in.
Collection, The
Museum of
Modern Art, New
York (purchase)

technical devices which would similarly trigger the imagination in
painting. In 1924, in Paris now, he made the picture-relief, *Two Children
are threatened by a Nightingale*. Its painted portion, though mysterious
and dreamlike, clearly echoes the Renaissance; to this he adds the Dada
element of nonsensical assemblage. This has the effect of throwing doubt
on any attempt to find a sensible interpretation of the pictorial drama and
makes the Cubist trick of confronting us with different sorts of reality
within one work into a painfully disruptive device. The title, written
unceremoniously on to the inner frame, adds its dimension of derange-
ment. Derangement of values, even: is that the way to label a work of art?
Is that roughly affixed toy gate good enough for the frame? Is the whole
thing worth putting in any frame? One almost forgets to ask oneself how a
nightingale can threaten two 'children', and who the third figure is.

In his pictorial novels—print sequences done from collaged
graphics—Ernst extends our doubts in several directions. Other artists

152

153

152 (left). Max Ernst: *Yachting* from *La Femme 100 Têtes.* 1929. Collaged engraving, $3\frac{1}{8} \times 4\frac{1}{4}$ in.

153 (right). Max Ernst: *People in a Railway Compartment* from *Une Semaine de bonté ou Les Septs éléments capitaux.* 1934. Collaged engraving, $11 \times 8\frac{1}{8}$ in.

had been doing pictorial novels, high-minded, often rather sentimental works in which successive images told a comprehensible story. In Ernst's there is no story. Each turn of the page jolts our attention. Our minds leap and twist in an effort to catch and link up sparks of meaning. That meaning tends, not surprisingly, to focus on a few perennial human concerns, sex, death, the loss of identity. Ernst achieved the images that make up these novels by doctoring illustrations he took from nineteenth-century magazines and sales catalogues. Sometimes the resulting hybrids consist of many fragments; often only one or two fragments have been imposed on an existing image. The result is always astonishing. The images disrupt our normal reading habits. Before long we find ourselves distrustful even of the straightforward information carefully delineated for us by the original draughtsman.

In paintings Ernst often worked more abstractly, using a growing range of sources and devices, from early photographs recording air-flow patterns to the tracks made on a canvas by paint trickling from a can swinging above it. Often his paintings seem to record a creative dialogue between the painter and his visual and physical material. Seen in large quantity, Ernst's work is like a vortex. We look in vain for the man or his co-ordinating spirit in the many different kinds of images around us. 'It is difficult', Ernst is reported to have said of women:

> for them to reconcile the gentleness and moderation of Ernst's expression with the calm violence which is the essence of his thought. They readily compare it to a gentle earthquake which does no more than rock the furniture yet does not hurry to displace everything. What is particularly disagreeable and unbearable to them is that they can almost never discover his *identity* in the flagrant (apparent) contradictions which exist between his spontaneous behaviour and the dictates of his conscious thoughts.

In 1940 this fecund and elusive artist went to America. Since the end of the second world war he and his work have been international property, particularly welcome in France, America, and his native Germany.

Another artist associated with Surrealism who was to be of particular influence in America is Joan Miró. He divided his time between Spain and Paris. Here Spain means Catalonia and sometimes Majorca; most especially Barcelona ('I paint in the room where I was born') and a farm owned by his father at Montroig near by. Until the Spanish civil war and then the second world war distorted his life, Miró tended in the twenties and thirties to spend his summer months in Spain and the winter in Paris. His early (pre-Paris) work shows insistent detail raised to hypnotic power. In *The Farm* the cracks in the building, the utensils lying about, the contents of the outhouse, the forms of plants, animals, the soil itself— everything is stressed with the passion of urgent recollection; the empty blue sky answers with equal force. All is conscious design, incorporating hints from Cubism. The affidavit character of such a picture may remind us of Rousseau, but Miró was a thoroughly trained painter and his super-realism was a chosen style.

In Paris he was drawn to Surrealism principally through its poetry. In the first Surrealist exhibition of 1925 he showed *The Farm* but by that time he had pared down his style. He was now using the canvas as a large or small surface on which to make his statements. He stained and rubbed

154. Joan Miró: *The Farm*. 1921–2. Oil on canvas, $48\frac{1}{4} \times 55\frac{1}{4}$ in. New York, collection of Mrs Ernest Hemingway

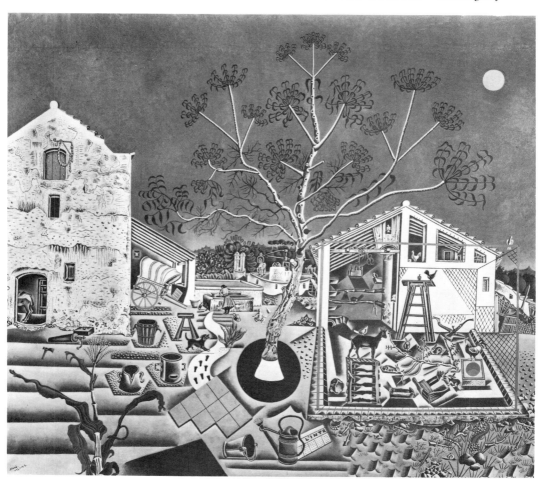

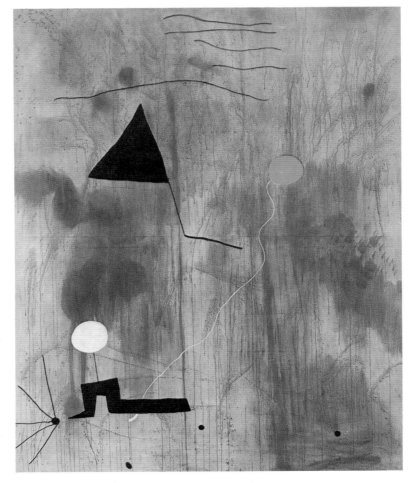

155. Joan Miró:
*The Birth of the
World*. Montroig,
1925 (summer). Oil
on canvas,
98¾ × 78¾ in.
Collection, The
Museum of
Modern Art, New
York (acquired
through an
anonymous fund,
the Mr and Mrs
Joseph Slifka and
Armand G. Erpf
Funds, and by gift
of the artist)

the surface to give it visual presence, and then he added signs and
symbols of several sorts—many of them prepared for in *The Farm*—that
hover in the ambiguous but shallow space created by his staining. We get
the sense of a declaration issued by a particular person, the language and
syntax of which are as idiosyncratic as intense inward focus can make
them but the urgency of which compels our attention. The process may
remind us of Malevich's Suprematist paintings, but these referred
outwards, to cosmic space and to what the painter conceived as universal,
impersonal truth. Also, difficult though it seems at first, Miró's sign
language explains itself through familiarity with his work and by the
recognition this brings of his ordinary, very human concerns. If
Malevich's white surface is outer space, Miró's is a familiar wall and his
marks are often like graffiti referring to all our personal lives. Miró's
paintings look spontaneous and some of them probably were painted
quickly. In any case they approximate to the 'pure psychic automatism'
Breton looked for, and it was this aspect of Miró's work that led Breton to
welcome him to the Surrealist circle. But Miró rarely worked purely
through automatism. His subsequent, very varied output (which

includes sculpture and other three-dimensional objects and painted and
ceramic murals as well as the normal range of production of a modern
painter) shows him moving freely between consciously designed and
composed images and more immediate, gestural work. The more
thoroughly planned paintings tend to be those in which external thematic

157 content dominates, as in *Still Life with Old Shoe.* This was painted from
objects set up in the studio—bottle, apple with fork, broken loaf of bread,
shoe. Working on the painting over five months, Miró transformed the
realistic subject into a super-realistic one. It symbolizes Spanish
peasantry under the shadow of the civil war. Abstract forms hover around
the recognizable objects; their setting is the nauseating space of
nightmares, and this sense is heightened by the electric or dark colours,
the over-sharp or indeterminable forms. On other occasions Miró
appears to work with completely abstract forms; these always function as
symbols for something in his experience and rarely lack a hint of animal
life. But on some occasions the marks and forms he uses are more
detached. In 1930, for example, he produced a large horizontal painting
that shows nothing but a small black disk and larger, softer red and yellow
disks on a white field. This side of his work found its climax in three large
paintings of 1962, intended to form a triptych. Each has its own ground

156 colour, red, green, and yellow-orange. A few sparse marks on these
grounds complement the colours in giving each painting its identity.
Together they strike one as particularly naked paintings in which each

156. Joan Miró:
*Yellow-Orange
(Mural Painting I).*
1962. Oil on
canvas,
$106\frac{1}{4} \times 140$ in.
Paris, Galerie
Maeght

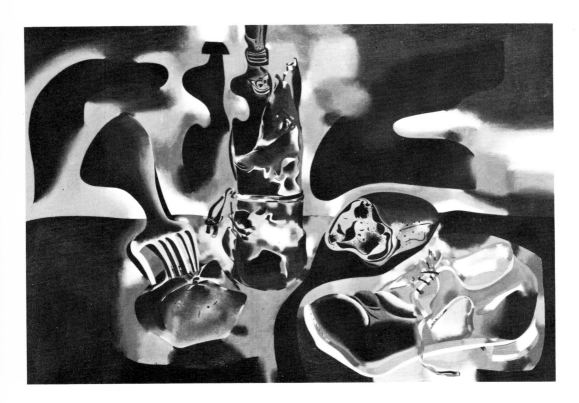

157. Joan Miró:
*Still Life with Old
Shoe*. Paris, 1937,
January 24–May
29. Oil on canvas,
32 × 46 in.
Collection, The
Museum of
Modern Art, New
York (fractional
gift of James Thrall
Soby)

element, formal or colouristic, has its greatest possible value. Such economical usage, combined with generosity of hue and size, suggests the art of post-war America. The Americans, Pollock, Rothko, and the others known as the Abstract Expressionists, were certainly affected by Miró's earlier work; it is likely that this triptych shows a return influence from the Americans on him.

The painting of Miró and Ernst, incorporating automatism but also presenting personal themes through signs and symbols, was countered by another sort of Surrealist art, highly detailed paintings purporting to offer scenes brought up whole from the unconscious. The most elaborate and in many ways most persuasive of these are the work of another Spaniard, Salvador Dali. Until 1929 he practised several styles, ranging from naturalism of an old-master sort to Cubism and the Metaphysical Painting of de Chirico and Carrà. In 1928 he visited Paris. In 1929 he sent a group of paintings to Paris for a one-man exhibition which Breton saw and welcomed warmly. Dali's professed purpose, 'to systematize confusion and thus to help discredit completely the world of reality', fitted well the Surrealist writers' programme, and his by then totally traditional methods of representation brought his pictures closer to the world of writing than were most of Ernst's and all of Miró's. Yet his means, at least the most effective of them, were visual, not literary. Dali has persistently exploited the ambiguities besetting our perceptual processes. We are always liable to misread what we see, especially so when we are in a state of diminished rationality owing to tiredness, illness, drugs or whatever. Dali's aim was to re-inforce such misreadings,

until they throw doubt on the reading we call correct or normal. He also knew how to exploit to their utmost a whole range of distortions—of the human body (to which we respond with acute discomfort), of space (nauseating), of matter (as when a rock becomes flesh or watches go limp; nauseating again), and even of form itself (when negative forms become positive, hollows become solid, and so on; disorientating). In the second Surrealist Manifesto, written in 1929 when he had just been studying Dali's paintings, Breton wrote that there exists a mental point 'at which life and death, real and imaginary, past and future, communicable and incommunicable, high and low, cease to be perceived in terms of contradiction'. 'It would be vain', he added, 'to examine Surrealist activity for any other motive than the hope of determining this point.' This aptly describes the functioning of Dali's work at its best; it is at once destructive and constructive, disruptive and didactic. In purely pictorial terms it is, however, firmly reactionary. We observe his painted scene as a theatrical illusion prepared for us beyond the proscenium arch of the frame. His painting technique, admired by many, entirely lacks the grace of Raphael and the cool objectivity of Vermeer, his chosen heroes. These 'hand-painted photographs', as Dali called his pictures, taste of nineteenth-century academic ponderousness. Only the brightness of his colours, echoing eighteenth-century painting and Impressionism, separates Dali's manner from that of a number of competent but timid painters of the age of Napoleon III. But these would have been as

Calls to Order

158

158. Salvador Dali: *The Birth of Liquid Desire.* 1932. Oil on canvas, $37\frac{3}{8} \times 44\frac{1}{8}$ in. New York, Solomon R. Guggenheim Foundation (Peggy Guggenheim Collection)

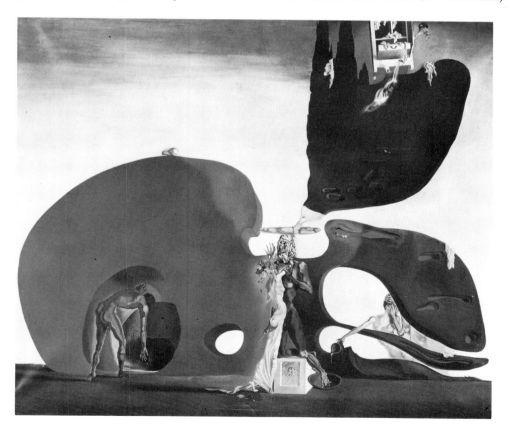

outraged by Dali's way of life as by such portions of his imagery as they would have admitted to understanding. In our own time, Dali's purposefully extravagant behaviour has greatly augmented his fame; he made a full-time style out of the more occasional naughtinesses the Paris Surrealists allowed themselves. His increasingly aristocratic view of the world led him into supporting fascism, and in 1938 he was repudiated by Breton and what then remained of the Surrealist group.

Many lesser talents were attracted to what is sometimes called naturalistic or veristic Surrealism. René Magritte was a naturalistic Surrealist in the sense that his paintings are representations of recognizable scenes or objects. The fantasy element in them seems, especially after Dali, modest and well-mannered. He lived quietly, in his native Belgium and from 1927 to 1930 in Perreux-sur-Marne near Paris. Yet he struck at the traditional core of art, at the source of art's agreed value as communication: the convention by which we identify an image with the thing it represents. More than any other Surrealist, more than any other artist except for Duchamp, Magritte was a painting philosopher. His usually very prosaic way of presenting images—in straightforward, frontal compositions, often painted rather heavily, as though with lard—disguises the edge of his paradoxes. *La Trahison des Images* illustrates this. It is one of a number of pictures in which Magritte set words against representations. Here he accompanies a picture of a pipe, such as a signwriter might have produced, with the words 'This is not a pipe.'

159. René Magritte: *La Trahison des Images (Ceci n'est pas une pipe)*. About 1928–9. Oil on canvas, $25\frac{3}{8} \times 37$ in. Los Angeles County Museum of Art

159

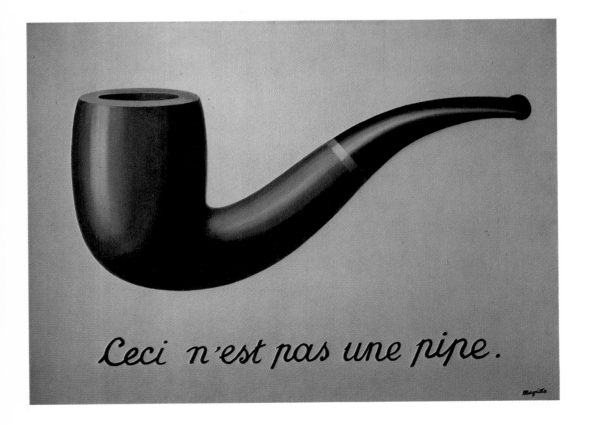

According to our expectations we might be taken aback by this declaration or accept it too readily. Of course this is not a pipe. It is paint on canvas, not to be filled with tobacco and lit. Yet our response to images rests on a suspension of such commonsense reading, and since images stir us emotionally it must be unrealistic to harp on the distinction between what is signified and what does the signifying. In some senses the painted pipe is more truly a pipe than the object in one's pocket: it is the pipe in general, not the pipe with this stem or that, with dirt in it or a chip out of the mouthpiece. It is the pipe in the head that asserts the existence of a class of object we call 'pipe'. Of course 'pipe' will do for an Englishman, or a Frenchman, but not for an Italian, Red Indian or Chinese. Some people who see the picture will instantly recognize the object but not be able to read the words. What does this do to the message? Others may never have seen a pipe but be able to read French. What does this do to their knowledge of the world? In another painting, *The Key of Dreams*, Magritte showed four objects and set nouns against each: a bag, 'sky'; a penknife, 'bird'; a leaf, 'table'; a sponge, 'sponge'. The last disconcerts us more than the others, and makes us wonder about names and titling. A picture of a naked woman may have a label 'Nude'. Why? Magritte's title for that four-part picture suggests that wonder and fantasy, and also perplexity, arise out of naming and out of our trust in names. Perhaps, after all, that leather container with handles should be called 'sky'. Words are arbitrary, unreliable things, yet we tend to put more trust in them

160

160. René Magritte: *The Key of Dreams.* 1930. Oil on canvas, $14\frac{7}{8} \times 20\frac{7}{8}$ in. Munich, private collection

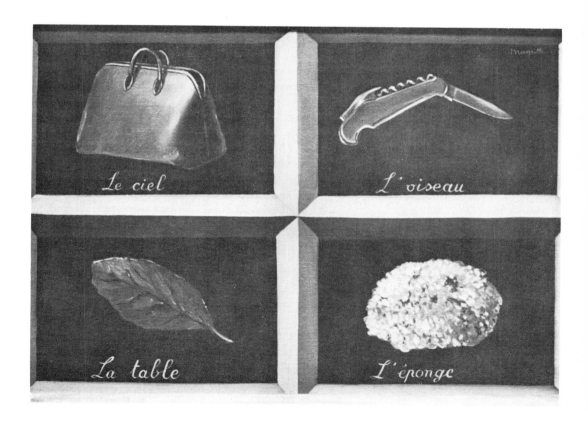

than in images even though we would agree that images can approximate to visual facts.

The Human Condition I leads us into a similar conceptual maze without recourse to words. For a moment we do not know how to read the picture. Then we recognize that it shows a picture within a picture. Magritte has made the landscape painting he shows standing on the easel perfectly identical with the landscape outside the window, hence our momentary confusion. But how much do we know of the landscape outside the window? It is just possible that that picture has been set up in front of the window to stop us seeing what is really outside, something unbearable perhaps. There is an ominous silence in Magritte's paintings. We shall probably prefer the option of returning to our first explanation: the landscape on the easel is identical with the landscape beyond it, so much so that we can mistake one for the other. But why do we accept this even momentarily when we all know that few things are less like actual living landscape than even the most accurate paint-on-canvas rendering of a landscape? When we are hungry do we go into a gallery to satisfy ourselves with a still life? Why this pleasure in imitation, in self-deception? We call it art and treat it as treasure. And none of this even touches upon the curious light in the pictured room. The curtains cast shadows that suggest they are lit from above (like the picture would be in a gallery), which is odd. What produces the shadows cast by the legs of the easel? Whether we notice them consciously or not, such details are part of the picture's needling effect.

Neither Dali nor Magritte wanted to create new forms of painting as such. Ernst, Miró, and other Surrealists worked through new techniques and devices as much as through images and symbols. Neither Magritte's poker-faced manner nor Dali's bland stylishness could be mistaken for the product of any century but our own, yet there is no stylistic conflict between them and the academic inheritance that modernism had shed. In this sense their art was reactionary. Nevertheless we have to accept that, if Cubism established the freedom of artists from restraints of medium or technique, then one of the strategies open to a painter was that of traditional illustrative painting. In asserting the efficacy of detailed representations Magritte and Dali were extending the life of late nineteenth-century Symbolism, on which de Chirico also had based himself; in using detailed illustration in order to question and to redirect the processes we employ in digesting the evidence of our eyes, they were themselves undermining the past. They went beyond the Cubist's questioning of a picture's relationship with reality. They were asking what use a man's perceptual and conceptual powers are to him, and what breaking the shackles of common sense would do to these powers. Like the Social Realists of the new Soviet and Mexican states, and like the New Objective painters in Germany, they were insisting on the primacy of meaning over aesthetic interest. Meaning, that is, in the old sense of discursive content partly or largely paraphrasable in words—not the latent meaning of a Mondrian or a Malevich where signs refer us to very general messages, nor that of a Kandinsky where intuitively assembled signs do not refer us to a body of ideas but are intended to transmit sensations through sensation. Kandinsky's programme of exteriorizing

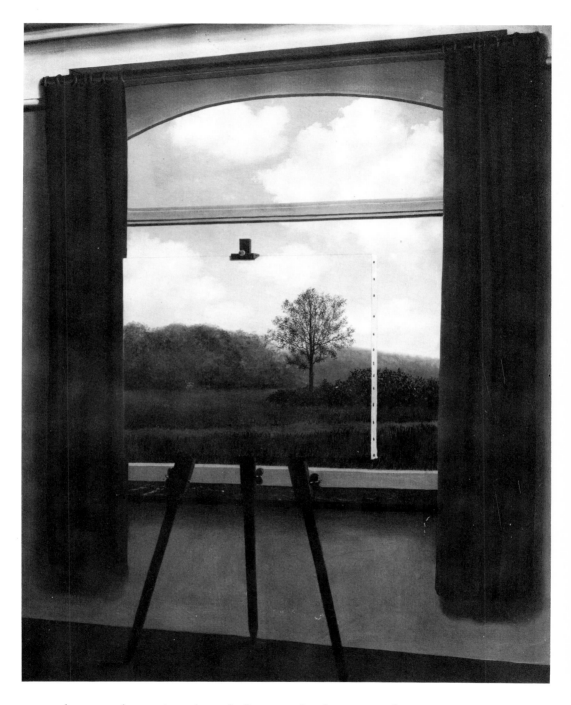

personal unconscious urges through forms and colours was close to Surrealist intentions, but his work is particularly inaccessible to literary analysis and was not recognized by the Surrealists as part of their world. (Significantly, the Surrealists were not interested in music either.) Klee's, on the other hand, was recognized. Ernst knew Klee personally and admired his work, and examples were included in the first Surrealist

161. René Magritte: *The Human Condition I*. 1933. Oil on canvas, $39\frac{3}{8} \times 31\frac{7}{8}$ in. Private collection

exhibition of 1925 and reproduced in *The Surrealist Revolution* in April the same year. Not only are there evidently fantastic elements in Klee's work; there is also something at least partly automatist about his way of letting images grow out of the marks he is making. Arp's presence in that 1925 exhibition may seem more surprising since his art lacks totally the convulsiveness that Breton said was the true beauty of modern times. Yet it is essentially metaphorical and springs from familiar human themes of the sort that motivated Miró's paintings. It contributed a benign, meditative aspect to the generally shriller body of Surrealist art.

The outsider who mattered most to the Surrealists was undoubtedly Picasso. They were right. During his long career Picasso adopted many roles but what links them all, what indeed goes some way towards explaining the hold that his flood of masterpieces, trifles and in-betweens has on our century, is his awe at the creative power of the imagination. He himself would not use such words. He was a deeply superstitious man, close to the primitive for whom an image is charged with spiritual powers and the environment is dense with omens. If one of the functions of Surrealism was to reawaken in man his ancient sense of dread and wonder, Picasso was its natural precursor. He had also been, of course, Apollinaire's prime artist-hero, and he was personally close to some of the poets who looked to Apollinaire as their master, especially Breton and Paul Eluard. It was Breton who, in or about 1921, persuaded the couturier Jacques Doucet to buy from Picasso the almost forgotten rolled-up *Demoiselles d'Avignon*. Breton wrote about Picasso in the July 1925 issue of *The Surrealist Revolution*, using him as the spearhead of his attack on those who held that Surrealism was out of reach of art. He illustrated his article with reproductions including the *Demoiselles* (which thereby became visibly part of the modern art world) and a new painting, *Three Dancers*. That November Picasso contributed to the Surrealist exhibition in spite of his general rule not to participate in mixed exhibitions.

'Beauty must be convulsive or cease to be', Breton had said. *Three Dancers* exemplifies that beauty. Its theme reflects Picasso's association, since 1917, with the Russian Ballet. He had designed decors for Diaghilev and had married a dancer in the company. Much of his graphic work of the early twenties was of dancers. By the mid-twenties he was tiring of the smart social life he had been leading and regretting his marriage. *Three Dancers* is the most emotionally charged painting he had done since the *Demoiselles*. The stylistic disarray of the earlier picture here becomes systematic. The distortion announced in the seated *demoiselle* but subsequently deflected by Cubist fragmentation, now takes full command. The *Demoiselles* became monstrous in the course of being painted; here dance itself is revealed in its primeval, Dionysiac role, a frenzied and fierce action, not an entertainment. It recalls Matisse's *Dance* mural of 1910 (the raised foot of the dancer in the centre is a quotation from Matisse), and also the German Expressionists' harsh portrayals of dancers, Kirchner's especially. But the much greater extremes of distortion and movement that Picasso here allowed himself go beyond theirs, and are further extended by dislocations and duplications of anatomy that come from Cubism. This is most noticeable in the wild dancer on the left, multi-breasted and altogether riven by the obsessively

162

162. Pablo
Picasso: *Three
Dancers*. 1925.
Oil on canvas,
$84\frac{3}{4} \times 56$ in.
London, Tate
Gallery

ambiguous interaction of her body, dress, and background. This figure
was the last of the three to be painted and involved a lot of reworking.
Behind the dancer on the right looms a tall dark shadow. It stands for
Picasso's friend Raymond Pichot, who died while the picture was in
process. He plays St John the Baptist to the Salome of the girl on the left.

Les Demoiselles d'Avignon had been conceived as a moral allegory and
had gradually become the less specific representation we know. *Three
Dancers* has no subject beyond that announced by the title. The setting is
a very ordinary French one, and even the intrusion of death does not

result in a focused theme. Picasso was to wrestle at various points in his career with the problem of using art as a vehicle for particular messages; his innate tendency was towards generalized comments about life and death. In 1930 he painted, exceptionally, a picture with a defined subject, a historical and Christian one at that, a *Crucifixion*. It is small and intense, vivid in colouring, appalling in its use of distortion and conflicting scales, and stuffed with iconographical and stylistic references. Studies led up to it over the preceding three or four years, and in 1932 Picasso made a series of drawings after the Crucifixion from Grünewald's Isenheim altarpiece that shows he was still held by the subject. But his intention was not devotional. The drawings and the little painting (which Picasso kept by him and few people knew about) are thoroughly Expressionist in character. In 1929 he had painted a picture known as *Self-Portrait and Monster* in which a horrifyingly distorted head, which from other pictures we know to be female, seems to devour the painter's passive profile. In the *Crucifixion* monstrous heads crowd in on the innocent victim. A soldier-picador lances Christ's side and soldiers throw dice on a drum, while the Mother and Mary Magdalen bewail and also threaten the slight figure on the cross with their gaping jaws. That figure, we conclude, represents the artist; the traditional theme, ubiquitous in Roman Catholic countries, yields a private image of desperation. The picture formed part of a one-man show Picasso had in Paris in 1932. The Surrealists must have approved the use of an ancient myth as a personal statement.

163

The first issue of the journal *Minotaure*, launched in 1930 and interested primarily in Surrealism, featured thirty small Picasso images, drawn the previous year. Each was a female figure, paraphrased by means of assembled objects suggesting furniture and other utensils. About this time Picasso was also experimenting with constructed iron sculpture, which could involve a similar use of objects to suggest a figure or a head. Freud, the Surrealists' reluctant mentor, had referred much earlier to the 'refashioning of ready-made and familiar material' as a means of conscious and also unconscious creation.

The essentially autobiographical nature of Picasso's art distinguishes it from most Surrealist art in spite of the programme of self-examination. The Surrealist artist who comes closest to Picasso in this respect was Miró; we know that Picasso was positively interested in his work. We tend to expect such an autobiographical emphasis from German Expressionism but are often disappointed. Instead, we find critical or challenging poses, or external subject-matter coloured by personal experience, rather than intimate statements. Max Beckmann, the German artist who invites comparison with Picasso, is not always considered an Expressionist, partly because his maturity belongs to the years after 1918 and partly because his was one of the most prominent names in the New Objectivity exhibition of 1925. His paintings of the immediate post-war years took on a prophetic status when fascism turned the most nightmarish of them into commonplace events. But they were not prophetic. They represent Beckmann's personal response to the world. What differentiates them from the work of Grosz and Dix is their relationship to reality. None of them is content to transcribe directly what

he sees. Each seeks a persuasive formula that will endure, making the particularities of an event survive its passing. Dix focused on telling detail while Grosz used Cubist devices to bring several actions or views into one dramatic whole. Both worked close to the edge of caricature. Beckmann's *Family Picture* is at first sight tranquil and straightforward, a modern genre scene based on classically composed prototypes. It is only when we can no longer resist the tensions built into this picture that we become aware of the expressive means used. The six persons are distorted, but moderately so. The colours tend towards the acid. It is the *mise-en-scène* that gives the picture its muted stridency. Floor, walls, ceiling press towards us, making a shallow and unstable stage for the figures, their actions, and the props. Everything tilts dangerously or leans loosely. However placid the poses of the actors, they are threatened by this. The disruption awaiting them physically has already taken place psychologically; we note their alienation from each other, their breathlessness. In other Beckmann paintings of the period the violence is more open. Robert Wiene's film *The Cabinet of Dr Caligari*, released in 1920, with decor designed by three artists associated with the Sturm gallery (Hermann Warm, Walter Röhrig, Walter Reimann), made similar use of oppressive geometry and space. The source for that decor and for

165

163. Pablo Picasso: *Crucifixion*. 1930. Oil on wood, 20 × 26 in. Private collection

164. Max
Beckmann:
Departure,
triptych. 1932–3.
Oil on canvas,
centre panel
$84\frac{3}{4} \times 45\frac{3}{8}$ in., side
panels each
$84\frac{3}{4} \times 39\frac{1}{4}$ in.
Collection, The
Museum of
Modern Art, New
York (given
anonymously, by
exchange)

Beckmann's compositions was probably German late-Gothic painting with its slanting planes and lines. Kirchner's street scenes of around 1913 may well have drawn attention to this source.

During the later twenties Beckmann became a markedly successful painter with exhibitions in New York, Basle, Zurich and, in 1931, Paris, as well as in Germany. Picasso is reported to have found his work 'very strong', and the Musée du Jeu de Paume bought two paintings for its collection—a rare compliment to a foreigner. Beckmann was to flee from Germany in 1937. Before then, on the eve of the Nazis' victory, he had begun a large, three-part picture, *Departure*. Again this seems prophetic, of his emigration and his 1947 voyage across the Atlantic, but its real meaning is more general. Alfred Barr has described it as 'an allegory of the triumphal voyage of the modern spirit through and beyond the agony of the modern world'. Only the word 'triumphant' gives one pause here. The painting implies that there will be no arrival, no rest. The voyagers seem trapped between the two scenes of physical and mental suffering. As in Picasso's *Crucifixion*, we are free to read much from and into the painting. If the side panels point to, perhaps, specific contemporary miseries, the centre panel has overtones of Charon's boat, of the miraculous draught of fishes, of Odysseus and other ancient tales of voyaging. The artist does not wish to make a more specific statement, nor to be understood too quickly. We meet his message by feeling our way into his partly realistic, partly metaphorical world, raising our awareness with our attention.

164

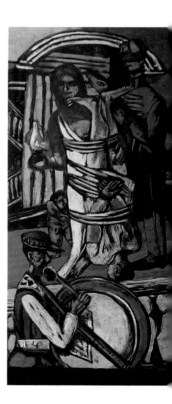

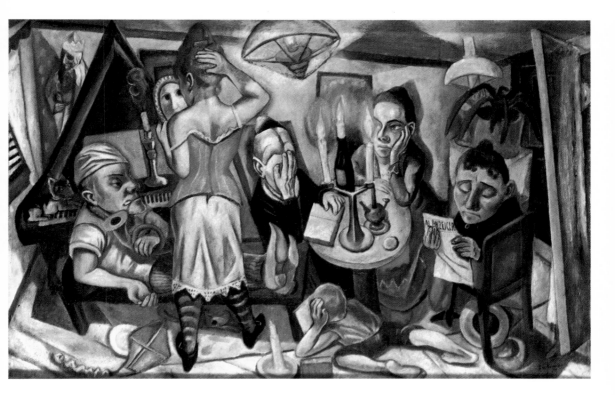

When Picasso was commissioned to paint a mural for the Spanish Pavilion at the 1937 International Exhibition in Paris he hesitated. Then German bombers called in by Franco bombed the little market town of Guernica. Picasso now felt he had found his theme. But the famous painting that resulted is neither a portrayal of that event nor a call to arms. Instead Picasso used the broad format of the mural to bring together a number of actions and symbols in one monumental composition. The symbolism is inexplicit but we can read what the figures are doing, that the horse is suffering, that the bull is vicious. The almost black-and-white painting (an effective economy in the midst of an exhibition) is air-less and space-less. The electric light, the oil lamp and the fire merely give nominal light. Compositionally *Guernica*, like *Departure*, is a triptych with a central triangular area flanked by vertical rectangles at either end. Both paintings are modern descendants of the altarpiece, and their epic ambitions recall the history painting. Unlike true history paintings, however, the Picasso and the Beckmann do not depend on myth or understood historical data. Their subject, obliquely viewed, is the contemporary experience of many. The bare bulb in the Picasso (which recalls the hanging lamp in *Family Picture*) reminds us that this is man's world awaiting man's amending; the open sky in the Beckmann implies the liberty of the mind. Neither painter takes refuge in pre-established allegory but can call on the understanding of his contemporaries, linked by the immediacy of newspapers. Neither Picasso's left-wing friends nor his critics on the right were happy about

166

165. Max Beckmann: *Family Picture*. 1920. Oil on canvas, $25\frac{5}{8} \times 39\frac{3}{4}$ in. New York, Museum of Modern Art (gift of Abby Aldrich Rockefeller)

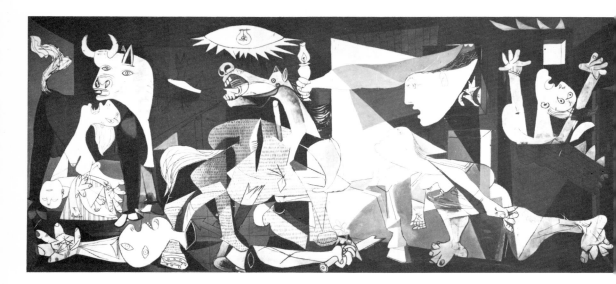

Guernica but with the passing of decades the painting has embedded itself firmly in modern consciousness. The bombing of that Basque town is now remembered more often because of the painting than as history.

Would sculpture be able to meet Surrealist aims? Surely the physical limitations and material substantiality of sculpture would not permit the full operation of fantasy and chance. Sceptics might have argued (they appear not to have done so) that sculpture is of its nature a surrealist activity, that one scarcely could go further than make a female figure 9 inches high for a mantelpiece or 40 feet high for a temple or 150 feet high for New York harbour, or to have a pair of anonymous lovers held for posterity in white marble, or a top-hatted mayor in black bronze. If sculpture is an art of physical, measurable fact, it is also the most mysterious of arts. Setting a sculpture on any sort of base, as until recently was almost always done, means refuting its actuality: like the stage and the picture frame, the base lifts the image on to a plane of unreality and therefore of special attention. Rilke called this special, removed space 'a sculpture's circle of solitude'—and this of itself suggests why Cubists and others sought ways of breaking this convention. It was an obstacle to Cubism's mediation between the realities of art and of nature, to Futurism's attempt to draw the spectator into the work of art, to Constructivism's ambition to make art into an active element in daily industrial life. Picasso's 1912 *Guitar*, placed on a chair, Tatlin's *Counter Relief*, hanging in space, and certain Brancusis were attempts to overcome this problem—but how real is a functionless cluster of pieces of metal, let alone a metal paraphrase of a guitar encouraged to advertise its anthropomorphism by being invited to sit down? The best sculpture associated with Surrealism reflects three impulses, one of which is Picasso's playing with ambiguities of this sort. The other two are Duchamp's transmutation of values, achieved by removing objects from their normal habitat, and the enrolment of existing and specially made objects as things charged with supernatural

powers as were those by African, Oceanic or American primitives. Indeed, primitive art was exemplary for all three. Through their regard for the primitive the Surrealists felt they were reconnecting the arts to their original function as necessary magic.

One way of making Surrealist sculpture was, of course, to make objects resembling goblins and fiends. Ernst did some of this sort in the thirties and forties; they are entertaining but of little interest as Surrealism. Another was to exploit, as Picasso had done already in the case of the *Guitar* and was doing in two and three dimensions during the twenties and after, our irrepressible human instinct for finding human images in everything. Another was to imitate Lautréamont's simile and bring together disparate objects to see what physical union would produce. The colanders that form part of Picasso's *Woman's Head* contribute to it a dimension of meaning that anonymous curved planes of metal could not have given it. But the process could be taken further at various levels of playfulness, as in Miró's *Object* or in Meret Oppenheim's

168

167

168.
Pablo Picasso:
Woman's Head.
1930–1. Iron,
$39\frac{3}{8} \times 14 \times 24$ in.
Formerly
collection of
the artist

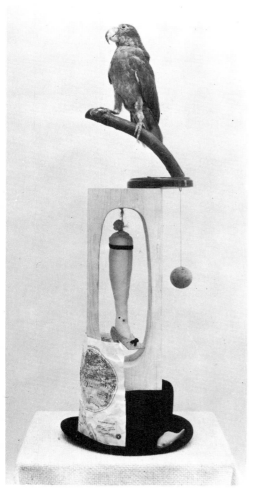

agreeable disagreeable object, *Le Déjeuner en fourrure*. Dali's 169 *Rainy Taxi*, made for the 1938 International Surrealist Exhibition in Paris, was a disagreeable object on a larger scale. It consisted of a taxi occupied by a blonde female dummy and a dummy driver wearing goggles and a shark's snout. The taxi rained internally; ivy grew over it and the girl inside shared the back seat with lettuces and live snails. The main room of that exhibition was designed by Duchamp. Its floor was covered with dead leaves. Over a thousand dirty coal sacks hung from the ceiling. A lily pond towards one corner was flanked by an unmade double bed. Coffee roasters made their aromatic contribution to the complex of ideas and sensations set off by an environment which also included Surrealist paintings.

An exhibition shown two years earlier had done much to stimulate adventures in three-dimensional Surrealism. This was the Surrealist Exhibition of Objects held in Paris at the house of Charles Ratton. Politely arrayed on walls and on little pedestals, in showcases and on shelves, was a multitude of smallish objects: bits of nature (bones, stones, minerals) as found or after artistic adjustment, primitive artefacts including Oceanic and American Indian masks, Duchamps's *Bottlerack*, and a collection of 'Surrealist objects' (thus distinguished in the catalogue) of past and present. Four pre-war sculptures by Picasso represented the past, including his *Still Life* of 1914, that remarkable 170 parody of domestic trivia, as threatening as humorous, and a fine *Guitar* construction. The present was manifested in a large number of objects, many of them made specially for the occasion, by artists and writers of the Surrealist circle, among them Arp, Breton, Dali, Ernst, Magritte, the American artist and photographer Man Ray, the German-Swiss painter

169. Meret Oppenheim: *Object (Le Déjeuner en fourrure)*. 1936. Fur-covered cup, saucer and spoon; cup diameter 4$\frac{3}{8}$ in., saucer diameter 9$\frac{3}{8}$ in., spoon length 8 in., overall height 2$\frac{7}{8}$ in. Collection, The Museum of Modern Art, New York (purchase)

and sculptress Oppenheim (with her furry object), Miró, and the English painter Roland Penrose. The different categories of object, old and new, Western and exotic, conscious art, unconscious art and nature's work, were jumbled together as equal in the sight of liberated man. This reminds us of the global embrace offered by the illustrations and text of the *Blaue Reiter* almanac. It should also make us aware of how much modern artists—as well as working their way more and more deeply into their professional and specialist concerns, away (it is often claimed) from anything they can share with the non-specialist world—have widened art's range of recognition and sympathy, turning art, in short, into a whole world of activities and objects of all regions and periods and of many disparate kinds.

Another contributor of Surrealist objects to the 1936 exhibition was Alberto Giacometti, from the Italian-speaking part of Switzerland. He had been in Paris since 1922, and had been influenced by Cubism as well as by primitive art. At the end of the twenties he found himself close to Surrealism. 'For some years now', he said in 1933, 'I have realized only such sculptures as presented themselves to my mind in a complete state; I have restricted myself to reproducing them in space without changing anything and without asking myself what they might signify.' Earlier he had habitually worked from the model; now he was working from the

170. Pablo Picasso: *Still Life*. 1914. Relief, painted wood with upholstery fringe, $10 \times 18 \times 3\frac{5}{8}$ in. London, Tate Gallery

Toutes choses... près, loin, toutes celles qui sont passées et les autres, par devant,

trois personnes, de quelle gare? Les locomotives qui sifflent, il n'y a pas de gare par ici,

qui bougent et mes amies — elles changent (on passe tout près, elles sont loin), d'autres approchent, montent, descendent, des canards sur l'eau, là et là, dans l'espace, montent,

on jetait des pelures d'orange du haut de la terrasse, dans la rue très étroite et profonde — la nuit, les mulets braillaient désespérément, vers le matin, on les abattait — demain je sors —

descendent — je dors ici, les fleurs de la tapisserie, l'eau du robinet mal fermé, les dessins du rideau, mon pantalon sur une chaise, on parle dans une chambre plus loin ; deux ou

elle approche sa tête de mon oreille — sa jambe, la grande — ils parlent, ils bougent, là et là, mais tout est passé.

ALBERTO GIACOMETTI.

18

19

171. Alberto Giacometti: *Mute and Moveable Objects* from *Surrealism in the Service of the Revolution*, No. 3, December 1931. Includes *Suspended Ball* (right page, top left) and *Object to be thrown away* (left page, bottom left)

imagination and, notably, from images that came into his head ready to be given three-dimensional material existence. In 1931 a spread in the December issue of *Surrealism in the Service of the Revolution* illustrated seven such 'mute and movable objects' after Giacometti's drawings of them. They vary as sculptures, some involving a space frame, others an indeterminate plane or arena. Some look as though they should be touched, like the *Suspended Ball* or the long, spiky thing, or the *Object to be thrown away*. The *Suspended Ball* (also known as *The Hour of Traces*) is not the first kinetic sculpture. Gabo had made a motorized sculpture in 1920 and in 1923 Man Ray had clipped a photograph of an eye to the pendulum of a metronome and called it *Object to be destroyed*. But Giacometti here introduced another function into sculpture, a new relationship between the art object and the spectator, bringing it painfully close to the attraction-repulsion experiences we know from life, wherein disgust and desire, pleasure and pain mingle inseparably. It is not the mobility of these things that matters but our urge to touch them and our fear of doing so. Like Picasso, Giacometti is unusually close to the roots of art. His work from nature too is charged with a primordial quality, as though he was the first man to turn formless matter into the image of a head or a figure. In 1935 he returned to working from the model, and found himself rejected by the Surrealists for doing so. They felt he had repudiated the imagination by turning to the visible world, and this demonstrates their shallow understanding of art. 'I worked from the model throughout the day from 1935 to 1940. Nothing was like I imagined it to be.' From 1950 he modelled figures from life as well as from memory; the results show no marked difference between one method and

171

the other. As David Sylvester has pointed out: 'Working from nature is working from memory: the artist can only put down what remains in his head after looking.' There has also to be a period, however brief, of maturation: 'our mind has to get outside the sensation before we can copy it.' Neither does Giacometti see his sculptures as reflections of the world we call real. A work like *The Forest* shows that his sculptures, whether or not modelled from nature, and whether we find them lifelike or not, are part of his own poetic world. The dichotomy postulated by the Surrealists is a false one.

This may help us to understand the confusion and also the resistance that art movements produced during the last 150 years. Every launching of a new development in art exaggerates its difference from what was there before. It tends to emphasize, for the sake of differentiation, aspects that are not necessarily central. Slogans produced for a specific moment and purpose become a part of that development and distort our reading of

172

172. Alberto Giacometti: *The Forest*. 1950. Bronze, painted, $22\frac{7}{8} \times 25\frac{3}{8} \times 23\frac{5}{8}$ in. Saint-Paul, France, Maeght Foundation

it. Surrealist art was not everything Surrealists wished it to be, nor only what they wished it to be. Of its nature, it was a reiteration of preferences (rather than principles) voiced before, in the Romantic age particularly. In seeking to define itself more closely, to surmount the charge of being Romanticism or Symbolism revived, Surrealism tended to become dictatorial. In the name of liberation, like other revolutionaries, the Surrealists had to become exclusive and censorious. The essential matter of a movement may well make a deep impact, even while its externals are rejected.

In so far as a movement such as Surrealism revives aspects of the past it can also strengthen and merge with surviving elements of that past. In Great Britain, physically and a little also temperamentally detached from the mainland of Europe, Impressionism had been received as a French usurpation of the vivid, lyrical naturalism of Constable and Turner. Fauvism, Cubism, and Futurism tended to be regarded as decorative modes, regrettably made unpalatable by typical Continental exaggeration. None the less, individual painters did effectively connect with aspects of Impressionism and Fauvism, and the Vorticists and their associates forged an original and powerful range of idioms out of aspects of Cubism and Futurism. The 1920s saw a variety of currents in British art that incorporated elements of Continental modernism without

173. Stanley Spencer: *Christ Carrying the Cross*. 1920. Oil on canvas, $60\frac{1}{4} \times 56\frac{1}{4}$ in. London, Tate Gallery

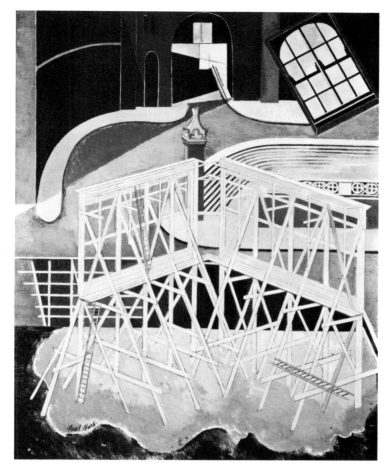

174. Paul Nash:
*Northern
Adventure.* 1929.
Oil on canvas,
36 × 28 in. City of
Aberdeen Art
Gallery

proving commitment to any of them. There were individual talents that
would, in a warmer cultural climate, undoubtedly have shown up more
proudly. One of these was Stanley Spencer, a thoroughly trained artist
with something of the primitive in his make-up. His works mark him a
descendant of the Pre-Raphaelites: like them he observed the daily life
173 about him closely with the eye of a participant in order to use what he saw
as a vehicle for myth and allegory. Genre material is endowed with the
meaning of a history painting. But he was more of a conscious stylist than
the Pre-Raphaelites (except perhaps for Rossetti): there was William
Blake in him (as in Rossetti), plus something of Gauguin's way of swaying
the beholder through emotionally charged distortion. This combining of
vision with carefully garnered fact, this poetry firmly rooted in particular,
174 unexceptional scenes, is found also in Paul Nash. Both painters might
have been part of a twenties Surrealist movement if Britain had had such
a thing. Nash was in fact much moved by a de Chirico exhibition that
came to London in 1928. The Italian's influence detached him a little
from his normal role as a painter of poetic landscapes and led him into
constructing dreamlike images from observed elements. The process was
not unlike collage, except that the pieces brought together existed in

175. Ben
Nicholson: *White
Relief.* 1934.
Carved wood and
paint,
$28\frac{1}{4} \times 38 \times 1\frac{1}{4}$ in.
London, Tate
Gallery

Nash's mind and sketches, not in newspapers or illustrated books. It is
significant that Nash should also have been an eager, sensitive
photographer.

Ben Nicholson's art too was rooted in observation, of still life as much 175
as of nature in his case. But he was more conscious than most of his
compatriots of what was going on in Paris. An easy relationship to this
knowledge and a detachment from favoured currents in British art
enabled him to respond to what he liked in Paris art without feeling the
need to arm himself with any of its doctrines. What struck him about a
Picasso painting was 'an absolutely miraculous *green*—very deep, very
potent and absolutely real', and his account of seeing a Miró, in 1932 or
1933, was: 'The first *free* painting that I saw and it made a deep
impression—as I remember it, a lovely rough circular white cloud on a
deep blue background, with an electric blue line somewhere.' Nicholson
had from the start the essential Cubist instinct: painting is making, not
imitating, and its subject is the sum of its 'potent and absolutely real'
constituents. In the early twenties he did some paintings that look quite
abstract and are based on observed still-life objects. In the mid-thirties he
made paintings and then also white reliefs that were patently abstract and
became part of the international mainstream of abstract and Elementarist
art. They showed nothing but a few circular and rectangular forms.
These were not pure forms, not exact and impersonal, but hand-drawn
and hand-carved, without measurement or precise placing. And the
spaces these works offered or implied are not self-explanatory as a true
Elementarist's would be; we are left in doubt as to the relationship
between one part of a composition and another. At this time Nicholson
was a member of the Paris association *Abstraction-Création*, devoted to
furthering abstract art at a time when its survival seemed in doubt. In
1936–7 he was one of the editors (with Naum Gabo and the British

architect Leslie Martin) of what was intended to become an annual publication but came out only once: *Circle—International Survey of Constructive Art*. Mondrian and the Paris architect Le Corbusier were among the contributors. Later Nicholson was to say that he had never thought of his paintings or reliefs as essentially abstract; they had meant to him things, as in a still life, a plate here, a book there. Neither was he an artist of the sort meant by the word 'constructive' (i.e. Constructivist): he worked as an old-fashioned craftsman, cutting shapes into and scraping them out of a wooden board.

Involved with Nicholson in *Circle* and other ventures was the sculptor Henry Moore. Moore's early work (he ended his studies in 1924) was reliably figurative—a figuration charged with energies drawn primarily from the primitive art (Cycladic and Mexican rather than African or Oceanic) he had studied and partly from an intimate rapport with the stone he was carving. In 1925 a scholarship sent him, reluctant, to Italy. He thought his allegiances lay elsewhere but the six months' tour through France and Italy taught him that art was one. He returned a synthesist for whom there was no essential conflict between a Mexican stone figure of the goddess Xochiquetzal and a Michelangelo marble. Realizing the synthesis took time: by the end of the twenties it was achieved in such a stone carving as the Leeds *Reclining Figure*, which is classical and primordial, stone and flesh, noble and natural, body and landscape. Michelangelo had hinted at the body-landscape metaphor; Mexican sculpture had helped Moore towards his brave acceptance of the stoniness of stone. Suggestions from Picasso are embodied in the sculpture too, and during the years that followed Moore was increasingly in touch with and aware of Paris.

Some of his work of the thirties tended to be called abstract (though it was never without organic qualities, usually human ones), and he was one of the contributors to *Circle*, with a statement plus illustrations. In his statement he spoke of the sculptor's freedom—as opposed to the architect's limitation by functional demands—to attempt 'the explor-

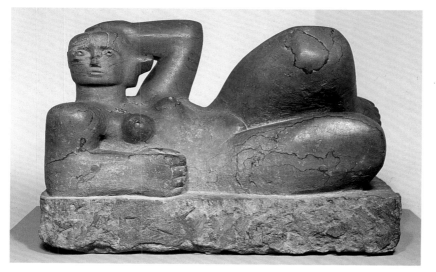

176. Henry Moore: *Reclining Figure*. 1929. Brown Hornton stone, length 33 in. Leeds City Art Gallery

ation of the world of pure form'. This was not a world Moore ever lingered in. Form for him is, typically, multivalent. His chief debts in the thirties were to Picasso and the Surrealists. In their different ways Picasso, Arp, Giacometti and even Dali encouraged in him a delight in metamorphosis and analogies. Thus in a few years Moore moved from the relative succinctness of the Leeds figure to so complex a formal and psychological work as *Four-Piece Composition: Reclining Figure*. Early in 1936 Britain had her first 'exhibition of abstract painting, sculpture and construction', and of course it included Moore. Later that same year, Roland Penrose and others presented in London an International Surrealist Exhibition that included all the main Paris Surrealists as well as Picasso, de Chirico and Klee and featured a British Surrealist group headed by Penrose, Nash, and again Moore. 'The violent quarrel between the abstractionists and the surrealists seems to me quite unnecessary', said Moore.

177

A few years later Herbert Read, the poet who indefatigably served the cause of modern art in Britain without feeling the need to take up partisan positions *vis-à-vis* this movement or that, wrote these words in his introduction to an exhibition entitled Living Art in England (1939): 'the triumph of fascism has everywhere carried along with it the exultant forces of philistinism, so that over more than half of European art, in any vital sense, can no longer be said to exist . . . even in those countries which are still professedly democratic, a wave of indifference has swept over the art world . . . it is only in the United States that art can in any sense be said to flourish.' That was written shortly before America launched a powerful new art that drew on several aspects of European modernism but sprang most particularly from a union of abstraction and Surrealism.

177. Henry Moore: *Four-Piece Composition: Reclining Figure.* 1934. Cumberland alabaster, $7 \times 17\frac{3}{4} \times 6\frac{3}{4}$ in. London, Tate Gallery

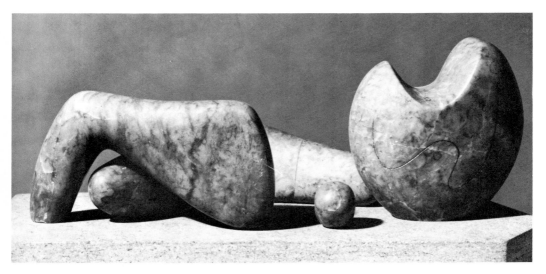

6 The Old Masters of Modern Art

You are perfectly free to leave that book on the table. But if you open it, you assume responsibility for it. For freedom is not experienced by its enjoying its free subjective functioning, but in a creative act required by an imperative. This absolute end ... is what we call a value. The work of art is a value because it is an appeal.

Jean-Paul Sartre, *What is Literature?*, 1947

When Pierre Bonnard died, in 1947, a large commemorative exhibition of his paintings was put on in Paris. They are typically colourful and treat easily recognizable themes—domestic interiors often, with people gathered around a table, or a naked girl washing and grooming herself, also still lifes and landscapes—and they had their public. They were neither Surrealist nor abstract, nor representational in an academic, pre-Impressionist sense. For over twenty years Bonnard had been living in the South of France. His paintings seemed charged with the lustre of the Riviera. People called them 'sumptuous', 'charming', 'joyous'. For lack of a more recent movement to be associated with, Bonnard called himself 'the last of the Impressionists'.

In the 1890s he had been part of a Paris group who called themselves 'Nabis' (prophets) and designated him 'the very Japanese Nabi'. It was one of them, Maurice Denis, who had issued the challenging statement about a painting being 'essentially a flat surface covered with colours arranged in a certain order'. Their hero was Gauguin. Like him they searched for a style at once simple and subtle, an answer to the tired complexities of official art. Bonnard was distinguished by his passion for 178 Japanese woodcuts, their flat colours, rhythmical organization, and often sharp and witty compositions. He made his early reputation with lithographs in which these characteristics were evident. His paintings of the same year were often gentler and warmer: small pictures, low in tone but softly mottled by patterns that echoed the bourgeois Paris interiors of the time. Critics called them 'intimist' because of their domestic note. Some of these paintings included nudes, one or two are unmistakably erotic—but their usual tone was one of domestic tranquillity. Bonnard could also on occasion produce larger decorative paintings, lighter in tone and flatter, and blatantly ornamental in their disposition of forms.

With the move south and the opening of his art to southern sunlight, the nudes become more frequent and the brushwork looser. *Nude in a* 179 *Bathroom* is a good example. In a glowing half-light, Mediterranean sunshine distilled by louvres and reflected by tiles, we see the girl, a dog and bathroom accessories. Knowing Bonnard, we know that the girl is

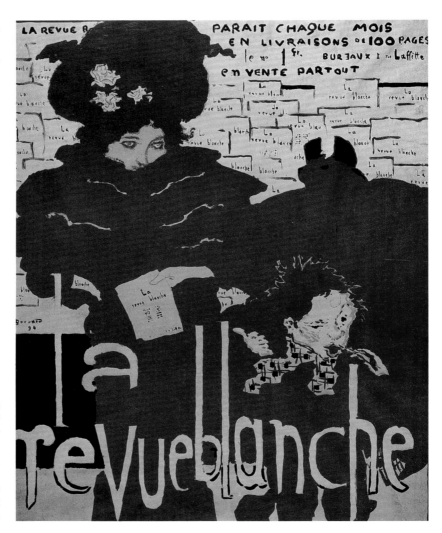

178. Pierre
Bonnard: Poster
for *La Revue
Blanche*. 1894.
Lithograph,
$30\frac{3}{4} \times 23\frac{7}{8}$ in.
Paris, Musée
National d'Art
Moderne

Marthe, his companion since the 1890s and now his legal wife. One is
struck first by the painting's mother-of-pearl luxuriousness. But it is also
a strange picture. The girl's pose is unusual, her action uncertain. The
dog by her feet is a soft silhouette in a wrong colour. Generally the
colours are contrary to sense: the tiles change colour oddly, the shadow
under the stool is white, the girl is violet and purple. Some things are
delineated sharply, others are left indistinct, and we cannot account for
the difference. Then we recall that Marthe must by now be in her fifties.
Slight of build and very charming to meet, she was a tense creature,
obsessed with personal hygiene. Bonnard painted her often in the
bathroom, and she is always a somewhat immaterial presence, a pearl
cradled by its setting. We also know how Bonnard worked. He would tack
a length of canvas on the wall of a room, often over patterned wallpaper,
and paint two or three quite different subjects on it, working from
memory, away from the motif. 'I am very weak, and it is difficult for me to
control myself in front of the object', he said; also 'The presence of the

object disturbs the artist' whose job it is to capture 'the first idea', 'the seduction': 'If this seduction, if the first idea vanishes, all that is left is the motif, an object which invades and dominates the painter.'

This means that he was not an Impressionist at all: his theme is not seeing but remembering. The American philosopher and psychologist William James around 1890 wrote about memory in words that seem relevant: 'Remembrance is like direct feeling; its object is suffused with a warmth and intimacy to which no object of mere conception ever attains.' Bonnard's French contemporary Marcel Proust devoted his life to constructing one delicate and enormous edifice of recollection, *Remembrance of Things Past* (more or less complete 1912, published 1913 – 27). Approaching the end of his labours Marcel, the 'hero' of the work, is overcome by 'a feeling of profound fatigue at the realization that all this long stretch of time not only had been uninterruptedly lived, thought, secreted by me, that it was my life, my very self, but also that I must, every minute of my life, keep it closely by me, that it upheld me, that I

179. Pierre Bonnard: *Nude in a Bathroom*. *c.* 1932. Oil on canvas, $47\frac{1}{2} \times 46\frac{1}{4}$ in. New York, collection of Mrs Wolfgang Schoenborn

was perched on its dizzying summit, that I could not move without carrying it about with me.' 'Secrete' is the word for Bonnard's activity, and the impulse to it is not joy but pain. He found paintings like *Nude in a Bathroom* a great strain. 'I shall never dare to embark on such a difficult subject again', he said when he had finished one, but he did embark again 180 and again. In a few of them a dog attends the girl, a foreign body in these visions of remote beauty. According to Thadée Natanson, who was close to Bonnard, 'a dog was always part of his person'.

An article published at the time of the 1947 exhibition in *Cahiers d'Art* asked in its title 'Was Bonnard a major painter?' and answered that only those could think him important who wanted their art 'facile and agreeable'. Matisse wrote a furious letter in defence of his deceased friend. Matisse was conscious at the time that he himself was at last meeting with official approval in his own country: in 1947 he was made Commander of the Legion of Honour and some Matisses were being put into the Musée d'Art Moderne, opened to the public that October. Just as Bonnard's reputation had been damaged by the onset of various forms of more obviously radical modernism, so Matisse's, in France at any rate, had been overshadowed by Picasso's, and his work misrepresented by the

180. Pierre Bonnard: *Standing Nude, with Head of the Artist.* 1930. Charcoal, $23\frac{3}{4} \times 18$ in. Courtesy of Theo Waddington, London

181. Henri
Matisse: *Interior
at Nice*. 1921. Oil
on canvas,
52 × 35 in. Art
Institute of
Chicago (gift of
Mrs Gilbert W.
Chapman)

critics. After his debut as leader of the Fauves, and after the patently bold
canvases of 1908 to 1917, it was said, Matisse had opted for a sweet and
self-indulgent kind of painting, deft and delicate but without risk or
discovery. 'Painting is always very hard for me', he had written in 1912;
'always this struggle—is it natural? Yes, but why have so much of it? It is
so sweet when it comes naturally.' The paintings of the 1920s, many of
them done in the South of France, suggest that he decided he would let it
come naturally, not press for a re-interpretation of the world. The
181 delicate colours and pleasurable mood of *Interior at Nice* can make one
overlook the knife-edge balance he achieves between the traditional,

perspectival vision of the West and the flat space construction—'a really plastic space'—he had learned from Persian miniatures. In fact this duality forces us to read and restlessly re-read the picture as we try to make sense of it by following the painter's visual moves: the flat pattern of the floor and the upholstered chair in the foreground (looking down), leading to the model seated on the balcony (seen in perspective), and to the planes of sea and sky meeting at the peculiarly compelling horizon. The short horizon is echoed by the frame of the picture to the left of it; also it comes at or close to the Golden Section point on the vertical. Pleased and satisfied by our first glance we may also miss aspects of the colour. Alfred Barr lists grey and blue, then adds sandy and pale salmon in a footnote. These boudoir colours do strike one first but they are accompanied by a strong turquoise and by powerful reds: notice how the painter leaves the red area at the left edge incomplete lest it dislocate the picture space, which thus remains for ever flat *and* deep.

There is no label for painting of this sort. Like Bonnard's, it comes without slogans and appears to offer no challenges. Yet, if this is significant painting, it questions the need for the new routes and routines of modernism. There are histories of modern art which do not bother with Bonnard, and the Matisse of the 1920s tends to be passed over. In his *Notes of a Painter* Matisse had expressly spoken of an 'art of balance, of purity and serenity . . . something that calms the mind.' In 1949 he said to his son-in-law Georges Duthuit: 'It is just a matter of canalizing the

182. Henri
Matisse: *The
Back, IV*. 1930.
Bronze,
$72\frac{1}{2} \times 44\frac{1}{2} \times 6\frac{1}{4}$ in.
London, Tate
Gallery

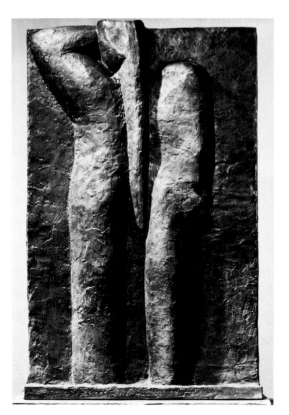

awareness of the spectator in such a way that he relates to the picture but is free to think of any other thing than the particular object that one wished to represent: to hold him without holding him back . . . Beware of acting through surprise.' French art easily tends to sweetness. The 1920s particularly witnessed Paris being offered charm by one side and the programmatic shocks of Surrealism by the other, and painting such as Matisse's was easily set aside as making no particular contribution. Yet it turns its back on nothing in modern art but subsumes elements of Fauvism and of Matisse's reading of Cubism in an apparently innocent process of observing and noting. In fact only the sunlight caught in the net curtains of *Interior at Nice* postulates something seen and recorded as seen.

By the end of the 1920s Matisse's work was again more austere. This is noticeable first in his sculptures: a climax comes in 1930 with the fourth in the series of reliefs known as *The Back*, nearly eight feet high, and also with a small sculpture, *Venus Seated on a Shell*. All Matisse's work maintains links with the classical tradition, but never more openly so than here. The relief belongs to the age-old tradition of large-scale figuration in relation to architecture, the small bronze to that of domestic devotional and then also decorative sculptures associated with Hellenistic Greece. One tradition is epic, the other lyrical, but for both he uses a markedly severe reading of the human form. The same year he was commissioned to illustrate a book of Mallarmé poems and to paint a 48-foot mural for

182
183

184

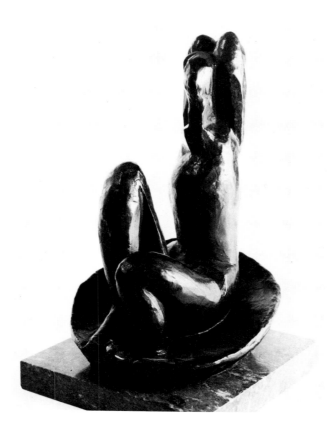

183. Henri Matisse: *Venus on a Shell.* 1930. Bronze, height 13 in. Baltimore Museum of Art (The Cone Collection)

the Barnes Foundation in Merion, Pa.; again, an architectural scale and 185 an intimate one. The illustrations hold the page magnificently, the shadowless etched line bringing light into the book. The mural went through many changes and occupied Matisse's winters until the spring of 1933 as he cut coloured paper shapes and lightly fixed them to the panels on which he was working, re-shaping, and rearranging them ceaselessly. Flat figures squat, leap, and tumble against a background of angled stripes, in pale colours that illuminate a shadowed part of the room. The artist was sixty years old in 1930.

Exceptionally powerful paintings followed, among them the *Pink Nude* of 1935 and *Music* of 1939. In his Matisse monograph Alfred Barr 186 illustrates sequential photographs of these, as well as of the Barnes mural, enabling us to glimpse something of the long process that Matisse's 'art of balance' demands. In 1941 he had to have a major intestinal operation; he recovered very quickly but was left much weakened and partly bed-ridden. He worked as much as he could, and in between working he prepared for work. 'Work cures everything', he wrote to a friend as late as September 1953—by which time, performed by a man in his seventies and early eighties, it had yielded a remarkable harvest. 'A flowering after fifty years of effort' he called it.

From 1944 to 1947 he worked on a book, *Jazz*, in which are pages of handwritten text by himself and large illustrations prepared by means of cut and coloured papers. This was to be the first in a resplendent series of works in cut paper. The technique suited Matisse physically: he could work in bed if necessary, cutting the paper that had been coloured to his instructions and watching over the arrangement of the cut shapes. In *Jazz*, under the heading 'Drawing with Scissors', he noted that 'Cutting directly into colour reminds me of the direct action of the sculptor carving stone.' Both associations are apt, with drawing and with carving. The works he went on to produce in this manner range from a 50-foot

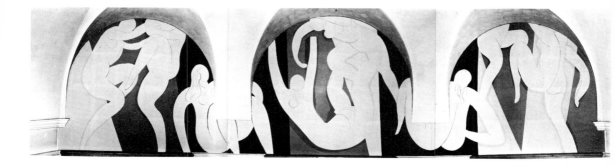

frieze for a swimming pool, to stained-glass windows, large wall decorations and also pictures, posters and book jackets. Before his operation he had hoped one day to find the means that would allow him 'to sing with all freedom'. Here he had found it. His forms are full of conflicting but joyful meanings. His colours, even within one work, can run the whole gamut from black to white via finely differentiated tones and hues.

185. Henri Matisse: *Dance Frieze*. 1932–3. Oil on board, 47 × 140½ in. Merion, Pennsylvania, © The Barnes Foundation

188
187 In the year of *Memory of Oceanic* and *The Snail* (1953) Matisse explained the importance and the nature of artistic seeing:

> Seeing is of itself a creative operation, one that demands effort. Everything we see in our ordinary life undergoes to a greater or lesser degree the deformation given by acquired habits, and this is perhaps especially so in an age like ours, when cinema, advertising and magazines push at us a daily flood of images which, all ready-made, are to our vision what prejudice is to our intelligence. The necessary effort of detaching oneself from all that calls for a kind of courage, and this courage is indispensable to the artist who must see all things as if he was seeing them for the first time. All his life he must see as he did when he was a child.

Earlier he had referred to 'the eternal battle between drawing and colour'. This battle is of special importance in France, where it was long the basis of all art debate; I referred to it earlier in connection with Cézanne. Drawing was associated with the mind and with classicism, while colour was associated with sensory appeal and with a willingness to dilute the virtues of classicism. Poussin and Rubens were enrolled as the unwitting champions of each school of thought. The moral overtones heard in this opposition still contributed to the denunciation of Fauvism in 1905 just as they had to the prejudice against Impressionism in the 1870s. Matisse, always an outstanding colourist as well as a draughtsman, brought the two talents into absolute concordance in his cut-outs. His last works declare that opposition not so much resolved as invalid, just as they denied the then fervid opposition of abstract art to figurative: 'for me nature is always present'. His essential means, throughout, was this seeing without prejudice.

His death, in 1954, coincided with the marked rise in his international standing, further enhanced by a commemorative exhibition shown in Paris in 1956. By this time many painters were under his influence, admiring not his work in its general character (rarely were they willing to be associated with an art of serenity) but his brilliant use of colour. A

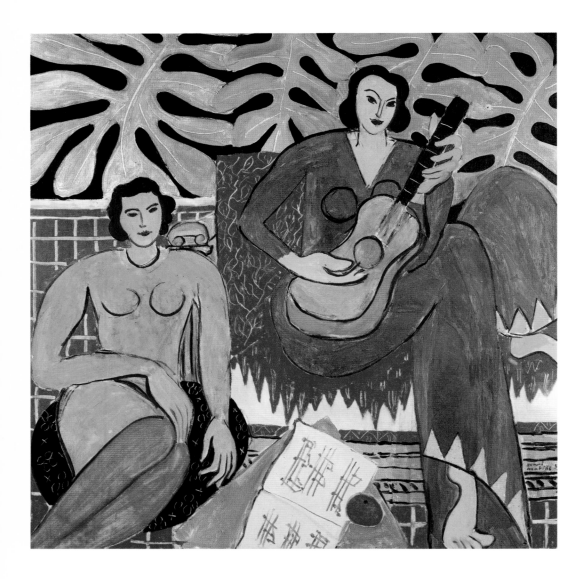

186. Henri
Matisse: *Music*.
1939. Oil on
canvas,
$45\frac{1}{4} \times 45\frac{1}{4}$ in.
Buffalo, Albright-
Knox Gallery

particularly telling comment was that of the painter and critic Clement
Greenberg, made when Abstract Expressionism was emerging in New
York. In March 1948, in *Partisan Review*, he asked why it was that
'Matisse, with his magnificent but transitional style ... is able to rest
securely in his position as the greatest master of the twentieth century, a
position Picasso is further than ever from threatening.' This question
occasioned surprise in America; in Europe it would at this time have been
unthinkable. Picasso's pre-eminence among living artists never seemed
more assured than in the years following the second world war. Already
in the 1920s he had seemed omnipotent: he could make Cubist paintings
and monumentally classical ones as well as apparently effortless drawings
in a neo-classical manner, and also produce paintings and sculptures full
of the dark power the Surrealists were seeking. The work of the 1930s too
shows great variety, including large and partly humorous sculptures as

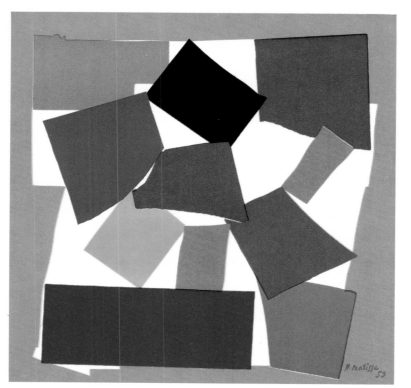

187. Henri Matisse: *The Snail*. 1953. Gouache on cut-out-and-pasted paper, $112\frac{3}{4} \times 113$ in. London, Tate Gallery

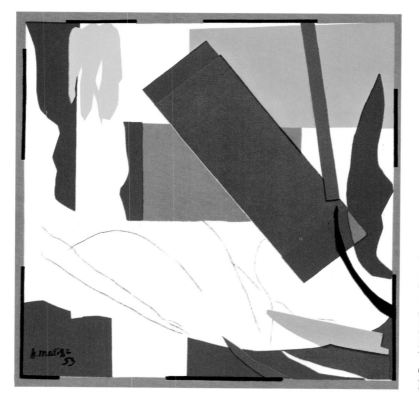

188. Henri Matisse: *Memory of Oceania*. 1953. Gouache and crayon on cut-and-pasted paper over canvas, $112 \times 112\frac{7}{8}$ in. Collection, The Museum of Modern Art, New York (Mrs Simon Guggenheim Fund)

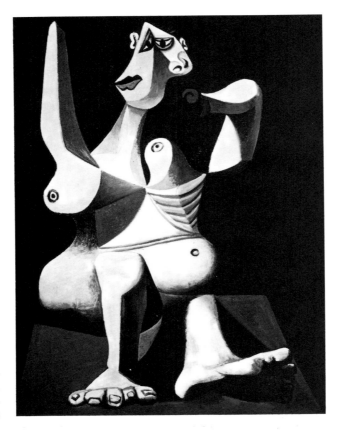

189. Pablo
Picasso: *Woman
Dressing her Hair*.
1940. Oil on
canvas,
$51\frac{1}{4} \times 38\frac{1}{4}$ in.
Private collection

well as Surrealist ones, *Guernica* and other images of conflict, but also etchings of reassuring charm and delicacy and lively decorative paintings, full of holiday feelings. Picasso was not only the most famous artist of the age; he was also by far the wealthiest.

Then came the war. Picasso remained in Paris during the German occupation. The manner, at times also the subject-matter, of some of his wartime paintings express the fears and dejection of the time. The nominal theme of *Woman Dressing her Hair* does not prepare us for this 189 stark image, not merely a nightmarish contrast with what the title implies but a tragic image on account of the underlying dignity of the so grievously distorted figure. The sculpture *Bull's Head* also is stark, but it 190 has its jokey side in being produced by joining two bits of an outdated bicycle together, with the visual and material pun being further compounded by casting the object in bronze. The large statue of the *Man with a Sheep*, Greek in type and Rodinesque in treatment, was taken to 191 indicate a return to the high road of classicism. With the ending of the war, however, all Picasso's playfulness came forward to screen the deeply romantic, distrustful and defensive man from the public gaze. He produced ceaselessly—paintings, sculptures of several sorts, and from 1947 onwards a flood of ceramics. Much of this work was parody and paraphrase. Picasso seemed to own the whole world of art, sometimes frivolously and sometimes in a more serious spirit of homage and

enquiry, borrowing, quoting, elaborating upon the work of others, from cave painting and Greek vase painting to the window-dresser's line in folded cardboard figures. Most of all he parodied himself. Characteristic sorts of distortion and elision, invented decades earlier to denote spiritual tension and dislocation, are now paraded in a skittish, exhibitionist way. Images we were taught by him to associate with tragedy now reappear as standard equipment in a repertoire generally devoted to comic sketches. One's impatience is sharpened by a profound admiration for his fecundity.

Mondrian's career and image were the opposite of Picasso's. After a slow beginning he achieved full artistic maturity about 1921 and then, it could be said, went on 'painting the same picture' (as Pissarro had said to Matisse to distinguish Cézanne's aims from those of the Impressionists). Vertical and horizontal bars, primary colours (of varying hue), rectangular canvases sometimes hung by one corner, asymmetrical compositions neither tragic nor smiling but calmly commanding the wall on which they are shown . . . the recipe was clear and did not need changing. His public was always small. He sent to many group exhibitions in Paris and elsewhere, and was deeply respected by devotees of abstract art, but he did not have a one-man exhibition until 1942, when he was in New York (not counting a small exhibition organized by friends in Holland to celebrate his fiftieth birthday). The first book about him, by Michel Seuphor, a fellow abstractionist, appeared in 1955. Today his paintings are hotly competed for; in his lifetime he sold only a few, and then very cheaply. Until the 1940s very few Mondrians entered public collections. He lived the life of a friendly hermit, his natural asceticism making poverty into a style. It is not until one sees a large Mondrian exhibition that one notices the broad range of expression he opened up within the confines of his idiom. The character of his paintings varies greatly according to their size and format and the disposition and quantity of

190 (left). Pablo Picasso: *Bull's Head*. 1943. Bronze cast of a bicycle seat and handlebars, $16\frac{1}{2} \times 16\frac{1}{8} \times 5\frac{7}{8}$ in. Formerly collection of the artist

191 (right). Pablo Picasso: *Man with a Sheep*. 1944. Bronze, height $86\frac{1}{2}$ in. Formerly collection of the artist

elements within them. And this character is what confronts one; it is not something to be searched for but presents itself in physical terms not unlike the spectator's, standing there. Some are more serious, some more serene. All the time one feels in contact with the whole of each pictorial statement: nothing is held back, nothing left undefined, nothing awaiting interpretation. They are the most open, most explicit paintings in the world, and thus they manifest one of the really important qualities of abstract art: it can be an art totally devoid of any thought of 'as if', or of 'once upon a time'. Each painting is merely itself and exists continually in the present.

New York almost distracted Mondrian from this integrity. He had always responded to his environment but New York especially stirred the elderly man, the pattern of its streets and the vividness of its popular music. A gramophone had long been part of Mondrian's basic equipment (he avoided having a telephone). *Broadway Boogie-Woogie* marks a 192
change of style if not of grammar. By his standards it is a large painting. Moreover, it is busier than his work had been for decades, with many small areas of colour marshalled into a Neo-plasticist structure but disputing its stability. All his Neo-plasticist paintings suggest they want to expand laterally; here this sense is especially strong as much of the activity in the painting is gathered left and right, leaving the middle relatively quiet. One cannot resist seeing something specifically American in this. It seems to echo the scale of the country as well as the vividness of New York and the pulse of its music. It is certainly assertive in a way not sensed in even the warmest of his European paintings, and

192. Piet
Mondrian:
*Broadway Boogie-
Woogie*. 1942–3.
Oil on canvas,
50 × 50 in.
Collection, The
Museum of
Modern Art, New
York (anonymous
gift)

193. Fernand
Léger: *The
Outing: Homage
to Louis David*.
1948–9. Oil on
canvas,
$60\frac{5}{8} \times 72\frac{3}{4}$ in.
Paris, Musée
d'Art Moderne

there are echoes of this in later American abstract painting that support
the thought. But one has to say that *Broadway Boogie-Woogie* is less
personal than Mondrian's European work, psychologically and quasi-
physically more distant; not a human confrontation. Perhaps this too is an
American characteristic, but we do not find it in the art, say, of Rothko,
de Kooning or Newman.

Geometrical abstraction continued in the work of Mondrian at its
highest level of achievement, historically an offspring of Cubism but heir
also to the formalities of classical and Neo-classical art. Other abstract
painters, to whom the vertical-horizontal basis of Mondrian's language
was merely a stylistic option, followed van Doesburg and Lissitzky into
other kinds of formal relationship and also into curvilinear, more or less
individualized forms. Arp, we noted earlier, spoke of art as a human fruit
and from about 1930 on worked in forms that echoed such forms in
nature as strike humans as particularly benign. Kandinsky, who in Soviet
Russia had exchanged his freely expressive forms for a predominantly
geometrical idiom, from the mid-thirties on made increasing use of
organic forms, softly curving shapes that suggest often amoebas and
marine creatures. Some of the paintings he did in Paris, after 1933, are so
luxuriant as to remind one of the artist's semi-Oriental origins, and it is
noticeable that as his work increased in richness it also became much less
intense, a vision without a message. Perhaps his role at the Bauhaus with
its emphasis on design and pedagogy had restrained his fancy; in Paris he
was part of a world of art and a small world at that, a somewhat defensive
gathering of all artists willing to be called abstract. He was a member of
the group called *Cercle et Carré*, founded in 1929, and then also of the
even more inclusive group, founded in 1931 and called *Abstraction-*

194. Fernand
Léger: *The
Constructors*.
1950. Oil on
canvas,
$118\frac{1}{4} \times 78\frac{3}{4}$ in.
Biot, Musée
Fernand Léger

Création, which put on exhibitions and published a journal until 1936. Both groups presented a rather self-contradictory picture of abstraction, and thus threw doubts on their idealism and its value. A great variety of abstract art was shown and supported by the groups but there was no opportunity for true debate (in order perhaps to hold the groups together) and thus no kind of guidance to a younger generation, to whom it must have seemed that everything was equally valid as long as it was abstract.

The 1930 *Cercle et Carré* exhibition included two mural compositions by Léger, done five years earlier. His willingness to participate may have indicated a desire to support a failing cause; at any rate Léger was never a convinced abstractionist and by 1930 his more or less Cubist paintings

show the influence of Surrealism. His responsiveness and adaptability were two of his chief strengths, bringing into the more exclusive forms of modernism a socially useful breadth and applicability. In *The Outing: Homage to Louis David* he was able to bring together the scale and formality of history painting with a modern genre theme, without doing violence to either and also without any falsifying of his own ideals. The painting is armed by much the same humanity as informed the best French films of the post-1945 period. In *The Constructors* he showed that he could manage with less support from the past to celebrate the particularly modern world of large-scale steel construction (what echoes from the past there are associate this painting, a little paradoxically, with representations of Christ being taken down from the cross). Against a brilliant blue sky, ordinary men are observed at the ordinary business of erecting an electricity pylon. Léger treats this unexceptional subject with all the heroicism it deserves: a great technical achievement, beneficial to man, and also men in collaboration, men at one, serving a wider world without loss of dignity. There is no hint here of the stylistic prevarications that so often vitiate art meant for 'the people'.

In the mid-thirties Giacometti, recently the creator of some of Surrealism's most compelling images, made a few abstract sculptures, more or less geometrical, that implied his apostasy from the movement,

193

194

195

195. Alberto Giacometti: *Cube*. *c*. 1934 – 5. Bronze, height 37 in. Zurich, Kunsthaus (Alberto Giacometti-Stiftung)

and then also some rather archaic-looking figures that confirmed it. In 1935 he was expelled from the Surrealist movement. He did not exhibit again until 1948. During the war he worked, in Paris until 1942 and thereafter in a hotel room in Geneva, on plaster figures. They got smaller and smaller until they were no more than an inch or two high. Back in Paris, in 1945, he embarked on a series of taller figures and found that they had to be extremely slender to be lifelike in the way he wanted. Working from the model and from memory, his hands tirelessly manipulating the plaster pressed on to his tall armatures, he was able to put all the detail and individual character into almost massless, linear forms. The prototypes for these emphatically vertical figures are found in Egyptian sculpture. Perhaps the affinity goes deeper than this may imply, the strength and serene severity of the Egyptian figures being a response to the eternity of desert and afterlife, while the rigidity and attenuation of Giacometti's figures reflect the anxiety and loneliness that is modern man's lot. Giacometti, however, does not say such things; they were said for him by the Existentialist philosopher Jean-Paul Sartre in a text he wrote for the 1948 exhibition, and were subsequently repeated and developed by others. To what extent is such a reading inherent in or wished on to works of art? The fact is that, observed patiently and preferably from close to, at not much more than the sculptor's distance from the piece as he worked on it, these figures lose their thinness. Our perceptual mechanism adjusts and we confront a human image that is remarkably alive and individual, yet keeps its distance from us, neither tangible nor desirable. Grouped together the sculptures do more certainly signal their separateness, from each other and from ourselves. If the figures can be said to shrink from the space in which they stand, they can also be said to assert themselves in it, possessing the earth with their mighty feet.

Works of art are often ambivalent or inclusive in their meanings. Asking the artist does not remove the problem. If he made a statement about his intentions one should want to know when he made it, to whom and for what purpose; we should also want to know whether alternative readings were prohibited. The artist in his studio is most concerned with pursuing his work. When he analyses his motives he engages in a different kind of activity, and one that puts him at least partly into the role of spectator. He may well be influenced by what others have said and written; he may be happy to see his work credited with a helpful relevance to the concerns of the day without consciously sharing them. Giacometti worked quickly and almost ceaselessly reworked his sculptures. As with some other artists, one senses a peculiarly direct bond between eyes and hands; perhaps one of the reasons for the thinness of the figures is that he liked to work looking past them, through them almost, at the model.

Whether we choose to stress themes of existential *Angst* or not, we should be aware that with these figures we are once again in the presence of human images made directly from human beings: Giacometti's is the most positive engagement with that sculptural process since Rodin. That said, we should also attend a moment to the verticality of the figures and to the self-evident fact that we never see them, indoors or out, without a more or less horizontal context. Mondrian noted the interaction of

196. Alberto
Giacometti: *Tall
Figure*. 1947.
Bronze, height
$79\frac{5}{8}$ in. Zurich,
Kunsthaus
(Alberto
Giacometti-
Stiftung)

verticals (man, trees, buildings) with the horizontal environment long
before the possibility of abstract painting entered his mind. Cézanne,
7 writing when he was especially concerned with his large *Bathers*
compositions, stressed the importance of the two co-ordinates: 'Lines
parallel to the horizon give breadth—that is, a section of nature or, if you
prefer, of the spectacle that the Pater Omnipotens Aeterne Deus spreads
out before our eyes. Lines perpendicular to this horizon give depth.' In
his sculpture Giacometti gave primacy to a relationship of inescapable
importance to rectangular pictures and reliefs of any period—so basic
that one could well start one's examination of such works by asking which

of the two options open to the artist he chooses, whether to work with or against the format. Giacometti rediscovered the independent and human value of this relationship for so-called free-standing sculpture.

It is striking that most of these artists attained maturity—a convincing identity of work and aspirations—in their forties, some time after most of them had been active in the movements within which they are historically located. Maturity implies some surrender of mobility. After his years of experiment and trial affiliations, the artist settles down—which in art as in life need not mean self-denial but can bring self-realization. Only in Picasso's case is it impossible to find signals of maturity—or rather, one finds them but they are instantly countered by other signals so that one is left admiring brilliance, not ripeness. Matisse at the age of forty embarked on the *Dance* and *Music* canvases, and with them reached a plateau of personal but well-rooted activity that could permit his departure into the suaver art of the twenties yet support also much of what followed, including the magnificent cut-outs of the last years. There is variety, surprise even, but no fickleness. Picasso's diversity, on the other hand, is as fundamental as Matisse's tenacity. 'I do not seek, I find', Picasso is often quoted as saying. (His words, recorded by Marius de Zayas in 1923, were: 'In my opinion to search means nothing in painting. To find, is the thing.') He also said the opposite: 'Paintings are but research and experiment. I never do a painting as a work of art. All of them are researches. I search incessantly . . .'

Paul Klee shows a similar duality, and it is the basis of his work. From early diary entries on into his public statements and teaching notes, he stressed again and again that art is not an object but a process, to which the artist contributes the initial energy, the seed, and over which he then watches, nurturing it to full growth. Paintings 'come into being'; the artist is 'glad to contribute something to the self-forming work.' But this required great skills and understanding. He took his Bauhaus students through an extraordinarily rigorous examination of the pictorial function of lines, patterns, colours, symbols, perspective, and so on, always emphasizing their kinship with the actions of nature. Mental as well as manual dexterity was essential. His own early career forms a remarkably coherent programme of self-preparation. He had shown special skills in life drawing at the Munich Academy. These he developed further until he felt in full command, but then turned to non-imitative drawing, testing the limits of line as a means of noting mood and fantasy without quite departing from representation. At the same time he studied the use of light and dark, in drawing and then also with paints. Colour became more and more important to him. He had always known it to be the essence of painting, and he sought a total familiarity with colour: 'One day', he told his diary in 1910, 'I shall have to be capable of improvising freely on the colour keyboard of my watercolour pots.' He felt he had reached this intimacy with colour when he visited North Africa in 1914. He was 35 then; the war intervened and it was not until 1918 that he could swing into full action as a painter. From then on, until his death in 1940, he worked steadily, producing paintings as well as drawings and occasional sculptures. Close on ten thousand works have been catalogued. There is little to be said about them as a whole from the point of

197. Jean Arp:
Amphora. 1931.
Painted wood
relief,
$55\frac{1}{8} \times 43\frac{1}{4}$ in.
Düsseldorf,
Kunstsammlung
Nordrhein-
Westfalen

view of style. Some are abstract; some figurative. Many look as though
the figurative element came last (followed only by the title of the piece), a
consequence of his exploration of some formal motif. Through his
association with the *Blaue Reiter* group he has tended to be classed an
Expressionist. Through his years as teacher at the Bauhaus he can equally
be associated with Elementarist art. The Surrealists saw him as an ally on
account of the instinctive, automatist aspect of his working process, and
his work was shown in Paris for the first time in 1925 under the Surrealist
umbrella. He showed no sign of the mysticism of Kandinsky and
Mondrian. Yet he drew much strength from his conviction that, in
'letting everything grow', he was as close as one could be to the true basis
of creation, the physical sphere of materials and the psychological sphere
acting in unison. Making art is man's way of being fruitful, of being
natural: there he agreed with Arp but, whereas Arp was happy to echo
natural forms, Klee studied microcosmic and macrocosmic nature for

197

visual evidence of nature's processes. One of his students has described how Klee insisted on 'the need to enter into the secret of the creative drive to form, to trace deliberately and intensively the path of creation from the mature organism to its origin, in so far as insight into these secrets is given to man.' Sight and insight: Klee hardly distinguished between them. The function of art, as he wrote in his first public statement, the *Creative Credo* of 1920, is not to 'reproduce the visible; it makes visible.'

In his studio he usually had several diverse works on the go, as he experimented with media and combinations, often (literally) cooking his own. He worked in different ways, much as a gardener might tend distinct species of plants, each according to its needs. *Ambassador of Autumn* represents the more abstract wing of Klee's work in the twenties. Fine stripes of varied and gradated hue make a more or less regular pattern within which every change of direction or form is very noticeable; an orange oval on a stem gives a particular note to the general tone of the picture and suggests the title. *Around the Fish* seems simple, with its attention-holding central motif, but is a remarkable compilation of natural and geometrical forms, of representations and of conventional

198 (opposite top). Paul Klee: *Ambassador of Autumn*. 1922.
Watercolour, $10\frac{3}{8} \times 12\frac{3}{4}$ in. New Haven, Yale University Art Gallery (gift of Collection Société Anonyme)

199 (opposite bottom). Paul Klee: *Around the Fish*. 1926.
Tempera and oil on canvas. $18\frac{3}{8} \times 25\frac{1}{8}$ in. New York, Museum of Modern Art (Mrs John D. Rockefeller, Jr., Purchase Fund)

200 (below). Paul Klee: *Still Life on Leap Day*. 1940. Paste colour on paper over jute, $29\frac{1}{8} \times 43\frac{1}{4}$ in. Berne, Kunstmuseum (Paul Klee-Stiftung)

signs. They circle singly around the fish but, for all their variety, refer to and echo each other in many different ways. Invention and imitation are utterly fused. The playful, whimsical whole is a product of an intelligent, if not intellectually pre-planned, process.

Klee left Germany in 1933 for his native Switzerland. During most of his remaining years he was in ill-health yet these saw the production of his most resonant works—profoundly original inventions in which linear elements fuse with colour, bringing his two pursuits into a particular kind of harmony. Some of the paintings of 1937–40 can be seen as a series, unlike the rest of his output, and they find their climax in the works of his last weeks. *Still Life on Leap Day*, painted or completed on February 29, 200 is one of the strongest, tragic in mood perhaps but overcoming its own low key thanks to its live areas of red and violet and its confident linear structures. Other paintings in the series are lighter in colour and in spirits; others again speak unmistakably of war and death. One of his very last paintings is also a curiously prophetic one. *Black, Still in Place*, a 201 roughly dabbed and smudged painting of tempera on a scrap of canvas, has much of the primitive, impulsive action associated with American Abstract Expressionism, which emerged as a movement about eight years later. The Klee is small; the American paintings are much larger and therefore very different objects. But there can be little doubt that Klee provided some of the impulse that produced the American movement. There were examples of his work in United States collections, and major exhibitions were shown in New York in 1940 and 1941, but much more could be known from books and magazines where difference of scale is suppressed. Moreover, by this time information about art was often conveyed through lectures illustrated with vividly projected colour slides that make every work screen-sized. The real difference between Klee's work and some American paintings that appear similar lies in their expressed intentions. We do not, in effect, know what Klee's intentions were, other than in the most general terms; there is no hint of venturing into deep psychic realms on mankind's behalf, nor of setting up a model of free activity to counteract restrictions imposed by the political and economic world. There is little self-revelation in his work. It is as ancient as it is new; as universal as it is one man's. Above all, it is open-ended, even at the end. With each work Klee enters into a sporting relationship, entrusting his artistic survival to his means—cloth, forms, paste, line, glue, colour, etc.—as a swimmer entrusts himself to the sea. He chooses his moment. He determines what the potentialities of his means are and which to seize upon; he also determines what for him constitutes a work of art, in other words when to stop. He is no more a servant of his work than was Duchamp in designating this or that object a 'readymade'. Both artists displaced the essential act of creative decision from the inventing and fabricating of individual works on to the programme as a whole.

201. Paul Klee:
*Black, Still in
Place*. 1940.
Unvarnished
tempera on canvas
mounted on paper,
12 × 3¾ in.
Basle,
Kunstmuseum
(R. Doestsch-
Benziger Bequest)

7 Art in the American Grain

I have allus held that sometime somehow *god damn* etc. something ought to git started ON THE BLOODY SPOT (especially as ole Europe ain't what she wuz).

Ezra Pound to William Carlos Williams, 1931

Now go ahead and do it. Name the actions and perform them—yourself . . .

You have now entered what is referred to as the divine function of the artist.

Let's keep away from frightening words and say you are nature—in action.

It is an action, a moving process—the verb dominates; you are to *make*.

William Carlos Williams, 'A Beginning on the Short Story (Notes)', 1950

America dominates the story of art from the 1940s to the 1970s. Since America's image looms large in other respects too, this need not surprise us. Many parts of the world have found themselves consciously and unconsciously under American influence, and this at many levels and in many forms from hamburgers and jeans to business and political tycoonery. Europe has been especially open to such influence. The second world war marked the end of European world leadership. It marked also the end of Paris's artistic leadership. The suppression of creative art in the totalitarian countries of Europe, followed by the closing down of Continental Europe as German military control spread and many Continental artists and intellectuals fled westwards, gave special opportunities to America and in some degree to Britain also. The modernist traditions for which Paris had stood continued to press upon European artists and critics. In America, thanks partly to the great collections of modern art assembled there and partly to the German occupation of France, those traditions could be viewed with some detachment, as history without location and thus without roots. Several important European artists spent the war years in America—they included Mondrian, Ernst, Dali, Chagall, Léger, and Moholy-Nagy— and through their presence gave added reality to what had been achieved in the preceding decades; but they also demonstrated that these achievements had been the work of men not unlike other men, men with courage and drive, reacting to and against the example of others, bold professionals armed with convictions, but not superhuman beings.

There was no one American painter who led the movement that became known as Abstract Expressionism. There was a handful of key men at the centre of it and many distinguished but less essential contributors to it. There was also the right spiritual environment. These

artists lived in or near New York, met frequently and talked about their work and aims, and they acquired a circle of interested writers, critics and poets, who could stimulate discussion further and distribute it to a wider world. The artists were not radical reformers so much as idealists more concerned with the universals they found deep in themselves and at times in ancient myths than with the world about them, and responding gratefully to ideas that could enrich their own. These could come from Europe—Kierkegaard, Jung, Existentialism—but also reflected American traditions of spiritual as well as geographical pioneering. One constantly hears echoes of Poe, Thoreau, and Whitman in their statements.

The immediate artistic issues confronting them can be summarized as the formal consequences of Cubism and the thematic primordialism of the Surrealists, but American artists could also look back to the example of Mexican mural painting and its social implications, to the at least partial failure of the art programme of the Federal Art Project (initiated in 1933 under the New Deal to sustain artists and 'work toward an integration of the arts with the daily life of the community' as its director, Holger Cahill, wrote), and also to other attempts, in American art of the preceding decades, to engage painting in American contemporary life through politically significant realism, the portrayal of city or regional life, and so on. American artists could also turn to relatively unmined veins within the range of European modernism, stimulated by works they could easily see on the walls of, particularly, the Museum of Modern Art and what was then called the Museum of Non-Objective Art, now the Solomon R. Guggenheim Museum. Matisse's *The Red Studio* and Monet's *Water-Lilies* in the Museum of Modern Art could be taken to raise issues no one had yet taken up: in the Matisse the ambiguously spatial and spaceless articulation of a flat colour field; in those vast Monets, some of them painted when Elementarism was forming in Germany and Surrealism in France, the combination of a large surface lacking any clear-cut compositional structure with clusters of legible, expressive brushstrokes. The Museum of Non-Objective Art offered a particularly lavish display of Kandinskys, mostly of the informal, pre-1920 sort. Moreover, in Hans Hofmann New York had an immigrant painter-teacher with close understanding of the great European movements and also personal knowledge of such men as Matisse, Delaunay, Picasso, and Kandinsky. But New York also had a teacher of another sort, in more or less permanent residence: Marcel Duchamp. His recent visible affiliation had been with Surrealism, and he continued to contribute as artist and organizer to international Surrealist exhibitions in the post-war years, but he could also be seen as a European who had abandoned Europe for the New World and as a modernist who had taken some of the findings of modernism to their logical, ironic conclusions. America's self-awareness as a global power, plus New York's growing awareness of itself as a self-sufficient cultural capital with an overview of the whole modern inheritance (only forty years have passed since the point at which our story opened), plus a belief in the possibility of a new start, the opening up of new frontiers, felt perhaps particularly keenly by immigrants who had grown up in America and could consider themselves

202
203

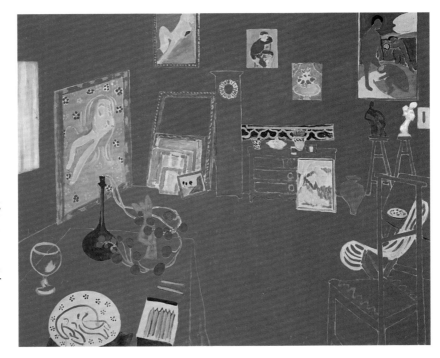

202. Henri
Matisse: *The Red
Studio*. 1911. Oil
on canvas,
71¼ × 86¼ in.
Collection, The
Museum of
Modern Art, New
York (Mrs Simon
Guggenheim
Fund)

203. Claude
Monet: *Water-
Lilies* (left panel of
triptych). *c*. 1920.
Oil on canvas, each
panel 78 × 168 in.
Collection, The
Museum of
Modern Art, New
York (Mrs Simon
Guggenheim
Fund)

American artists yet had a special consciousness of their European
origins—all of this and much else supported an artistic adventure of
exceptional intensity. Yet two general points remain to be made. One is
that this adventure began in an environment that at first was as guarded
and uninterested as any other, and that it gained first the support of a few
New York critics and dealers, then of far-sighted (notably British) artists
who also functioned as critics, and then of a rapidly swelling American
supporting chorus. By the late fifties the new American art was seen by
Washington as a major prestige-building export and was busily promoted
around the world. The other point is that the extremist attitudes taken by
the leading Abstract Expressionists, in their work, in their public

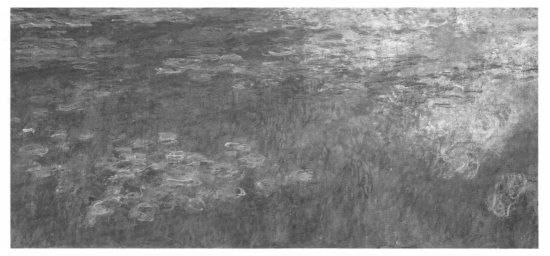

statements and to some extent in their lives, called for either all-out corroboration from other artists or for equally whole-hearted challenges and contradictions. Here the example of Duchamp was to become particularly compelling; from this time dates his growth, in the minds of the art world, to super-heroic status as the Mephistopheles of the old modernism and the Messiah of a new.

The pioneer Abstract Expressionists were interrelated individualists. One of them, Tobey, lived and worked in Seattle, on the West Coast of America, but his work was known in New York. The others were New Yorkers. None of them was young. In 1948, the key year, their average age was over forty: Tobey was 58, Rothko 45, de Kooning and Still 44, Gorky and Newman 43 (Gorky committed suicide that year), Kline 38, Pollock and Motherwell 35. Gorky, de Kooning, and Rothko were immigrants: de Kooning had arrived in his twenties, a trained painter, the others earlier. Of the native Americans, Tobey and Motherwell were markedly cosmopolitan. Motherwell was steeped in French poetry and aesthetics. Tobey, early a convert to the Bahai faith, had spent some years in Europe in the twenties and thirties and had travelled to China and to Japan, where he spent a month in a Zen monastery. The others strike one as more emphatically American—if that adjective is allowed to include a consciousness of alien roots and even of isolation in the cultural mixture of the United States. What they shared was the feeling that it was time for a new art which would spring partly from a passionate resistance to the constraints of a materialistic social system: the new art would not only be un-European but also un-American in its insistence on stylelessness and on profound personal revelations. Motherwell described their adventure as 'voyaging into the night, one knows not where, on an unknown vessel,

204. Jackson Pollock: *Number 1, 1948*. 1948. Oil on canvas, 68 × 104 in. Collection, The Museum of Modern Art, New York (purchase)

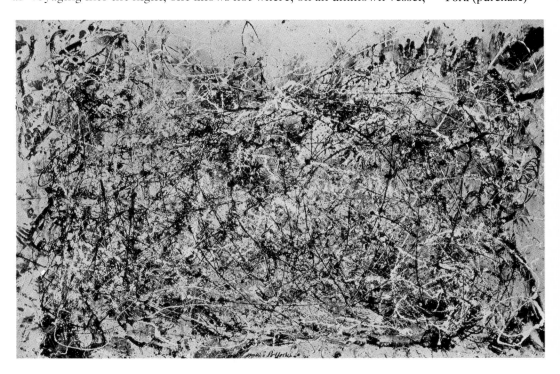

an absolute struggle with the elements of the real'. What mattered was the authenticity of the voyage and pursuing it to the end.

In January 1948 Jackson Pollock exhibited for the first time some drip 204 paintings he had done the previous year. With them, as de Kooning said later, he 'broke the ice' and for some time their image and the painting activity that produced them dominated outsiders' understanding of the new art. They were large canvases, painted on the floor by the artist walking around and into the painting, dribbling and pouring paint from a can or a dipped stick. The marks on the canvas record the painter's motion, approaching the canvas from different sides, swinging his arm and turning his wrist above its surface. Mind, spirit, eye and hand, paint and surface were brought into intimate alliance; the painting became not a representation, direct or symbolic, but a terrain bearing the vestiges of the painter's action, the swirls of paint on it his representatives, a simultaneous 'still' of the whole of his action in that terrain over a period of time. Commentators around the world found this art shocking— which now seems just as odd as their subsequent idolization of it. Many a young artist, as the news broke out, associated vanguard art and individual expression with wild methods of applying paint, by throwing it, riding a bicycle through it, bursting paint-filled bags by shooting at them, arranging for bepainted but otherwise naked women to imprint their bodies on a vertical or horizontal cloth (the invention of the Frenchman Yves Klein in 1960; we shall return to him in due course), and so on. In fact, Pollock's paintings of the years 1947 to 1951 were graceful rather than violent or wild, rhythmical rather than random, 205 balletic and ritualistic in effect. His earlier paintings had been much more vehement, the products of a personality struggle pursued through glimpsable references to archetypal myths. He had also been attracted to primitive artefacts. This attraction he shared with the European Cubists, Expressionists and Surrealists, but he used it to drive a wedge between himself and his awareness of Europe. He greatly valued what he knew of the sand paintings of the Pueblo Indians, elaborate ephemeral works made by trickling sand of different colours to form symbolic images for

205. Jackson
Pollock: *Pasiphaë*:
1943. Oil on
canvas,
56 × 96 in.
Collection of Lee
Krasner Pollock

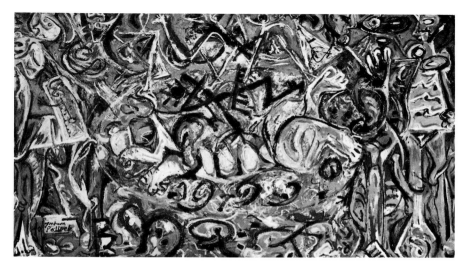

ritualistic purposes. He may also have known of Ernst's trick of running a line of paint on to a canvas from a perforated tin swinging over it like a pendulum. He had almost certainly seen paintings by Tobey in which white lines, inspired by Oriental calligraphy, form something like a thicket of light in a dark space.

Pollock's paintings of those years are meditative without attempting the mystical character of Tobey's, inventive without being satisfied with the conjuror's magic of Ernst's, above all fresh and engaging. The critic Harold Rosenberg in 1952 named this kind of painting Action Painting (which again could be misinterpreted as implying a wild or even desperate activity). Photographs of Pollock at work, published and republished avidly, showed him in jeans, T-shirt and bespattered boots moving around a large canvas in a studio littered with lidless tins of paint and drippy buckets. Commentators quoted and requoted his statement, first published shortly before the 1948 exhibition (in 'My Painting', *Possibilities 1*, winter 1947 – 8; the only issue of this magazine, edited by Motherwell and Rosenberg), about working on the floor, from all sides of the unstretched canvas, 'akin to the methods of the Indian sand painters of the West', and continuing:

> When I am *in* my painting, I'm not aware of what I'm doing. It is only after a sort of 'get acquainted' period that I see what I have been about. I have no fears about making changes, destroying the image, etc., because the painting has a life of its own. I try to let it come through. It is only when I lose contact with the painting that the result is a mess. Otherwise there is pure harmony, an easy give and take, and the painting comes out well.

The violence that people claimed to see in the paintings, and the attack on artistic values they interpreted it as, are both countered in Pollock's words, which belong to the language of intimacy rather than destruction. The paintings they relate to were the product of a relatively tranquil period in his life, when he felt no need to call up the morbid symbolism of his earlier paintings. For a while he merely numbered his works, or combined numbers with descriptive titles of a quiet sort, like *Summertime (Number 9, 1948)* or *Arabesque (Number 13, 1948)*. In 1951 – 2 images or hints of images began to reappear in his paintings, and with them the anxiety that had weighted his earlier work. It is likely, though, that this development arose from other factors than his spiritual condition: once he had tried out a variety of colours and densities, on glass as well as canvas, in a variety of formats large and small and with or without additional elements (collage, sand, etc.), Pollock had had to face the limited potential of the idiom he had invented.

Tobey had reached his superficially similar idiom, which he called 'white writing', under the influence of the Far East (closer to West Coast America than to Europe), and he must be seen as a forerunner of Abstract Expressionism as well as a contributor. Arshile Gorky too: the adolescent, who had come to America via Eastern Europe in 1920, worked his way through the masters of modernism from Cézanne onwards to develop an abstract form of Surrealism stemming from Miró and others. His paintings of the 1940s, hailed by Breton as important and original additions to the spectrum of Surrealist art, are outstandingly fluid, suggestive compilations of soft, sometimes enchanting colours and tense,

232
Art in the
American
Grain

206. Mark
Tobey: *Shadow
Spirits of the
Forest.* 1961.
Tempera on
paper,
19 × 24⅞ in.
Düsseldorf,
Kunstsammlung
Nordrhein-
Westfalen

sometimes screeching lines. As in pre-1947 Pollocks, myth serves as stimulus, but it was a more personal body of myth Gorky drew upon, the folk tales and folk art of his native Turkish Armenia and his poignant memories of home and family. In the 1940s Gorky repeatedly worked in series, using the sketch as a basis for a sequence of paintings, rather than reworking a composition on one canvas, for the sake of spontaneity and an appearance of freshness. Yet his mature art was always marked by a bitter note of melancholy—a peculiarly European note that associates lyricism not with joy but with a sense of loss. One feels that it was in good part due to friendship and to the wide respect in which Gorky was held as an exceptionally single-minded painter, deeply concerned with the recent history of painting, that the Abstract Expressionists embraced him posthumously as one of themselves.

Willem de Kooning called him 'sweet Arshile' and deferred to him as his master, but then de Kooning too, seen like Pollock as a spearhead figure in the movement, had his European links. In 1948 he impressed the New York art world with an exhibition of black and white paintings, abstract in appearance and impulsive in implication. The freedom, the incisiveness of his brushwork struck people first of all, and it was, again, the appearance of vehemence that was to dominate critics' accounts of his

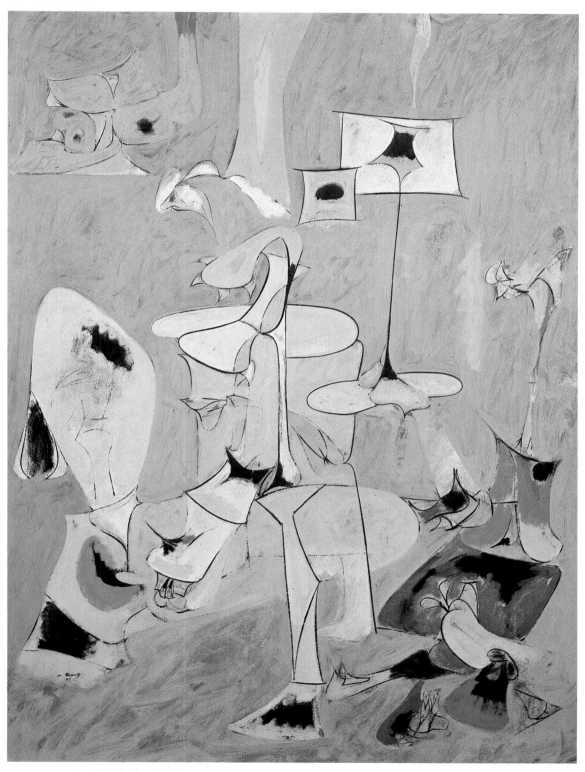

207. Arshile Gorky: *The Betrothal II*. 1947. Oil on canvas, 50¾ × 38 in. New York, Whitney
Museum of American Art

work. A few years later, in 1953, de Kooning shocked his admirers by exhibiting a series of large paintings of monumental women—daughters, it seemed, of the *Demoiselles d'Avignon* but Daughters also of the Revolution, and images in which repulsion warred with love. These paintings should have proved what his earlier paintings had already provided evidence for: that the abstract black and white paintings of 1948–9 referred to human anatomy too. Above all, the new paintings demonstrated de Kooning's mastery of the brush, and it was admiration for this, even if wrongly interpreted, that maintained his position as a leading figure in what became known as the New American Painting—a position which his apostasy from abstraction might otherwise have cost him.

Today, retrospectively, de Kooning appears the key and essential figure in the 'action' area of Abstract Expressionism, not Pollock. His painting (and recently some sculpture too) is first and foremost a matter of process: an encounter, on the canvas, with or without preparation, of marks that suggest forms, of forms that suggest spaces, of forms, spaces and indeed colours that at once convey a configuration (which may be a human image or, sometimes, a landscape, or refute any specific associations of this sort) and also announce a spiritual condition. Abstract Expressionism had been taken to permit only the latter function. Kandinsky's first 'abstract' paintings of 1910 onwards had self-evidently made reference to figures, horses, buildings, landscape etc.; Klee, Miró, and Ernst had, in their different ways, elicited imagery out of the process of painting. And these were widely honoured names. That many critics and members of the interested public objected on principle to de Kooning's incorporation of figures in his paintings suggests what a delicate matter the opposition of abstraction and figuration still was. But there was another problem. People associated the painting of Pollock and his friends not only with abstraction—and thus with an aversion from materialism and with a sort of highbrow obscurity—but also with expressionism in the special sense of an exclusive focus on the deepest levels of the artist's personality. What the public knew of Jung prepared it for the discovery of archetypal myths, as in Pollock, but not for the dreadful—at once overbearing and pathetic—women presented by de Kooning. They were ready to welcome something high-minded and pure and to accept vehemence, even violence, as evidence of the struggle entailed in the search for authentic expression. They were not prepared to accept vulgarity. De Kooning later remarked that no one had realized that his women were funny. But Abstract Expressionism was not expected to be funny, not even in a Surrealist 'black humour' sense. De Kooning had failed his friends and was liable to drag down the rising name of Abstract Expressionism.

What adds to the interest of this moment is that de Kooning himself had had doubts about this development. He had begun the first of his *Woman* paintings in the summer of 1950. After eighteen months' work on it he had abandoned it as worthless. The art historian Meyer Schapiro persuaded him to work at it again. Thus the six *Woman* paintings came into existence and were exhibited in March 1953. 'Even abstract shapes must have a likeness', de Kooning said. His *Woman* paintings show what

208

he meant, as indeed their 'abstract' predecessors had too: that the painter freed from the duty to represent an external object may naturally find recognizable motifs occurring in his work and would be misrepresenting himself in excluding them. De Kooning's brush tends towards the formation of mouths, shoulders, breasts, hips, legs: to accept such references and with them the whole infinitely variable and distortable structure we call 'figure' was both honest and a further liberation. The authentic, totally abstract painting tends to turn itself into the painter's 'mark', his signature so to speak. By not excluding figures, and sometimes landscape forms, from his pictorial equipment, de Kooning freed himself from that trap and kept his mobility. Subsequently he was to produce apparently abstract and blatantly figurative series in turn, all marked by exceptional vividness of expression and suggesting extraordinary spontaneity. Those who know the artist well and have watched the progress of his work have described the preparations and the long labour of painting and repainting, and reconsidering, that goes into those impromptus.

210

Pollock and de Kooning were seen as the leaders of the Action Painting wing of Abstract Expressionism, and it was this that first gained public attention. Other painters were quick to respond to their example. Franz Kline, a friend of de Kooning, switched in one year from realistic paintings to Abstract Expressionist ones. Small brush drawings done with black paint on paper, a little like Oriental characters sometimes, suggested the idea of doing similar things on a much larger scale, on canvases six or more feet across and with house-painters' brushes. Such paintings could make a strong impact: they looked bold, implied an ideographic image, and could be read, like a Pollock, as an action made visible. Taking the big brushmarks one by one, the spectator can easily empathize into this action and experience its vigour. The considerably younger painter Sam Francis, a student still when Abstract Expressionism surfaced, invented for himself a much lighter formula of swiftly brushed patches of light paint drifting across spacious canvases. Helped perhaps by his physical distance from New York—Francis hailed from California and from 1950 onwards worked in Paris—he shunned the anxious and often tragic note of typical Abstract Expressionism, yet like most of his colleagues he allowed the duty of authenticity to lead his art into repetitiveness. This matters less, however, with art of a cheerful and engaging sort than with works we are expected to confront in awe.

209

The question of formula relates both to authenticity and to success. The success of Abstract Expressionism was a remarkable victory for an avant-garde tendency over all the usual defences that any substantially new idea faces and also over what remained of the old and hitherto well-founded American assumption that the best of modern art was made in Europe. It was useful to the movement to have distinct and memorable personalities reliably visible in their art and to have a clear theory or programme. It takes a deeply trusting and committed public to follow an artist through dramatic changes in his work. Since style is identified, usually much too directly, with the artist, any substantial change implies dishonesty or at least a wayward sense of purpose. Critics supporting Abstract Expressionism had successfully implanted a simple explanation of what was at stake—the profoundest, most reckless self-expression,

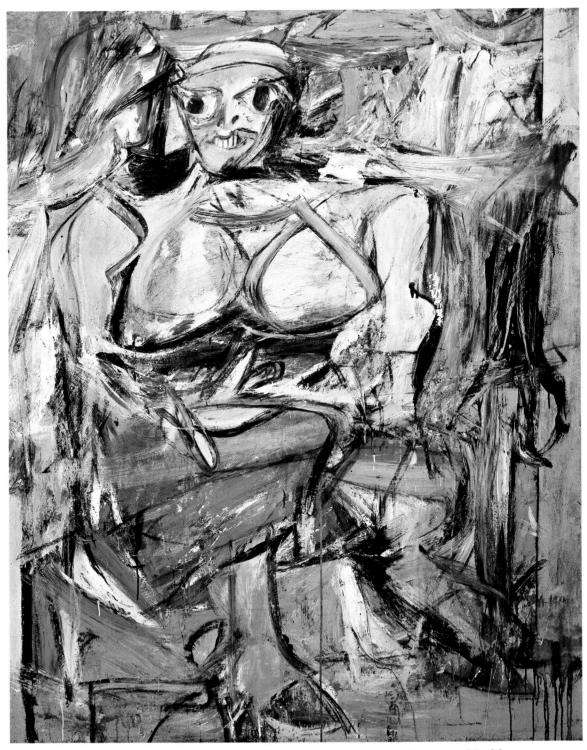

208. Willem de Koching: *Woman I*. 1950–2. Oil on canvas, $75\frac{7}{8} \times 58$ in. Collection, The Museum of Modern Art, New York (purchase)

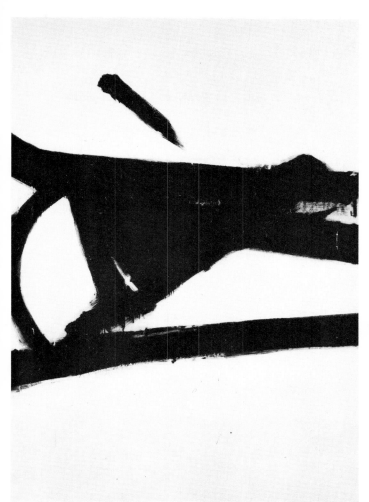

209 (left). Franz
Kline: *Accent
Grave*. 1955. Oil
on canvas,
$75\frac{1}{4} \times 51\frac{3}{4}$ in.
Cleveland
Museum of Art
(anonymous gift)

210 (below). Willem
de Kooning:
Merritt Parkway.
1959. Oil on
canvas,
$89\frac{3}{4} \times 80\frac{3}{4}$ in. New
Jersey, private
collection

shunning all the conventions that could still be thought to inhibit modern art, and often on such a scale as to demand full bodily involvement and effort from the painter—and the public wanted to be able to fit this explanation to art bearing that label. It makes not only commercial sense: it is a way of carrying a public with you, and thus is especially valuable when the artistic idiom is in any sense difficult. Yet artists often desire to deviate from their own previous performance, from the grouping that they accepted for one reason or another, above all from the too pat an explanation their work may have been saddled with. What spectators are often told is the goal of their art, artists are liable to see merely as a starting point. Art history includes many examples of artists staying with a formula they have created for themselves: Mondrian is the outstanding example, a leader whose formula matched his philosophical convictions and offered him all the expressive potential he required, and it was certainly not commercial success that kept him producing easily recognizable Mondrians. There are relatively few examples of artistic

promiscuity: Picasso stands alone as a major artist for whom a vast variety of pictorial and sculptural ideas, invented and borrowed, served as raw material. Most artists fall between such extremes of consistency and variety. In any case, change and development must be seen in relation to the nature of an artist's work. Thus the addition or elimination of one element, or even its growth or diminution, may mark a considered and indeed considerable step in Mondrian's work whereas a switch of subject, medium or style means less of a change in Picasso's. I feel that Pollock was trammelled by his drip painting and the fame it brought him while Kline was not too confined by his quasi-ideographic images; that Francis was, and continued to be, satisfied with his idiom, finding enough to work on within the loose limits he set himself; and that de Kooning is the most splendidly mobile man of his generation, remarkably detached from market pressures and as generous in feeding his life into his art as in his response to the life around him. It may also be that Kline's ease indicates a relatively minor artist, while Pollock's malaise indicates a relatively great one.

It was, understandably, those Abstract Expressionists most intent on creating paintings of high seriousness who were most likely to chain themselves to a formula. Clyfford Still rejected all European art as the 'sterile conclusions of Western European decadence', eradicated from his work all references to the visible world, did his best to sever colour from its associated meanings and his handling of paint from all personal qualities of handwriting or emotional expression, and substituted plain numbering for the rather weighty titles he had used earlier. 'It was a journey one must make, walking straight and alone', he wrote; '... Imagination, no longer fettered by the laws of fear, became as one with Vision. And the Act, intrinsic and absolute, was its meaning, and the bearer of its passion.' There is certainly something heroic and visionary about his paintings of 1949 and after. Large paintings, dark at first with a predominance of black, later more luminous and colourful, they seem composed of flat vertical shapes, each its own colour, their edges torn or eroded, their surfaces uneven to hint at density and weight. Were they painted more flatly, these canvases would suggest hoardings on which generations of large posters had been worn away by time and vandalism; with their variegated surfaces they come close to presenting themselves as natural cataclysms, awesome and compelling. Their vertical emphasis echoes our stance but also conveys rising and falling. Shreds of bright, high-toned colour are sensed as light breaking through between large dark obstacles.

Barnett Newman strove long to achieve what he called, in 1948, 'an art that would suggest the mysterious sublime rather than the beautiful'— echoing a distinction very effectively offered to the world by Edmund Burke nearly two hundred years earlier as part of the gathering challenge to classical aesthetics. In search of a primordial image, Newman reduced his pictorial language to two basic elements, the large unbroken area of unmodulated colour, or colour field, and the column or caesura of another colour interrupting the field or breaking through it. He spoke of mankind's earliest expression, 'a poetic outcry ... of awe and anger at his tragic state, at his own self awareness and at his own helplessness before

211

212

the void', and later, in 1966, à propos fourteen paintings entitled *The Stations of the Cross*, of Christ's last words on the cross, 'Why hast thou forsaken me?' as 'the universal cry'. The vertical marks are read as positive acts—akin to lightning, the rending of the veil of the temple, God dividing the waters even—in a passive and possibly infinite setting. The paintings are sometimes very large and the contrast of scale provided by the field and the caesura implies vast visions.

213 Between 1947 and 1950, Mark Rothko achieved his characteristic pictorial statement of two or three colour rectangles, hovering above each other against a ground of another colour. None of the colours is clear and final: there are hints of colour breaking through the soft veils of colour before us, or seeping round their vague edges, and the ground colours too are liable to change almost imperceptibly. The image is, again, very simple and—perhaps even more than Newman's—suggestive of the mystery of divine power as it might have appeared to prehistoric mankind or might appear now to man *in extremis*. The subtlety of the relationships of size between the forms, and of hue and weight between the colours, is such that the best Rothkos appear to move almost subliminally: the abstract composition becomes a living presence. In an age when religious painting tends to be timid, the works of Still, Newman, and especially Rothko—not known adherents of particular religions—present remarkably eloquent images to which a world reeling from mass racialist murder, global war, and the threat of global destruction could attach what meanings it wanted. Their initial attitude was not markedly different from that of the other leading Abstract Expressionists, in that they saw their first duty in turning inwards upon themselves, not outwards for social themes or in celebration or criticism of their world. But their subjective quest was in search of universal significance. They insisted on the importance of what they called subject-matter and were able to persuade their many admirers that abstract compositions can after all carry implications akin to meaning.

In 1958 Rothko worked on a series of mural canvases for a hall in the new Seagram Building in New York City. When it was decided to use this hall as a restaurant he withheld his paintings, saying that they could not exist in such a setting; they are now in the Tate Gallery in London. Subsequently he painted another series, his 'chapel paintings', for the Chapel of the Institute for Religion and Human Development in Houston, Texas. The chapel and the paintings were planned together, and Rothko structured a studio so that he could see his paintings in conditions of space and lighting similar to those they would inhabit. They were installed in 1971, a year after Rothko's suicide. The main wall, the high-altar wall so to speak, is occupied by three canvases forming a triptych. Clyfford Still too has been passionately concerned with the manner in which his paintings are shown. The Albright-Knox Art Gallery at Buffalo, New York, which gave Still a retrospective exhibition in 1959, has a major group of his paintings on conditions imposed by the artist relating to their display, and they may not be lent by the Gallery for exhibition elsewhere. When Newman exhibited a large painting in 1949 he had a notice set up next to it, asking spectators to stand fairly close to the canvas and not to observe it from a distance: the paintings should

211 (right).
Clyfford Still:
1957-D No. 1.
1957. Oil on
canvas,
113 × 159 in.
Buffalo, Albright–
Knox Art Gallery
(gift of Seymour
H. Knox)

212 (opposite). Barnett Newman: *Covenant*. 1949.
Oil on canvas, 48 × 60 in. Washington,
Hirshhorn Museum and Sculpture Garden,
Smithsonian Institution

213 (above). Mark Rothko: *No. 8*. 1952.
Oil on canvas, 80½ × 68 in. Meriden, Connecticut,
collection of Mr and Mrs Burton Tremaine

envelop us, not be seen as discrete, designed objects. Later he developed and exhibited (in an exhibition otherwise showing designs by major architects) a model for a synagogue, incorporating an idea he had for zigzag walls as surfaces for large paintings. The fourteen abstract paintings, *The Stations of the Cross*, painted during 1958–66, were exhibited as one composite work at the Guggenheim Museum in 1966.

This is evidence of a concern for effectiveness, for impact, that goes beyond the Expressionists' desire for intimate communication. In reaching out, beyond subjectivity, for general human significance, these painters appear to withdraw from their art. The formula plus the quality of the painting can replace the signature (it is striking that Barnett Newman went on using visible signatures, at least up to 1961; perhaps he felt that his small signature, in a corner of a large canvas, added to the sense of scale and thus to the meaning). But the painters then reappear, as impresarios for their art. The communication they offer does depend on nuances, and these need an ideal environment if they are to reach us the way they are intended; they are easily silenced. Thus the movement associated with vehemence and bodily attack here produced convinced, suave, managers staging tragic acts that were also acts of faith in art. Their ambition was high. Perhaps the time demanded it. Perhaps— using the story of Renaissance art for analogy, as they did—we could say that in the Rome of New York, after the Florence of Paris and the quasi North Italian response made in central Europe, it would be possible to achieve a transcendent climax comparable to that of the High Renaissance. Rothko, discussing his Seagram paintings, had compared them with those in the Sistine Chapel. Newman is said to have cut into a dispute over the value of the work of two minor painters with the admirable comment, 'I thought our argument was with Michelangelo!'

We should not question that ambition too harshly as time distances us from it. These painters came as close as anyone has done to answering the Romantic age's call for salvation through sublime aesthetic experience. Nietzsche had written about it in *The Birth of Tragedy* (1872): 'There is a need for a whole world of torment in order for the individual to produce the redemptive vision and to sit quietly in his rocking boat in mid-sea, absorbed in contemplation.' A few years later, in *Human, All-Too Human*, he described this 'metaphysical need' as a weakness, a self-indulgence which even the 'free spirit' is led into by 'the highest effects of art': 'it is in such moments that his intellectual probity is put to the test'. Our ultimate assessment of what some have called the Abstract Sublime of Rothko, Newman, and Still depends on how willing we are to join them on their visionary plane. It is not merely a matter of aspirations to transcendence, however. Unlike Malevich, these painters did not offer their paintings as manifestos announcing a new metaphysics. Unlike Mondrian, they did not work and rework pictorial propositions as essays towards a better physical as well as spiritual world. Their thinking was not orientated towards the future. For all its splendour, their art has a dying fall. In an essay Rothko wrote in 1947 and published in *Possibilities 1*, he considered whether modern art could be as miraculous, revelatory, as all art should be. Impossible: 'Without monsters and gods, art cannot enact our drama: art's most profound moments express this frustration.

214. Robert
Motherwell:
*Elegy to the
Spanish Republic
XXXIV.*
1953–4. Oil on
canvas,
80 × 100 in.
Buffalo, Albright-
Knox Art Gallery
(gift of Seymour
H. Knox)

When they were abandoned as untenable superstitions, art sank into
melancholy.' The same publication contained Pollock's account of how
he did his drip paintings, and retrospectively this reads like an answer:
instinctive, almost animal action will save us from the void.

American Abstract Expressionism was, and announced itself as,
extremist art, the unguarded, unqualified act, the product of full
commitment to that act, shunning no risk. But of course risks were
shunned—most obviously the risk of living in the present. That is why de
Kooning's acceptance of 'vulgar' subject-matter stands out, and that is
also why one admires the relatively cautious art of Robert Motherwell.
Most obviously in his *Spanish Elegies*, springing from a decoration he did
for a poem by Harold Rosenberg (for inclusion in the projected but
unaccomplished second issue of *Possibilities*, 1948), but also in other
ways, Motherwell the painter constantly reaches out into life. He
described the *Spanish Elegies* as 'general metaphors of the contrast
between life and death, and their interrelation.' They suggest resistance
as much as oppression; also, having something of the apparent casualness
of graffiti as well as the frontality of hoardings, they sound a firm note of
protest, not a truly elegiac one. In fact, Motherwell, though one of the key
persons in the story of Abstract Expressionism, has always been
somewhat isolated in the movement on account of his wide sympathies
and studies. He has always emphasized his debt to French culture, and
especially to Surrealism. Finding himself mocked by his fellows he
thought it necessary, in 1965, to stress that his attachment to the French
tradition in poetry and painting is matched by a regard for the English
and the Russian novel and that, in the end, Motherwell the painter is

214

more truly Motherwell than is Motherwell the writer. The series of books, 'The Documents of Modern Art', which he directed for a New York publisher from 1944 on, served as an important part of that store of essential information available to American artists we spoke of earlier. More particularly one volume in that series, his collection of texts and illustrations under the title *The Dada Painters and Poets* (1951), helped substantially to arm an attack on Abstract Expressionism in the late 1950s.

Another sort of response was that of Ad Reinhardt. An exceptionally young member of the small American Abstract Artists group, formed in New York in 1936 as a defence against descriptive painting of the American scene, he moved from geometrical abstraction through a controlled and markedly impersonal form of Abstract Expressionism, into a uniquely concentrated and super-elegant geometrical abstraction. From 1960 until his death in 1967 he painted nothing but square canvases of one size in which two barely distinguishable coats of black present a cruciform trisection of the surface. Like Tobey, Reinhardt had long studied Oriental art. His characterization of what he admired in Oriental art, in an article of 1960, reveals also his aims as painter:

> Nowhere in world art has it been clearer than in Asia that anything irrational, momentary, spontaneous, unconscious, primitive, expressionist, accidental or informal, cannot be called serious art. Only blankness, complete awareness, disinterestedness; the 'artist as artist' only, of one and rational mind, 'vacant and spiritual', empty and marvellous; in symmetries and regularities only; the changeless 'human content', the timeless 'supreme principle', the ageless 'universal formula' of art, nothing else.

Reinhardt was a man of acute intelligence and sharp wit. He must have known that he did not achieve blankness: the cross form is not blankness and the finely wrought paint surface through which he delivered it has itself a personal intensity, particularly so in the context of American painting. Yet his campaign for 'art-as-art-as-art', as he called it, and against art-as-expression or art-as-apocalypse, was an effective counter to the pictorial and verbal rhetoric of his colleagues. The Minimalist tendencies of the mid-sixties, to be discussed in Chapter 9, owed something to his economy of means—to his rhetoric of economy as against the rhetoric of maximal expression.

In 1962 the critic Clement Greenberg, earlier one of the astutest champions of Abstract Expressionism and by this time widely regarded as the most important voice in American art writing, announced his programme for the painting that should follow Abstract Expressionism. It was, he claimed, in the nature of modern art that it should progressively distinguish between essential and inessential elements. As regards painting, 'the irreducibility of pictorial art consists in but two constitutive conventions or norms: flatness and the delimitation of flatness.' After 'the turgidities of Abstract Expressionism' what was needed was openness. Rothko and Newman had given hints in this direction, but now there were two painters, Louis and Noland (in parentheses Greenberg also praised Olitski) whose work showed the desired openness, flatness and delimitation. By these words Greenberg

215

215. Ad
Reinhardt:
Abstract Painting.
1959. Oil on
canvas,
108 × 40 in. New
York,
Marlborough
Gallery, Inc.

probably meant an expansive composition, as opposed to the centripetal Cubist one which, he claimed, still dominated modern painting; unmodulated colour areas balanced so as to avoid spatial illusion; and clear divisions within the painting unambiguously related to its edges. Over the next decade and more, Greenberg and other critics who accepted his analysis of the situation and the duties it indicated ceaselessly discussed, and by implication promoted, the work of Louis, Noland, Olitski, and a few other painters worthy to be included in the canon, notably Stella.

What these painters had in common, most obviously, was a much cooler view of art, a much more limited ambition. This said, one wants to qualify it for the sake of Louis and Olitski, who can on occasion challenge the heroic grandeur of Newman and the Romantic expression of Rothko, but none of them would invite comparison with Michelangelo, could usefully be studied in terms of the Romantic concept of the sublime, or speaks of his art in terms of dark, audacious voyages into the unknown. Altogether, they said relatively little, shepherded as they were by a group of critics ready to analyse and evaluate every move they made when they made it and at length. Greenberg, in his accounts of Abstract Expressionism, tended more and more to comment on formal and colouristic development, leaving others to expound philosophical and psychological positions, and this was his and his critic allies' method also with what they called Post-Painterly Abstraction. Meaning was left aside; their concern was with flatness and the delimitation of flatness, and with watching their painter friends' development towards some impersonal absolute of clarity and openness. They wrote about each hair's breadth with assiduity, focusing attention on pictorial facts and presenting the artist once again as a sentient being capable of conscious choice. More regrettably they tended to write (mostly in articles appearing in such internationally read magazines as *Art International* and *Artforum*) as though each move invalidated every previous work by the same artist and by any other artist fit to be considered as in the same line of activity. It must be added that the writers and painters involved were often men of exceptional intelligence and seriousness.

Colour, suave or radiant, was to be of prime importance in Post-Painterly Abstraction; the writers, there still being no secure way of discussing colour, centred their accounts on their painters' casting off of the Cubist tradition and thus also (forgetting Monet and Matisse) of the apron strings of European art. (It is not certain what their definition of the Cubist tradition was; it probably relates to the question of central compositions versus expansive ones and the spatial recession or projection that goes with centrality, and perhaps also to the use of colour as an added element—for coding or decoration—and not as a necessary part of the structure.) A more important distinction between the new abstraction and what came before, in Europe or in America, was its overcoming of the old duality of the painting as object and the painting as image. This is the duality still dear to the heart of the general public: here is a picture, now let us see what it is a picture of. Abstraction attacked this convention by challenging the notion that a picture need be a picture of anything at all. The Cubist insistence that the picture was an object on a

wall that may or may not hint at other kinds of objects attacked it from the other end in theory but not in practice: the invitation to read and interpret the signs and marks of which the picture is composed reinforces the old habit. Abstract Expressionism rested on related dualities: canvas and marks as arena and action, symbolic configurations and interpretation. In the works of Louis, Noland, Olitski, and Stella there is full integration. The painting is the image and the image is the painting. The whole of it *is* the whole of it. There is no distinction of image and ground; no spatial illusion (it is unavoidable that there should be some spatial connotation the moment a mark is made on a canvas, but these painters have gone surprisingly far in eliminating it); no clear sense of weight, of top and bottom even (Louis left no instructions regarding a number of his paintings so that arguments arise over how they should be hung); no intrusion of personality through painterly handwriting but rather an air of detachment and a regard for impeccable craftsmanship not unlike Reinhardt's.

How new such painting is, in terms of its strategies and visual presence, must be considered in view of the claims so persistently made for it. Monet was no Cubist. The late *Water-Lily* paintings show him adapting an Oriental centre-less and wellnigh spaceless concept of composition to paintings that are as much curtains of colour as they are panoramas. Mondrian's Neo-Plasticist paintings go far beyond their duty to exemplify his theories by persistently exploring the possibility of an open, weightless picture-object orientated not to nature but to the spectator. Matisse's late collages, and in some respects his much earlier painting *The Red Studio*, go a long way towards the integration of image and painting valued by the new Americans, and by means often close to theirs. Post-Painterly Abstraction does without the motif of a Monet, mostly it does without the visual tensions and extensions of a Mondrian, and it does not even attempt the unpretentious vigour of the Matisses. In eschewing these it runs a risk which is the opposite one to that so readily accepted by their Abstract Expressionist forebears: where these ventured close to the edge of overstatement and melodrama, their successors risk tasteful vacantness.

In 1953–4 the Washington painter Morris Louis began to stain his canvases with a recently developed form of acrylic paint (a plastic-based paint, water-soluble, luminous and enduring, and giving a flatter, neater surface than oil paint). That is, he used the canvas as an absorbent material, letting the paint run on to it, soaking into the fibres and becoming one with the cloth texturally. At first he used delicate hues and ran them through each other in central arrangements. The climax of his work came in 1960–2, extraordinarily fecund years that ended with his death in September 1962. During those years he was using saturated colours and a wide range of compositional formulae, from the diagonal runs to the left and the right on sometimes vast canvases, known as his *Unfurleds* (1960–1), to his *Stripes* (1961–2), usually modest-sized canvases containing clusters of rising or hanging soft bands of rich colour. In both sorts of painting the fullness of the colour is preserved by keeping colours separate or just contiguous, which demands a high degree of control over a not entirely controllable process. The *Stripes*, full and

216

gentle, imply a man-made world; the diagonal runs of the large *Unfurleds* a natural growth and an opening vista. There are hints of Newman and Still in these Romantic compositions, as there are reminiscences of Pollock in the poured paint, but Louis accorded each element a new role and character. For example, Pollock's dripped and trickled paint reveals the movement of the painter and implies his tempo; in Louis, for all his control, we witness the apparently independent action of fluid colour (and, curiously, we tend to read the flow as going in the opposite direction to that which took place). Not only space and gravity but time itself, and with it the possibility of tragedy, seem negated in this magical though limited art.

Kenneth Noland's process of refinement has led him from square canvases emblazoned with central signs to 'shaped' canvases (i.e. not rectangular or, if a rectangle, hung so that the edges are not vertical and horizontal), back to the rectangular canvas, now coextensive with his painting, and back again to the shaped canvas. The development continues, as he tacks this way and that towards the ultimate in open yet delimited flatness. Always an intelligent and also a very careful painter, Noland seems to have been liberated by the death of his friend Louis. It enabled him to essay compositions that might otherwise have seemed dangerously close to Louis's. Thus in 1963 – 4 he painted some large canvases on which stripes forming a symmetrical or asymmetrical V seem to hang from the top edge—a fusion of Louis's *Unfurleds* and *Stripes* and with something of Louis's visionary quality about them. The essential Noland appeared in a series of diamond-shaped canvases occupied edge

216. Morris Louis: *Gamma Delta*. 1959 – 60. Synthetic polymer on canvas, $101\frac{7}{8} \times 152\frac{5}{8}$ in. New York, Whitney Museum of American Art (gift of the McCrory Corporation)

217

to edge by neatly parallel and contiguous bands of colour. Their colour chords imply again the example of Louis but Noland's colour is subtler and more inventive if less friendly. In subsequent paintings on rectangular canvases (I continue here to use the word canvas to indicate the cloth support, even though Louis, Noland, and others often used cotton duck instead of canvas which is made from flax or hemp), Noland used the entire surface for horizontal or vertical + horizontal bands and lines of colour. Most recently he has turned again to the shaped canvas, but now to shapes that evade geometrical classification and thus also the sign implications carried by the basic geometrical forms. Straight lines— the boundaries of colour areas, not drawn or painted lines—divide the irregularly edged surfaces into neat but unpredictable fields. There is a positive sense of the visible painting now being a more or less arbitrary section out of a large expanse of continuing colour areas, yet the divisions Noland has made in his paintings are so free that one would not know how to predict their continuation. This release from total clarity is welcome; it introduces an element of complexity without involving the painter in expressive gestures.

Comparable alogical shapes and divisions were reached some years earlier by Frank Stella in an attempt to break out of the identity of all-over shape and internal structure he had himself established with his first exhibited works. In 1960 he had begun a series of striped paintings whose non-rectangular format was presented as the product of the stripes rather than the stripes as a means of dividing up a given surface. Painted with great care and developed with a grammarian's precision, this series occupied Stella for some years. Exhibitions and illustrated articles made his work well known internationally and had the effect, among others, of encouraging other painters to work with shaped canvases. There have always been paintings of a non-rectangular format, of course, but they were rare in the fifties. Their relative frequency in the sixties fits the decade's cooler conception of the role of painting: the shaped canvas tends to present itself as a relatively dispassionate object, not a great

217. Kenneth Noland: *Mach II*. 1964. Acrylic resin on canvas, 98 × 208 in. Aspen, Colorado, collection of Mr and Mrs John Powers

218

218. Frank Stella:
Kingsbury Run.
1960. Aluminium
paint on canvas,
78 × 78 in. Private
collection

poetic vision. Stella's series moved from monochrome to multi-coloured compositions and then to monochrome done with metallic, lustrous paint that combined with the horizontally extended formats he was then using to suggest a barrage of stripes streaking their angled way along a wall. The absence of old illusions attracts new ones. In 1966, as though impatient with the finiteness and easy readability of his paintings, Stella adopted a different form of composition, fragmentary and arbitrary, creating logical puzzles and at the same time bearing complex spatial implications. In his most recent work he has turned his paintings into three-dimensional relief constructions.

Jules Olitski's work, from 1963 on, raised unexpected questions. If a painter sprays his colours on to a canvas so that the result shows some variations of hue but is otherwise without form, what happens to flatness and delimitation of flatness? When he provided small marks or accents as well, or tenuous strings of colour close to one of the edges, then Olitski hinted at an illusory, possibly cosmic scale and thus also at some sort of meaning. When he provided merely a scarcely modulated mist of colour, the only delimitation left was that of the edge of the canvas; flatness itself often was left in doubt as changes in tone or hue seemed to bend the surface. Such work tended to sweetness; since 1973 Olitski has returned to using the brush and has used it forcefully, to apply thick and often uningratiating pigment to his surfaces. The new paintings are lugubrious where the others were seductive, and they bear some hint of Action

219

Painting's reliance on the expressive application of paint. Other painters, in America and Europe, have also returned to a heavier use of pigment in reaction to the delicate stains and fine surfaces they were seeing in the galleries.

Ellsworth Kelly stands apart from these artists socially and is not associated with them by the critics, but his progress has not been unlike theirs though his starting point was distinct. He studied art in Paris. Some of his artistic roots are in Europe, in Mondrian, Matisse, and Arp and in a response to architecture and to the forms of nature encouraged by their example. When he returned to New York at the age of 31, in 1954, his character as artist was substantially formed. He was then making abstract paintings and reliefs derived from things seen— windows, plant forms, bodies, shadows and reflections, colour in man-made things and in nature. He was using art to convey, in a concentrated form, the visual richness he had found in observed things. Abstract Expressionism and the reactions to it that were beginning to form in the mid-fifties were equally foreign to him. Retrospectively one may today wonder whether the distance between a Kelly colour composition and a Newman or a Rothko is all that great. In all of them resonant colour and directness of formal statement go with a powerful visual result, concision with a rich experience. But Kelly could not sympathize with verbal or pictorial rhetoric. For all its sobriety his art is optimistic: it is about fullness and ripeness, about the pleasures to be found in the un-spectacular. It is, in the remarkable succinctness of a mature Kelly, ruthless also. A series of small canvases is painted as one composition, occupying a lot of wall (1956). A vertical canvas set low against a wall is partnered by a similar canvas making an angle with it on the floor; together they make one painting (1965). Similar planes in steel, one upright, one horizontal, make a matt white sculpture (1966). A yellow painting consists of two vertical canvases of the same area, but one thicker (because of a deeper stretcher) than the other, so that the only articulation is the change of level from one half of the painting to the other (1955). If the art of the Abstract Expressionists calls for an act of faith, art like Kelly's (and Reinhardt's also) calls for intense visual attention. It imposes conditions not unlike those demanded by Rothko, Still and Newman: immaculate display and delicate handling. Yet its precision and perfection are not symbolical. A fingerprint, a dented surface, lighting that produces too pronounced a shadow next to the canvas—any such accidents can easily disrupt Kelly's carefully weighed visual statement.

Kelly's art now looks like a forerunner, and also the best example, of the Minimalism that emerged as a movement in the mid-sixties, though most commentators, echoing the leaders of Minimalism, tend to stress its independence. Perhaps it is most useful to see both, and cognate developments such as the international wave of 'Op' art of about 1960 to 1965, which aimed at expression through sharp stimulus of the retina, as part of the reaction to post-war emotionalism. The presence in America of Moholy-Nagy, Albers, and Mondrian gave continuing support to artists inclining to geometrical abstraction and Constructivism. Albers's long series, the *Homage to the Square* paintings begun in 1949, served as a

219.
Jules
Olitski: *Thigh
Smoke*. 1966.
Acrylic on canvas,
167 × 92½ in.
Seattle, First
National Bank
Art Collection

220.
Ellsworth
Kelly: *Red-
Green-Blue*. 1965.
Oil on canvas,
91 × 91 in.
Amsterdam,
Stedelijk
Museum

beacon to artists everywhere impatient of emotional display and wasted resources. Yet America has in Charles Biederman a native artist whose long research into the structural and also the semantic function of colours and forms had made him a profound teacher and a fine artist. Biederman, of an age with the leaders of Abstract Expressionism, studied art in Chicago and worked in the 1930s in New York and Paris. By this time he had explored Expressionism and aspects of Surrealism and was drawn most to Cubism, Mondrian, and Léger. He began making constructions; in 1937 he painted his last picture and since then he has worked almost exclusively on reliefs. The characteristic Biederman relief came into being in 1954. He reduced his means to colour planes attached to a single colour background, and these have continued to provide him with what he needed. They have proved infinitely adaptable. Colour, angle, size, internal scale, quantity, rhythm, compositional associations: each yields a whole range of opportunities and the variety of expression they offer is endless. The reliefs are constructed. That is, Biederman makes sketches and then a model out of wood, then exact measured drawings, and then the elements that will make up the relief are cut from aluminium, sprayed with the exact colour, and assembled. Moreover, he has repeatedly

221

221. Charles Biederman: *No. 23, Red Wing.* 1968–9. Painted aluminium, $38\frac{5}{8} \times 31 \times 5\frac{3}{8}$ in. Minnesota, collection of Mr and Mrs Carl R. Erickson

stressed his awareness of living in an age of technology and presented his constructed reliefs as a response to it. And so he tends to be associated, willingly to some extent, with the Constructivist tradition. In his writings he was one of the first to show Russian modernism, together with Cubism and *De Stijl*, as forming the mainstream of twentieth-century art. Yet his own art is more about nature than about technology and life in an industrialized world. He uses the relief as a form of painting, summarizing his experience of light and natural growth through colour planes that are cut and affixed to a support rather than brushed on to a canvas.

His master, he says quite rightly, is Cézanne. Like Cézanne he makes (to use the Frenchman's words) 'constructions after nature'. Moreover, he has demonstrated the importance of his art in writings that analyse the past from Courbet and Impressionism onwards and offer some succinct criticism of contemporary American trends. As a result his countrymen have tended to ignore his existence. Large, splendid retrospective exhibitions in London, in Minneapolis and other American cities have been ignored in New York. Critics and curators have difficulties with an artist who explains his work with such care and thus turns away their verbal support. Yet the work produced by the now ageing Biederman in the seclusion of an isolated clapboard home outside Red Wing (not far from Minneapolis), deep amongst the trees, radiates intelligence and is of outstanding beauty. Its historical roots may be European but the plant itself is American just as Biederman (whose parents were Czech immigrants) is an American. His understanding of the European tradition remains part of his art, and he was inspired by the major artists he knew in Paris during 1936–7 (they included Mondrian, Arp, Léger, and Brancusi), yet he also sensed then that the world was changing. 'I am getting a fine impression of a washed-up art center', he wrote not long after arriving in Paris, and a little later he added, 'The coming art is not for, or from, the French temperament.' If for him the inalienable past of art lies in Europe, he sees its future in America, where 'the conditions are ripe for starting the world out of the muck and ruin of Aristotelianism in art', and artists must seize their opportunity 'to continue the evolution of the *art of mankind*'. His art meanwhile represents that art (he never claims that it represents the end of the road). It is neither abstract in concept, nor figurative, but reflects the life of nature in its visual components and their composition and the life of modern man in the constructional process.

The Abstract Expressionist years produced in America a wave of activity in sculpture also. Expressive figuration and Surrealist conceits were replaced by abstract configurations appealing to human anxieties and awe. Constructed sculpture of welded steel or iron came to dominate over carved or modelled and cast sculpture, and the technique encouraged a growth of scale and a relative freedom of action that enabled the new sculpture to exist as a counterpart to Abstract Expressionism and even to Post-Painterly Abstraction. Some critics, notably again Clement Greenberg, saw in David Smith—a sculptor whose early experience of working in a car factory and on the construction of locomotives had implanted a deep understanding of steel and working with steel—the unchallenged leader in this field. By 1948 Smith, then aged 42, had

experimented with a range of modern tendencies in sculpture, most of all with aspects of Surrealism. That year he developed a linear idiom involving thin steel members and signs set into space, sometimes more three-dimensionally, often flatly and thus pictorially. Similar work occupied Smith during the fifties. Greenberg was to write that 'by the early 50s he had already done enough to make him the best sculptor anywhere'. This assessment becomes less startling if one recognizes its role. The same years saw the emergence and growing acceptance of more demonstrative and even melodramatic forms of abstract sculpture, much of it making its impact through an open use of bits of metal collected from the junk yards, including brightly cellulosed sheet steel taken from jettisoned cars, carrying an ambiguous message of smartness and of death. Smith's lyrical, freehand sculptures, seemingly drawn in space without effort, neither devoid of meaning nor heavy with it, evaded pathos. By the end of the fifties he was replacing his linear frameworks with broader steel elements that would support themselves, straight and curved planes at first, then cubes, cylinders, beams and other 'solids' constructed from sheet steel. The open planes were painted in bright colours, and in other respects too show an awareness of current developments in painting; the 'solids' were made in stainless steel and Smith coarsely ground their surfaces so that they catch the sunlight vividly and variously. In either case he was counteracting the natural character of his material: its implication of weight and also of utilitarian earnestness. We experience *Zig IV* first as coloured forms in space, almost floating and almost unsupported by the little mobile-looking base.
223 We read the *Cubi* series, for all the monumentality of their solid geometry

222 (left). David Smith:
Blackburn, Song of an Irish Blacksmith.
1949 – 50. Steel, bronze,
$46\frac{1}{4} \times 40\frac{3}{4} \times 24$ in.
Duisburg, Wilhelm-Lehmbruck-Museum

223 (right). David Smith:
Cubi XIX. 1964. Stainless steel,
$113 \times 61\frac{1}{2} \times 41\frac{1}{4}$ in.
London, Tate Gallery

and scale, as compilations of volumes, as hovering apparitions rather than as masses, as insubstantial still lifes offered to a rural divinity (Smith, unlike the majority of modern sculptors, liked his work to be shown out in landscape, and himself photographed it thus). The effect is still primarily pictorial. The apparent weightlessness, the ease with which these forms, made almost immaterial by their luminosity, hang in space, kept there by momentary conjunction, makes his work akin to Noland's—limpid, fresh, well-judged, tacit, and impoverished by its unremitting niceness. Witnessing Smith's major change of direction in 1960, Hilton Kramer wrote that Smith 'restored the Constructivist idea to the Cubist tradition, which had spawned it in the first place, and then threw in the Surrealism for good measure'. But who would have thought that such all-round scooping of the modernist pool—and perhaps one should add the hovering squares and bars and rectangles of Malevich for good measure—could produce so polite a synthesis?

We shall see that this dogma-based shift from, to put it crudely, the overstatements of Abstract Expressionism to the polite understatements of Post-Painterly Abstraction—which, of course, left untouched but also underconsidered the central activity of a de Kooning and the culturally central but geographically separate activity of a Biederman—produced strong reactions in America. Dogma invites counter-dogma. It seems characteristic of American art, or at least of the campaigns through which art in America is set before the public and the effect of these campaigns on the art they select, that it should reach out towards absolute definitions and claims that make rejection and reaction the only possible next moves in the game. As a process it is very wasteful of talent and ideas. It may be answered that this is merely the surface of the world of art, the national and international skirmishing of the fashion-houses of art, whilst the art that matters continues, untouched by that world. Theoretically this is possible but experience proves it unlikely. The support system of modern art, in many respects most highly developed and most commanding in the United States, encourages and disdains, feeds and starves, picks up and drops artists of all sorts, including artists of great and precious ability. The best, the most powerfully motivated and self-critical artists probably survive, but the public is encouraged in its lust for new stars and new slogans and discouraged from any continuing engagement. Attention is taken from the work of art and focused on personalities and strategies.

8 Post-war Art in Europe

It is the constant presence of more or less subtle varieties of apocalyptism that makes possible the repetitive claims for uniqueness and privilege in modernist theorising about the arts.

Frank Kermode, 1966

The object that is the true opposite of Verne's *Nautilus* is Rimbaud's *Drunken Boat*, the boat which says 'I' and, freed from its concavity, can make man proceed from a psycho-analysis of the cave to a genuine poetics of exploration.

Roland Barthes, *c*.1955

No one European school or centre could catch and hold the attention as New York did after the war. That war had seen Europe engaged in a desperate internecine struggle. Now the Continent was divided into a Western and an Eastern stronghold, and seemed likely to serve as arena for a renewed war. Western Europe laboured to provide itself with a new cultural identity whilst, to the east of the Iron Curtain, Russia's European satellites tried in varying degrees to escape the smothering blanket of Russian Social Realism. In Poland especially artists have been able to respond to developments in the West and to develop their national modernist traditions. Russian artists have not had such freedom, though with the passing of the years Soviet officialdom appears to have set less store by preventing independent art even if recognition has gone only to politically approved work. That art could not thrive without public support was now accepted everywhere, but in the West ways had to be found of administering support with the least possible show of governmental direction and in collaboration with private enterprise.

Many of the leading artists of heroic modernism were still alive, among them Arp, Braque, Léger, Matisse, Miró and Picasso. Their continuing activity hovered over that of younger generations like an empyrean, remote but encouraging. The story of modernism, increasingly recorded and analysed—its Dutch, German, Italian, and Russian aspects now as well as the Parisian—presented a picture of bold endeavour and lavish achievement unchallengeable by new avant-garde efforts but questionable as to its true nature. The story was full of adventure: peak after peak was scaled by those intrepid men. Yet what, in the end, did it all prove? The resourcefulness and agility of the human mind, perhaps, but to what purpose? Admirable though this work had been in itself, what was its worth in the real world? As its financial value soared, with museums, corporations and millionaires vying for possession—as stories of art thefts and art forgeries, and also of record prices paid, filled the newspapers, and exhibitions began to be advertised in terms of their

insurance values and security arrangements—its functional value to society was questioned more and more sharply. None of this brilliant creativity, not even the most self-effacing Utopian programmes of Elementarism or the extended consciousness promised by Surrealism, had left any mark on Europe at large. The warnings given by Dada seemed to have been forgotten, and now were relevant again. Those who thought such things could consider the sharp contrast between the shattered Europe they inhabited and those preciously protected master-works, or, alternatively, turn to the work of a Matisse, a Picasso, a Mondrian or whoever as evidence of a transcending and surviving human spirit.

The dominant note sounded by post-war art was that of survival, often joined to anxiety in view of the continuing threat of local or global destruction, sometimes with confidence, but most often with an ambiguity common to our response to dramatic events. Images of fear and of despair became commonplace and had much success in the fifties. Some of them, the work of outstanding artists, were negative images of the human condition and at the same time, in their expressive energies, symbolic triumphs over it. A succession of Henry Moore's sculptures, now mostly in bronze and thus multipliable and increasingly honoured around the world, was of this kind though the artist's natural bent continued to be towards harmonious and reassuring forms. The thin 224 figures of Giacometti perfectly express both the weakness and the resolution of a humanity uncertain of its world. Moore's idiom is more physical, an arrangement of anatomies with which we can identify more or less directly whether their outline announces figuration or not. Francis Bacon's images of dread are often monumental in scale where Giacometti's tend to be delicate, and they appeal to intimate, present-day experience while Giacometti's associate with the image of man through the ages. In his claustrophobic spaces—stage-like, but a close, informal stage, the stage of cabaret not of formal drama—Bacon enacts ambiguous horrors that may hint at the efficient breaking of dissidents belonging to modern statecraft, but equally at the actual and imagined cruelties that we know as part of ordinary life. Yet we are shocked to find that many of these painful, if ordinary disclosures are based on photographic material of a public and not necessarily troubling sort. In several paintings, including *Study for Crouching Nude*, Bacon has used frames from 225 Muybridge's sequential studies of human and animal motion, photo-graphs made in a scientific spirit. It is even more shocking to find Bacon's frightful images presented through such beautiful passages of paint. Only Goya has as effectively explored such an incongruity of means and message. Partly because of this duality one associates Bacon with the Surrealist tradition rather than with the Expressionist, and for other reasons one could similarly place Moore. But while we can also reasonably describe them as late contributors to the long classical tradition even when, by showing man suffering and perplexed, they seem to invert its meaning (this inversion may be said to have happened in response to Christianity's call for images of heroic suffering long ago, but the suffering of saints is a gateway to glory), Bacon's lay and inglorious martyrdoms must be linked to a different tradition, not of heroism but of

plain commonalty. We know it in fact and fiction, from newspapers, novels and potted psychology, and above all from the amalgams of such matter that reach us through the persuasive medium of film. It is small wonder that art like Bacon's runs the risk of turning into an expensive, take-away form of cinematic nastiness. Other artists attempting to convey suffering through more or less realistic means, however fine their motives (and at times one has reason to doubt these), repeatedly fall into this trap. Bacon mostly evades it thanks to the unremitting acerbity of his eye, so that every part of his best paintings, body, stage and properties, speaks of obsession and loathing. Only the paint has glamour. They belong to the tradition of genre painting, of scenes of commonplace and anonymous actions—Vermeers for an age of Kafka and Beckett.

224. Henry Moore: *Three Upright Motives.* 1955–6. Bronze, 131$\frac{5}{8}$ × 126 in. Otterlo, Rijksmuseum Kröller-Müller

225. Francis
Bacon: *Study for
Crouching Nude*.
1952. Oil and
sand on canvas,
78 × 54 in.
Detroit Institute
of Arts (gift of
Dr William R.
Valentiner)

One of the precarious advantages of abstract art is that it can claim to embody a grim view of the world and yet thoroughly beguile us with its aesthetic charms. Rothko's last black-and-grey canvases were attempts to shed those attractions. The scale of most Stills, many Newmans, and some Rothkos was meant to stimulate awe where the same compositions on a smaller scale would have been merely pleasurable. Recent European art has included a lot of abstract painting and some abstract sculpture made to express horror at the modern world and to protest in the name of humanity, yet quite unable to sustain such a message. Often one could blame traditional refinements in the use of the material for this, as with

226 Fautrier's series of *Hostage* paintings, built up with thick creamy paints to quite delicious effect but intended to signify oppression and terror. Sometimes the preferred sign or structure, powerful at first encounter, has proved to be too limited to survive exploitation, as in the case of Soulages, whose big black beams of paint, hovering over a glowing background and tapping every Westerner's inherited response to the
227 image of the cross, soon strike one as theatrical. Burri's rough collages of stained and charred sackcloth, stitched together to leave glimpses of black or red beneath, were undeniably redolent of war, and were indeed the work of a man who had worked in field hospitals and was attempting to transmit authentic experiences; they soon looked like rhetorical confections. Impetuous expressionist action like that of the painter Mathieu, sometimes performing his paintings before an audience, had an initial drama that repetition vitiated; intended as nihilistic signals about the state of the world, they soon signified little more than self-regard.

It is those abstract artists who accepted the inherent ambiguity of their pictorial statements whose work has survived deflation. This ambiguity is particularly marked in the case of Fontana, whose immaculately painted, slashed, and sometimes bejewelled canvases of the fifties and sixties can be interpreted as ultra-sophisticated art objects of a highly commercial sort, or as blatant attacks on painting as an art form, or as experiments in the spatial development of a two-dimensional medium. Fontana's own

226. Jean Fautrier: *Tête d'Otage No. 3*. 1943. Oil on paper on canvas, 14 × 11 in. Sceaux, Musée de l'Ile de France

227. Alberto
Burri: *Wheat*.
1956. Hessian,
59 × 98½ in.
Düsseldorf,
Kunstsammlung
Nordrhein–
Westfalen

comments centred on this *spazialismo*; what the observer receives is the
duality of a perfect canvas + paint surface, expensively framed and
displayed on a gallery wall, and the rupturing of that surface. The
symbolism is multivocal. The paintings of Tàpies, obviously more earthy
and less dashing in character, depend on some of the same effects.
Fontana's earliest paintings had been scratched and pock-marked with a
pointed instrument; the characteristic Tàpies is larger and more massive,
a wall rather than a tablet or a membrane, rougher and rustic in its
textural associations, yet it too is articulated with incised marks
suggesting graffiti or the traces of some possibly tragic event. It has
aesthetic appeal through its textures, tones and markings, like a Fontana;

230

228

228. Antonio
Tàpies:
Perforated Body.
1956–8. Mixed
media on canvas,
57½ × 45 in.
Milan, Panza
Collection

what sets the Spaniard's work apart from the Italian's is its reference to village architecture and the passage of time whereas Fontana's violated decorations are emphatically urban and contemporary. The much smaller paintings of Bissier, easily mistaken for watercolours on paper, owe much to Oriental traditions. A German, Bissier had shared in the New Objectivity tendencies of the later twenties, and had subsequently turned to semi-abstract forms under the influence of Oriental paintings and also of Brancusi. The example of Brancusi, himself a mediator between Oriental refinement and Western assertiveness, perhaps supported by knowledge of the work of Arp and Klee, helped Bissier to regain a foothold in Western art. The delicate paintings that resulted, and with which he gained sudden international fame in the late fifties, bridge East and West more justly than anyone else's work, not forgetting Tobey's. Like Fontana's, Bissier's art announces its delight in sophistication; like Tàpies' it is rural and unmodern; unlike either's, it seems detached from the pressures of existence, an art of serenity and effortless grace. Yet it is likely that, of the three men, Bissier was the one with the direst physical and spiritual burden.

Bissier's near contemporary and, for a time, relatively near neighbour, was Ben Nicholson, champion of international modernism in Britain in the thirties. Unlike a number of his painter friends who around 1940, as the war forced Britain into self-reliance, turned to the national Romantic inheritance associated with William Blake and his followers to develop a modern romanticism that linked the delight in old ruins with horror at the new, he remained detached, his art moving freely over different categories of modernism and all the other boundaries or unities with which one associates art. Personal experience always provided the basic

229

229. Julius Bissier: *Monti 60.92*. 1960. Oil tempera on canvas, 8 × 10 in. Düsseldorf, Kunstsammlung Nordrhein-Westfalen

230. Lucio Fontana: *Concetto Spaziale*. 1960. Oil on canvas, $39\frac{1}{2} \times 31\frac{1}{2}$ in. Bochum, Gallery M

impetus, whether he was drawing Siena's striped cathedral or the view out of his window in St Ives or letting the line of a jug set off a weaving flight of lines across a sheet of paper. We accept without surprise a painting such as *November 11 1947 (Mousehole)*, yet it combines two old forms or types of painting—still life and landscape—that are very rarely brought together, marries two distinct, even antagonistic languages of painting in treating the still life as a cluster of planes and the landscape in

a more or less naturalistic manner (embodying touches of primitivism), and ranges stylistically from sharp and exactly placed accents to areas of suave, visual texture. Nicholson relies on his visual response, his response to the motif and equally his response to what is happening on the paper, canvas, board or copper plate in front of him. His more recent work has shown him mostly exploring the basically Cubist language of clustering planes, usually for landscape subjects or stimuli, in his often three-dimensional paintings, while his graphic work often exploits still-life motifs.

None of the great pioneers of abstract art—Malevich, Mondrian, Kandinsky or Delaunay—had ever insisted on abstract form as a means totally distinct from representation. They had wished to deepen as well as generalize visual experience, to make it reach out beyond the particular to the lasting and universal. Picasso is often quoted by the opponents of abstract art, but his words, 'There is no abstract art. You must always start with something' (1935), do not deny the possibility of abstract art but merely assert that abstract art has its roots in visual experience. In his Jena lecture of 1924, Klee had offered a useful simile to help his listeners accept non-representational art. He had spoken of a tree, the artist functioning like the trunk of a tree, drawing subject and sustenance from the ground through his roots and putting forth branches and leaves that

231. Ben Nicholson: *November 11 1947 (Mousehole)*. 1947. Oil and pencil on canvas, $18\frac{1}{4} \times 23$ in. London, British Council

232. Ben
Nicholson: *June
1964 (Valley
between Rimini
and Urbino)*.
1964. Oil on
carved board,
$25\frac{1}{2} \times 27\frac{1}{8}$ in.
Private collection

need not at all resemble the roots. It seems to have been the defenders of
Cubism who first made an issue of abstraction, accusing those who
excluded direct references to the visible world of jettisoning all possibility
of meaning. With Communism's and then also Fascism's insistence on an
art conveying carefully rehearsed meanings directly and unambiguously,
the abstract-figurative opposition became doctrinal, even where neither
political system came to power. I have already suggested that abstract art
was a dying cause in the thirties, with Surrealism, rather than the more
impersonal, formal ways associated with the abstract groups, attracting
new talents. After the war new movements in abstract art were roundly
attacked as they surfaced—once again war had implanted a longing for an
art that would move gently, within sight of secure traditions—yet in the
fifties and early sixties abstract art became dominant.

It would be possible to outline the campaign of publications,
exhibitions, and open as well as private debate, that accompanied this rise
to power, but that in itself would not explain it. Neither would reference
to American Abstract Expressionism since it did not exercise any
influence on European art until after abstraction had there broken
through and established itself as a viable part of post-war art. Why did
abstract art succeed so rapidly after the war when it had seemed
moribund before? Perhaps it was partly that Fascism and Communism
forbade it: abstract art signified the free society as well as the free
individual. Also, by association with the pioneers of abstraction, abstract
art could be presented as a heroic adventure. Michel Seuphor's book,
Abstract Art: its Origins and First Masters, published in French in 1949
and soon translated into other languages, provided the kind of glowing
background the new movement needed, and he followed it up with a
study of Mondrian and a dictionary of abstract art, both in 1957. By that
time the battle for abstraction had been won, and the ease of that success

233. Germaine
Richier: *Grande
Tauromachie*.
1953. Bronze,
height $45\frac{1}{4}$ in.
London, Gimpel
Fils Gallery

leads us to another reason for it. The kind of abstract painting mostly developed after the war, in Europe as in the United States, was of a fundamentally ambiguous sort. It often carried messages of personal suffering or general calamities in very seductive visual terms. People could bring to it their own fearful and also perhaps thrilling recollections of the war and at the same time receive gratification from it. The abstract art that flourished then was informal, linked to Expressionism and Surrealism in its methods (again as in America) and not to formal abstraction of the Elementarist or Constructivist sort. This, sometimes referred to as classical abstraction, continued but was hardly noticed until the sixties.

When figurative artists attempted to express what people in the sixties called 'the human condition' they tended to fall into melodrama. Even so outstanding an artist as Germaine Richier came close to it in her sincere attempts to find a compelling image for the barbarism she had personally
233 experienced during the war. Picasso produced one of his least creditable paintings in his attempt to bring Goya up to date in *Massacre in Korea*. Renato Guttuso has been responsible for the most convincing attempts in
234 the West to create large paintings with overtly political themes and to address them to a wide public. He strives to rise above the banalities of Russian Social Realism and of Western advertising which is, in many senses, its equivalent; his convictions charge the manner of his paintings with stylistic effect, thus also identifying them as art, diminishing their popular appeal. His paintings do not reach the public they were intended for, and the art public tends to find them over-emphatic. Yet Guttuso's ambition is honourable, whereas the playing with classical figuration that had much fashionable success in the fifties—especially in sculpture—is not.

It was the informal sort of abstraction that became dominant in the

234. Renato
Guttuso:
Discussion.
1959–60. Mixed
media on canvas,
$86\frac{5}{8} \times 97\frac{5}{8}$ in.
London, Tate
Gallery

236 (opposite).
Richard Lohse:
*Fifteen Systematic
Rows of Colour
with Central
Vertical
Compression and
Horizontal
Compression
Downwards.*
1943–68. Oil on
linen, 59 × 59 in.
Collection of the
artist

West. In Paris, during the first years immediately following the end of fighting in Europe (1945), it looked as though Elementarist and Constructivist art was about to take a leading role, with the opening of the Denise René Gallery in 1946 and the formation that year, to promote annual exhibitions, of the Salon des Réalités Nouvelles, both devoted to a wide range of formal abstract art, including kinetic and, as it was called later, Op art. Paris continued to be a centre for such art in the fifties and sixties, partly thanks to the influx of artists from other countries, notably from South America. But the most impressive individual pursuit was to be found elsewhere, especially in Switzerland, Holland, and Britain. Max Bill, a student at the Zurich design school before he went to complete his studies at the Bauhaus in Dessau, in 1950 was appointed the first director of a new Bauhaus he had helped to found at Ulm in Germany, the Hochschule für Gestaltung. Bill is an almost unique instance of the kind of master-of-every-art the Bauhaus had hoped to produce: he works as architect, industrial designer, typographer, painter, and sculptor, as well as theoretician. In his paintings he explores mathematical relationships through juxtaposed colour fields; his sculpture makes use both of basic geometrical solids and such concepts of topology as the Moebius strip or 235 endless loop. Some of the sculpture is carved, some constructed: Bill's allegiance is to the formal tradition of *De Stijl*, not to any method of production, and his career has been a remarkable vindication of the *De Stijl* dream of an essential unison of art and design activity and thus of closing the gap that has divided, or has seemed to divide, art from the actual world. Another former student at the Zurich design school, Richard Lohse, has specialized in mathematically planned paintings of 236 varying complexity. The result is a structure of very precisely adjusted colours and tones, varying in character with every alteration in ingredients and disposition. His concentration on painting proclaims his

235. Max Bill:
Endless Torsion.
1935 – 53.
Bronze, height
49¼ in.
Middelheim,
Open Air
Museum of
Sculpture

237. Alan Davie: *Entrance for a Red Temple No. 1*. 1960. Oil on canvas, 84 × 68 in. London, Tate Gallery

sense of the vast potential of two-dimensional colour structures; perhaps one of the most telling contrasts to be found in the world of formal abstract art is that between the concentrated research of a man like Lohse, proceeding systematically even if his preferences show a subjective, emotional base, and the ceaselessly varying production of others, who may adhere to something like the Elementarist language of geometrical forms but in the end negate it by introducing disturbances of various sorts—optical disturbance through assaulting our retina or formal disturbance by means of light and movement. It is the particular achievement of Lohse, and to some extent also of Bill, to have re-emphasized the efficacy of colour in an area where colour had tended to become subservient to materials or had been limited often to the primaries—as Mondrian had limited colour, but without his care for the adjusting of primaries to each other and to the white ground.

Why did informal, Expressionist abstraction achieve such an easy triumph where the objective mode of formal abstraction has failed to make much headway? Perhaps the same implications that, as I suggested, supported something close to a rebirth of abstract art in Europe kept the public away from formal abstraction. To this day intellectual control appears to many to imply something other than art, to be of its nature inartistic; certainly the consort of this assumption, that art is a matter of emotional self-expression, implanted by the Romantics, today rules almost without challenge. People look for signals of fervour, where a hundred years ago they looked for the smooth surface and gradations that indicate painstaking effort with a small brush. All Western European countries contributed to a great wave of abstract and semi-abstract Expressionism, and even in the countries that are under Soviet control, including Russia herself, unofficial art has also tended to choose the way of emphatic self-expression. A kind of art suppressed in Eastern Europe, or at least frowned upon by officialdom (depending on which country one thinks of), in Western Europe met with remarkable official encouragement. The Cobra group brought together artists in Copenhagen, Brussels, and Amsterdam, as its name hints. As a group Cobra existed for only a few years, from 1948 to 1950, but some of the artists who became known through it have remained well known. Some of them moved to Paris, but they retained the Nordic quality they had perhaps consciously sought in their work. Appel is the most famous, partly because his art appears to be the wildest of the group. Like other Cobra artists, Appel has exploited personal imagery as well as a fantasy rooted in folklore, but the impact of his art relies primarily on the dramatic value of fierce action and bright colours. In some ways it recalls the work of the American Dutchman, de Kooning, especially in incorporating figuration in an activity that seems to belong to abstraction, but de Kooning is not satisfied with pictorial fireworks.

The British painter Alan Davie found a public for his work on the Continent of Europe and in America some time before the British art public could reconcile itself to his mixture of ancient and newly invented symbols and his explosive brushwork. His paintings at their best appear at once apocalyptic and triumphant, and one could argue that they are therefore a link added to the chain of British Romanticism and thus

should offer no problem to a public that can usually be relied upon to respond with warmth to that tradition. It was the impetuosity of Davie's art, its base in improvisation, that gave pause. In his lectures and other statements Davie, a jazz musician as well as a painter, stressed the importance of improvisation as his chosen method and also his intimate, almost necromantic relationship with his means. His stance was that of the inspired soothsayer, but a physical being as well as a spiritual one, resisting the inroads of rational civilization. He wrote in 1958:

> When I am working, I am aware of a striving, a yearning, the making of many impossible attempts at a kind of transmutation—a searching for a formula for the magical conjuring of the unknowable. Many times the end seems just within reach, only to fly to pieces before me as I reach for it. In this respect I feel very close to the alchemists of old; and, like them, I have in the end reached some enlightenment in the realization that my work entails a kind of symbolic self-involvement in the very processes of life itself.

The more artists 'went abstract'—the phrase had a solemn ring to it—the less the barrier between figuration and abstraction mattered. It was striking, for example, how the art of Matisse achieved its present high status through the admiration brought to it by abstract painters and sculptors, and not only to his late abstractions. Moreover, some abstract works seemed in themselves to demolish the categories. A slashed Fontana, for instance: is it an abstract image or a self-sufficient object that is neither figurative nor abstract, an event rather than a picture? It does not represent a cut membrane; it *is* a cut membrane. A Tàpies *is* an inscribed or marked surface. And so on, though the question is sometimes more easily raised than answered. Some Pollocks are read as traces of paint; in others the traces cohere visually to convey an image, with or without figurative connotations. If the late forties saw renewed controversy over the question of abstract art, by the end of the fifties the art world could consider the matter settled, not by the all-out victory of one side but thanks to the evaporation of the question. Other polarities soon demanded attention; for the present it was possible for what had once seemed mutually exclusive kinds of art to exist side by side and for one artist's work, as in the case of Nicholson's now and Klee's earlier, to ignore the old barrier without causing surprise.

In this respect too we have to note quite different attitudes and methods. One of the most admired painters of the fifties was the Russian-born aristocrat and orphan Nicolas de Staël. At the end of the war, when he was just over thirty, he had begun to paint in an abstract style: firm patches of dark paint left glimpses of brighter colour below. Put on with a palette knife, this paint was at once solemn and luscious. As his work became known internationally, at the end of the forties, it also became more colourful and returned to representation, using much the same broad patches of paint to suggest landscapes, still lifes, and occasional figures and groups. Thus he combined recognizable subject-matter and a masterful display of the attractions of paint as matter and as colour, bringing back into figurative painting satisfactions discovered while making his abstract compositions. Dubuffet, de Staël's older contemporary, had his first one-man exhibition in 1944, having abandoned

238

238. Nicholas de Staël: *Figure by the Sea*. 1952. Oil on canvas, $63\frac{5}{8} \times 51$ in. Düsseldorf, Kunstsammlung Nordrhein-Westfalen

239. Jean Du-
buffet: *Sang et Feu
(Corps de Dames)*.
1950. Oil on canvas,
$13\frac{3}{4} \times 6\frac{1}{4}$ in.
New York, Pierre
Matisse Gallery

painting for more than a decade. From then on he rose to rapid fame,
initially on account of the scurrilous character of his art. He had
developed a passionate interest in the art of children, amateurs,
psychotics and other more or less unselfconscious artists, and over the
years he formed a large collection of such work, exhibiting and
publicizing it as the true stuff of human creativity. He called it *art brut*,

239 rough, raw art, and felt free to adapt aspects of it for his own sophisticated production. His work derived at times from graffiti seen on Paris walls, as in his *Corps de Dames* series (1950–1), which may have influenced de Kooning at an important moment. These scatological images, crude maps of the female body untouched by the selectivity of idealism, suggested lavatorial scribbles and were themselves scratched roughly into thick paint. Subsequently he was to paint other series, cows, bearded men, the surface of the earth *(Texturologies;* these paintings were easily mistaken for abstracts), Paris street scenes bustling with activity. 'My position is exclusively that of celebration', he wrote in 1959, by which time people had begun to see in his paintings not only their guttersnipe qualities but also their powerful imagery and the beauty of their coloration. In some respects the works of de Staël and of Dubuffet are akin, though the younger man always worked towards beautiful and harmonious statements while the older immersed himself in uncouth imagery. Both captured for figurative painting qualities of matter and texture and weight that had belonged to abstract painting.

240 In Britain Victor Pasmore made a similar transfer of qualities but in the opposite direction. In 1947–8 this fine and admired painter in the

275
Post-war Art in Europe

240. Victor Pasmore: *The Snowstorm (Spiral Motif in Black and White)*. 1950–1. Oil on canvas, 47 × 60 in. London, Arts Council of Great Britain

tradition of Whistler and Turner abandoned representation and occasioned a heated public debate on the old issue of abstraction versus figuration. It was easy then to overlook the fact that his apostasy had been far from total, that many of the qualities praised in his earlier paintings could still be found in his abstract work. His statements rapidly became radical: the future of painting lay not only in abstraction but in the three-dimensional development of form. Biederman had made the same assertion. Pasmore, however, did not entirely abandon two-dimensional painting and was to return to it later as his main pursuit. In the fifties his stance was firmer. He preached an abstract art of material elements placed in real space, basing himself on Biederman and also on at least the title of Kandinsky's Bauhaus book, *Point and Line to Plane* (1926). Those words, extended to the developing of planes in space, formed the synopsis of a course of instruction Pasmore invented for art schools. A 'basic' course suited to be the first programme for artists and designers alike (echoing the *Vorkurs* or preliminary course established at the Bauhaus and variously run by different teachers there, of which little was known however), it proceeded by the intuitive deployment of what seemed to be the fundamental grammar of art and design; others, taking up Pasmore's programme, preferred to start with colour. In any case, although such a course in no way prohibited the application of what was learned to figuration, it opened up in students a sensitive, constructive response to the qualities of abstract form: the representation of real objects, it implied, was an additional possibility rather than the starting point from which one might or might not reach out towards abstraction. In the fifties Pasmore's example supported a broad range of abstract art in Britain, including a Constructivist movement that tended to be more rigorous than he; in the sixties he and others, such as Coldstream, guided the reorganizing of British art schools into markedly more professional and enquiring institutions than they had been.

This reorganization was at once a response to changes under way in British art and the establishing of its essential support system. There was a new sense of ambition, a new impatience with conventional British views of the artist as a kind of poet proceeding by visual means but essentially a nature lyricist. The brief Vorticist adventure on the eve of the first world war had been a start in the same direction. The pioneering efforts of Moore, Nicholson, and others in the early thirties provided a more direct stimulus. Most important now, however, was the recognition that culturally as well as geographically Britain stood between Europe and America. Moore and Nicholson had proved that British artists could attain international stardom; others, painters and sculptors, had achieved international success, notably the painters associated with St Ives and thus also with Nicholson but not stylistically his disciples. The St Ives painters had allegiances to Paris but had also been amongst the first anywhere to respond to Abstract Expressionism. Their own work was not of one kind but tended to embody landscape qualities in abstract configurations: qualities of space, form, solidity against the openness of sky and water, motion as in birds and boats. To this extent it seemed fully in the British tradition; where it departed from it, as Pasmore's also did, was in breaking the old concord with literature. Until the fifties it had

241

been surprisingly close. Sickert, of Danish parentage and artistically close to French Impressionism, was one of very few major painters in Britain who had not supported that convention; most of the time he was emphatically a visual painter, yet even he invented some of his best-known paintings as visualizations of a dramatic scenario. The British enthusiasm for Post-Impressionism and Fauvism had produced a school of painters whose preferred subjects were of the non-literary sort, portraits, still lifes, simple landscapes, but their work remained curiously tentative and its partial success within the country owed much to the unquestioning support of the informal literary tribe with which it was associated, the Bloomsbury Group. Landscape painting, a major stream in British art ever since the coming of Romanticism, tended to carry implications of literary meaning, perhaps because of the powerful tradition of English landscape poetry and rural fiction. At times this has carried over into abstract work, as in the case of Pasmore. He was conscious of the burden and sought to elude it. In 1949 he claimed an alternative though scarcely new allegiance for abstract art: 'It associates

241. Roger Hilton: *October 1956*. 1956. Oil on canvas, $29\frac{1}{2} \times 35\frac{1}{2}$ in. Private collection

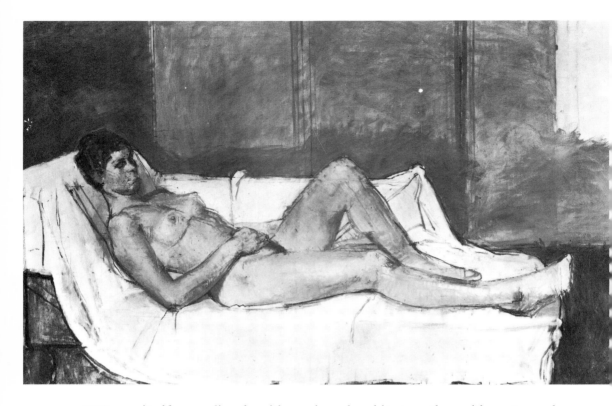

242. William
Coldstream:
Reclining Nude.
1953 – 4. Oil on
canvas,
$34\frac{1}{4} \times 53$ in.
London, Arts
Council of Great
Britain

itself more directly with music and architecture than with poetry and
drama.' The St Ives painters also sought to elude the embrace of
literature. With Pasmore, their work stressed the independent, object-
like quality of the means of painting even if it included references to
landscape. A similar effort was made by painters at the other end of the
abstract-figurative spectrum. William Coldstream and some painters
associated with him had since the end of the thirties concerned
themselves with painting as a quasi-scientific pursuit of exact repre-
sentation of three-dimensional objects on a two-dimensional surface via
persistent binocular observation. They were not after style, nor pictorial
charm, no fine passages of paint or sweet lines, nor, above all, anecdote,
but undiluted and undecorated transcription as process and aim, with the
end result, the picture, almost a by-product, an unavoidable but
troubling recipient of the process. 'Prose painting!', Coldstream is said to
have exclaimed in front of a painting by Jacques-Louis David, the painter
of the time of the French Revolution: 'Anyone can get away with poetry.'

The ambitions of the painters associated with the Situation exhibitions
held in London in 1960 and 1961 were the extreme opposite to that of
Coldstream and his followers but echoed his firmness. Prose not poetry,
once again, and to them the landscape elements in St Ives painting were
vestiges of the English weakness for sweetening every pill and hedging
every bet. The twenty painters included in the first of the two Situation
exhibitions did not share a style but their work tended to be large where
much St Ives painting was modest in size, and flat or in effect coming
forward from the wall where St Ives painting mostly employed the

receding space of landscape. And although Situation painting included some soft forms and loose brushwork, it rejected both the personal handwriting of St Ives painting and the dramatic action of the Abstract Expressionists. This younger generation was ambitious to stand on an international stage, and they brought energy and debate into the British art world, partly in emulation of the professional wholeheartedness some of them had experienced in New York. Yet there remain qualities in their work that future historians will probably designate as local; a quirkiness, a reluctance to be identified with totally unambiguous pictorial statements, sometimes a suavity of colour that compensates for a tight pictorial structure. Yet these characteristics may also point to an element of doubt within this new tradition of large-scale, bold abstraction; it hints at developments in British painting that no one then foresaw but that followed hard upon Situation's heels.

One sculpture was shown in the 1961 Situation exhibition—a large assemblage of rough steel beams, sheet and angles, bolted and welded and painted brown, placed directly on the gallery floor, and entitled *Sculpture 1*. It was the work of Anthony Caro, recently returned from a few months in America, where he had made contact with David Smith and with Kenneth Noland and other young painters. His was by no means the first abstract or constructed sculpture produced in Britain, and it is not easy to explain the immediacy of Caro's rise to a dominant role in British sculpture, even allowing for his sculptor's intelligence, his effectiveness as teacher and the large exhibition he was able to put on in London as

243

243. Bernhard Cohen: *Painting 96.* Oil on canvas, 96 × 144 in. Liverpool, Walker Art Gallery

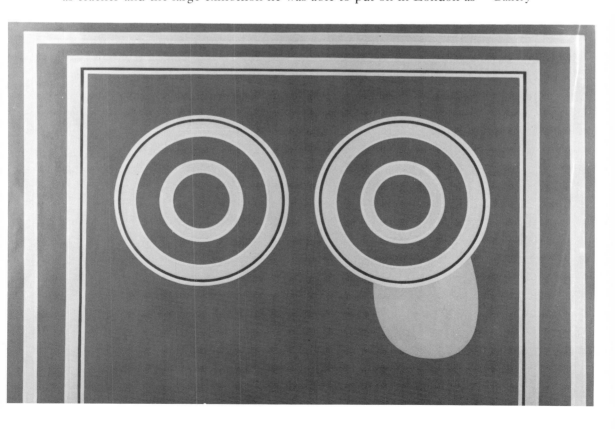

early as 1963. Certainly his new work stood apart from the abstracted and distorted figuration that dominated British sculpture in the fifties and to which he had himself contributed. What distinguished the new Caros from other abstract sculpture, in America as well as here, was their avoidance of any reference or significance other than that inherent in relationships of coloured forms in space. Every sculpture, every part of every sculpture, was to be pure sculpture. Placing the sculpture directly on the ground, indoors or outdoors, asserted its factuality: it is not on-stage, it does not perform 'as if', its dimensions are its actual dimensions. It is fair to say that the intellectual and aesthetic basis for such work had been explored for Caro by the painters he admired, but then one has to add that the object-ness they sought is never quite unambiguously to be achieved in painting. It finds its full realization in Caro's sculpture. By the mid-sixties he was demonstrating the rich resources of what may sound like a very limited form of art, and abandoning some of the solemnity with which he had launched it. His sculpture varied surprisingly widely in mood without abandoning constructed metal, usually with colour. So confident was his position within the new idiom that he could give some of his sculptures lyrical titles such as would have signalled everything bad about British conventionalism a few years earlier: *Month of May*, *Early one Morning*. Perhaps, again, this suggests a British reluctance to pursue one particular character or role with knitted brow. Perhaps it reflects some of the changes in contemporary British art by then in full cry.

244

245

244. Anthony Caro: *Lock*. 1962. Painted steel, $34\frac{1}{2} \times 111 \times 120$ in. Collection of T. M. and P. J. Caro

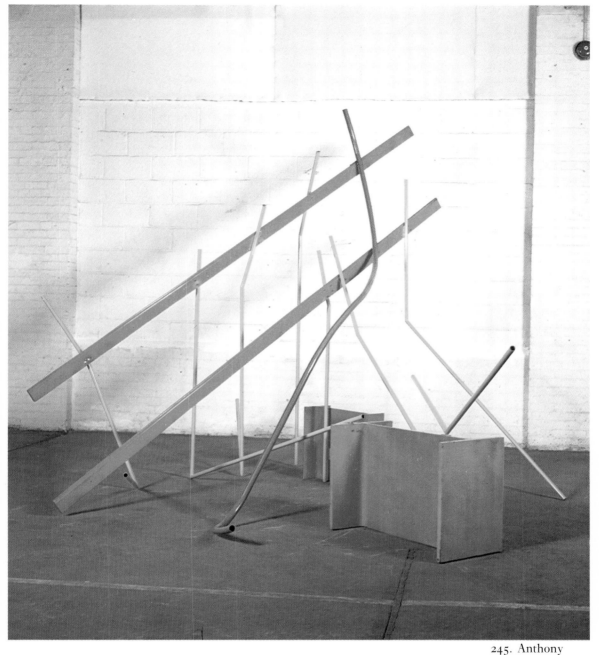

245. Anthony
Caro: *Month of
May.* 1963.
Aluminium
and steel,
110 × 120 × 141 in.
London, collection
of T. M. and
P. J. Caro

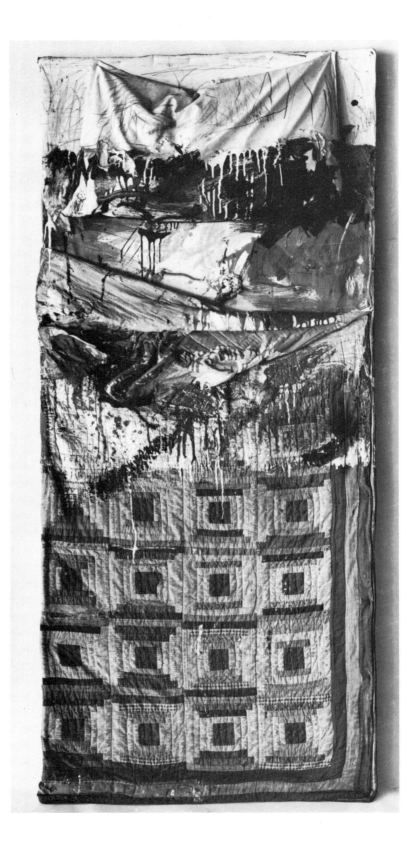

246. Robert
Rauschenberg:
Bed. 1955.
Combine
painting,
$75\frac{1}{4} \times 31\frac{1}{2} \times 6\frac{1}{2}$ in.
New York,
collection of Mr
and Mrs Leo
Castelli

9 Recent Painting and Sculpture

In philosophy one feels *forced* to look at a concept in a certain way. What I do is to suggest, or even invent, other ways of looking at it. I suggest possibilities of which you had not previously thought ... Thus your mental cramp is relieved, and you are free to look around the field of use of the expression and to describe the different kinds of uses of it.

Wittgenstein, quoted by Norman Malcolm in *Ludwig Wittgenstein—a memoir*, 1958

In 1955 the American painter Jasper Johns, aged 25, produced a series of American flags. He used an old medium, pigment mixed with wax; the result was a fine old-masterly richness that upstaged the dribbling and staining of the Abstract Expressionists and their successors. Yet when these paintings were first exhibited in New York, in January 1958 at Leo Castelli's gallery, they gave offence. Was Johns mocking the national flag or honouring it? Many countries, including the United States, have laws against making sport of the national emblem. Was he mocking painting? No law against that, but irritating to a national art-world basking in the warmth of recent international acclaim. Some of the paintings show nothing but the flag; they look like home-made flags. In others the flag occupies part of the canvas—the centre of the upper part, where the head would come in a typical portrait—set against a background of contrasting colour. Some paintings are entirely white: texture and slight variations in whiteness alone reveal stars and stripes. In one, flag paintings are
247 mounted on top of each other, the smallest to the front like in a commercial display. Is it an artist's business to display his paintings in gradated sizes, as though they were suits or suitcases? In other paintings he turned from flags to numbers, to targets and then also to maps of the United States, but he also made paintings without such evident and imposing motifs. A key instance is *Canvas*, which consists of a small canvas stuck face-to-face on to a larger canvas. Where and what is the motif here? Painting and painter remain silent.

Also in 1955 Johns's friend Robert Rauschenberg, aged 30, executed a series of combine paintings, as he called them, strong, clamorous compilations of this and that, including painted and often photographic
246 images taken from newspapers and magazines. *Bed* is one of the most striking. It implied extreme degradation—of the person associated with the object and also of art. Rauschenberg went on for some time making similarly disconcerting objects, but his exhibition of March 1958, also at the Castelli gallery, included paintings that announced what was to be his main interest. *Factum I* and *II* have the same borrowed images combined with Abstract Expressionist brushwork. These human, individual marks

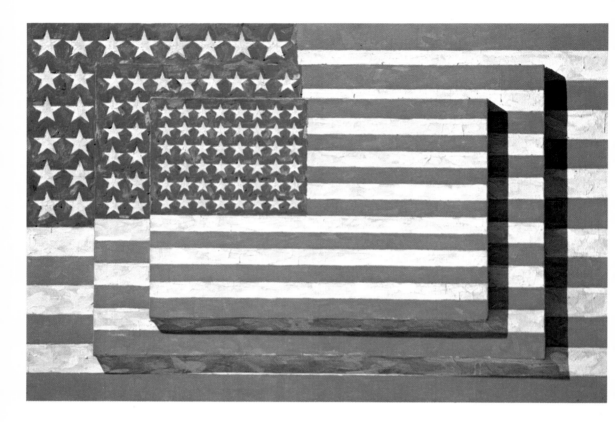

247. Jasper Johns: *Three Flags*. 1958. Encaustic on canvas, $30 \times 45\frac{1}{2} \times 5$ in. Meriden, Connecticut, collection of Mr and Mrs Burton Tremaine

seem to counter the mechanized, purposeful signals we get from the press photographs, calendars, etc., and advertise the artist's presence. But they give no hint of any intention or attitude, and in case we are tempted to read anything poignant into them Rauschenberg repeats the marks of *Factum I* in *Factum II*, not exactly but approximately, as though it did not matter. The first painting looks arbitrary, pointless; repeating it forces us to acknowledge that.

248
249

Whatever interpretations one brought to such novelties, one thing was clear: they belonged neither to the Abstract Expressionist school nor to that of the cool and elegant school of Post-Painterly Abstractionists. Were they perhaps mocking both? One way of coping with them was to deny their newness, to identify them as Dadaist gestures, as nihilistic challenges to America's high and solemn art. (Parallels with the Berlin Dadaists' denunciation of Expressionism in 1918 suggest themselves, but Huelsenbeck and his friends were motivated by social ideals and could justify their vehemence in terms of the war, whereas Johns and Rauschenberg seemed to be breaking in upon a cultural honeymoon.) What was unmistakable was the painters' taste for banal motifs and processes. Was it not the business of art to counter the banalities of daily life?

248 (opposite). Robert Rauschenberg: *Factum I*. 1957 Combine painting, $62 \times 35\frac{1}{2}$ in. Milan, Panza Collection

Though relatively isolated for a while in America, Johns and Rauschenberg were not alone. In London, during the years 1952 to 1955, a small group of artists, designers, and art historians was analysing the

symbolism and presentation of mass imagery as found in films, comics, advertising and in consumer-orientated design. Here was an alternative world, not valued and hardly studied except by its own creators but built by them with marked professional seriousness and sometimes verve, and evidently of potent appeal to a much larger section of mankind than would ever be reached by art. Since it tested itself continuously against consumer response, it could be seen as a form of mass-society folk art. The group had no certainty where their studies would lead, but artists in the group tended to reveal their interest in mass imagery by incorporating specimens of it in their art, often in a primitivist way. In 1956 an exhibition called 'This is Tomorrow', intended to show ways in which architecture and the visual arts could collaborate, included a particularly surprising display organized by the painters Richard Hamilton and John McHale with the architect John Voelcker. It consisted of advertising material, brought together but otherwise unchanged: a large dummy beer bottle, a large image of Marilyn Monroe (then emerging as a major international star), and a huge science-fiction monster carrying off the usual fainting blonde, recently displayed on the façade of a large cinema

249. Robert
Rauschenberg:
Factum II. 1957.
Combine
painting,
$62 \times 35\frac{1}{2}$ in.
Chicago,
collection of Mr
and Mrs Morton
Neuman

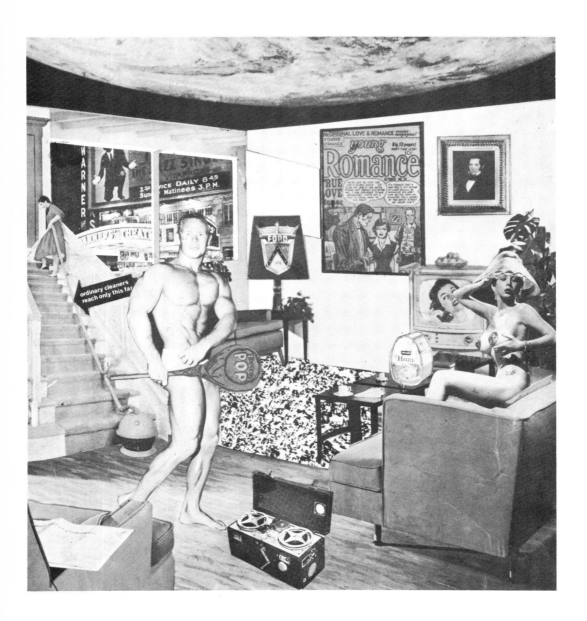

250. Richard Hamilton: *Just what is it that makes today's homes so different, so appealing?* 1956. Collage on paper, $10\frac{1}{4} \times 9\frac{7}{8}$ in. Tübingen, Kunsthalle (Dr Georg Zundel Collection)

overlooking Piccadilly Circus. It was not clear whether the public was being asked to accept this arrangement as a work of art; the exhibition as such did not suggest an art show. For its poster Hamilton had produced a now famous collage that consists of ready-made motifs culled from many non-art sources, apparently to summarize the life and dreams of everyman in the Western world: film and television, tinned food, compliant home appliances, male beefcake and female cheesecake and, on the sitting room wall, overshadowing the ancestral portrait, the cover of *Young Romance* presented as a painting. Hamilton's insistence on making art from commonplaces, could be seen as anti-traditional. But his manner was traditional: before all else the picture resembles a type of Renaissance painting depicting the five senses of man. It also suggests a seventeenth-

century Dutch genre painting of a couple at home plus glimpses of a servant at her tasks and the urban world beyond.

In subsequent paintings Hamilton pressed his investigations further, fusing his thematic material with processes that were far from primitivist in their care and self-consciousness. *Hommage à Chrysler Corp* is:

> a compilation of themes derived from the glossies. The main motif, the vehicle, breaks down into an anthology of presentation techniques. One passage, for example, runs from a prim emulation of in-focus photographed gloss to out of focus gloss to an artist's representation of chrome to

251

251. Richard Hamilton: *Hommage à Chrysler Corp*. 1957. Oil, metal foil and collage on panel, 48 × 32 in. Private collection

an ad-man's sign meaning 'chrome'. Pieces are taken from Chrysler's Plymouth and Imperial ads, there is some General Motors material and a bit of Pontiac ... The sex symbol is, as so often happens in the ads, engaged in a display of affection for the vehicle. She is constructed from two main elements—the Exquisite Form bra diagram and Volupta's lips. It often occurred to me while I was working on the painting that this female figure evoked a faint echo of the Winged Victory of Samothrace. The response to this allusion was, if anything, to suppress it. Marinetti's dictum 'a racing car ... is more beautiful than the Winged Victory of Samothrace' made it impossibly corny. In spite of distaste for the notion it persists. The setting of the group is vaguely architectural. A kind of showroom in the international style represented by a token suggestion of Mondrian and Saarinen. One quotation from Marcel Duchamp remains from a number of rather more direct references which were tried. There are also a few allusions to other paintings by myself.

Hamilton's words reveal, as intended, a great deal. He wrote them originally to go with a version of the painting specially prepared to serve as a full-page illustration in an architectural magazine (*Architectural Design*, March 1958); they were reprinted in the catalogue of his 1964 one-man show in London. He wanted the spectator to know what he was doing; he wanted the spectator to know that he knew what he was doing, that he was working with intelligence as well as artistic judgment. Had Sir Joshua Reynolds wished to add a commentary to one of his more elaborate compositions, such as the *Three Ladies adorning a Term of Hymen* of 1773, he might have written similarly about his sources and their implications—about the classical prototypes from which he drew the Three Graces and the image of Hymen, about the classical forms he adopted from Poussin and Rubens, and about the symbolism of the poses and actions of the three girls and their relevance to the sitters whose historied portrait the whole thing is. He would have made it clear that his grand but also charming painting was intended to appeal to learning and intelligence as well as to the senses. But Reynolds did not need to explain his painting in this way: his public was more or less as educated as himself and his sitters would seem to have been involved in deciding on the theme of the painting. Hamilton's public needed telling. Much of the material he was using may have been familiar to them but they were disinclined to apply any kind of intellectual examination to a work of art; in any case, art and the mass media were conventionally kept firmly apart. Hamilton was asking for, so to speak, an old-fashioned awareness, but on the basis of modern mass iconography, not of classical learning, though the two are evidently neither totally distinct nor opposed. The demand needed to be made again and again. It was implied in the work of Johns and Rauschenberg. It had been blatant in the work and commentaries of Hamilton's hero, Marcel Duchamp.

'All the arts live by words. Each work of art demands its response; and the urge that drives man to create—like the creations that result from this strange instinct—is inseparable from a form of "literature", whether written or not, whether immediate or premeditated. May not the prime motive of any work be the wish to give rise to discussion, if only between the mind and itself?' Max Kozloff aptly quotes these words by the poet

Valéry at the start of his book on Johns (1968). Johns is not one to accompany his paintings with explanations. The fulsome but unrevealing statements of the Abstract Expressionists may have inclined him to silence. But his works confront us with questions about art's processes and function that lead directly into debate. Thus one of the most popular dogmas of modernist art—that art must separate itself from words, from literature, in order to elicit a more instinctual and therefore more vital response—was being controverted. We shall see in the next chapter that this was also being attempted by a growing number of other artists by means other than painting and sculpture.

The public outcome of the instances we have looked at was the Pop movement of the 1960s. This emerged concurrently and independently in America and Britain. The exploration of mass-media imagery undertaken in London prepared the ground intellectually years before Pop art surfaced and was named, but America was the prime source for that imagery and it may be that American artists, steeped in it and also inheriting a strong tradition of descriptive painting from the nineteenth century, did not need this kind of preparation. The heroic ventures into the self of Abstract Expressionism may have invited Pop art as a reaction. De Kooning hinted as much. In any case, if the then much-discussed visual and verbal arts of advertising are so invidious, as many feared, and therefore of proven effectiveness, does this not indicate their profound significance?

The word Pop was to cover a large range of different art activities. What they shared was a reliance on mass-media images and sometimes processes. Many other names were proposed for the new trend. Some, like 'New Vulgarianism', expressed the American critics' disgust; others, like 'New Realism' and 'Neo-Dadaism', suggested links with art history. The name Pop stuck because it appealed to the media, which rallied to celebrate this art movement as they had never rallied to any other, because it was entertaining as well as slightly shocking and, of course, because the media could see themselves as its collective father. Pop also implied kinship with popular music, especially with the new world of pop singers and groups, whose extraordinary global appeal and success was such a surprising phenomenon of the sixties. Some of the earliest Pop paintings done in England justified such an interpretation of Pop: they celebrated film and pop stars and other popular heroes and showed the painters (most of them in their early twenties) openly aligned with mass youth and its enthusiasms. That was the world—rather than the more sophisticated one of high commerce, as in Hamilton—from which they drew their iconography. Their styles were intentionally mixed, mingling elements from traditional folk art with the new folk art of the pinball machines and the comics, and incorporating passages of artful brush-work. Other painters in England were more concerned to show that art could once again be concerned with narrative or even polemics, accepting once again the great tradition of discourse through art. In R. B. Kitaj's case political and cultural arguments were supported by annotations that showed the painter as a highbrow equivalent to Hamilton, proud to display his wide and learned reading both in his paintings and in catalogue notes. In Hockney's art we find a more innocent response to the

252

252. R. B. Kitaj:
*The Murder of
Rosa Luxemburg.*
1960. Oil on
canvas with
collage,
60 × 60 in. Private
collection

modern world, spiced with humour and set down with outstanding graphic talent and true English charm. His series of prints, *A Rake's Progress*, tells of his experiences on a visit to New York in 1961 by means adapted from Hogarth's moralizing print sequence of 1735. Richard Smith, though his paintings, too, incorporate references to film and pop stars and to jazz, contributed a nearly abstract dimension to what was otherwise a vividly figurative art movement by exploring the formal language and visual appeal of advertising. He had been in the Situation exhibitions of 1960 and 1961. The catalogue text of his London show in 1962 (written by Roger Coleman, author also of the catalogue of the first Situation show) makes a point of saying: 'Incidentally, he is *not* a so-called "pop" painter'. Smith was, in effect, finding a place for himself between the formal interests of Situation and the mass allure of Pop, and

253

254

253. David Hockney: (above) *Receiving the Inheritance* and (below) *The Gospel Singing (Good People) Madison Square Gardens* from *A Rake's Progress*. 1961–3. Etching and aquatint, 12 × 16 in. London, Tate Gallery

254. Richard
Smith: *Panatella*.
1961. Oil on
canvas,
90 × 120 in.
London, Tate
Gallery

to help him hold that place he could call on remarkable gifts for the
handling of paint and of colour.

The British reaction to the new movement was, for a while, uniquely
enthusiastic. Fears of modernism and a general distrust of the visual arts
were temporarily set aside as a swollen public discovered the vividness
and intelligibility of this art and found itself able to deploy in appreciating
it tastes and moods that accorded with Britain's current stardom in
international fashion and pop music. British critics saw little need to
defend other directions against the newcomer, and British media showed
uncharacteristic interest in it. In America opinion first rallied to the
defence of the serious art of the preceding ten or fifteen years, though
some of the younger critics welcomed the emergence of this more easily
discussible art with evident relief. As Irving Sandler pointed out in 1962,
there was something folksy and also hip about this new American
painting, but many others saw this marriage of fine and commercial art as
a selling-out to capitalist motivation and style. It was not until about 1964
that critics found fully apt characterizations for the movement. Essays by
writers such as David Sylvester in London and Kozloff and Sidney
Tillim in New York provided a basis for a positive and discriminating
response and also for useful distinctions within the range of Pop.

For instance, British artists reacted with greater romantic warmth to
mass imagery than did their American colleagues; that largely American
imagery had a special glow in a European country where wartime

rationing, extended into the post-war years, was a recent memory. To the American the brilliant world of consumer manipulation was less unambiguously appealing. Many of its images suggested childhood appetites and adolescent adventures, but they also pointed to greed and social blindness on a national scale. American Pop art was certainly initially more challenging to art and to society than the British equivalent, but it was also more rapidly assimilated, with artists finding quick notoriety and also financial success and continuing to produce the kind of work expected from them as though to reassure the world that they were just professional artists after all. In Britain the Pop movement soon disintegrated as artists pursued their deeper individual aims. In America, the Pop artists of the early sixties are still, at the end of the seventies, Pop artists.

The range of activity within American Pop was wider even than that in British. The most blatant appeals to mass imagery were those of Roy Lichtenstein and Andy Warhol, one borrowing wholesale the visual language, subjects, and techniques of the comic strip, the other the ubiquity and drumming repetitiveness of advertising. Of course, artistic decisions and skills went into transcribing these materials, but this was largely overlooked and both artists were seen as slavish imitators of the commonplace. Yet both owe something of the quality of their work to the refinements associated with Post-Painterly Abstraction. More particularly, some Warhols invite comparison with the carefully structured compositions of Ellsworth Kelly; some Lichtensteins recall the succinct expressiveness of Japanese prints as ·well as the monumentality of traditional history painting. Both painters had had some experience of commercial art work. Both, independently, hit upon their particular graphic sources in the mass media during 1960 – 1. Lichtenstein went on to translate other motifs into the vulgate idiom of the comic strip—paintings by Cézanne, Picasso, Mondrian, and other heroes of modernism, postcards of Greek temples, sunsets and landscape, adaptations of twenties *Art Déco* design, and so on. In 1965 – 6 he did a series of large paintings exhibiting a comic-strip version of one or more broad,

255

255. Roy Lichtenstein: *As I Opened Fire.* 1964. Magna on canvas, $68 \times 168\frac{1}{4}$ in. Amsterdam, Stedelijk Museum

Expressionist brushstrokes; these were widely received as mocking the rhetoric of Abstract Expressionism. Warhol early added photographic images to his sources, transferring on to canvas single or repeated images of well-known people such as film stars (Marilyn Monroe, Elvis Presley, Elizabeth Taylor), other public figures (Jackie Kennedy, Warhol himself), and criminals, also blood-chilling subjects such as the electric chair or car crashes, and innocuous ones such as cows and flowers. The repetition on canvas of such already mass-produced imagery, and in many cases the adding of a layer of more or less arbitrary colour, has curiously ambiguous results. The image becomes both more banal and more appealing or terrible as the case may be; we are both repelled by the boringness of it all and made aware of our ready exploitation of people (Marilyn Monroe's suicide in 1962 was an occasion for widespread breast-beating in the media; the Jackie Kennedy portraits came after President Kennedy's assassination in 1963 and in several instances use photographs of her in widow's black), and of our ready acceptance of daily manslaughter in the cause of mobility. Warhol has always disclaimed any significance for his work. Among his many recorded statements is the following, published in 1968: 'The reason I'm painting this way is because I want to be a machine. Whatever I do, and do machine-like, is because it is what I want to do. I think it would be terrific if everybody was alike . . . In the future everybody will be world famous for fifteen minutes . . . if you want to know all about Andy Warhol, just look at the surface of my paintings and films and me, and there I am. There's nothing behind it.' He built up a team of friends and associates, known as the Factory, with whom he has produced paintings, novels and other books, and world-famous films starring his friends.

The work of Claes Oldenburg and James Rosenquist is related to large-scale advertising. Oldenburg in December 1961 opened as an exhibition a shop in New York which he had equipped with fittings and objects made in imitation of the average contents and appearance of a New York general store. Thus The Store was both an exhibition of individual studio-made merchandise and an art environment, surrounding the spectator and controlling his response by excluding non-Oldenburg matter. In September 1962, in an exhibition at Green Gallery in New York, he combined elements from The Store with his first giant soft objects—a *Giant Ice Cream Cone*, a hamburger as large as a bed. Other objects followed, hard and soft, multi-coloured, black or white, a typewriter, bathroom fittings, a car engine, an electric fan, ice creams and other foodstuffs, cigarette ends, etc., some designed (and some executed) as outdoor monuments. Wit and good humour competed with the essentially surrealistic magic achieved via outlandish scale and via valuelessness, as in the case of cigarette ends. We normally reserve monumentality for symbols of divine or worldly significance. By at once challenging and indulging our taste for public rhetoric, Oldenburg is forcing us to question the occasions we normally choose, or find chosen on our behalf, for it. Rosenquist spent some months as a billboard painter before developing his particular form of billboard-like surfaces filled with apparently disparate, mutually interrupting images that look like sections

256

257

258

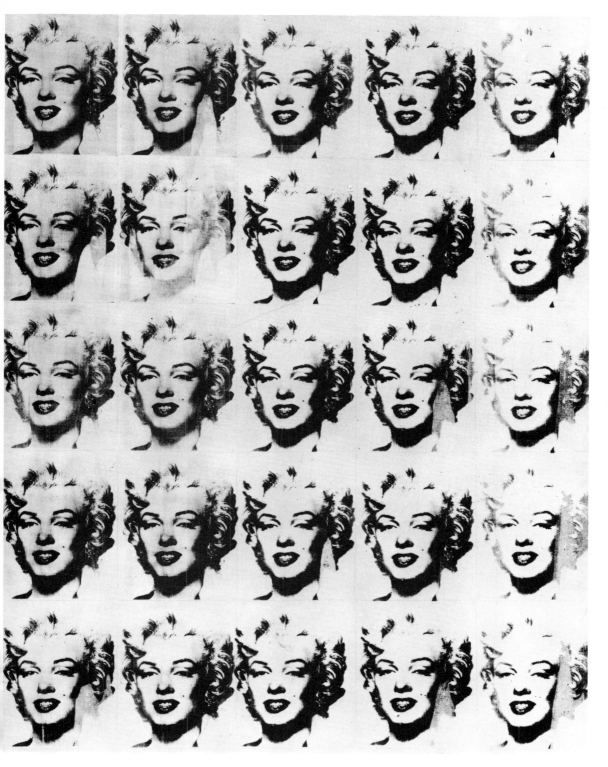

256. Andy Warhol: *Marilyn Monroe*. 1962. Silkscreened enamel and acrylic on canvas, 82 × 55 in. Stockholm, Moderna Museet

assembled from a number of separate hoardings. The specific message of his art is even less clear than his fellows', even when it seems to be political, but his work expresses unmistakably the shallow aspirations and satisfactions of the prosperous strata in Western societies. Tom Wesselmann's images, too, illustrate the dreams of Western man, though at a lower social level and with more feeling of indulgence: invitations to make love, to eat, to listen to the radio or otherwise get through the day are built into paintings and assemblages that echo the careful management of silhouette and space that Ingres brought to early nineteenth-century portraiture. 259

Many other artists on both sides of the Atlantic produced paintings and also sculptures that could be classed as Pop. The art movement rapidly spread to become as international as the consumer society itself, even if it tended to have an American accent. The painter Martial Raysse applied Pop's mass-media idiom to parody—and in parodying also to celebrate—honoured monuments of French art. *Made in Japan in Martialcolor* is a consumerized version of a painting by Ingres, the great 260
champion of classicism in the Romantic period: the suave image, now associated with mass-production, keeps much of its appeal but exercises it in the supermarket. Pop, it is clear, was not a style, nor really a range of subject-matter though subject-matter was once again of refreshing importance in determining the spectator's response; it was above all an invitation to explore, to become critically conscious of, the forms of communication through which the trivia of everyday life in the Western

257. Glaes Oldenburg: *Giant Ice Cream Cone.* 1962. Canvas filled with pieces of foam rubber and paper cartons, painted with liquitex and latex, length 120 in., diameter 36 in. New York, private collection

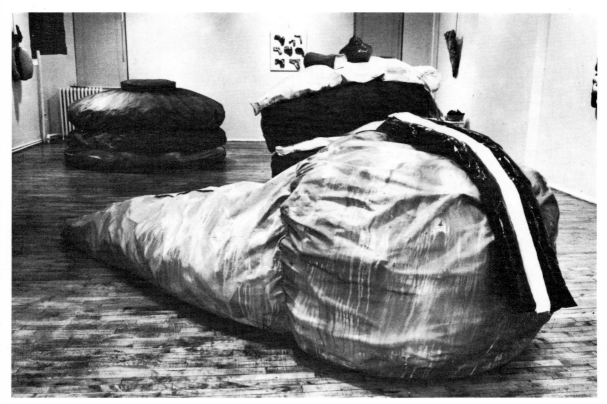

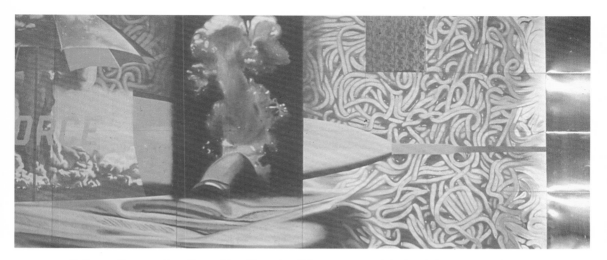

258. James Rosenquist: *F-111* (detail). 1965. Oil on canvas with aluminium, one of four panels, each 10 × 86 ft. New York, private collection

259. Tom Wesselmann: *Great American Nude No. 99.* 1968. Oil on canvas, 60 × 81 in. Courtesy Sidney Janis Gallery, New York

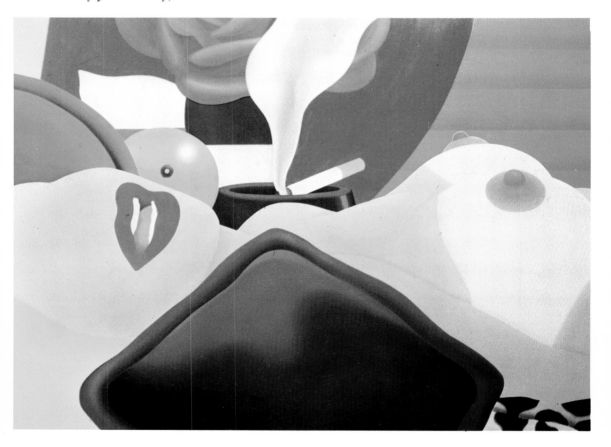

260. Martial Raysse: *Made in Japan in Martialcolor*. 1965. Acrylic on canvas and collage. Private collection

261. Ed Kienholz: *The Portable War Memorial*. 1968. Environmental construction with Coca-Cola machine, $9\frac{1}{2} \times 8 \times 32$ ft. Cologne, Ludwig Museum

world are kept seductive to Western eyes. Its most immediate artistic consequence was that figuration was once again normal in avant-garde circles. Indeed, a great part of Pop art is concerned with more or less direct description of aspects of reality (we cannot but accept that the flood of media words and images is part of the real world), and usually it aims at a high degree of naturalism as well as at that vein of criticism that is implied in realism. Ed Kienholz's tableau *The Portable War Memorial* can stand here for a broad stream of international work of this kind, often in three dimensions, combining passages of extreme naturalism with surrealistic stage-management. The conquering soldiers (taken from a Korean War photograph) are juxtaposed with a common roadside refreshment bar; a functioning coke machine invites the spectator to become part of the tableau while the strains of an ultimately unbearably self-regarding national hymn, 'God bless America', issue ever and again from a bin-shaped lady on the left. Such works, as also some by Rosenquist, Warhol, and others, make great demands on galleries and owners, similar to those we noted in connection with Newman, Rothko, and Still, but are even more totalitarian in that here the demand is not so much for perfect visual presentation as for space and, with it, some surrender of the need for peace and privacy of other art works. As this in itself implies, Pop raised questions also concerning the nature of art, not only on the visual level of advertising technique. Lichtenstein painted a largish picture showing nothing but the word ART in smart shadowed capital letters that would serve well on a shop front. A painting by John Baldessari exhibits merely advertising phrases recommending the painting to the spectator in rather less up-market lettering. One of Keith Arnatt's exhibits in a Tate Gallery show of 1972 was the following words painted on the white wall of an otherwise bare space: KEITH ARNATT IS AN ARTIST. He also provided a linguistic analysis of the statement to be read

261

262

263

262. Roy Lichtenstein: *Art*. 1962. Oil on canvas, 36 × 68 in. Minneapolis, Locksley Shea Gallery

KEITH ARNATT IS AN ARTIST

by such spectators as could muster the intellectual energy, but the issue
was not linguistic. It was the old and continuing one: what is an artist,
what is a work of art (what differentiates it from things we do not call art),
what is the function of places and occasions set aside for art?

Thus the art of the sixties and seventies, burdened both by Western
man's questioning of the values of his society and its standing in the wider
world and by his vast consciousness of the strengths and limitations of the
art of the past, veers between two poles. At one end of the range is the
artist who labours to produce beautiful and significant works of art,
usually within existing categories of art: the Matisse tradition, let us say.
At the other stands the artist who works by various means to question art
and challenge unconventional complaisancy about art's place and role in
the world: the Duchamp tradition. In Chapter 1 of this story we spoke of
Matisse as the challenger, but his challenge went out to accepted styles,
almost manners, of art, and any deeper social criticism can only be
thought of as implied in that. The sixties and seventies have witnessed the
creation of a great deal of very fine, subtle, poetic or dramatic painting
and sculpture, the very quality of which is held by many to justify its
existence and its recognition in the institutions of art. Perhaps we should
go further and see this persistence within categories of art often called
obsolete as a positive challenge to the revolutionaries to let art grow
naturally out of the desires and talents of working artists and not demand
adherence to a strategy of change worked out intellectually and in accord
with social theory. Chapter 10 will deal with the rise of other art activities,
calling for new categories and new institutions. We shall end here by
referring to other developments in 'the Matisse tradition'. Pop, it is clear,
was ambiguously placed within this spectrum of art attitudes. The
effective use of colour, form, scale, etc., is as much part of the ad-man's
concern as the particular messages he must promote, and awareness of

this side of mass-media effort stimulated renewed explorations of the visual bases of art. It gave support, for instance, to the keen, almost scientific, examination of visual phenomena that had brief fame as Op art (short for 'optical'). In Op art stimulation of the retina is the chief, usually the only, means of communication, and the intention is to produce physiological visual responses in the spectator.

265 266 As this may suggest, a lot of Op art was content with setting up clever perceptual games by means of two- or three-dimensional objects, moving or still, with or without built-in lights. Interest in such things was necessarily short-lived, and not much Op art has retained its standing as
264 art, the main exception being the work of Bridget Riley. In 1960 she began to adapt diagrams through which scientists were studying perceptual processes in order to paint powerful black-and-white paintings. After ever subtler ventures in this field, she began to introduce greys and then other colours also. Optical stimulus for its own sake was never her aim. Riley sees the elements she uses as part of nature, as are the elements of landscape—trees, clouds, hills, and rivers—and she works to weave these elements into magic appearances that are much more than the sum of their formal and colouristic parts. Perhaps they correspond to the 'celestial light' that the world bore for us in childhood, if Wordsworth is right. Their effect is certainly lyrical, poetic, rather than scientific.

Pop art also gave support to a tendency in painting, presented as a coherent movement in a series of American exhibitions from 1969 onwards, and at first glance worlds apart from Op art. Photo-Realism was allied to Pop though its dependence upon the photograph for image and

264. Bridget Riley: *Late Morning*. 1967. Acrylic on canvas, $89\frac{1}{8} \times 141\frac{5}{8}$ in. London, Tate Gallery

265. Victor Vasarely: *Metsh*. 1964. Gouache, $15\frac{3}{4} \times 15\frac{3}{4}$ in. London, private collection

266 (opposite). Jesus Raphàel Soto: *Horizontal Movement*. 1963. Oil bound distemper on chipboard with iron rod, $24\frac{1}{2} \times 20\frac{3}{4}$ in. London, Tate Gallery

method. Again, the range of artists included under this heading is wide (in fact many painters since the middle of the nineteenth century have worked directly from photographs). Malcolm Morley, for instance, has carefully copied magazine photographs on to large canvases since the mid-sixties, inviting comparison and also contrast with Warhol's photomechanically transferred photographic images. But Morley insists on disclaiming any interest in the subject-matter of his chosen images. He claims to paint them upside down in order to escape being influenced by the meaning of the colour and tone changes he is copying and to concentrate on its surface qualities. 'Everything is useful, everything is a suitable subject for art', he has said, like many an artist before him. Yet paintings such as *Race Track* suggest selection for meaning rather than surface: the sunny photograph of a glamorous pastime enjoyed in South Africa, here crossed out threateningly in blood red. Compared with this, most Photo-Realism has been cool and non-committal. Many of the artists take photographs of bits of the world about them and make

267

paintings by projecting them on to the canvas and painting them in with the projected image as control. These may well be the most purely descriptive paintings possible. Particularly attractive examples have come from Richard Estes. What makes work of this sort valid is the wealth of artistic decisions made consciously and unconsciously along the way, combined with visual data that could not be held in their complexity without the help of the projected image. The camera sees with an objectivity limited only by technical parameters; even the most objective of artists cannot give his attention to a scene with such open-handed

egalitarianism, and it must follow that he must in some degree personalize also his reading of the photograph. In any case, he photographs this scene and not that, and uses this transparency of it and not another taken at the same time. He determines on a painting of this size rather than another, and is then still faced with the problem of fixing in terms of pigment an image he holds in terms of light. At its best, painting of this kind offers many pleasures, and with them also matter for thought. In *Food Shop*, for instance, there is the rich interplay of different surfaces and levels as we look at and through the restaurant's window, whilst catching in it reflections of the other side of the street. There is the contrast of broad areas without detail (simplified by the artist?) and the clutter of detail here and there; there is the socially significant contrast between the commercial front with its discordant styles and the solemn classicism of the almost totally obscured architecture of the building itself; there is also (of particular interest to Estes, judging by his preferred subjects) the multiplicity of kinds and levels of lighting offered by the subject and captured for him by the camera. Such magic, for all its debt to the camera, is not totally distinct from that of the best Op painting.

268

Hyper-realistic sculpture based on photographic information outbids Photo-Realist painting in realism if not in magic. At the other extreme, under the name Minimal art and deriving some force from the techniques of advertising, we find a form of sculpture that adopts only the simplest

267. Malcolm Morley: *Race Track*. 1970. Acrylic on canvas, $68\frac{7}{8} \times 86\frac{5}{8}$ in. Aachen, Neue Galerie, Ludwig Collection

268. Richard Estes: *Food Shop*. 1967. Acrylic on canvas, $65\frac{3}{8} \times 48\frac{5}{8}$ in. Cologne, Ludwig Museum

269

269. Donald
Judd: *Untitled*.
1966. Galvanized
iron and blue
lacquer on
aluminium,
40 × 190 × 40 in.
Pasadena, Norton
Simon Museum
(gift of Mr and
Mrs Robert A.
Rowan, 1966)

and barest of forms, singly or in repetition, but can produce surprising
illusions or hitherto unnoticed visual phenomena. Here too what had
been a number of individual artists' preferences were corralled into a
movement with a name, primarily through exhibitions shown in 1966.
The range covered by it goes from monumental indoor or outdoor
structures to much more discrete formal arrangements in which content
is given by the play of form against void or, sometimes, by the
development or inflection of simple forms according to a preconceived
rule or system. Man's respect for the basic solids goes back, via countless
modern works and Neo–classical monuments, to the Pyramids. In its less
rhetorical instances, Minimalism indicates an appetite for clarity and
understatement; the more grandiloquent instances echo the tone, if not
the idioms, of the hoarding. All of it proposes art as specifically a man-
made object set up against the flux and profusion of nature.

The groupings invented in this way serve not only commercial ends.
We have few concepts to help us relate intelligently to recent art, and it
seems to be in the nature of art, since the Renaissance perhaps, certainly
since Romanticism, that it should attempt to elude the understanding we
bring to it. There is no reason why it should not do so. Those who would
command art to put general intelligibility first condemn it to repetition of
the known. Time has shown that the difficult art of yesterday can become
the unquestioned and even the popular mode of tomorrow. It is also in
the nature of almost every artist to wish to be seen and valued. Being
enrolled as contributing to a tendency is a way of becoming noticeable,
and the theories with which each tendency is associated by its supporting
writers provide the art world and the wider public with the first means of
access. These theories, as we have seen repeatedly, relate to the obvious
and superficial aspects of the tendency and may well be what the
individual artist is working away from. Not just in order to be different

from his fellows: the definition that works is likely to describe only the process or the raw material of the group's art. A rough analogy could be found in the matter of food. We have raw food, boiled food and baked food, but we do not expect all the foods in each category to taste or to be the same or to serve the same dietetic function. To assume that the categories stand for true identities could be a dangerous mistake. To do without categories at all could prevent all understanding.

To end this chapter we shall look briefly at a variety of paintings and sculptures of recent times and avoid approaching them via the labels they are asked to support. Even though we can use only a very small number of examples, considering the range of work being produced, the effect may well be comparable to eavesdropping on the Tower of Babel. But need we worry so much about that 'confusion of tongues'? A shared language has never guaranteed peace and understanding; multiplicity of languages enriches mankind. Painting and sculpture can be many things, but they are all visual statements made by fellow human beings. Not all are equally significant but we shall learn to recognize significance only by listening to many and prejudging none.

270 The American painter Agnes Martin marks her often square canvases with regular but imprecise lines that are barely visible and tend to elude reproduction techniques. The colours she uses are gentle, so that her canvases seem to give off light which she inflects by means of her linear filters. Her words, when she speaks about painting, are not about

270. Agnes Martin: *Morning.* 1965. Acrylic drawing on canvas, $71\frac{7}{8} \times 71\frac{7}{8}$ in. London, Tate Gallery

271. Juan
Genovés: *Beyond
the Limit*. 1966.
Oil on canvas,
$51\frac{5}{8} \times 43\frac{1}{4}$ in.
London,
Marlborough
Fine Art Ltd

geometry or economy of means but about joy, the 'holiday state of mind'. The Spaniard Genovés paints images of oppression, using the photographic scenes of violence that are our daily news and entertainment. He imitates the tones and elisions of the original but ignores the normal adjunct, the explanatory caption. The resulting anonymity leaves our responses in doubt. Are the victims terrorists, enemies, our fathers, ourselves? Is he contributing to the trivialization of violence by its ceaseless representation or counteracting it? Carl Plackman, the British sculptor, assembles and sets up carefully considered groups or roomfuls of found and shaped matter, sometimes including words and images. Their purpose is symbolical. He can if asked explain the meaning of every part and its relevance to the whole, but rather than ask we are invited to engage our own sensibilities and recollections with his. Just as an

271

273

impression on the retina can produce a visual sensation known as an after-image, so perhaps can thoughts and their embodiment in matter produce
274 afterthoughts in us. Arakawa, the Japanese painter who lives in America, uses the canvas as a surface for semi-mysterious verbal and pictorial expositions that open up questions of meaning in language as well as in the visual arts.

272 The American sculptor Dan Flavin has since 1963 specialized in setting up fluorescent light tubes in relation to particular spaces. He avoids all hint of symbolism but works with lines of light in varying dimensions and thus quantities, and with interval and rhythm. He plans the arrangement; electricians execute it. There is no hint of a meaning in the usual sense. Instead of drawn lines or brushstrokes, lines of light; instead of area or volume, the partly controlled radiance. The Italian painter Michelangelo Pistoletto mounts life-sized photographs of figures on a large polished steel sheet which reflects their setting, including us and any objects such as other works of art (Pistolettos perhaps) that may

272. Dan Flavin: *Untitled (to the 'Innovator' of Wheeling Peachblow)*. 1968. Fluorescent lights and metal fixtures, $96\frac{1}{2} \times 96\frac{1}{4} \times 60\frac{3}{4}$ in. Collection, The Museum of Modern Art, New York (Helena Rubinstein Fund)

273. Carl Plackman: *Any Place You Hang Your Hat: Wedlock.* 1977–8. Wood, plaster, slate, cloth, glass, striplight, 84 × 144 × 18 in. Bristol, Arnolfini Collection Trust

274. Shusaku Arakawa: *Anything No. 2.* 1969.

be at hand. The realistic illusion is extreme, but so is the unreality of the monochrome, immobile figures amongst the reflections which move of their own accord or as we change our angle of vision. Another Italian, Valerio Adami, paints pictures that seem to offer themselves as easily read compositions in a comic-strip or animated-film idiom, only to elude our understanding the moment we try to assimilate them. Everything in them is familiar; everything is different, wrong. Yet the sense of familiarity remains and it is a profoundly disconcerting feeling we get with it, for the details he harps on (fingertips, for instance), however unjustifiably placed

275
276

275. Michelangelo Pistoletto: *Self-Portrait with Soutzka*. 1967. Transparent painted paper on Inox polished steel, $90\frac{1}{2} \times 42$ in. United States, private collection

or scaled in his picture, insist on our awareness of them and match ancient irritations deeply lodged in our minds. The American sculptor Larry Bell turned in 1970 from making semi-transparent glass cubes to making larger sculptures of hinged sheets of glass which thus became environmental in effect, in contrast with his smaller, object-like cubes. The glass is coated with metallic compounds to make portions of it opaque and reflecting. The number of sheets, their arrangement, and the quantity and composing of their opaque portions, can all be varied according to their setting. The result is quite mysterious as we are forced

276. Valerio Adami: *Bedroom Scene*. 1970. Acrylic on canvas. Private collection

277. John Walker: *Conservatory*. 1978–9. Oil on canvas, 80 × 62 in. New York, private collection

to relate ourselves to these structures, which stand in our space yet give us contradictory and unreliable information about where they and we are in relation to each other. Finally, the English painter John Walker disposes hard and soft areas of colour, mists and textures, precise objects and hinted-at structures over broad surfaces as though to champion single-handed the right to go on painting when many think of painting as an old habit that long ago lost its validity. The mood of his paintings is always grave, but he can combine solemnity with splendour and never asks us to surrender to any sort of narcissistic presentation.

If we now associate the work of these artists with the categories to which it would seem to belong, we are unmistakably doing it violence. Martin, Flavin, and Bell tend to be seen as Minimalists because they use limited, clear forms in simple and self-explanatory arrangements. Yet is there anything more lush and complex than the carefully controlled vacuum-coating with which Bell turns a sheet of glass into an object of mysterious materiality? There is something inescapably monumental and architectonic about Flavin's light installations, imperious acts that transform space; nothing, one feels, could be further from Martin's gentle, calming insertions into the world, delicate as a spider's web and— if we accept the square canvas as a starting point, chosen for its undemonstrative form rather than as an assertion of the rightness of basic geometry—as organic. Pistoletto, Genovés, and Adami can be grouped with Pop art, but again their intentions as well as the effect of their art are quite distinct. Walker's painting could be described as a form of Post-Painterly Abstraction. It shares with the Americans' work a drawing away from the Abstract Expressionists' insistence on a personal, instinctive idiom, yet, like theirs, also owes something to the colouristic inventiveness and iconic drama of Rothko, Newman, and Still. But it also embodies elements of Surrealism which the Post-Painterly Abstractionists would reject on principle, and it shows none of their desire to limit painting to irreducibly basic ingredients. Arakawa may owe something to the Pop artists' use of words or hieroglyphic images, but draws close to Conceptual art in his demoting of the picture surface to the role of blackboard. Plackman's sculpture is hardest to place. The kind of symbolism he uses his material for has some connection with Surrealism (as in the objects of Giacometti) but, except for special public occasions, the Surrealists were not concerned with works on an environmental scale. Nowhere do we find a comparable combination of subtle poetic utterance with such deliberate staging.

The question arises whether such work is sculpture at all. The fact is that we go on speaking of painting and sculpture, and usefully so, although these concepts themselves have lost their clear and reliable definitions. A lot of paintings since the war are three-dimensional or even assemblages of various elements, and we know that this suggestion was inherent in some of the devices of Cubism. Yet painting has tended to keep its essential character of an image lifted one step away from reality, while sculpture has tended to insist on its existence in the physical world as a physical object. In their different ways Larry Bell's glass screens and Carl Plackman's multiform compositions have controverted that opposition: with them sculpture becomes an art of fable. Its physicality is now

merely an unavoidable fact and plays little part in our response to the work. To put it another way, the physical character of the sculpture, its presence as form in space, becomes the least reliable aspect of it. Form, placing, matter itself are made to seem temporary or provisional, and so we are forced to engage with other aspects. Not with 'what' but with 'why'. Earlier modernism had put so much emphasis on the autonomous existence of every work of art, had so emphatically jettisoned the burden of discussible meaning, that we almost have to force ourselves to ask what such sculpture is about. This need becomes especially acute when we confront the work of artists such as Barry Flanagan and Eva Hesse. Encountered in a gallery it shocks us by the way it ignores the virtues of contemporary abstract sculpture such as Caro's, and simultaneously, by its initial gruffness, it attacks the gallery context. As works they look off-hand. They suggest poverty, or a bread-line existence, and a nomadic rather than an art-collecting society. Exactly what meaning such sculptures carry is ultimately open to individual questioning, and I

278
279

278. Barry Flanagan: *June 2.* 1969. Canvas and wood, 115 × 200 × 35 in. London, Tate Gallery

279. Eva Hesse:
Installation
photograph of
work at the
Fischbach
Gallery, New
York, 1968. From
foreground:
Schema, 1967;
Sans I, 1967 – 8;
Sequel, 1967; and
Stratum, 1967 – 8

suspect that this is precisely part of their significance: that by refusing enquiry into their aesthetic or formal functioning, they force us into interior argument. Art is never without a moral charge. Here it is very potent. We are not confronted by an artist's introspection but rather by a parable, and one we are likely to interpret in terms of world concerns. Such an awareness of the world, this insistence on making our cultural life fuse with our political awareness, is characteristic of much of the new art of the seventies. Hesse and Flanagan achieve this more persuasively than most because of their unmistakably poetic method.

10 Beyond Painting and Sculpture

Can one make works which are not works of 'art'?
Marcel Duchamp, 1913

Perhaps we should marvel not at the diversity but the constancy of modern art. In 1955, as in 1905, an exhibition of 'new art' was likely to consist of paintings and sculpture, and perhaps drawings and prints. An exhibition consisting of the best and also the most provocative works produced during that half-century would of course demonstrate its diversity—not only stylistic change but drastic changes in materials and methods such as would not have been dreamt of during the centuries between the Renaissance and our own time, and of course the establishment of abstract art. Artists had on occasion gone into adjacent but non-art areas to explore other processes—one thinks of Tatlin's venture into large-scale engineering and into aeronautics, Gabo's motorization of sculpture, Richter's, Léger's and others' venture into film, Schwitters' and others' into a literature or music of oral sounds, and so on. And there had been two truly radical challenges to the status of art and of the artist: Duchamp's detaching of the concept of art from that of a specially created object and the rejection of art as an activity of any social value in favour of a direct contribution to the life of society through productive work in factories, argued for and exemplified by a group of Russian Constructivists in the early twenties. Duchamp's act identified all artistic value with the artist; the Productivists denied the existence of artistic value and refused the artist any place in the modern world. (Mondrian envisaged a world in which art would no longer be needed and used his art to show us the way towards that world. Surrealism, too, implied a fusion of art and the world; once art had liberated man's imagination from internal and external censorship and his actions from civilized restraints, Surrealism's task would have been accomplished.) But, in spite of all this, and in spite of all the radical claims made in manifestos and by critics, art continued to be almost exclusively a matter of hand-made objects offered for sale through galleries and enshrined in museums. Style varied widely, few artists not being concerned with giving a personal flavour to their work. Content varied a good deal less. Sculpture, as has been said, still centred on the figure. The first world war had produced an art movement dedicated to campaigning not just against traditional but especially against modern art. But soon Dada was fragmented and diverted into other pursuits as it allied itself to political action in Berlin and to exploring the unconscious in Paris; only Duchamp remained committed to a negation of art, and even his increasingly rare works could be assimilated to art as a satirical activity performed on art's fringes by a smiling cynic. His survival as an honoured figure in the art world proved its easy tolerance; his seemingly total inactivity in the end

suggested that art had won. The art produced by the second world war, for all its real or feigned feverishness, was in no way aimed against art. On the contrary, it promoted the cause of free and openly subjective expression as a counter to Fascism in particular and the state in general, and even as a statement against war itself. In Abstract Expressionism especially, as in *Blaue Reiter* German Expressionism, art appeared as a positive spiritual and moral force. Whatever infection Robert Motherwell's book on Dada generated in obscure places, it was received in 1951 as an exceptionally interesting piece of history, an account of strange, often nonsensical, and sometimes foolish things done a long time ago when the world was very different.

Since the mid-fifties a multitude of works and activities have been presented as art that have little in common other than that they are not, in any normal sense, paintings, sculpture or graphics. Most of these manifestations could individually be shown to have antecedents of a sort within modern art history—with the Futurists' and the Dadaists' soirées, the street decorations put up temporarily for the festivals of the new Soviet Republic, the environmental works of Lissitzky and others, and the exhibition-as-art-work pioneered by the Dadaists in Berlin and Cologne and made fashionable by the Surrealists. Those had been the work of artists, and so were these of the later fifties and after, and it would have been difficult to withhold from them the art label even when they ventured into areas bearing other names. It would certainly have been impossible to claim that label exclusively for painting and sculpture as the traditional forms of Western art. Thanks largely to the artists' own catholic appetites the world of art already in the books, the museums and in what Malraux christened the 'museum in the head' was wellnigh infinite. There was no reason why painting and sculpture should have exclusive rights. There were, and continue to be, good reasons why an artist aware of Marx and of post-Marxian sociological thought should ask himself whether his role in society was not as much nullified by the form of art he was producing as by any lack of art experience in the public. What was the point of painting a picture or carving, modelling or constructing a sculpture if the best one could hope for was its showing and sale in a commercial gallery? Art promotion works only for a few artists at a time and chooses them opportunistically even if with care. Even those who benefit from it can doubt its ethical worth: it encapsulates in a particularly glamorous but also ruthless way the efficiency and the vanity of capitalism. The artist makes—and if he is successful what he has made is snatched from him and made physically and psychologically remote from him. The artist not among the elect has additional material reasons for trying to circumvent the system. In a world divided by Marx into exploiters and exploited he cannot fail to see himself among the latter. The question had now arisen whether he should accept that passive role in the hope of gaining the stardom that is the system's reward to a few, or whether he should use what invention and cunning he has to survive without the system and ignore its particular market. Finding another market, another public, could well be the way towards reintegrating art with contemporary society.

One area we find him exploring with great success is that of what the

mass media call entertainment. The artist invents, presents, and participates in, some sort of performance. Its character can vary widely, from something akin to a fairground sideshow, blatantly popular in its appeal, to a one-man action of a profoundly tragic and disturbing sort, possibly occupying a great span of time and requiring marked powers of self-control and endurance from the artist-performer, or to a ritualistic or balletic enactment that may be as abstract as a Constructivist composition or as programmatic as a historical pageant or a religious ceremony. The form in which this sort of performance surfaced in recent times was the Happening, a form of theatre, performed in the open or in any space other than a theatre and consisting of a planned or spontaneous action (usually something between the two: a predetermined outline or code of signals plus invention in response to these and to the audience's reactions) in a prepared setting and with particular props. Its historical links are with the Surrealist exhibitions, some of which offered special performance elements on the occasion of the private view, rather than with the polemical soirées of the Futurists or the cultural cabarets of the Zurich Dadaists. But once the idea of performance as art had been established all sorts of variations became possible. Allan Kaprow's Happening of 1959 appears to have been the starting point. The news spread rapidly. The speed with which Happenings and other kinds of performances were set up throughout the Western world suggests the

280

280. Allan Kaprow: *18 Happenings in 6 Parts*, at the Reuben Gallery, 1959

281 (below).
Stuart Brisley:
*You Know it
Makes Sense.*
1972. London,
Serpentine
Gallery

282 (opposite).
Richard Long:
*Walking a Line in
Peru.* 1972.
(Photograph
courtesy of the
artist)

particular inducements this art form offers: close personal contact with an audience in place of the chilling rite of setting your works up in a gallery and then stepping back to watch the public engaging, or refusing to engage, with it; on the public's side a disposition to give time and attention to an action offered in the guise of theatre or circus; the chance to tune one's work to a particular place or moment. 'Performance art' now serves as a term that embraces all these activities.

281

There is no name for another activity, cognate with Performance art in some respects. Artists make polemical statements not through performance but through an exhibition of relevant data. Statistics, photographs, statements, videotapes, press cuttings, and many other sorts of information are brought together in an exhibition likely to have an archival and journalistic character. By these means the artist can exercise political pressure just like a journalist who is accorded substantial space and perhaps a research team to investigate a particular problem; also, he exercises this pressure in a gallery, a place where most visitors expect an aesthetic encounter rather than this form of realism, an escape from questions of slum housing or labour relations or asbestosis rather than hard evidence presented in clear and didactic ways.

A very different category—under various labels such as Land Art, Arte Povera, Impossible Art, and so on, depending partly on the particular form it takes—is that of Eccentric Action. A man walks along a plotted line in a remote part of the world, back and forth, until he has worn a path over previously untrodden earth. He brings back a photograph and a map. Another digs two parallel trenches in the desert, two sculptural marks in the blank, unused landscape. A photograph

282

283

283. Walter de
Maria: *Mile Long
Drawing*. April
1968. Chalk, two
parallel lines 12 ft
apart, Mojave
Desert, California

records his action. Time will obliterate his work, as it will also the first man's path. The works are transient and unmarketable, but their status is accorded to the photographs which are sold to finance the work. Others, where necessary using machinery and labour to execute their schemes, rearrange larger portions of the globe's surface, shifting masses of earth into temporary sculptural forms, cutting patterns into the frozen surface 284 of a river or into a newly ploughed field by re-raking its surface. Similar 285 actions can be taken in a city setting, and here, inevitably perhaps because of current doubts about urban existence, the action is likely to challenge the setting. One artist fills the gallery in which he is exhibiting with good rich soil to about knee height; another covers a New York parking lot with 286 bakers' salt; another arranges, on the floor of a public gallery, concentric

circles of natural stone that recall the ritual structures of early man and produce an unmistakable culture and time shock in that engineered setting (Stonehenge will long outlast the modern building). What characterizes such art is not its impracticability or its uselessness so much as its positive irrationality: thought, labour, and materials are expended to make a temporary mark of no apparent significance. Pointless? Wasteful in a world that is beginning to worry about its prodigality? If we think about these works of art they become statements against exploitation of men or materials, against the accelerating rhythm of construction and demolition by which we recognize the twentieth-century city, against man's arrogance in the face of nature and of time. Is all man makes but a ditch in a desert, a pattern of twigs beneath the tree? Some of

Beyond Painting and Sculpture

284. Robert Smithson: *Broken Circle and Pyramids.* 1972. Emmen, Holland (Photograph by Peter and Paul Massee)

285 (above).
Dennis
Oppenheim:
Directed Seeding-
Wheat. 1969.
Earth and wheat
seed. Holland,
Finsterwolde

286 (right).
Walter de Maria:
50m³. 1968.
Earth, 1,600
cubic feet.
Courtesy Heiner
Friedrich,
Cologne

these artists bring rare skills of diplomacy and salesmanship to their work. One of them adopts from the Surrealists the mystery inherent in displaying a wrapped object, but gives it new meaning by applying it to landscape as well as to large monuments. Some of his schemes remain projects; others, demanding extraordinary planning and negotiations, are realized. A long stretch of Australian coast is wrapped; a vast orange curtain is drawn through the Californian landscape. Attractively made drawings and collages describe his projects and give a permanent record of the executed works, and they are sold to finance further work. The impracticability of ideas looms larger than their Surrealist quality and becomes their subject, reinforced by the fact of occasional execution: the impossible can be done. For military purposes it is being done all the time; human and material resources are made available and social obstacles are ignored. A particularly enticing art project, conceived and pursued by the American Newton Harrison but not yet executed, involves the launching of obsolete military rockets into the atmosphere above California in order to discharge chemicals which would produce an artificial aurora borealis. The idea, dependent upon a long programme of cajoling military and civic authorities, and involving extraordinary expenditure, would culminate in a brief but marvellous experience—a sword beaten, so to speak, into a magnificent firework. A megalomaniacal joke? But to what use do the generals intend to put all that shelved hardware?

287

287. Christo
(Javacheff):
Wrapped Coast,
Little Bay,
Australia. 1969.
1,000,000 square
feet

Another is Word art. One artist exhibits, in the form of enlarged photos on canvas, selected definitions taken from an English dictionary. You have come to see a work of art, a picture perhaps of something you can recognize and like seeing; instead, here is a definition of the word 'art' or another of the word 'water'. The definition on the wall has a visual presence and at the same time triggers memories of the named object or concept, whilst also demonstrating, more trenchantly even than Magritte, the difference between a work of art and any object to which it may refer. A group called Art Language, reacting perhaps to the highbrow art writing that is being produced by philosophically minded critics in the art magazines, analyse endlessly and repetitively the linguistics of art. Individually or in teams they produce elaborate texts that smack of semantics and philology, and these are published or displayed in various ways in galleries. It is an open question whether their intention is to instruct or to perplex. A world still uneasy about abstract art, and always readier to read a catalogue than a picture, finds itself amid a swarm of words that, for all their professionalism of tone, elude sense. Quantity itself becomes a means of disorientation. Verbal explanation, refuge of the puzzled and the insecure, becomes a trap. Other artists use extreme brevity to surprise the spectator into a sympathetic recognition of the artist's problem, as in the case of Keith Arnatt's statement referred to in Chapter 9.

There must be good reasons why this adventuring beyond the confines of painting and sculpture should have happened on such a wide front since the end of the fifties, but we cannot be certain of them. We can point to some of the factors behind it—a great war culminating in unique proof of man's vast gift for inventing means of destruction, a fragile, nervous peace fitful with local wars and revolutionary struggles, an almost sudden awareness of the conditional nature of man's lease on a world he had thought he owned, and with all these things a sharpened understanding of our mutual needs and of our remarkable failure to supply them—but they are best summarized as a change in the artist's stance *vis-à-vis* the world of art commerce and art consumption. Paintings and sculptures need not be seen as eternally valid forms of art, but at least they have proved their adaptability as art vehicles over a long time. Galleries, art dealing, art critics, national and international art exhibitions with or without prizes are still quite new phenomena, by-products of the eighteenth century's break in tradition. They serve a function, but it is a very limited one and they serve it imperfectly because they cannot act disinterestedly. The very liveliness of the art world during the last twenty years, the frequent discovery of new talent and new tendencies and their promotion to some degree of international stardom, throws its effectiveness into doubt. For all the intentions of just judgment brought to it by some, others operate—with varying degrees of care for the short- and the long-term effects of what they are doing—from crude motives of self-interest. The initiative tends to remain in their hands. The several attempts by Western countries to devise forms of state patronage and state support have led as much to further promotion of already promoted individuals and groups as to spreading its benefits to those who have been overlooked by the commercial network. All artists know that the art

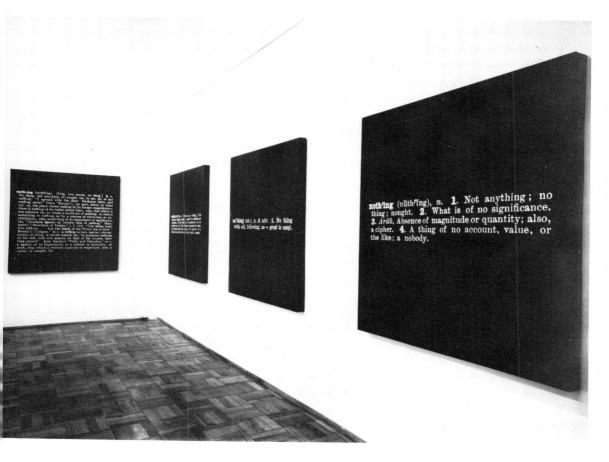

nothing (nŭth'Ing), n. 1. Not anything; no thing; nought. 2. What is of no significance. 3. Arith. Absence of magnitude or quantity; also, a cipher. 4. A thing of no account, value, or the like; a nobody.

288. Joseph Kosuth: Mounted definitions of *Nothing*. Exhibition at Gallery 669, Los Angeles, 1966

world is a crude instrument, undiscriminating even where its support is justified but, once its maw is full, uncaring of the demands of wider justice. However much wisdom and truth it enrols in its own support, it has many of the aims and habits of the business world to which it increasingly appeals for sponsorship and from which, less openly, it derives its financial fuel. To them particularly it smacks of exploitation and manipulation. The new art forms we have been glancing at have in common a marked element of manipulation: one marvels that this or that action was not merely performed but also in some way forced on to the art world's notice, given a price tag by one means or another and thus also commercial status in the eyes of dealers and patrons.

The patron who brings home a photograph of some ephemeral mark made by an artist on the face of nature or of a city, or even a certificate of ownership of a non-visual work of art, must wonder what this new item in his collection does for or against the paintings, sculptures or whatever else he already has. Some recent works of art have been auto-destructive: they have had fast or slow obsolescence built into them so that they are in themselves a kind of Happening. A museum that allocates funds to acquiring a piece of auto-destructive art is attacking the very role of museums. The gallery that is willing to be filled with soil or otherwise deprived of saleable items may justify this disruption of its normal

function by the news value of the event and the charisma that goes with avant-gardism. In any case gallery exhibitions serve mainly to advertise its existence and range of interests; the dealing goes on behind the scenes. But what of its visitors? Why do we go to galleries? For pleasure or to be surprised and perhaps stimulated? To be made to change our habits of thought, our values? Art has never been without some ideological content, but these new art forms tend to proffer their message without the emollient of an evident aesthetic medium. The very unattainability of these art forms, the fact that we cannot possess them in any substantive way—not even via the museums—imposes a new kind of relationship on us, and it is clearly a less pleasurable one. Avid as we may be for the excitements as well as the pleasures of art, infinitely capacious as our museum-in-the-head is, can we accommodate an object-less form of art? There is something truly extreme and possibly final about these developments, and it is more than a little troubling that they should have included, in Germany and Austria at any rate, a kind of Performance art that consists in the artist mutilating his own body. In one instance at least this culminated in the artist's willed death—at which point even the most open-minded bystanders may wonder whether that act, at any rate, must not fall outside any past, present or future definition of art.

These developments, and also the situation that gave rise to them, recall in some respects the middle of the eighteenth century, the very time when the modern art world, including art history and art criticism in the forms in which we know them, was being born. 'What!', exclaimed the French writer Diderot in 1763, 'hasn't the brush been wielded more than enough and for too long in the service of vice and debauchery?' Should not art cease indulging our appetites or assuaging our suppressed desires and become morally purposeful, an ethical force rather than an aesthetic one, leading mankind on to a higher social and spiritual plane? Is art ornament or instruction? Then as now, such questioning went with a wider questioning of all authority. With every day the news media remind us that nothing is settled.

When the art-world dust has settled we shall see that these developments too, like those of the eighteenth century, represent a search for the proper, the necessary subject-matter for our time. Whatever the motives behind the many inventions, transmutations, and reversions that make up the story of modern art may have been, and however unacceptable individual works once seemed, almost everything has gradually turned into a pleasure object, at least in part a means of self-gratification. Humanity has a remarkable gift for enjoyment. Rightly so, perhaps, when confronting the work of fellow humans. Where delight and amusement fail, we can summon up what Aristotle called 'the tragic pleasure that is associated with pity and fear'. We also have a remarkable gift for trivialization, for turning every masterpiece into mental or actual ashtrays but also for cocooning it with praise until we take our pleasure easily from the enveloping warmth, rather than from the thing itself. As Walter Benjamin argued in the thirties, and many others have repeated recently, the work of art loses its authority, its aura, when reproductions abound. One might go further and suggest that it acquires another sort of status, relating not to the quality of the work or its meaning but to the

sheer weight of its fame—its stardom. The reproductions do not replace the original. In 1976 Leonardo da Vinci's portrait of a Florentine lady now known as 'Mona Lisa' went on exhibition to Japan and was there seen by millions who filed past the picture day and night at an average rate of six per minute or ten seconds each. What did they see? Familiarity with a good reproduction must serve more purpose than such a short and pressurized encounter but only this gives one the right to share in the applause. The original becomes very nearly invisible, a shadow within a cloud of incense. Its true meaning is an unbidden guest at the feast. Something akin to this is happening even to quite recent works of art, works by Picasso, Dali, Rothko even. Fame replaces tragic pleasure with self-congratulatory adulation.

This the Concept artist is out to prevent by withholding the object to which it could attach, the possessible, exhibitable, reproduceable object. By whatever means he chooses on each occasion—Concept artists have shown remarkable inventiveness—it is an idea he is putting before us. We can, intentionally or unintentionally, refuse to receive it, just as we can withhold our attention from other works of art. We can also receive it and find it slight. As the artist Sol LeWitt has said: 'Conceptual art is only good when the idea is good' (1967). The degree to which we are gripped by an idea depends on its particular validity for ourselves and on our general responsiveness to ideas. All Concept art contributes to the broad idea of art as something not to be identified with a special kind of object (painting, sculpture or whatever) and a special location (gallery, museum; is Duchamp's *Fountain* a work of art if we find it on a rubbish heap or at a builders' merchant's store among other pieces of sanitary ware?), but the best pieces illuminate other questions: how do we communicate? How do we act? How do we live? Patterns of behaviour, patterns of relationship; obsessive, repeated actions or once-only and perhaps particularly arbitrary actions; actions outrageous and harmful (as in self-mutilation) or harmless (as in designating a natural event as a personal work of art); emphatically pointless performances given meaning by their location and by the expectations to be assumed in the audience assembled there, or open political speeches and debates; records of change in nature, in the man-made world, in people, through photography or tape-recording or taking samples or counting or verbal note-taking ... One could go on, listing the sorts of action that have constituted Concept art. And of course one could add to them, which implies that we can all be Concept artists. In the end, Concept art implies and instils a special consciousness of our own actions and responses. All the arts have this potential: at times we know we have been changed in our understanding of the world by seeing a painting, listening to a piece of music, reading a book, watching a film or whatever. Concept art comes to us with that function more or less undisguised, without the wrapping of charm or drama or the reassuring context of a familiar social setting. We may meet it in a gallery but we can also find it on our television screens, in a newspaper, in the street, and the most effective Concept works are those where ordinariness and the idea being communicated very nearly match, as in the two halves of a stereoscopic slide, together producing a surprising perspective on reality. If we begin to feel that we too can create Concept art this only means that

289

289. Jan Dibbets: *T.V. as a Fireplace*. 31 December 1969. 24 minute television film transmitted on Westdeutches Fernsehen

we have been alerted to the multiplicity of meanings behind the familiar (is it?) surface of ordinary (is it?), daily (why?) life. In disallowing us our comfortable responses to art, Conceptual art forces us to reconsider much more than art and makes us accomplices in its own disruptive questioning. We can hold the idea it brings, but we cannot frame it or sell it, reproduce it or turn it into a paperweight.

A selection of Concept works is given in the chronological summary that follows, to indicate something of the range we have witnessed and, perhaps, to impart something of the feel of this new art. By the mid-sixties Concept art was being pursued in all Western and Westernized countries. There has been no evidence that it has in any sense replaced painting and sculpture, though it has, of course, drawn some of the art world's attention from the traditional media to these often surprising, sometimes amusing and generally newsworthy actions. From about 1970 onwards economic crises in Europe and America have directly and indirectly helped this tendency. Our daily news, full of financial problems, and unemployment or strikes, gives added edge to an art that eschews the luxury character of fine art, does not demand high quality colour reproductions and is sometimes even called Arte Povera (*povera* is Italian for poor). Concept art continues, in ever new forms. It has not evaded the promotional embrace of the art world—did it ever entirely mean to? Artists have human needs and aspirations—but it has greatly

stretched the art world's institutional conventions and methods. Most obviously, it has led to the development of markedly utilitarian galleries and journals beside the lavish ones that are the prestigious face of art commerce. And it has forced us all to think again, and think harder, about the function of art in the modern world and in our individual lives.

In 1954 the American composer John Cage first performed a piece of music entitled *4′ 33″*. Cage was and is close to avant-garde art, and this piece has generally been adopted as a significant forerunner of Concept art (which, in any case, has at times used sound). Cage's piece consists of four minutes and thirty-three seconds of musiclessness: performers by some means indicate the beginning and end of the piece, which consists of all the sounds that occur during its period. (Its effect, on an unprepared public, must be quite frightening: we go to hear music and to witness a performance; performance, it seems, is wilfully withheld; instead we become conscious of the unreality of the music we have come for, of its importance to us as a shield against reality.)

In 1956 the French artist Yves Klein began his long series of monochrome blue paintings, done in an exceptionally intense and rich blue which the artist subsequently patented as 'Klein International Blue' and also applied to a variety of other objects. Soon he was to experiment with blue flames and blue liquids, and also with naked women covered with his blue paint pressing themselves, at his direction, against vertical or horizontal canvases.

In 1958 Klein presented an exhibition at the Galerie Iris Clert in Paris, entitled *Le Vide* (emptiness, vacuum): the windows of the gallery were painted blue, the interior was painted white and was left empty. Also in 1958 the British artist John Latham began to make relief constructions of old books mounted on canvas and painted, charred, and adjusted.

290

290. Yves Klein: *Anthropométries.* Performed at Galerie Internationale d'Art Contemporaine, Paris, 9 March 1960. Body-prints in blue paint on canvas

Subsequently he constructed sculptures of books, including *Skoob Towers* (Skoob = books backwards) which were ceremoniously destroyed by burning.

In 1959 the Italian Piero Manzoni, inspired by the example of Klein, began to produce lines of ink on paper of unstated or definite lengths. Carefully packaged and attested, these were made available as art objects (for example the Museum of Modern Art in New York owns *Line 1000m*, done on 24 June 1961). At this time he conceived the idea of signing people as Manzoni art works; this project he carried out in 1961. In 1959 also the French artist Arman began his *Colères* (*colère* is French for anger, rage; it echoes the by now ordinary art term, collage). These are constructions of broken objects such as musical instruments. He also began his *Accumulations* of refuse and of consumer goods. The following year he presented an exhibition he called *Le Plein* (fullness) at the Iris Clert gallery, having filled the space with all sorts of stuff up to the ceiling. 1959 was also the year in which the American painter Allan Kaprow, who had studied music with John Cage, presented a performance entitled *18 Happenings in 6 Parts* at the Reuben Gallery in New York. From then onwards, Kaprow, Oldenburg, and other American artists presented many Happenings in New York and elsewhere. By 1962 Happenings of various sorts were being put on in Europe.

About 1960 George Brecht, the American artist, began making

291. John Baldessari: . . . *no ideas have entered this work*. 1966 – 8. Acrylic on canvas, $67\frac{1}{2} \times 56\frac{1}{2}$ in. Courtesy the artist

EVERYTHING IS PURGED FROM THIS PAINTING BUT ART, NO IDEAS HAVE ENTERED THIS WORK.

292 (opposite). Jean Tinguely: *Homage to New York*. Exhibited 1960 in the garden of the Museum of Modern Art, New York. (Photograph © David Gahr)

291 Concept art events of various sorts: for example, in the summer of 1961, three works used ice, water, and steam. About this time, too, the American John Baldessari ceased making works of art by hand. He was to exhibit paintings, executed for him by a sign-writer, consisting of a few words inscribed on an otherwise blank canvas. Later he turned to making

video-tapes, recording long, slow, and uninformative actions (such as his hands holding and turning his hat), and to writing concise and pointed 296 fables about modern art. In 1960 another American artist, Lawrence Weiner, exhibited as a one-man show a crater he had made with explosives in Mill Valley, California. Also in 1960 the Swiss sculptor Jean Tinguely, known for his mechanized sculptures made mostly of old iron work, exhibited in the garden of the Museum of Modern Art in New York a particularly complicated construction entitled *Homage to New* 292

293. Robert
Morris: *Untitled.*
1967. Red felt.
Detroit Institute
of Arts

294. John Latham:
Art and Culture.
1966–9.
Assemblage: book,
labelled vials filled
with powders and
liquids, letters,
photostats, etc., in
a leather case,
$3\frac{1}{8} \times 11\frac{1}{8} \times 10$ in.
Collection, The
Museum of
Modern Art, New
York (Blanchette
Rockefeller Fund)

York. Uncharacteristically, it was painted white. About seven-thirty on 17 March, a cold and wet Thursday evening, an invited crowd witnessed this complex object (which incorporated an old upright piano, an old addressograph machine, a klaxon, fire and smoke-making chemicals, and a fire-extinguisher) as, electrically powered, it shook and burnt itself to pieces: made of rubbish it lived, cavorted briefly as a work of art in one of the great modern art museums of the world and turned itself back into rubbish. The event was widely reported and discussed. Other artists were interested in a variety of forms of auto-destructive art, and a Destruction in Art symposium was held in London in 1966, to which artists from several countries contributed.

From this time on Concept art developed and spread fairly rapidly. By 1966, the year in which Allan Kaprow published his book *Assemblage, Environments and Happenings*, Concept art was being produced widely in Europe and America and was being discussed with growing attention and seriousness in the art press. Some milestone events can be listed here, out of the many that are recorded. In 1963 Robert Morris, the American Minimalist sculptor, issued a notarized *Statement of Esthetic Withdrawal* by means of which he removed 'all esthetic quality and content' from one of his sculptures. This Duchampian act has many implications. Most pressingly it asks, and perhaps answers, the question of the efficacy of any artistic act, including one that denies the efficacy of artistic acts. In 1966 John Latham, with the assistance of the sculptor Barry Flanagan,

293

organized the *Still and Chew* event. This consisted of borrowing Clement
Greenberg's book *Art and Culture* from the library of St Martin's School
of Art in London, where Latham was a part-time teacher, and inviting
guests at his house to chew selected or random pages from the book and
spit out the mixture thus produced into a flask. Other pages were
processed chemically, and the combined solution was fermented with
yeast. A year later the return of the book was urgently requested by the St
Martin's librarian. Latham distilled and bottled the liquor of learning
and dogma he had thus produced and persuaded the librarian to accept
this as the (digested?) book borrowed from the library in his care. Latham
was informed the next day that he would no longer be teaching at the
school. The bottle and its contents, plus documentation, is now in the
Museum of Modern Art in New York. In 1969–70 a large exhibition of
Concept art, entitled 'When attitudes become form' was shown in major
cities in Europe, offering a survey of current work in this field and
supporting statements. In that year also the first issue of the journal *Art-
Language* was published in England (edited by Terry Atkinson and
Michael Baldwin), artists' video-tapes were shown on German television,
the Bulgarian sculptor Christo wrapped a million square feet of
Australia's coast in plastic sheeting, and Joseph Beuys, the German
sculptor, accepted full personal responsibility for any snowfall in
Düsseldorf during February. Beuys subsequently worked and ex-
hibited in many places, combining environmental Happenings with
long political addresses and debates. Like many another artist he came

294

287

295

295 Joseph Beuys
speaking at the
Tate Gallery,
London

to feel that making any sort of art is in itself a reactionary activity, a gesture of support for an inegalitarian society, and that this conviction needs driving home everywhere and again and again, and especially in the strongholds of art. Another German artist, Hans Haacke, has found subtler and perhaps more persuasive means to the same end, by exhibiting, as works of art, analyses of the social status, business connections, places of origin and current dwelling, of the boards of trustees of museums and of museum visitors. A particularly telling instance was his *Manet Project* of 1974. Invited to contribute a work to an exhibition in the Wallraf-Richartz Museum in Cologne, he proposed the display, on an easel in a room of the gallery, of a painting by Manet (*Bunch of Asparagus*, 1880) and, on the walls, panels summarizing the social and economic position of the people who owned the painting from the time of its first purchase in 1880, by a banker from Manet for 1,000 francs, to the time of its acquisition by the museum in 1968 through the action of the Friends of the Museum for 1,360,000 Deutschmarks. The proposal was praised by the modern art curator of the museum but turned down as unacceptable by the organizing team of the exhibition in order to retain the support of the chairman of the Friends whose positions on nineteen boards were to be listed on a panel. Haacke's work was thus rejected by the museum. It formed instead an exhibition at the Paul Maenz Gallery in Cologne, with a reproduction standing in for the original Manet. The Museum's exhibition, under the title 'Art remains Art', opened the same day as the Haacke show. It included work by Daniel Buren, the French painter, who pasted a scaled-down version of Haacke's *Manet Project* on to his stripe paintings. These Haacke reproductions were then pasted over with paper on the orders of the director of the museum, whereupon some of the other artists withdrew their exhibits; others had already done so, hearing of Haacke's exclusion. Thus the Haacke project was not only realized in a Cologne gallery—and also briefly in the Wallraf-Richartz Museum by courtesy of a fellow artist—but also attracted immediate notoriety through the press. Moreover it is easily, and more truly than the Manet, reproduced in print, losing nothing by the process and becoming widely and permanently available. It is a powerful demonstration of art as a social weapon, showing the political implications of the nature and structure of the modern museum, its activities and its support system. No one would envy the director's dilemma. His solution was to give primacy to the wealthy chairman over the invited artist. What, then, was the museum created for?

296

Haacke's display stays in the mind more tellingly than most works of art attempting socio-political criticism. Though the information he put before us is primarily verbal and numerical, he structured it to form a powerful visual experience—plain and direct, but also rhythmical and emphatic. The same data delivered through written or spoken diatribes would have little lasting effect. Moreover, since Haacke provided objective information only, without adding any form of interpretation or argument, he is not easily answered. The message seems clear, yet the viewer finds that he himself has formulated it in going from panel to panel: not only do admired works of (past) art achieve financial valuations

beyond the imagining of most people, leaving the real world for an Arabian Nights' dreamland of treasures acquired by means of magic, but this dreamland is associated with the self-reflecting, self-rewarding world of big business. Conspicuous cultural consumption is shown to be a cosmetic device for the face of capitalism. Summarized in this way, Haacke's implied statement is familiar rhetoric; mutely contained within his chaste project, it survives and reverberates in the recipient, a new element added to the tradition of politically motivated art. Like *Guernica* 166 it is memorable and thus attains a stature that transcends its specific, local content.

ART HISTORY

A young artist had just finished art school. He asked his instructor what he should do next. "Go to New York," the instructor replied, "and take slides of your work around to all the galleries and ask them if they will exhibit your work." Which the artist did.

He went to gallery after gallery with his slides. Each director picked up his slides one by one, held each up to the light the better to see it, and squinted his eyes as he looked. "You're too provincial an artist," they all said. "You are not in the mainstream." "We're looking for Art History."

He tried. He moved to New York. He painted tirelessly, seldom sleeping. He went to museum and gallery openings, studio parties, and artists' bars. He talked to every person having anything to do with art; travelled and thought and read constantly about art. He collapsed.

He took his slides around to galleries a second time. "Ah," the gallery directors said this time, "finally you are historical."

Moral: Historical mispronounced sounds like hysterical.

296. John Baldessari: 'Art History' from *Ingres and Other Parables*, 1971

11 Post-Isms, Neo-Isms and Art

> . . . it is simplicity you lack and in exchange they give
> you comedy . . .
> Lvov, in Howard Barker's play, *The Last Supper*, 1988

Schoenberg said there was no need to speak of 'new art': if it's art, it's new. The art world continues to operate in terms of novelty. It ushered in the 1980s by proclaiming a renaissance. This was something more than a new generation's efforts to push aside its predecessor, more even than the 1980s denouncing the 1970s. It was part of a general attack on modern art. Those who present contemporary art in exhibitions and publications announced a new age that rejected innovation and returned to traditional methods and values. The term Post-Modernism was borrowed from architectural criticism, where it asserted the ending of a specific movement in architecture, the International Style created in the 1920s, principally by Le Corbusier, Gropius and Mies van der Rohe. In art writing it was used to signal a wholesale denial of Modernism: Modernism had never happened; had been naïvely wedded to utopian visions of a world transformed by the marvels of technology; had been isolationist, ivory-tower, preaching the automomy of every art form and art's exclusive concern with pure art issues; had pinned its faith on successive avant gardes that in their haste to innovate and surprise prevented all significant evolution; had failed to innovate; and so on.

The answers are within Modernism—a complex of ideas and work developing over time that are not to be embraced in summary charges. What may be true of this or that aspect of Modernism or, rather, of this or that conventional account of a tendency or a career, does not hold for another. These are temporary instructions, waiting to be replaced by solidly founded accounts. Meanwhile, the attacks on Modernism get in the way of a deeper enquiry into what modern art has been. Modernism had made a scapegoat of nineteenth-century academicism. The Modernism now in the stocks is no more than a caricature of what Modernism has been. Perhaps the most important claim made for 1980s art is that it addresses itself to human issues, and this we shall return to. The point here is that this is true of the best Modernist art too, and that the claim could not be made if Modernism was better understood. Another claim, most frequently heard but obviously false, is that the 1980s have witnessed a return to figuration after decades of abstraction. Figurative art had never ceased and was probably always pursued by more artists than abstraction. It is the spokesmen and the organizers who have changed their minds and redirected their attention; they have returned to making old-fashioned attacks on abstract art as art without meaning.

Almost blinded and deafened by the promotional rhetoric of the art world, we must and can penetrate to art itself. The 1980s have produced important, even great, art. In some ways it contrasts with the sorts of art given priority in the 1960s and 70s, often by the same organizers and commentators. In fact most of it was already under way then and even exhibited and debated, only not given the exclusive, isolating attention it now gets. So the only definite change has been in where promotional power has been focused. The art most promoted in the 1960s and 70s is denounced as cold and empty. Yet 1980s art is obviously involved in Modernism and in post-1945 art. Moreover, the intensity and specificity of promotional campaigns has stimulated reactions which are now gathering force and which will in turn carry in them the imprint of what they are rejecting.

The loudest assertion is that painting has been reborn, raised from the dead. In the 60s and 70s sculpture had become more prominent than it had been for centuries, perhaps since the Early Renaissance; in the 70s those championing Concept art suggested that sculpture had moved into alternative modes and that painting had lost for ever the predominant place it held in western art of the last five hundred years. Not only had painting never ceased, continuing to be the prime art form quantitatively and perhaps also qualitatively, but some of the painters now presented as stars were painting and exhibiting in the 1960s and 70s and were even getting some recognition then. Painters are now given the encouragement long withheld from them. This, too, is likely to breed a reaction. Today the pendulum swings ever more powerfully, heavy with hyped-up commercialism. Never has art—not as it is produced but as it is made public—been more subject to the priorities of marketing strategy. Time will show that the ideals tested in art and debated in the art world in the 1960s and 70s were essential to 1980s art, and that Modernism not only provides support for everything done today but is drawn on at specific points. In short, Modernism lives on.

What characterizes the best art presented by the 1980s is fullness of colour, fullness of form, richness of presentation; also, on occasion, expressive sparseness for dramatic impact. Sometimes this is used to present slight, in-turned thoughts about art, sometimes to carry complex messages about all-important human concerns. Many works are large, and are done in series so that to know them one needs to study a group of paintings or sculptures; much work is done as installations in a particular place. Size, quantity and fullness of means and tone add up to compelling, enveloping communication and recall the nineteenth-century's taste for vast paintings on great themes, novels and learned works published in several volumes, Wagner and the overpowering total art experience. It also recalls the age of the Baroque, when, especially in honour of God and the divine right of kings, the arts raised their voices and combined to persuade and to confirm. But the 1980s artist of note is more often intent on questioning hegemony; his or her concern is to raise the consciousness of modern man, just like Kandinsky, Malevich, Mondrian and many another artist of that generation. The dominant art of the 1980s is rarely celebratory, and it may well be said that the decade has little to celebrate. Much of the most powerful art of the time has come

out of a Germany divided between opposed ideologies and allegiances and burdened by an ugly past.

This swing to fullness is seen not only in the 'new' artists of the 1980s (i.e. those who became stars in the 80s and those who emerged since 1980) but also in some of the best established earlier artists. A telling example is that of Frank Stella, whose neat, cool, flat compositions were succeeded in the 70s by relief works that seem hyperactive in their swerving, conflicting forms and arbitrary colours and textures. The expressive activation of space has become his chief concern. Another instance is the work of John Walker, rich and dramatic already in the 1960s, and by the end of the 70s so powerful in imagery that we hesitate to call it abstract. Another is that of the sculptor William Tucker. In the 60s and 70s his work was known for its diagrammatic sparseness. It was resolutely abstract and usually constructed in metal or wood or synthetic resin. Around 1980 he needed to make sculpture that would be almost the opposite of what he had done: 'he wanted to take a lump of matter and shape it, pull it, so that it rose and stood in the world, a thing' (Dore Ashton). It was as though he, most learned and thoughtful of modern sculptors, needed to return to primordial basics. The new pieces remind us of Rodin and at times Michelangelo, but also of the little figures left us by prehistoric man. Tucker named some of them after ancient gods, and they carry their names convincingly for all the ambi-

218

297

277

297. Frank Stella: *Diavolozoppo (4X)*. 1984. Oil, urethane enamel, fluorescent alkyd, acrylic and printing ink on canvas, etched magnesium, aluminium and fibreglass. $139\frac{1}{8} \times 169\frac{3}{4} \times 16\frac{1}{8}$ in. Private collection

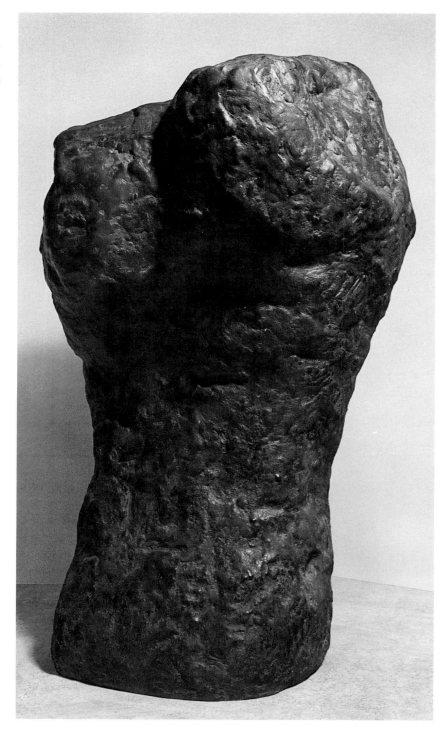

298. William Tucker: *Gaia*. 1985. Bronze, 87 × 55 × 50 in. Collection of the artist

guity of their forms: they are full of a mysterious energy and move before us mightily as we look up at them on their bases. Gaia was the earth goddess who married the sky; their offspring were Titans, Cyclopes, giants.

The 1960s–70s artist who has most evidently and powerfully continued into the 1980s and wielded unmistakable influence has been the German Joseph Beuys. His message was that art was human thought and action, and that the world needed actions against the socio-political constraints of our time. There are alternatives: how can we realize them? In Germany he issued direct challenges to controls on higher education and to the party system, but his broader challenge was to the world's misunderstanding and misuse of human creativity. Unused creativity breaks out as criminality, he claimed, and all around he saw creativity denied. Eloquent in performance, he could also create symbolic objects and environments related to his own history and referring to everyone's experience and situation. Sometimes he spoke through visual epigrams, as when he redesigned the West German flag to show, in the proportions of its three colour bands, the inequality obtaining in the land of the capitalist *Wirtschaftswunder* (economic miracle); or when, on a postcard, he named the two towers of the New York World Trade Center after the twin healers and protectors against plague of early Christian times, known as 'the holy moneyless ones', Cosmas and Damian, saints and martyrs. His London installation sculpture of 1985 (developing ideas sketched and noted in 1958) encapsulated much of his thinking. The two spaces of the gallery were lined with rolls of grey felt and were empty but for a piano on which lay a blackboard and a thermometer. The felt provided solemnity and breathlessness and offered warmth, protection, insulation from the hubbub of central London. The closed piano, the

298

299

299. Joseph Beuys: *PLIGHT*. Detail. 1958–85. Environmental sculpture with felt, piano, blackboard and thermometer. London, Anthony d'Offay Gallery

blank blackboard, the thermometer measuring what for whom, spoke of human aspirations and faculties and of their oppression. He called it *Plight*: the word spoke to him not only of the human condition but also of duty or task in echoing the German *Pflicht*, from which indeed it derives. Beuys has guided many other artists towards important issues; above all he confirmed the gravity and centrality of art.

Georg Baselitz began his upside-down paintings in 1969. Born in East 300 Germany, he studied painting in East and West Berlin. His first exhibition, in 1961, was of fierce, disrupted images. His second, in 1963, included harsh sexual representations that were seized by the authorities; a two-year law suit ended with their being returned to the painter. By 1969 he had had thirteen one-man shows. His paintings tended to be images of despairing heroism, of strong young men vertical and alert among broken buildings and wasted landscapes. As a student in East Germany he had been expected to adopt the compliant habits of Socialist Realism; in West Berlin the model offered him had been that of international lyrical abstraction. He had refused both. His art had to be declamatory and rooted in the Germanys he knew.

In 1969 he painted an upside-down landscape: *The Forest on its Head*. It is almost a portrait of trees: two pines fill the vertical canvas, one slender, one stout. He had been repainting some of his primitive heroes, casting doubt on them by dividing, breaking their images. He was putting obstacles in his own path lest painting should become a glib performance, and also in the path of his admirers. Now he painted everything upside-down, distancing himself and us from his images. It takes a major act of self-denial to draw and paint upside-down, challenging the habit of expecting images to be 'the right way up'. Carpets do not comply with it, of course, nor do various non-classical modes of picturing: relating images directly to a vertical viewer is a strategy of Graeco-Roman classicism in confirmation of a particular view of the world and of art's place in it. Baselitz's world is that of a divided Germany perplexed by its past and present, a Germany that had lost command of its native artistic tongue—lost command again. Expressionism had been a partly nationalistic, partly also more broadly Nordic or Teutonic, assertion against the classicism received from Italy and France. The trees and figures in Baselitz's paintings, and his powerful brushstrokes and often strong colours, belong to that alternative tradition. Some of them refer openly to Nolde and the Brücke painters of Dresden (now in East Germany) and to Edvard Munch. Baselitz is painting against world and art-world vetoes, including those deeply implanted in himself. His skills could have served a more glamorous art; as it is they both justify his aggression upon art and bring dignity to a bitter art whose concern is, none the less, with survival and honour.

Baselitz lived in West Berlin until 1966. Around him worked other painters with similarly divided personal histories (e.g. Markus Lüpertz, A. R. Penck, both from East Germany), as well as West Germans and foreign visitors whose art increasingly spoke of their situation. That feverish and unreal half-city, stronghold of the 'free world' within the Communist bloc and thus also Communism's hostage, has become the noisiest and most active of German art centres, regaining some of the

300. Georg
Baselitz: *Weeping
Head
(Tränenkopf)*.
01.XII.86–
23.XII.86. Oil on
canvas,
$78\frac{3}{4} \times 63\frac{3}{4}$ in.
Cologne, Gallery
Michael Werner

cultural power it had wielded in the days of Expressionism. Among its
diverse offerings what the Germans call *heftige Malerei*, vehement paint-
ing, has been accepted as 'revelations of the soul'. How to present one's
soul in ways that outshine and out-astonish another's soon becomes a
problem, as does the question of whether revealing one's soul can usefully
continue once it is backed by exhibitions, praise and patronage. Thus
the Expressionist problem is compounded by Berlin's desire to show
its vehemence as part of a broad, international urge to make art emotional
and figurative. American commentators have labelled the tendency Neo-
Expressionism, echoing the Post-Modernist desire to step out of the rat
race of successive avant gardes: they implied it should be understood
as a return to something that flourished generations ago. Yet this Neo-
Expressionism and the circumstances under which it emerged are unlike
the art and context of 1905 and after. It is a corrective extension of its
predecessor, and thus an avant-garde action as much as any other.

Beuys' and Baselitz's example weighed heavily with a much younger
artist, who turned from law studies to painting, was in touch with Beuys

during 1971–2 and became a particular friend of Baselitz's in 1973. Even before then Kiefer had found his primary subject: Germany's past in historical events and in the priorities represented by her choice of cultural values, experienced both personally and as a hidden national sickness. The legends and spiritual leaders in which the German people saw itself, and which it had used and abused to permit the horrors of the Nazi years, became his symbolical material, often set against significant sections of German landscape. In picturing this material, Kiefer brought renewed power and relevance to western art's most weighty and most admired art form, History painting: a work on a major theme known from literature or history and re-examined for its moral values. From the first his art has been religious in character ('I think a great deal about religion because science provides no answers'), and ancient myths as well as motifs from the Old Testament have recently appeared in it to broaden its range of reference beyond the German. His art too owes something to Baroque modes of address but his style and tone are ascetic, mortifying and penitential rather than celebratory, with echoes of Spanish painting and of the bitter German art of Grünewald and Altdorfer. His large paintings are black and brown amid the loud colours of his contemporaries and speak of death and burning in poetic terms that ask to be meditated upon. There is hope in them too—in the poetry itself as living creativity and recently also in hints that evil demands the possiblity of good.

Kiefer's seriousness is seamless and the methods by which he works are deeply studied and deeply felt. He speaks through compiled books and assembled woodcuts as well as through large paintings, and in these he has used various materials and processes apart from paints and collage, including, since 1981, straw, sand and lead and other metals, always to symbolical as well as aesthetic purpose. The ladder in *Untitled* (1984) 302 may denote breaking through materiality and away from the dynamic of worldly evil, symbolized by the snake. That the ladder is of lead may merely indicate Kiefer's interest in this processed metal, but in alchemy lead represents a container of the spirit and is associated with the white dove; the bottom rung of the ladder of ascent to a new consciousness was said to be of lead. This sort of analysis is essential for reading Kiefer: he reaches out for references of this sort to locate his apprehension of the world within the accumulated heritage of non-scientific knowledge which our own century long spurned. But here too, as he knows, other modern artists have preceded him—Beuys of course, but also Duchamp and several others. *Untitled* (1984) echoes quite directly late-medieval representations of Jacob's ladder in the Old Testament.

These artists insist on pulling art out of the entertainment and leisure activities category into which we have put it. Art is not jam on the bread of life; least of all should it be used for distraction. It should not be easy, platitudinous. They demand our attention, not our approval or disapproval; they take us seriously. Other artists of the 1980s have used their skills and an often ironical view of art's situation to produce witty images, at times chattily autobiographical, sometimes commenting on the art of the past through parody or quotation. Twentieth-century Italian art has opted for elegance rather than dealing with major issues

234 (though it has shown notable exceptions, such as the work of Guttuso), and the later 1970s in Italy saw the emergence of talented and intelligent painters whose work addresses us as comedy. Compared with the guru or oracular role of Beuys and Kiefer, they present themselves as cabaret

301 performers. Sandro Chia's *Courageous Boys at Work* represents one of the best of them, well known outside Italy. The young men in his picture, adding to the graffiti on the grey wall which fills it, are painted in a

41 Fauvist manner (close to Malevich's version of it) but also echo a subject dear to the classical tradition, *Et in Arcadia ego*: I (Death) too exist in Arcady (perfect, innocent paradise). Chia may be warning us that death awaits all us urbanites too, and perhaps he is speaking of the death of art, but his overt message is only that the boys are making their marks and probably breaking the law, and his manner is playful.

303 The art of Julian Schnabel, who shot to fame in the late 1970s, balances more troublingly on the edge of entertainment and high sentence. He has usually produced monumental images in paintings developed as reliefs, with projecting or receding areas or with a surface that, by one means or another, is broken up. In this rather than in his wielding of the brush we find his handwriting and his expression, and the results can be powerfully assertive as well as ultimately puzzling. Are his heroes

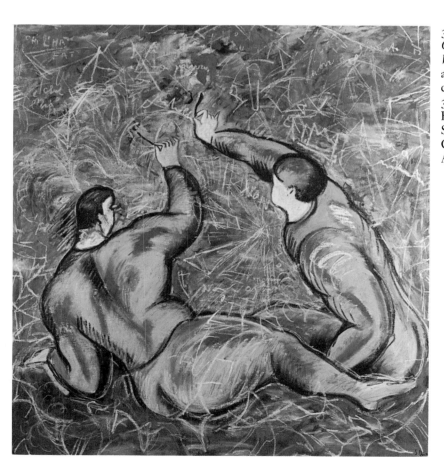

301. Sandro Chia: *Courageous Boys at Work*. 1981. Oil and oil pastel on canvas, $33\frac{1}{8} \times 31\frac{1}{8}$ in. Edinburgh, Scottish National Gallery of Modern Art

302. Anselm
Kiefer: *Untitled*.
1984. Oil,
emulsion, straw,
shellac and lead on
canvas,
$110\frac{1}{4} \times 96\frac{1}{2}$ in.
London, Anthony
d'Offay Gallery

potent or broken? Is this art nihilistic or positive? His headlong promo-
tion has thrown doubts on his quality, perhaps unfairly, and has made
it difficult to assess his work, but there is no doubt about its power.
If his pictures leave one in some doubt, it is about their content; but
at least they do raise questions about content.

Content, I repeat, was not absent or inferior in much of the best
modern art; indeed, abstract art was created to enable major themes
to be attempted again in an art made stale by academic formulae. The
1980s has seen art that deals with such themes given the main stage
and has opted to see only figurative art as capable of it. We shall soon
see renewed respect for abstract art, and we shall also see how deeply
the new figurative art is indebted to abstraction—as, for example,
Schnabel's is to Jackson Pollock's—so that the line newly redrawn
between the two major modes will be allowed to fade again. What is
to some degree special about content in 1980s is that it may again be
delivered through symbolic material. In Kiefer this is cultural and
learned; in Ken Kiff it is both personal and cultural, the latter reinforcing
the former. Kiff's *Mayakovsky* painting illustrates this. He had set out
to paint a seated man, reading or writing; this motif had haunted him

for a time and probably referred to himself. But he was also thinking about and reading Mayakovsky, the great Russian poet of the Revolutionary period. The painting became an imaginary portrait of this great man, and illustrates a poem in which Mayakovsky, for once weary of struggling with words and all his work for the new society, notes the sun's easy daily round and cheekily invites him down to come to tea and talk with him. The poem ends with the poet accepting that both have their allotted tasks; both must shine in their particular ways. So the general theme has become a particular one, with a particular literary reference. But the painting is also about all creative labour and has a wider reference, since Kiff's representation echoes centuries of images showing the evangelists and other authors at their work; moreover, the paper or cloth the poet is holding in the painting bears Michelangelo's features as shown in the Sistine Chapel's *Last Judgement*. Once again, the modern painting, secular in its concerns, derives some of its vitality from religious imagery.

This applies even in the case of Gilbert and George's gaunt pictorial discourses. *Death* could be pictured in many ways. In a composition typical of their 1980s work, the two former sculptors have used photographic montage to build something not unlike a stained-glass window and to represent death as ascent and as progressive, enhanced births. Their hard forms and colours counter the quasi-religious imagery and format, as do the insistent ordinariness of signature and title in the picture and the large mouths that replace the clouds and angels we would expect in an *Assumption*. In that conflict, as in the gap between action and sophisticated presentation in a Bacon, lies the particular charge of this kind of work; additionally we sense the open arrogance of the artists who offer themselves not only as their own preferred, almost exclusive, subjects but as embodiments of art in everything they do and are. Thus they are saintlike, wholly committed to their vocation, and they are dandies; at the same time they deal with fascism, violence, homosexuality

304

225

303. Julian Schnabel: *King of the Wood*. 1984. Oil and bondo with plates and spruce roots on wood, 120 × 234 in. Photograph courtesy The Pace Gallery, New York

304. Gilbert and
George: *Death*.
1984. Photo-piece,
166 × 99 in.
London, Anthony
d'Offay Gallery

and prostitution, leaving the viewer struggling to find his or her position
vis-à-vis their pictorial sermons and uncertain of theirs.

Gilbert and George began to exhibit in 1968; Ken Kiff in 1970. In
the 1980s they have acquired high status in an international art world
content to encompass such very contradictory work, linked only by the
word 'figurative'. Yet it is obvious that the much-vaunted return to

figuration—interpreted by some as a return to humanity in art—is not in itself the significant moment of the decade, but rather the insistence on meaning as a priority and as something to be delivered through means that demand thought and at times learning in artists and in us. More and more—more, to be specific, than with the art of Matisse or Nicholson, more than with much Cubism, Expressionism or Surrealism, but no more than with Brancusi, Mondrian and the major Russians—we have to consider each work and sometimes each life's work to extract and analyse meaning. Intuition is not enough, any more than it is with the art of classicism. This applies also to the best sculpture of the 1980s.

Tony Cragg, resident in Germany, has been exhibiting widely since 1979. He can be seen as one of an exceptionally interesting range of new British sculptors, but this tells us little about him, since their work varies widely in character and intention. Cragg's roots are clearly in Concept art. Until recently the process by which his sculpture was created carried its meaning. For ten years, from 1977 to 87, his method was to collect selected items of refuse where he was living or exhibiting, usually bits or objects of plastic, and to arrange these on floors or walls to form a design or to describe objects. The objects invited thought (e.g. *Red Skin*, 1979; *Riot*, 1986) but it was principally the process that held attention: rubbish turned into significance, the positive use of the environment, creativity displayed in its most essential form. Since 1982 he has also been making sculpture by several processes, including the traditional ones of carving and modelling, and his emphasis has been on the resultant objects and groups of objects. To represent him here I have chosen an unusually concentrated work, a bronze he named *Mother's Milk II* (1988). Vesels have always had strong human or animal connotations. This one, the size of a big man, hints at ancient jars, alchemical retorts and industrial containers, yet confronts us like a living presence, a giving creature or one that has given and is spent. In fact it refers us to the nuclear disaster of 1985, the explosion at Chernobyl and the fall-out still poisoning parts of Russia and Western Europe. It cannot be chance, though it may not have been a conscious factor, that this sculpture reminds us also of a late and exceptional work of Brancusi's, his *Turtle*, done in 1943 in what was the grimmest period of the war and said by Sidney Geist to speak of the artist's 'last-ditch tenacity'; like the Cragg it rests on the floor, without a base and with a curiously uncertain relationship to that plane. Cragg explores that narrow band between the familiar and the strange where some of the most compelling art has always been found.

No short chapter can begin to do justice to this decade, and I am conscious of using a few instances to represent many and even so of leaving whole sectors and aspects aside. Feminist art has become very potent since Judy Chicago brought media interest to it through her elaborate collaborative presentation of 1979, *The Dinner Party*, in celebration of women in western civilization. There has not yet been, as far one can tell, a female Beuys, Kiefer or Cragg, though Susan Rothenberg and Rose Garrard come close to that. But do we need to think in terms of sexual competition in art? It is the feminine element that makes those men powerful artists. What has widely been noticed

306

305. Ken Kiff: *The Poet Vladimir Mayakovsky Invites the Sun to Tea*. 1985–7. Oil on canvas, 73 × 51 in. USA, private collection

about the 1980s is its more even-handed internationalism. America is less dominant now and more receptive to European initiatives. Europe is more conscious of regional as well as national variations. Yet consciousness of their roots does not prohibit artists from working far away from them. There is much international movement, movement between western countries and also between West and East, but not for the sake of an artistic Esperanto. Thus, for example, artists from India and Japan work in the West, and western artists readily settle or work in Asia and Australasia. The Soviet Union is ending government control of art, and

admitting, even publicizing, its all-important contribution to Modernism. The consequences must be an artistic growth that accommodates international relationships but above all permits expression of regional and national idioms reflecting the capaciousness and complexity of Russia. A full account of 1980s art would have to show the vitality of a much wider range than the art media tend to admit to: Concept art, Land art, Performance art, abstract art, Constructive art, descriptive painting based on the careful recording of visual data, romantic visionary art in praise of life in this world and the next—it all goes on, on many levels of interest and ambition. Historians, highlighting this and that, have to remind themselves how selective they are being, but an all-embracing chronicle, were it possible, would be pointless.

History invites a further consideration of a perhaps less judgemental sort. We are in the closing years of the twentieth century: *fin de siècle*. Are we also in a time of decadence? Modern art's self-consciousness has never been greater, and whether or not we see modern art as the second wave of Romanticism, and thus as an aspect of developments at least two centuries old, we should at least face the possibility that we live in a dying phase and await a new impulse. Again the past is not simple. The 1880s and 90s did indeed bear signs of decadence, and there were those who took pride in extreme sophistication and others who denounced them as degenerate. But those years were also the time of Post-Impressionism and of Tolstoy. The end of the eighteenth century was the time of David and Neo-classicism, when art again stressed its moral function and engaged in public affairs. I have here given priority

306. Tony Cragg:
Mother's Milk II.
1988. Bronze,
$35\frac{3}{8} \times 71\frac{3}{4} \times 56$ in.
London, British
Council

307. Anselm
Kiefer: *High
Priestess
(Zweistromland)*.
1985–9.
Photographed in
progress in the
artist's studio,
December 1988.
Courtesy, Anthony
d'Offay Gallery,
London

to this moral, reformatory tendency in contemporary art, but it also offers parallels with the decadence of a century ago.

Kiefer's *High Priestess* is a major work that points forward and backward in the history of art as knowledge and communication and is relatively silent on the theme of individual self-expression. The title refers us to the Tarot, the second Arcanum of which is named 'the Door of the Sanctuary' or Knowledge. Its image is that of a robed woman, seated between two columns, with a book in her lap and behind her sometimes the sea. The German title for this work is *Zweistromland*, meaning the land between the Tigris and the Euphrates, the cradle of civilization and the site of the first great library. Massive books bound in lead and stored on mighty steel shelves symbolize human achievement, but it is of course an ambiguous arrangement, as much cemetery as resource. Lead covers withhold as well as preserve. Lead pipes full of water rise up the steel frame, the two streams of the German title. The scale of the piece is super-human, a library for ancient giants or future gods. Kiefer implies the might and preciousness of knowledge and also the difficulty of using it. In working with and away from the language of painting he is both reinforcing and opening up conventions of art. The innovator is also defender of the faith.

12 The Artist in Modern Society

True progress consists not in being progressive
but in progressing.

Bertolt Brecht, 1930

Our notions—and theirs—of what artists are and what may be expected
of them have as long a history as art itself. In *The Story of Art*
E. H. Gombrich surveys it comprehensively, if briefly, placing art in its
changing context of ideas and functions. In addition, he ends each
chapter with an illustration that indicates the period's view of the artist
and of his product. Which image would we choose to represent the artist
in the twentieth century? Duchamp making his elaborate quasi-scientific
notes for his *Large Glass*, or playing chess; Moholy-Nagy in his boiler
suit, at the telephone, perhaps, instructing the sign-writer who will carry
out paintings for him; Andy Warhol, behind his dark glasses, seen with
the glamorous companions who form both his court and the Warhol
'Factory'; Matisse drawing and re-drawing the same face; a sculptor
welding; a Photo-Realist over-painting a photographic image projected
on to his canvas; an artist working with a video camera, a bulldozer,
a computer . . . ? No one of them will do. We should have to make up
a kaleidoscopic collage of images to show this variety, and it is symboli-
cally apt that we should have to turn to a technique brought into art
by Cubism. Technically, at least, much of the diversity seems to originate
in the Cubists' introduction of collage. Ideologically, it was not only
Cubism but also Futurism, aspects of Expressionism, and especially
revolutionary developments in Russian art, that brought art out of its
relatively limited field of activities into its present, apparently infinite
range of concerns.

Professor Gombrich entitled his chapter on the twentieth century
'Experimental Art' and terminated it with one of Picasso's eloquent
etchings from the set done for a 1931 edition of Balzac's story 'The
Unknown Masterpiece'. The story is a parable of the aspirations and
perplexities that typify the free artist, the Romantic and post-Romantic
artist charged by us to find his own programme and standards. It tells of a
painter who devotes years of effort and the most exalted ideals to creating
one magnificent painting of a beautiful woman; when, at last, he is
persuaded to show his great work to two friends, they see nothing but
'confused masses of colour and a multitude of fantastical lines that go to
make a dead wall of paint'; the painter himself for a moment doubts his
success, and dies the following night after burning his masterpiece.
Picasso does not hint at this consummation but shows the artist intently,
endlessly it would seem, at work on finding the pictorial image for his
model—who appears to be growing old under his scrutiny. Fantastical
lines? Picasso's artist has been marking his picture with straight and

297

curved lines that show little resemblance to the model ... yet Picasso in 1932 painted a series of particularly seductive nudes, and one of them, *Nude Woman in a Red Armchair*, in the Tate Gallery, could have been developed out of those lines. In any case, the etching expresses with unusual force the interaction of artist, motif and image, which is the source of all representational art.

Source and, to a very significant degree, also the content of such art. Our sympathy may go to the woman but our admiration goes to the artist on account of the intensity of his tacit struggle. That struggle can matter more than the work coming out of it: there can be no ultimately satisfying way of translating a living person into a 'wall of paint'. Having left the artist without a specific role, we have made his task vast and deep: to see and sense more than we see and sense, and to build out of this experience works that lead us towards his more comprehensive experience. The picture that Picasso's artist is preparing is not intended for a specific place or function, and the artist seems unaware of anything outside his studio, outside this strange triangular relationship between artist, seen object, and work, which to many of us is the unquestioned norm. What is the artist doing, we may ask ourselves, and for lack of a better answer we say he is 'expressing himself'. In other words, we know that he is doing something that is not mere copying, and that even when a work of art 'is like' an object in the visible world, its art-ness, its value to us, resides in something else, some process of transformation, some insight incorporated in the work by departure from the visual data. We still believe in an impulse that makes the artist different from ourselves and therefore of use to us. Plato had spoken of the poet 'as a light and winged thing', adding that 'there is no invention in him until he has been inspired and is out of his senses, and the mind is no longer in him', and he had condemned artists because of their concern with copying mere appearances. We think of the artist as a poet-artist and believe in an element of inspiration, even if today we associate this more with the unconscious, with hidden personal stores and with a collective realm of symbolical material, to which plunging into the individual unconscious can give access.

Belief and doubt—we believe in the artist because we need his work. Significantly, the period which has required us to believe in the artist and in which we have demanded of the artist that he work on a plane where objective criteria for judging his product fail us, has been the period of successive industrial revolutions, political instability, rapid urbanization, and other extremes of social change, of, in short, alienation. The artist in our society may become alienated from the product of his labours (though losing his product is also his way of making relationships within society), but in other respects he is the least alienated worker, his labour being a natural part of his life as a whole, self-directed, self-assessed and self-satisfying, and his product always remaining identified with him even if it go far afield. But, though we yield faith to this exceptionally whole person, and use him as a symbolical counter-agent to the routines imposed on us by the world we have inherited, we also doubt him— because we lack criteria and because we depend so desperately on his authenticity. We wish the artist to be totally free, a model of free action,

yet we cannot bear him to take the freedoms that move him beyond our easy comprehension lest he be mocking our faith.

It is a paradoxical situation, and obviously not a satisfactory one. That part of the public that takes some interest in art tends to look to the past because there it feels secure. This is not because Rembrandt or van Gogh are easier to understand than twentieth-century artists, but because time and repeated praise have removed their art beyond the reach of doubt (though it is worth noting that Rembrandt's super-stardom was not awarded before the nineteenth century, and van Gogh's only during the last thirty or so years): we may idolize them unhesitatingly as models of freedom, as rebels even, whose unconventional work no longer seems to challenge any conventions. Idolization is a form of dismissal: when Rembrandt and van Gogh look safe we have stopped looking at them. That modern artists have not attained this blind admiration may in the end be their salvation and ours. Attempts are made to take fan-clubbish possession here and there—of Picasso, for instance, by casting him as a sort of court jester to the Western world, whom we allow to perform all sorts of pranks because he has proved that he can draw—but van Gogh and, perhaps, Rodin are the latest artists to whom the public offers total faith. Cézanne may be next, but I suspect his work is too deliberate, too understated, to accept this kind of embrace. Yet, as a kind of late Impressionist, he is highly eligible, and I stress this because if Cézanne

297. Pablo Picasso: *The Painter and his Model* (illustration to Balzac's *Le Chef-d'œuvre inconnu*, published 1931). 1927. Etching, $7\frac{1}{2} \times 11$ in.

can become an art hero, if his work can at last receive from a wide public the sort of attention it requires and deserves, then a major difficulty may be overcome. Not just because artists throughout this century have seen him as their father but because he demonstrates so convincingly the nature of that triangular relationship—artist, motif, image—which Picasso's etching illustrates, and because the reticent character of his mature art may teach us all the patience and the attention that worthwhile art requires.

The issue of attention is cardinal. Art's most obvious handicap is that it can be taken in at a glance. A book, a play, a poem, a sonata, a pop song—all of them receive from us some span of attention before we judge them. Art we judge instantly. And we even pride ourselves on it, praising the impact of something we like, dismissing other things because 'they don't speak to me'. Some art speaks, some art shouts, but the best art needs to be questioned a little and needs to be listened to a lot. It is hard work at first, and that is why faith may still come into it.

In other respects I am as impatient of faith as of doubt. Artists are human beings and the fact that they remain identified with their products should help us to give them the basic credence on which all social existence is founded. If the artist can be returned to his true status as man, not worshipped as a superman, then perhaps he can be met without the false expectations and defences that the thought of modern art evokes in most of us. The diversity of modern art, the many different roles in which the artist now appears before us, may in the end effect such a change of status: since again and again the artist finds new media and methods we have to become conscious of him as a maker and a performer, a kind of worker among other workers.

In his poem 'Popularity' Browning describes the creative man's labours, symbolized as extracting from sea shells the powerful dye for which the Tyrians were once famed. Today the poet works to 'pound and squeeze and clarify . . . While the world stands aloof'; tomorrow perhaps he will achieve the potent essence, whereupon others will rush in to 'put blue into their line':

> Hobbs hints blue,—straight he turtle eats:
> Nobbs prints blue,—claret crowns his cup:
> Nokes outdares Stokes in azure feats,—
> Both gorge. Who fished the murex up?
> What porridge had John Keats?

Until Romanticism originality had meant adding new beauties and elements of meaning to time-honoured themes and formulations. Now originality was to mean a personal style and a personal subject, or at least a style and a subject given marked personal inflection. And since originality can come from mere cleverness and opportunism (as when Nokes outdares Stokes) we ask for a guarantee of sincerity. Until the eighteenth century there was no shame attached to having copies of works of art. The word 'authentic' was brought in when it became important to assert that the work on offer was the original. Today we want to yield admiration only to a real Hobbs and a real Nobbs, but more than that: we want to feel that the work represents the whole, the essential Hobbs

or Nobbs, the true 'artistic personality'. More than that even, for if we are after blue art then it is the instigator of blueness we want, not Hobbs, Nobbs, Nokes nor Stokes. We want Keats, forgetting that when he showed us his hard-won extract we thought it too blue or merely blue, a blue attack on the spectrum we claim to hold dear. (Yves Klein's decision to patent and label his International Klein Blue warrants an additional verse to Browning's poem.) We want the original and the authentic but have no sure way of recognizing it.

We look for signs—for inside evidence of these valued qualities. One is the very all-outness that we actually recoil from when we encounter it. We admire the artist from whom our fathers recoiled and think him our brother. Radicalism has our support as long as it is not our roots that are being uprooted. Another sign is spontaneity. We want 'the spontaneous overflow of powerful feelings' and ignore the words with which Wordsworth continued his definition of good poetry: 'it takes its origin from emotion recollected in tranquillity'. The public continues to pin its faith on signals of immediacy: on sketchiness, on roughness, on any mark of impetuousness. We overlook the paradox inherent in this—we expect the artist to be carried away by emotional impulse again and again and again—and we do not wish to know what every artist can tell us, that signals of this kind are as easily provided as their opposites. In short, the public is not awake to the art-ness of art.

Since the thirties we have spoken more and more often also of another sort of commitment. We want the artist not only to give himself wholly in his art and to his art; we also want him to dedicate his resources to political progress. For too long, the argument goes, has art been an ornament and a diversion; the time has come for the artist to accept adult responsibilities and to make art a weapon. Art that does not help in the fight diverts attention from it. This too stems from Romanticism. Shelley called poets not light, winged and holy things but 'the unacknowledged legislators of the world'. By the time he wrote this, in 1821, Europe had already witnessed and admired the work of its first great political painter. Jacques-Louis David directly served the cause of the French Revolution. In addition, he exercised lasting influence through his teaching, his paintings and the more ephemeral art of staging the festivals through which Robespierre hoped to instil a new kind of civic-cum-religious piety in the people. David had responded to a call for art to become a moral force in society.

Yet the public is even less likely to recognize the art of political action than the art of avant-garde aestheticism. Our attitudes to the artist of our own time—the attitudes, that is, which the media represent as *vox populi*—are too confused to cope with the thought of an artist who focuses his ambition not on worldly success nor on developing his artistic ideas as far as they will go but on a humanitarian cause. We want the artist to be either distant and difficult, a mad alchemist who could just possibly produce a speck of gold, or close at hand in the role of entertainer, a 'personality'. We respond to success and accord to the successful artist film-star status, but we also enjoy the image of the starving, disregarded artist working for posthumous fame. We actually do our best to make sure of both by celebrating and rewarding a handful

of successful artists to excess, whilst disregarding completely artists whose merit may be as great or greater.

We who write and talk about art, educators, museum curators, art critics, and art historians, have not yet discovered the way to clear up this confusion. We have neither the methods for it nor the institutions. We account for art by historical explanations, speaking of development, of the artist's place in it, of his contribution to the history of art; increasingly we speak also of art's place in the life of society—which leads us, in our various ways, to contrast the modern world's helplessness before art with the people of Florence carrying Cimabue's new altarpiece from the artist's workshop to the church in proud procession or with the cave painter's central role in the survival of his group. Such explanations are not untrue and can be illuminating. They have their own inherent interest. They also have their limitations. They tend to illuminate the artist but not art, a category or sequence of art but not the work of art itself. This matters most when we come to modern art.

The puzzled public turns to us and says, in effect, 'What are we supposed to do with this thing?' And we, wanting to help, seem unable to do more than offer a map. We say, in effect: 'This is an example of Blueism, and the Nokes you are standing in front of is a particularly interesting instance of it. You'll notice that Nokes outdares the Stokes you saw in the last room: look how big and resonant and exclusively blue this recent one is. Keats, of course, invented Blueism; you saw a few of his pioneering efforts in the first room and he must take the credit for the movement as a whole.' We may then offer some quasi-philosophical support for the movement, in terms of idealism and theories of pure visibility, and assert the hard realism of a work of art that calls itself blue and is indeed blue to the exclusion of everything else, and still we are trying to tell the truth. The preferred form of art presentation of modern times, the one-man show, both helps and hinders. By bringing together a lot of work by one man we produce instant history: we see development and can draw its particular map. And at the same time we can note the common ingredients that link the development and hope to distil from them that elusive essence we call the personality of the artist. The map fits the exhibition as a whole, and may even partly undo the harm caused by showing one man's art in isolation and implying importance without showing the standards by which one is judging, but it says nothing about the individual work. It actually goes some way towards forbidding attention to it by treating it as a stage, a location on the way to or from somewhere else.

Art history was born on the eve of Romanticism, and the art museum a day later. It too has its limitations. As a preserver of works of art and a collector of information about them, the museum is invaluable. But it is, of course, the wrong place for art. It is also just about the only place where the public can see art. The museum stresses both the variety of the world's art and the underlying unity of man's creativity, and if it embraces contemporary art in its range it may help to reduce the public's suspicion that recent art is nothing but a number of irresponsible, arbitrary acts. But the museum is a herbarium, not a garden or a piece of the countryside. It cannot help denaturizing art. A history painting

of *The Rape of Europa*, a half-length duke, a view down the Grand Canal in Venice, a still life of a copper pot and vegetables, and a bosomy *Repentant Magdalen* hang side by side in a hushed, air-conditioned fort, watched over by guards. If today we enquire into the social functions of these works it is because they have lost them. We have to remind ourselves even of the subjects of the paintings and their implications; to remind ourselves first of all that when they were painted sin and repentance were matters of unquestioned significance and that Ovid's story of the carrying off of the princess of Tyre, probably a piece of history in the form of a pleasing myth, was part of every educated person's mental store; that dukes were more special because more powerful, and copper pots and real vegetables were more ordinary, while Venice was further away and the camera had not yet trivialized the scene. People valued paintings once for the information they gave about dukes and about Venice as well as for the skill and taste that went into them. Religion was part of their shared and everyday life and they shared also a pleasurable familiarity with the great authors of classical times as well as a liking for the physical charms of bodies and situations. Today Ovid's poem is remote and unread; the duke is just a man with an aroma of period; Venice is a postcard; St Mary Magdalen is a bundle of Freudian ambiguities, a female body and a character in a half-forgotten story; and the still life is an enticing photograph in an up-market colour magazine. In any case, we look more at period and style than at subjects. Even if the subjects were more real to us the museum context would inhibit our response. Museums are the treasure cabinets of history, and what we see in them is history and treasures. It takes a positive effort to focus attention on one work and to see it as itself, not as a representative of an age, an artist, a culture. Nothing is unexpected. There is no encounter.

In the media art becomes yet more remote. We are offered art as thriller or mystery when there is a big theft or the disclosure of an august fake; art as sport and gamble when prices soar in the auction rooms; art as sport of another kind when a museum spends its money on a work too far outside the journalists' comprehension. Art critics have their reviews printed on the pages devoted to entertainment. Television, that adaptable and inventive visual medium, has not yet found a way of delivering visual art into the home. The professional art journals wage internecine warfare and address their readers either through professorial exposition or political platitudes, but at least they do not decide on their coverage by asking what will make a good 'story' or 'good television'.

The museums and the media were set up to inform and to guide— guide taste in one case, conventional attitudes in the other. We are becoming more conscious of their distortion of what they present. The media turn everything into news and entertainment. The museums turn everything into history. Neither can offer the actual experience yet, paradoxically, it is our hunger for experience that keeps these institutions busy.

The artist's position in all this is just as confused and paradoxical, though the individual artist may have quite a clear view of it. The only benefit he derives from his situation is that he can adopt one of a whole range of roles, suited to his personality and programme. The past offers a

great variety of models. The museums, said Ad Reinhardt, show us artists what does not need doing any more. The museums also show art's vast variety and confirm the artist's right to add to it—the right which Romanticism inflated into a duty and made into the artist's burden.

To discuss these roles we have to typify them, and we exaggerate them in the process. No type is likely to fit any artist completely, and the more profound the artist the more multifarious may be his roles. A useful distinction may be suggested by speaking of the artist as teacher and the artist as researcher. Both are artists first and foremost, but the teacher is conscious of addressing a public and uses his art at least in part as a way of influencing people, whereas the researcher gives priority to defining his artistic problem and finding or working towards his solution to it. The teacher has a message or a vision he wants to transmit and his works are his formulations of it (and he too may be struggling towards *the* formulation); they are meant to be seen and only live through being seen. The researcher would rather be silent. Showing his work may well be a nuisance to him, a distraction that can have practical advantages but is an interruption of his real activity and is likely to misrepresent it. The end he is working towards may be unattainable and he probably knows it. Pissarro said to Matisse that the difference between an Impressionist and Cézanne was that Cézanne all his life was painting one picture. This aptly describes the researcher artist. He is, clearly, a rarer type than the teacher. In any case the norm is in between: the artist whose work is motivated partly by artistic questions and partly by voiceable convictions.

Artists who use their art directly for social statements and exhortation are clearly teachers, but so also were men like Mondrian, Malevich, and Lissitzky, even though elements of artistic research and spiritual self-analysis provided the basis for their mature work. The researcher image attaches to the Abstract Expressionists and their pursuit of an ultimate, all-expressive painting, but their emphasis on spontaneous, instinctive creation demands also that we should receive each of their works as a complete and self-justifying act. Paul Klee spent much of his life locked into a studio where he tried ever-new combinations of marks and materials in an effort to find a conclusive synthesis of the personal and the universal. Brancusi spent the second half of his career reworking sculptural themes and inventions he had already developed through several stages earlier on. These two we can safely use as instances of the researcher type.

Another way of assessing the social role of an artist's work—one that involves much less polarization—is to examine and interpret his process of working, the physical as well as (in so far as we can know it) the mental. Artists frequently ask us to consider their work not merely as finite products but as embodying a complex of activities. As Klee stressed: 'The work of art is above all a process of creation; it is never experienced as a mere product'. As we see it, *if* we see it, we experience in some measure the making of it. If, then, we examine the work of various artists we shall see that differences between them take on social significance. The Constructivist, for example, works often in materials that not only are factory-made but also symbolize the world of technology. His

personality is by no means absent from his work but it is not part of his visible offering. He structures his work according to formal relationships that are rooted in mathematics. An exact copy of his work would be its twin. If a part of a construction broke it would be possible to replace it with a piece of the same material cut to the same size and fixed in the same position. His guise would seem to be that of the researcher, but the implications of his process are social and point to an accord with his physical environment and a constructive, optimistic relationship to the world at large. His activity is a model for social life. At the opposite end stands the artist who works exclusively from unconscious stimulus— whose activity is primarily that of gaining access to his unconscious imagery. The Surrealists made it their announced purpose to prove to the world that sanity lies not in reason and useful order but in the free life of the imagination and in sensory adventure. Their process had to be intensely private, yet their aim too was public. The purpose of their work, of transmitting their findings in the form of art, was totally social and remedial. The Expressionist similarly works inwardly with outward purpose. The Abstract Expressionist who worked as action painter is presented as the explorer of some private and distant realm, averted from his fellow men, but if we imagine him at work we see that he was also a man of ritual, putting into a socially admitted form an activity that society would consider insane or at least pointlessly anachronistic. Pollock worked like a tribal rainmaker, not like a raging prophet or a saint in ecstasy, and the action he was performing as he moved around his canvas and gestured over it is as much the content of his painting as is the unconscious motivation that affected his movements. The apparent formlessness of his paintings reveals itself as another sort of form, and as we respond to the new form, and learn from it to accept the possiblity of an infinitude of orders in place of the orders we are taught to recognize as such, we add to our stature as social and political beings as well as individuals. There is no work of art that is not of some profit to society.

The charge of obscurity, so often brought against the modern artist, is oddly inept. It is possible that another century will accuse the art of ours of simple-mindedness. Compared with the art of the classical past, of the Renaissance, and with much of the nineteenth century too, much modern art offers direct, untutored access. We saw that Duchamp and others have been troubled by this. Traditionally Europe has reserved its highest praise for art that exhibited a clear intellectual base and presumed some learning of classical or Christian history and literature in the spectator. Those arts, notably landscape and still-life painting, that relied on taste operating only on common experience were given the lowest rating in the academic scale, and it is precisely these forms of painting that accommodated the most radical pioneering of the nineteenth century. Not only does modern art rarely address itself to a learned viewer, but much of it confronts the public with clear statements through simple means. Moreover, no age has shown more concern with the efficacy of communication. When Kandinsky said, 'The more abstract form is, the more clear and direct is its appeal', he was basing himself on the findings of researchers in the field of perceptual psychology as much

as upon his own experience. The other pioneers of abstract art showed a similar concern for comprehensibility.

Mankind has lost neither its eyesight nor its faculty for admiration. What Western man has lost is the kind of tempo that goes with looking and the stillness that goes with focused attention. Again, modern art is thought to be rough and clamorous. In fact, so much of it has to do with peace, calmness, dignity. Modern art has tended to avoid the time-worn melodramas of Victorian art, and can be accused of attending only rarely to the real dramas of twentieth-century existence. But then these too are immediately, routinely dramatized and melodramatized by the media and devalued by overstatement and repetition. Turning art into a political weapon risks merely involving it in that hubbub, a pigmy beside the big machines of the mass media.

The world is changing. Capitalism and the ideal of virile competition are in decline. The work ethic no longer rings true in an age of mass unemployment and computerization. Thanks partly to the influence of non-European ideals, we are beginning to be more interested in living than in achieving. Every day we are made more conscious of our need to live with nature rather than exploit her, and of the harm we are doing to ourselves by living our stop-watch lives. For all sorts of reasons our tempo will decelerate, the hubbub will decrease. With this change will come some reintegration of pleasure with existence, pleasure with work, pleasure as something contributed to and built, not passively received.

I sense an opportunity to be seized. We need all art as we need all nature; there is a balance in both. We need easy, ordinary contact with art. With ordinary art: we must stop talking as though only masterpieces mattered. We must altogether stop speaking of art in terms of war. Individual artists may improve their work with experience and keener understanding, but art as such does not progress and least of all does it triumph over art. Nokes may outdare Stokes but that in itself does not mean that Stokes's art is inferior to Nokes's. Both may have their value. It was Keats who fished the murex up and laboured to distil the dye, and he neither aimed at nor claimed to be leading a revolution. Browning's metaphor suggests that what was new in Keats was also ancient. If we adopt Klee's organic model for the life of art—invented by early Romanticism whereas later Romanticism brought in the language of war—we have a truer and more useful image of the relationship of new art and old, of their interdependence and coexistence. In one cardinal respect art goes beyond nature, and this is art's ability to fertilize without dying. One of the justifications for studying and writing art history, and more particularly for writing the history of recent art, is that of showing the unity of the new growth with the old. That established, we can close the book, silence the tape-recorded guide, and listen with our eyes.

Biographical Notes

These entries are mostly kept quite short, giving little more than the most important dates and events in each artist's life. Selected bibliographical references supplement the main Bibliography that follows on p.392. More information can be found in a variety of reference books, notably the Macmillan encyclopaedia of *Contemporary Artists*, London and New York 1983.

Valerio **Adami**

Born 1935 in Bologna. Studies at Brera Academy, Milan. First one-man show Galleria del Naviglio, Milan, 1959; shows in Bremen 1960, London 1962, Antwerp 1965, Paris 1968; first show in USA 1970 at Hansen Gallery, San Francisco.

Damisch, Hubert, and Martin, Henry, *Adami*, New York and Paris 1974

Joseph **Albers**

Born 1888 in Bottrop, Germany; died 1976 in New Haven. School teacher, then art training in Berlin, Munich, and at Bauhaus (Weimar) 1920–3. Teaches at Bauhaus (Weimar, Dessau, and Berlin) until 1933; then at Black Mountain College, North Carolina, until 1949. Many other teaching engagements. Exhibitions in USA and internationally from 1936 on.

Albers, Josef, *Interaction of Colour*, London and New Haven, Conn., 1963
Gomringer, Eugen, *Josef Albers*, Starnberg and New York 1968
Weber, Nicholas, *The Drawings of Josef Albers*, New Haven and London 1984

Karel **Appel**

Born 1921 in Amsterdam. 1940–3 studies at Amsterdam Academy of Art. Founder-member of Cobra group in 1948. 1950 to Paris. Visits USA and Mexico 1957. Now lives in New York.

Catalogue, *Karel Appel*, Stedelijk Museum, Amsterdam 1965

Shusaku **Arakawa**

Born 1936 in Nagoya, Japan. Organizes Neo-Dada group in Tokyo 1958; moves to New York 1961. 1963 begins his diagrammatic paintings, gradually replacing depiction of objects with words, 'attempting to pic-

torialize the state before the imagination begins to work'. Film *Why Not* 1969.

Schwarz, Ellen (ed.), *Arakawa: The Mechanism of Meaning*, New York 1979

Keith **Arnatt**

Born 1930 in Oxford; studies at Oxford School of Art and at Royal Academy Schools, London, 1951–8. First one-man show in Amsterdam 1970; contributes to exhibitions of Concept art in Europe and America from 1969 on. Arnatt's work often comments ironically on avant-garde attitudes and jargon, mostly through words and/or photographic images.

Parry-Crooke, Charlotte (ed.), *Contemporary British Artists*, London 1979

Jean (Hans) **Arp**

Born 1886 in Strasbourg; died 1966 in Basle. Art studies in Strasbourg, Paris, and Weimar. To Switzerland 1909; founder-member of Zurich Dada group in 1916. Participates in Cologne Dada around 1920. Marries Sophie Taeuber in 1921. Collages, reliefs, and Dadaist poems; from about 1930 also three-dimensional sculptures. Associated with abstract art groups in Germany and France, but also with Surrealism.

Soby, James T. (ed.), *Arp*, New York 1958
Read, Herbert, *Arp*, London 1968
Catalogue, *Arp 1886–1966*, Cambridge 1987
Catalogue, *Hans Arp: Nach dem Gesetz des Zufalls geordnet*, Kunstmuseum, Basel 1982

Lawrence **Atkinson**

Born 1873 in Chorlton upon Medlock, near Manchester; died 1931 in Paris. Studies singing in Berlin and Paris; performs and teaches singing in England. Self-taught artist. Exhibits 1913 in London. 1914 joins

Wyndham Lewis's Rebel Art Centre and co-signs *BLAST* manifesto. 1915 work included in Vorticist exhibition, Doré Gallery, London, and publishes poems *Aura*. 1921 one-man show at Eldar Gallery, London, and major prize for sculpture in Milan international exhibition.

Shipp, Horace, *The New Art*, London 1922
Cork, Richard, *Vorticism and Abstract Art in the First Machine Age*, London 1976

Francis **Bacon**

Born 1909 in Dublin. Self-taught, painting from early thirties on, also designer of rugs, furniture etc. Paints exclusively from 1944, mostly in London. His international fame dates from 1960s.

Russell, John, *Francis Bacon*, London 1971
Sylvester, David, *Interviews with Francis Bacon, 1962–1979*, London 1980
Ades, Dawn, and Forge, Andrew, *Francis Bacon*, New York and London 1985
Catalogue, *Francis Bacon*, Tate Gallery, London 1985

John **Baldessari**

Born 1931 in National City, California. Studies painting at San Diego State College, 1949–57. First one-man show 1960 at La Jolla Museum of Art; first New York show 1971 at Richard Feigen Gallery.

Catalogue, *John Baldessari*, Van Abbemuseum, Eindhoven 1981

Giacomo **Balla**

Born 1871 in Turin; died 1958 in Rome. Art training in Turin; settles in Rome 1895. Visit to Paris 1900. Signs Futurist painting manifestos in 1910 by invitation of Boccioni and Severini, former pupils. Paints studies of movement inspired by chronophotography; then also diagrammatic studies of movement, and abstract studies of colour and light. Designs Futurist clothes, furniture etc.; about 1930 turns to descriptive painting.

Catalogue, *Giacomo Balla*, Galleria d'Arte Moderna, Turin 1963
Robinson, S. B., *Giacomo Balla, Divisionism and Futurism, 1871–1912*, Ann Arbor 1981

Georg **Baselitz**

Born 1938 in Deutschbaselitz, East Germany. Studies art at E. Berlin Academy, then moves into W. Berlin and studies at Academy there. First exhibitions W. Berlin 1961 and 1962; issues 'Pandemonium Manifestos'. Paintings removed by police from first one-man show 1963. Further exhibitions, also abroad from 1967 on. 1966 moves to Osthofen near Worms, 1971 to Mussbach, 1975 to Derneburg near Hildesheim, where he still lives and works. 1978 on, professor at Karlsruhe Academy. 1980 on, carves and

paints wood figures, in addition to making paintings. That year controversial display of a single carved figure in German pavilion at Venice Biennale. 1983 on, professor at W. Berlin Hochschule der Künste.

Catalogue, *Georg Baselitz*, Venice Biennale 1980
Catalogue, *Baselitz*, Waddington Galleries, London 1982
Catalogue, *Baselitz*, Waddington Galleries, London 1984
Catalogue, *Georg Baselitz, Sculpture and Early Woodcuts*, Anthony d'Offay Gallery, London 1988

Max **Beckmann**

Born 1884 in Leipzig; died 1950 in New York. Studies at Weimar Academy 1899–1903, then travels to Paris, Florence and elsewhere before settling in Berlin 1907. Medical orderly 1914–15; then lives and works in Frankfurt until 1933. Early recognition, but characteristic, strongly constructed, and unsentimental form of Expressionist painting dates from about 1921. 1925 professor at Städel School in Frankfurt; dismissed 1933. Leaves Germany 1937 for Paris and then Amsterdam. 1947 to USA; exhibitions and prizes as painter, including 1950 Venice Biennale prize.

Selz, Peter, *Max Beckmann*, New York 1950
Schulz-Hoffmann, Carla, and Weiss, Judith, *Max Beckmann: Retrospective*, New York and London 1984

Joseph **Beuys**

Born 1921 in Krefeld, West Germany; died 1986 in Düsseldorf. War service, gravely injured in aeroplane crash in Crimea 1943; later prisoner of war. Studies art at Düsseldorf Academy 1947–54. First one-man shows in Germany 1953, abroad 1968 on. 1961–72 professor of sculpture at Düsseldorf; dismissed for political/institutional reasons. 1973 professor at Berlin Hochschule der Künste; founds Free International University for Creativity and Interdisciplinary Research. Much public speaking; stands for European Parliament (1979) and Nordrhein-Westfalen Diet (1980).

Catalogue, *Joseph Beuys*, Guggenheim Museum, New York 1979
Tisdall, Caroline, *Joseph Beuys*, London 1979
Catalogue, *Joseph Beuys: Œuvres 1963–1977*, Centre Georges Pompidou, Paris 1985

Charles **Biederman**

Born 1906 in Cleveland, Ohio. Commercial art apprenticeship 1922–6, then School of the Art Institute of Chicago, 1926–9. To New York; abstract constructions and paintings. 1936–7 in Paris. 1938 studies under Alfred Korzybski (founder of General Semantics Institute); begins work on book, *Art as the Evolution of Visual Knowledge*, published by himself 1948. Further books: *Letters on the New Art* 1951, *The New Cézanne* 1958.

Catalogue, *Charles Biederman*, Minneapolis Institute of Arts, Minn., 1976

Max **Bill**

Born 1908 at Winterthur, Switzerland. Studies design in Zurich, then student at Bauhaus, Dessau, 1927–9. Active as architect and industrial designer as well as painter and sculptor. Member of Paris *Abstraction-Création* group 1932–7; from 1937 member of Swiss *Allianz* artists' association. Organizes 'Concrete Art' exhibition in Basle 1944; another in Zurich 1960. 1951–6 director of Hochschule für Gestaltung in Ulm.

Maldonado,Tomas, *Max Bill*, Buenos Aires 1955
Huettinger, E., *Max Bill*, New York 1978

Julius **Bissier**

Born 1893 in Freiburg-im-Breisgau, Germany; died 1965 in Ascona, Switzerland. Art studies before and after first world war. Realistic paintings, then drawn to Chinese art and abstraction. Abstract paintings from about 1930, increasingly influenced by Oriental calligraphy and thought.

Schmalenbach, Werner, *Bissier*, Stuttgart 1963 and New York 1976

Umberto **Boccioni**

Born 1882 in Reggio Calabria; died 1916 in Sorte, near Verona. 1900 to Rome, where he begins to paint, becomes friends with Severini and is guided by Balla. 1906 visit to Paris and Russia. Settles in Milan 1907; meets Carrà and Russolo, also Marinetti the writer. 1910 chief author of two Futurist painting manifestos. 1911 to Paris with Futurist friends; 1912, after Futurist exhibition in Paris, he turns to sculpture, which he shows in Paris 1913. Active service 1915; dies after fall from horse.

Ballo, Guido, *Boccioni, la vita e l'opera*, 1964
Boccioni, Umberto, *Gli scritti editi ed inediti*, Milan 1970
Calvesi, Maurizio, *Boccioni*, Milan 1983

David **Bomberg**

Born 1890 in Birmingham; died 1957 in London. Apprenticed to lithographer; studies painting in spare time; scholarship to Slade School of Art 1911–13. Personal version of Cubism in paintings of 1912–14; associates with Vorticist circle. Crisis when Canadian War Memorial painting is rejected 1918; turns to more Expressionist, observation-based painting, which he teaches at Borough Polytechnic 1946–53, powerfully influencing younger generation. Works also in Palestine 1923–7, in Spain and in Cornwall.

Catalogue, *David Bomberg*, Arts Council of Great Britain, London 1967
Catalogue, *David Bomberg*, Whitechapel Art Gallery, London 1979

Cork, Richard, *David Bomberg*, New Haven and London 1987
Catalogue, *David Bomberg*, Tate Gallery 1988

Pierre **Bonnard**

Born 1867 in Fontenay-aux-Roses; died 1947 in Le Cannet. After law studies, attends Ecole des Beaux-Arts and Académie Julian; meets Denis and others who become the Nabis group. In 1890s active as poster and stage designer and decorative painter; also 'intimist' paintings of interiors. From 1900 paints more or less exclusively; from 1910 on spends part of year in South of France, later living there continuously.

Fermigier, André, *Pierre Bonnard*, New York and London 1987
Terrasse, Antoine, *Bonnard*, Geneva 1964
Newman, Sasha, *Bonnard*, London 1984

Constantin **Brancusi**

Born 1876 in Hobitza, Rumania; died 1957 in Paris. Peasant origins; art studies in Craiova and Bucharest. To Paris via Munich 1904; works for some months with Rodin; independent work from 1907 on. Early work is modelled for casting in bronze; from 1908 on mostly carved sculpture, in stone or wood, though some of the sculptures are then also carried out in highly polished bronze and steel. The same themes reappear: *The Kiss*, heads, birds, fish, torsos, *The Endless Column*, reworked many times; wood carvings suggest fusion of Rumanian folk decoration with African tribal carving. 1933 discusses design of mausoleum and temple for meditation for Maharajah of Indore, India; 1934–7 works on *Gate of the Kiss, Table of Silence*, and *Endless Column* for Tirgu Jiu in Rumania. He leaves his studio, including carved doorways etc., to the French nation; now at the Centre Pompidou, Musée d'Art Moderne.

Geist, Sidney, *Brancusi, a Study of the Sculpture*, London 1968
Catalogue, *Brancusi*, Gemeentemuseum, The Hague 1970
Geist, Sidney, *Brancusi*, New York 1975
Varia, Rudu, *Brancusi*, New York 1987
Istrati, Alexandre, and Dumitresco, Natalia, *Brancusi*, London 1988

Georges **Braque**

Born 1882 in Argenteuil-sur-Seine; died 1963 in Paris. Trains as painter and decorator; turns to fine-art painting in 1902, studies at Académie Humbert and Ecole des Beaux-Arts. Influenced by Fauvism, then by Cézanne and Picasso; with Picasso evolves Analytical and Synthetic Cubism from 1908 on. His later work, still lifes and studio interiors, are poetic variations of Cubism, sensuous in colour and form and without the teasing character of Cubism.

Russell, John, *Braque*, London 1959

Mullins, Edwin, *Braque*, London 1968
Cogniat, Raymond, *Georges Braque*, New York 1980

Stuart **Brisley**
Born 1933 in Haslemere, Surrey. Studies art at Guildford School of Art and Royal College of Art, also at Munich Academy and at Florida State University. In late sixties turns from making constructions to Performance Art. Since 1970 has presented performances, solo and with collaborators, throughout Europe: London, Warsaw, Berlin, Vienna, Milan, Paris, Amsterdam etc.

Parry-Crooke, Charlotte (ed.), *Contemporary British Artists*, London 1979
Catalogue, *Stuart Brisley*, Institute of Contemporary Arts, London 1981

Alberto **Burri**
Born 1915 in Città di Castello, Italy. Serves as doctor in North Africa in second world war; begins to paint while prisoner of war, 1944–5. Gives up medicine 1945, settles in Rome and exhibits work regularly from 1947 on, internationally from 1950.

Catalogue, *Alberto Burri*, Museum of Fine Arts, Houston 1963

Anthony **Caro**
Born 1924 in London. Royal Academy Schools 1947–52; part-time assistant to Henry Moore 1951–3; 1953–66 part-time teacher in St Martin's School of Art. Powerful modelled figure sculptures in late 50s. Visit to USA 1959; on return changes to constructing metal sculpture: new works exhibited London 1961. 1963 large one-man exhibition Whitechapel Gallery, London; 1966 one-man show in British Pavilion at Venice Biennale, awarded David Bright sculpture prize. 1967 included in Los Angeles County Museum's 'American sculpture in the sixties' exhibition. Many exhibitions since then, including retrospective at Hayward Gallery, London, 1969. Knighted 1987.

Catalogue, *Anthony Caro*, Arts Council of Great Britain, London 1969
Whelan, Richard, *Anthony Caro*, Harmondsworth 1974 and New York 1975
Rubin, William, *Anthony Caro*, London and New York 1975
Catalogue, *Caro*, Arts Council of Great Britain, London 1984
Waldman, Diane, *Anthony Caro*, Oxford 1982

Carlo **Carrà**
Born 1881 in Quargnento, Italy; died 1966 in Milan. Studies under decorative painter, and then at the Brera, Milan. Joins Futurist group 1910, visits Paris with them 1911. Publishes his Futurist writings about art, *Guerra Pittura*, 1915. Serves in army; meets de Chirico in military hospital in Ferrara 1916 and they join forces with Metaphysical Painting. Growing interest in Giotto and Italian Renaissance painting dominates his painting of 1920s; softer, more painterly and prettily coloured paintings from 1930s on.

Carrà, Carlo, *La mia vita*, Rome 1943
Carrà, Massimo, and Bigongiari, Piero, *L'Opera completa di Carrà*, Milan 1970

Paul **Cézanne**
Born 1839 in Aix-en-Provence; died there 1906. Boyhood friend of Zola. Studies painting in Paris, meets Pissarro. Work rejected by 1864 Salon and frequently thereafter. Works with Pissarro; included in first Impressionist exhibition 1874. Works mostly in South of France, and little known in Paris until first one-man show at Vollard's gallery 1895. In last years visited by painter Emile Bernard, with whom he also corresponds. Further shows at Vollard's 1898 and 1899; 1899–1902 sends annually to Salon des Indépendants; larger groups of paintings at Salon d'Automne 1904–6, and memorial exhibition there 1907. Bernard publishes correspondence in articles from 1904 on.

Rubin, William (ed.), *Cézanne – The Late Work*, London and New York 1977
Rewald, John, *Cézanne: a Biography*, London 1986
Catalogue, *Cézanne: The Early Years*, Royal Academy of Arts, London 1988

Marc **Chagall**
Born 1887 in Vitebsk, Russia; died 1985 at St-Paul-de-Vence. Studies painting in Vitebsk and St Petersburg. 1908 first contact with Post-Impressionism through Bakst, and first characteristic paintings. 1910–14 in Paris, sponsored by patron; contact with Delaunay, Apollinaire and others; 1914 in Berlin, exhibits at Der Sturm Gallery. Visits Vitebsk; war. After October Revolution 1917 appointed commissar for art in Vitebsk; 1919 director of Vitebsk Academy; resigns 1920 after quarrel with Suprematists; to Moscow. 1922 to Berlin, 1923 Paris. First retrospective exhibition 1933 in Basle. 1941–7 in USA. 1948 back to France. Retrospectives in Zurich and Cologne 1967.

Cassou, Jean, *Chagall*, London and New York 1965
Catalogue, *Marc Chagall*, Réunion des Musées Nationaux, Paris 1969
Haftmann, Werner, *Marc Chagall*, London 1985
Catalogue, *Marc Chagall*, Royal Academy of Arts, London 1985

Sandro **Chia**
Born 1946 in Florence. Studies at the Florence Academy until 1969, then travels within Europe and to India. 1970 on, lives and works at Ronciglione, near Rome: first one-man show in Rome 1971, followed by many others in Rome and other Italian cities, also abroad from 1978 on. From 1980 on, lives and works at Ronciglione and in New York.

Anne Seymour, *The Draught of Dr Jekyll: An Essay on the Work of Sandro Chia*, London 1981

Catalogue, *Sandro Chia: Bilder 1976–1983*, Kestner-Gesellschaft, Hanover 1983

Catalogue, *Sandro Chia*, Scottish Arts Council, Edinburgh 1983

Giorgio de Chirico

Born 1888 in Volo, Greece; died 1978 in Rome. Studies art at Athens Academy and in Munich; 1911–15 in Paris. Italian army 1915–17. Meets Carrà in Ferrara; together they found Metaphysical Painting. After 1918 mostly in Florence and Rome, with periods in Paris in mid-twenties and thirties. Surrealists honour his early paintings, but in the twenties he abandons his obsessive fantasies for a Renaissance-based classicism and denounces anti-classical tendencies in modernism.

Soby, James T., *Giorgio de Chirico*, New York 1955
The Memoirs of Giorgio de Chirico, London 1971
Legrand, Gerard, *De Chirico*, New York and London 1979
Rubin, William (ed.), *De Chirico*, New York 1982

Christo

Christo Javacheff, born 1935 in Gabrovo, Bulgaria. Studies at Sofia and Vienna art academies. Paris 1958–64; begins to make wrapped objects 1958. Moves to New York 1964. Packages public building first in 1968, Spoleto, Italy; wraps part of Australian coast 1969; Valley Curtain, Rifle, Colorado 1971.

Bourdon, David, *Christo*, New York 1971

Bernard Cohen

Born 1933 in London. Studies at St Martin's and Slade Schools of Art; teaches part-time at Slade. 1961–2 exhibits with 'Situation'. 1968–70 in USA as Visiting Professor at University of New Mexico. 1972 retrospective exhibition in Hayward Gallery, London. 1988 Slade Professor of Fine Art, London.

Catalogue, *Bernard Cohen*, Arts Council of Great Britain, London 1972

William Coldstream

Born 1908 in Bedford, England; died 1987 in London. Trains at Slade School of Art, London 1926–9. Works in documentary films 1934–7 and founds School of Drawing and Painting ('Euston Road School') in 1938. In 1940–5 serves as camouflage officer, then war artist. Slade Professor of Fine Art, London 1949–75; 1968–71 chairman of National Advisory Committee for Art Education: promotes constructive reform of art and design training. Knighted 1956.

Catalogue, *William Coldstream*, Arts Council of Great Britain, London 1962

Tony Cragg

Born 1949 in Liverpool. After two years as lab technician studies art at Wimbledon School of Art and Royal College of Art, London. First assembled sculptures 1975. In group shows New York and London 1977; one-man exhibitions London and abroad 1979 on. 1977 settles in Wuppertal, West Germany; 1979 on teaches at Düsseldorf Academy. 1988 represents Britain at Venice Biennale and receives Turner Prize, Tate Gallery, London.

Catalogue, *Tony Cragg*, Arts Council of Great Britain, London 1987
Catalogue, *Tony Cragg*, British Council, London 1988

Salvador Dali

Born 1904 in Figueras, Catalonia; died there 1989. Studies at Madrid Academy 1924; suspended, 1925 expelled for extravagant behaviour. Explores new art from Impressionism onwards, but drawn to detailed naturalism of Vermeer and Pre-Raphaelites and to the suggestive forms of Gaudi's architecture. 1928 two visits to Paris: meets Picasso and Miró. When he brings his new work to Paris (for one-man show at Galerie Goemans), Breton recognizes its Surrealism, writes catalogue introduction for Dali and reproduces his work in *The Surrealist Revolution*. 1930 Dali moves to Paris and works as member of Surrealist group, developing his 'critical-paranoiac method' as an active process going beyond Breton's passive invitation of inspiration from within. Collaborates with Bunuel on films *Un chien Andalou* (1929) and *L'Age d'Or* (1931). Expelled from group 1938, partly for his support of the Spanish dictator, Franco. Lives in USA 1940–55, then returns to Spain and lives at Cadaques.

Cowles, Fleur, *The Case of Salvador Dali*, London 1959
Dali, Salvador, *The Diary of a Genius*, New York 1965
Gerard, Max, *Dali*, London and New York 1968
Catalogue, *Salvador Dali*, Tate Gallery, London 1980
Ades, Dawn, *Dali*, London 1982

Alan Davie

Born 1920 in Grangemouth, Scotland. Trains at Edinburgh College of Art 1938–40. Travelling scholarship 1948–9; one-man exhibitions London from 1950. 1955 studies Zen Buddhism. 1956 first exhibition in New York.

Catalogue, *Alan Davie*, Whitechapel Art Gallery, London 1958

Stuart Davis

Born 1894 in Philadelphia, Pennsylvania; died 1964 New York. First associated with New York Ashcan School, then affected by Cubism and by urban rhythms and visual intensities (jazz, neon, posters). Works in Paris 1928–9. Murals for Radio City 1932 and for Works Progress Administration programme in later thirties.

Goossen, Eugene C., *Stuart Davis*, New York 1966
Catalogue, *Stuart Davis: Art and Art Theory*, Brooklyn Museum, New York 1978

Robert **Delaunay**

Born 1885 in Paris; died 1941 in Montpellier. Trains as decorative painter; full-time artist from 1904. 1907–8 studying Neo-Impressionism and colour theory. 1910 marries painter Sonia Terk. 1911–12 contact with *Blaue Reiter* group; 1913 exhibition at Der Sturm Gallery, Berlin. 1915–17 in Spain and Portugal. 1921 returns to Paris. 1937 murals for International Exhibition in Paris.

Delaunay, Robert, *Du Cubisme à l'art abstrait: Documents inédits*, Paris 1957
Vriessen, Gustav, and Imdahl, Max, *Robert Delaunay: Light and Colour*, New York 1967
Catalogue, *Robert Delaunay*, Staatliche Kunsthalle, Baden-Baden 1976
Cohen, A. A., *The New Art of Color. The Writings of Robert and Sonia Delaunay*, New York 1978

Charles **Demuth**

Born 1883 in Lancaster, Pa.; died there 1935. Studies at Pennsylvania Academy of Arts, and in Paris 1912–14. Returns to USA in 1914; works as illustrator and starts playwriting. 1920 visits Europe. 1924 designs stage sets.

Ritchie Andrew C., *Charles Demuth*, New York 1950
Eiseman, Alvord, *Charles Demuth*, New York 1982

André **Derain**

Born 1880 at Chatou, near Paris; died 1954 in Garches. Studies 1898–9 in Académie Carrière in Paris; meets Matisse. Works with Matisse in South of France; friendship with Vlaminck. 1905 shows at Salon D'Automne with group there labelled Fauves. 1908–10 influenced by Cézanne and Cubism. Subsequently returns to a more traditional idiom, a classicism reflecting early Italian and French Renaissance art. About 1966–8 carves some strongly primitivist sculptures.

Diehl, Gaston, *Derain*, New York 1964
Catalogue, *André Derain*, Grand Palais, Paris 1977

Jan **Dibbets**

Born 1941 in Weert, Netherlands. Studies art at Tilburg Academy and privately with painter Jan Gregoor, 1959–63. Contact with Richard Long in London 1967. Co-founder of International Institute for Re-education of Artists, Amsterdam 1968. First one-man show Galerie 845, Amsterdam, 1965; one-man shows 1968 Düsseldorf (Konrad Fischer), New York (Siegelaub), etc. One-man show within Venice Biennale, 1972.

Catalogue, *Jan Dibbets*, Stedelijk Van Abbe Museum, Eindhoven 1980

Otto **Dix**

Born 1891 in Untermhaus, Gera, North Germany; died 1969 in Hemmenhofen on Lake Constance. Studies in Gera and Dresden, then war service and renews studies at Düsseldorf Academy, 1919–22. Drawings and prints about war, then idiom of sixteenth-century German painters. 1927 professor at Dresden Academy; dismissed 1933; works included in 1937 exhibition of 'Degenerate Art'; 260 works removed from public collections.

Löffler, Fritz, *Otto Dix: Life and Work*, New York and London 1982

Theo van **Doesburg**

Pseudonym of C. E. M. Küpper, born 1883 in Utrecht; died 1931 at Davos. 1908 exhibits Impressionist paintings in The Hague; 1913 publishes volume of poems. 1914–16 military service. 1916–17 contact with Mondrian and others leads to founding in 1917 of *De Stijl* artistic movement and journal, which is edited by him until death. After war, increasing international and multi-media activity. Periods in Paris, Berlin and Weimar; in Weimar runs *De Stijl* courses in opposition to Bauhaus, 1921–2; much lecturing and writing, also architectural designs with van Eesteren, Dada writings and performances under pseudonyms I. K. Bonset and Aldo Camini. 1922 participates with Lissitzky and others in Düsseldorf Progressive Artists Congress. Settles in Paris 1923. 1924–5 introduces dynamic element in *Counter-Compositions*. 1926–8 decorations for café-cinema building, L'Aubette, in Strasbourg, with Arp and Sophie Taeuber-Arp. 1930 begins new journal *L'Art Concret*.

Catalogue, *Theo van Doesburg*, Stedelijk Van Abbe Museum, Eindhoven 1968
Baljeu, Joost, *Theo van Doesburg*, London 1973 and New York 1975
Doig, Allan, *Theo van Doesburg*, Cambridge 1986

Jean **Dubuffet**

Born 1901 in Le Havre. Brief art training; paints occasionally until 1924, then works in wine trade. Full-time painter from 1942; one-man exhibitions in Paris 1944 and New York 1947. 1949 shows his collection of *art brut* in Paris, and publishes his essay, *Art Brut Preferred to the Civilized Arts*. 1960 very large retrospective exhibition in Paris; retrospectives subsequently in London and Amsterdam.

Ragon, Michel, *Dubuffet*, New York 1959
Catalogue, *The Work of Jean Dubuffet*, New York 1962
Catalogue, *Dubuffet Retrospective*, Akademie der Künste, Berlin 1980
Franzke, Andreas, *Dubuffet*, New York 1981

Marcel **Duchamp**

Born 1887 in Blainville, near Rouen; died 1968 in Neuilly. Brother of painter Jacques Villon and of

sculptor Raymond Duchamp-Villon. Trains as librarian and as painter. Associates 1911 with Cubists of *Section d'Or* group who, in 1912, rejected his *Nude descending a Staircase*. 1914 first 'readymade'. 1915 to New York, centre of Dadaist group; begins work on large painting on glass, *The Bride Stripped Bare by her Bachelors, Even*. 1934 publishes portfolio *The Bride stripped Bare*. Helps organize modern art exhibitions in New York and Paris, notably the 1947 Surrealist exhibition in Paris. Posthumous revelation that he had devoted much of his last years to a second work summarizing much that had preceded it, this time an assemblage entitled *Etant Donnés: 1. La Chute d'Eau, 2. Le Gaz d'Eclairage*.

Catalogue, *Marcel Duchamp*, Museum of Modern Art, New York 1973

Golding, John, *Marcel Duchamp: The Bride Stripped Bare by her Bachelors, Even*, London 1973

Sanouillet, Michel, and Peterson, Elmer, *The Essential Writings of Marcel Duchamp*, London 1975

Marquis, Alice, *Marcel Duchamp. Eros c'est la vie: a Biography*, New York 1981

Viking **Eggeling**
Born 1880 in Lund, Sweden; died 1925 in Berlin. Studies painting in Milan. Moves to Paris 1911, where he meets Arp, and to Switzerland 1915, there meeting Hans Richter. 1919–21 works with Richter near Berlin on 'scroll pictures'. 1921 abstract film *Diagonal Symphony*, premièred in Berlin 1922.

James **Ensor**
Born in 1860 in Ostend; died there 1949. Trains at Brussels Academy. Begins to be noticed in early 1880s, but his work repeatedly rejected by avant-garde groups. From 1883 on he produces his characteristic visionary and often grotesque paintings which continue until about 1900.

Haesaerts, Paul, *James Ensor*, London and New York 1959

Lesko, Diane, *James Ensor: the Creative Years*, 1985

Max **Ernst**
Born 1891 at Brühl in the Rhineland; died 1976 in Paris. Studies at Bonn University. No art training but begins to paint; meets Macke and other artists and begins to exhibit. Deeply affected by 1914–18 war. After the war leads Cologne Dada group. 1920 exhibits in Paris and in 1922 moves there; associates with Breton, who is developing Surrealist theory of automatism and of art as revealing dream states. Exhibits with Surrealists; develops frottage and other semi-automatist techniques. 1941 emigrates to New York; after second world war lives mostly in California and France. Several major retrospective exhibitions, including Paris 1959, New York and London 1961, Stuttgart 1970, Munich and Berlin 1979.

Ernst, Max, *Beyond Painting*, New York 1948

Russell, John, *Max Ernst*, London 1967
Quinn, Edward, *Max Ernst*, London 1977
Turpin, Ian, *Max Ernst*, Oxford 1979
Rainwater, Robert (ed.), *Max Ernst: Beyond Surrealism*, New York and Oxford 1986

Richard **Estes**
Born 1936 in Evanston, Illinois. 1952–6 studies at Chicago Art Institute. Lives in New York. First one-man show at Allan Stone Gallery, New York 1963

Perreault, John, *Richard Estes: the Complete Paintings*, New York 1986

Jean **Fautrier**
Born 1898 in Paris; died there 1964. Studies in England at Royal Academy and Slade School of Art; returns to France 1917. 1942 first of *Hostages* series. First painting prize at Venice Biennale 1960.

Malraux, André, *Les Otages*, Paris 1945
Bucarelli, Palma, *Jean Fautrier*, Milan 1960

Barry **Flanagan**
Born 1941 in Prestatyn, Wales. Studies 1964–6 at St Martin's School of Art. First one-man show 1966 at Rowan Gallery, London, and frequently there subsequently. One-man shows in Milan, Krefeld, New York, Venice etc., 1968 on. Major retrospective in Eindhoven and London 1977–8.

Catalogue, *Barry Flanagan*, Stedelijk Van Abbe Museum, Eindhoven 1977

Catalogue, *Barry Flanagan. Sculptures*, British Council, London 1982

Dan **Flavin**
Born 1933 in Jamaica, N.Y. Largely self-trained, he does not become professional artist until 1959. 1961 begins composing electric light bulbs; Minimalist compositions, using fluorescent light tubes, 1963 onwards.

Lucio **Fontana**
Born 1899 in Argentina of Italian parents; died in Varese, Italy, in 1968. Goes to Milan as a child. Studies at Brera Academy 1927–9; exhibits abstract sculptures in 1930. In Argentina during second world war. Issues *White Manifesto* 1946; in Milan founds *Spazialismo* group 1947. 1954 one-man show at Venice Biennale. Works as painter, sculptor, and ceramicist, and experiments with electric light and total environments: creates environments for Walker Art Center, Minneapolis, 1966, and Stedelijk Museum, Amsterdam, 1967

Tapié, Michel, *Fontana*, New York 1962
Crispolti, Enrico, and Van der Marck, Jan, *Lucio Fontana*, Brussels 1974
Schulz-Hoffmann, Carla, *Lucio Fontana*, Munich 1983

Sam Francis
Born 1923 in San Mateo, California. Studies medicine and psychology, then art at California School of Fine Arts, San Francisco, and at Berkeley. 1950 to Paris. First one-man show 1952; many exhibitions since. Influenced by world trip 1957, especially by Japanese traditions.

Catalogue, *Sam Francis*, Museum of Fine Arts, Houston 1967
Selz, Peter, *Sam Francis*, New York 1975

Naum Gabo
Pseudonym of Naum Pevsner, born 1890 in Briansk, Russia; died 1977. Studies medicine and then engineering in Munich, and attends Wölfflin's art history lectures; visits to Paris and Italy 1913–14. First constructions 1915, in Scandinavia; 1917 to Russia. 1920 open-air exhibition with brother Antoine Pevsner in a Moscow street and publication of *Realistic Manifesto*. 1922–32 in Berlin; exhibits in Russian exhibition in Berlin and Amsterdam 1922–3 exhibits with Pevsner in Paris 1924, and with Pevsner and van Doesburg in New York 1926. 1930 one-man exhibition at Kestner Gesellschaft, Hanover. 1932 to Paris; member of *Abstraction-Création*. Visits and exhibits in England; moves there 1935 and lives in London and Cornwall. 1946 moves to United States; 1948 exhibition with Pevsner at Museum of Modern Art, New York. Many other exhibitions. Large retrospective exhibition tours European cities 1965–6.

Read, Herbert, *Gabo, Constructions, Sculpture, Painting, Drawings, Engravings*, London 1957
Catalogue, *Naum Gabo: Sixty Years of Constructivism*, Dallas Museum of Art and Munich 1985

Paul Gauguin
Born 1848 in Paris; died 1903 in the Marquesas Islands. After some years at sea he becomes a stockbroker and a 'Sunday painter'; gradually starts collecting paintings. Friendship with Pissarro from 1875; contributes to Impressionist exhibitions 1880–6; full-time painter from 1883. 1886 visits Pont-Aven, Brittany, and again 1888, when he abandons Impressionism for an expressive and primitivist form of Symbolism. Exhibits with French Symbolists in Paris and in Brussels, 1889. 1891–3 in Tahiti; back in France, in Paris and Brittany 1893–5. From 1895 on in Tahiti and the Marquesas. One-man exhibition at Vollard's gallery, Paris, 1898–9 includes the famous *Where do we come from . . . ?* A large memorial exhibition at Salon d'Automne 1906 establishes him as pioneer of expressive anti-naturalistic trends, such as Fauvism in France and Expressionism in Germany and elsewhere.

Goldwater, Robert, *Paul Gauguin*, New York 1957
Catalogue, *Gauguin and the Pont-Aven Group*, Arts Council of Great Britain, London 1966

Fezzi, Elda, *Gauguin: the Complete Paintings*, London 1985
Prather, Merla, and Stuckey, Charles (ed.), *Gauguin: a Retrospective*, New York 1987
Thomson, Belinda, *Gauguin*, London 1987

Juan Genovés
Born 1930 in Valencia, Spain. Art studies in Valencia, now working in Madrid.

Catalogue, *Juan Genovés*, Marlborough Fine Art, London 1967

Alberto Giacometti
Born 1901 in Stampa, Switzerland; died 1966 in Chur. Son of painter; trains in Geneva, travels in Italy, settles in Paris 1922. Works in sculptor Bourdelle's studio till 1925. Interested in Cubism and primitive sculpture. 1929–35 associates with Breton and the Surrealists; sculpture exhibited in Surrealist shows and illustrated in Breton's journal. War years in Geneva: begins attenuated figures, developed in Paris from 1945 on. Main prize for sculpture at Venice Biennale 1962; Guggenheim prize for painting 1964.

Dupin, Jacques, *Alberto Giacometti*, Paris 1963
Catalogue, *Alberto Giacometti*, Museum of Modern Art, New York 1965
Catalogue, *Alberto Giacometti*, Arts Council of Great Britain, London 1965
Matter, Herbert, *Alberto Giacometti*, London 1988

Gilbert and George
Gilbert born 1943 in Dolomites, Italy; studied art at Munich Academy. George born 1942 in Totnes, Devon, England; studied at Dartington Hall and Oxford School of Art. Met as students at St Martin's School of Art, London 1967, since when they have lived and worked together in London as sculptors. 'Living Sculpture' performances 1969 on, also postal sculptures, books, paintings etc. shown in London and internationally from 1970 on. Nostalgic and ironic tone gradually abandoned for harsher commentary on urban life.

Ratcliff, Carter (intro.), *Gilbert and George, 1968–1980*, Eindhoven 1980

Vincent van Gogh
Born 1853 at Groot-Zundert in Netherlands; died 1890 at Auvers-sur-Oise, France. Works for art dealers, where his brother Theo was also employed; turns to theological study in hope of missionary work. 1880 decides to be a painter; studies in Brussels and lives in parents' house; then lives in The Hague and later moves to Antwerp to study at Academy. 1886–8 with Theo in Paris; contact with Impressionists and Neo-Impressionists. 1888 to Arles in Provence where he hopes to found group of artists; greatly disturbed

by visit of Gauguin, October–December. 1889 voluntarily enters asylum at Saint-Rémy; discharges himself 1890 and goes to live at Auvers. Shoots himself. retrospective shows at Galerie Bernheim-Jeune, Paris, 1901 and Salon des Indépendants 1905.

Schapiro, Meyer, *Vincent van Gogh*, New York 1950 and London 1951
The Complete Letters of Vincent van Gogh, New York and London 1958
Hammacher, A., *Van Gogh: a Documentary Biography*, London 1982

Arshile **Gorky**
Born 1904 in Turkish Armenia; died at Sherman, Conn., 1948. To America in 1920; studies at Rhode Island School of Design and in New York. First one-man show at Mellon Galleries, Philadelphia, 1934. Works for Federal Art Project, designs a mural for Newark Airport. Contact with Breton and other Europeans in New York from 1944 on; friendship with de Kooning.

Catalogue, *Arshile Gorky, Paintings, Drawings, Studies*, Museum of Modern Art, New York 1962
Catalogue, *Arshile Gorky, a Retrospective*, Guggenheim Museum, New York 1981
Jordan, Jim, *The Paintings of Arshile Gorky: a critical Catalogue*, New York 1982

Juan **Gris**
Born in Madrid 1887; died 1927 in Boulogne-sur-Seine, France. Early interest in art; decides 1904 to be painter. 1906 to Paris, where he earns his living with drawings printed in reviews. 1911–12 influenced by Picasso and Braque; exhibits with *Section d'Or* 1912. Contact with Matisse during war years. Growing success after war; from 1922 creates several stage sets for Diaghilev ballets, also illustrations for books by Max Jacob, Gertrude Stein, Tristan Tzara, and others.

Kahnweiler, Daniel-Henry, *Juan Gris*, New York and London 1947
Catalogue, *Juan Gris*, Editions des Musées Nationaux, Paris 1974

Carl **Grossberg**
Born 1894 in Wuppertal-Elberfeld; died 1940 in France. Studies at Technical College, Aachen and Darmstadt, and 1919–21 at Weimar Art Academy and Bauhaus. 1925 visits Holland. Works as painter and interior decorator, concentrating on city and industrial themes. Interior decoration of Universum Cinema, Berlin, for Erich Mendelsohn.

Catalogue, *Carl Grossberg*, Hessisches Landesmuseum, Darmstadt 1976

George **Grosz**
Born 1893 in Berlin; died there 1959. Studies art in Dresden and Berlin; publishes drawings in satirical magazines before 1914. Deeply affected by war, teams up with John Heartfield and his brother Wieland Herzfelde to use images and texts to promote anti-capitalist views in their reviews and in albums of prints, such as *Ecce Homo* (1920). Influenced about 1920 by de Chirico but subsequently more aggressively denunciatory in his painted and drawn images of German society, for which he is repeatedly taken to court. 1925 included in Mannheim *Neue Sachlichkeit* show; growing sales of his paintings in mid-twenties. 1933 to New York; increasingly romantic style, though second world war elicits further horror images. Returns to Germany in 1959.

Catalogue, *George Grosz*, Akademie der Künste, Berlin 1962
Schneede, Uwe, *George Grosz*, London 1979
Hess, Hans, *George Grosz*, New Haven and London 1985

Renato **Guttuso**
Born in 1912 in Bagheria, Palermo; died 1987 in Rome. Works in Sicily and in central and north Italian cities. During 1943–5 active in Italian resistance. After end of war founder-member of *Fronte Nuovo delle Arti* movements: realism with political content and with Cubist formal elements, religious and historical subjects inflected as attacks on fascism. Later paintings more Expressionist, without change of purpose or loss of energy. Lenin Peace Prize 1972; 1974 on, Communist senator in Rome.

Catalogue, *Renato Guttuso*, Kunstverein, Darmstadt 1967

Hans **Haacke**
Born 1936 in Cologne. Studies art at the Kassell Academy until 1960, then on scholarship in Paris 1960, and on Fulbright Fellowship at Tyler School of Art, Philadelphia. Since then living mostly in New York. Turns from sculpture to using art as investigation of role of art and art institutions in the socio-political structure. Major works: 1970 *MOMA Poll*, Museum of Modern Art, New York (contribution to 'Information' exhibition); 1974 *Solomon R. Guggenheim Museum Board of Trustees* (shown in 'Live!' exhibition at Stefanotty Gallery, New York); 1974 *Manet-PROJEKT '74* (rejected by Wallraf-Richartz Museum, Cologne: exhibited at Paul Maenz Gallery, Cologne, 1974); 1975 *On Social Grease* (one-man show at John Weber Gallery, New York).

Haacke, Hans, *Framing and Being Framed*, New York 1975
Catalogue, *Hans Haacke*, Stedelijk Van Abbe Museum, Eindhoven, vol. 1 1978, vol. 2 1984

Richard **Hamilton**
Born 1922 in London. Works in advertising and dis-

play and studies engineering drawing as well as art at St Martin's, Royal Academy and Slade Schools. 1952–5 member of the Independent Group. Prepares poster for and collaborates on display in 'This is Tomorrow' exhibition, Whitechapel Art Gallery, London. Exhibition of paintings at Hanover Gallery 1955 and 1964. First visit to United States 1963. 1965–6 reconstruction of Duchamp's *Large Glass*; 1966 organizes Duchamp exhibition for Arts Council of Great Britain. Increasingly international range of shows: London, Kassel, Milan, New York, Hamburg, Berlin. 1970 large retrospective exhibition at Tate Gallery, London.

Catalogue, *Richard Hamilton*, Tate Gallery, London 1970
Hamilton, Richard, *Collected Words, 1953–1982*, London 1982

John **Heartfield**

Born 1891 in Berlin-Schmargendorf; died 1968 in East Berlin. Studies design in Munich. War experience 1914–15; discharged. Anglicizes his name in protest against war and propaganda. Collaboration with George Grosz on collages and with his brother Wieland Herzfelde on publication of left-wing journals. Joins Communist party and Dada movement in Berlin. Develops satirical and propagandistic photomontages used mainly in newspapers in support of Socialist party in Germany and Soviet Russia. Sets and projected images for Piscator's 'political theatre'. 1933 flees to Prague; 1938 to 1950 in England, then moves to East Berlin.

Catalogue, *John Heartfield, Photomontages*, Arts Council of Great Britain, London 1969

Erich **Heckel**

Born 1883 in Döbeln, Saxony; died 1970 in Hemmenhofen on Lake Constance. Architectural studies in Dresden; founds *Die Brücke* artists group with friends 1905. 1911 moves to Berlin. Red Cross orderly during war; after war works in Berlin, increasingly in landscape painting. 1937 his works removed from public collections and displayed in 'Degenerate Art' exhibition. Moves to Hemmenhofen when his studio is destroyed in 1944 air raid.

Vogt, P., *Erich Heckel*, Recklinghausen 1963
Catalogue, *Erich Heckel, 1883–1970*, Munich 1983

Eva **Hesse**

Born 1936 in Hamburg; died 1970 in New York. 1939 family emigrates to New York. Studies at Pratt Institute, Art Students' League, and Cooper Union, New York, and Yale University, 1952–9. Lives in Germany 1964–5. First one-woman exhibition 1963 at Allen Stone Gallery, New York. 1970–1 memorial exhibition touring from Guggenheim Museum, New York, to Buffalo, Chicago, Pasadena, and Berkeley; retrospective exhibition London, Otterlo and Hanover, 1979.

Lippard, Lucy, *Eva Hesse*, New York 1976
Catalogue, *Eva Hesse, 1936–1970*, Whitechapel Art Gallery, London 1979

Roger **Hilton**

Born 1911 in Northwood, Middlesex, near London; died 1975 at St Just, Cornwall. Studies painting at the Slade School, London, and in Paris at Académie Ranson (1929–39). Divides his career between London and Cornwall, especially St Ives. First one-man show 1936; regular exhibitions from 1952 on in London and abroad. 1964 wins UNESCO prize at Venice Biennale. The characteristic Hilton pictures fuse references to figures and landscape in abstract compositions, reflecting the influence of both French and American postwar painting.

Catalogue, *Roger Hilton*, Arts Council of Great Britain 1974

David **Hockney**

Born 1937 in Bradford, England. Studies art in Bradford and at Royal College of Art, London: awarded Gold Medal 1961. 1963 first visit to USA, and first one-man show, Kasmin Gallery, London. From then on much travel in Europe and America: visiting, teaching posts and exhibitions; international prizes for graphic work and for paintings.

Catalogue, *David Hockney 1960–1970*, Whitechapel Art Gallery, London 1970
Hockney, David, *David Hockney by David Hockney*, London and New York 1976
Livingstone, Marco, *David Hockney*, London 1981
Catalogue, *David Hockney*, Tate Gallery, London 1988
Webb, Peter, *Portrait of David Hockney*, London 1988

Ferdinand **Hodler**

Born 1853 in Berne; died Geneva 1918. Apprenticed to painter, then art studies at Geneva Ecole des Beaux-Arts. Early admiration for Holbein and Dürer. First one-man show 1885; 1887 exhibition at Bern Kunstmuseum; 1889 honourable mention for painting at Paris World's Fair. 1891 *Night*, withdrawn from Geneva exhibition by order of mayor, shown in Paris; other paintings shown in Paris, in Symbolist exhibitions and elsewhere during 1890s, and 1899 in Venice at Biennale. At 1904 Vienna Secession shows 31 paintings: wide international fame thereafter, and many honours and commissions. 1913 special display at Paris Salon d'Automne. 1917 large retrospective exhibition at Zurich Kunsthaus.

Catalogue, *Ferdinand Hodler*, University Art Museum, Berkeley 1972
Hirsh, Sharon *Ferdinand Hodler*, Munich and London 1982

Hirsh, Sharon, *Hodler's Symbolist Themes*, Epping 1983

Jasper Johns

Born 1930 in Allendale, South Carolina. Studies at University of South Carolina; settles in New York 1952. First one-man exhibition, Leo Castelli Gallery, New York 1958. Retrospective exhibitions 1960, 1964 and 1965 in USA and London. From 1966 artistic adviser to Merce Cunningham Dance Company.

Kozloff, Max, *Jasper Johns*, New York 1972

Donald Judd

Born 1928 in Excelsior Springs, Missouri. Studies art privately in Omaha, Nebraska, 1939–40; at Art Students' League, New York, 1948 and 1949–53; at College of William and Mary, Williamsburg, Virginia, 1948–9; and Columbia University, New York 1949–53 and 1957–62. First one-man show at Panoras Gallery, New York, 1957. Exhibition reviewing for *Art News* 1959; contributing editor for *Arts Magazine* 1959–65. His work included in 'Primary Structures' exhibition, Jewish Museum, New York, 1966.

Judd, Donald, *Complete Writings 1959–1975*, New York 1975

Smith, Brydon, *Donald Judd – catalogue raisonné*, Ottawa 1975

Judd, Donald, *Complete Writings 1975–1986*, Eindhoven 1987

Vassily Kandinsky

Born 1866 in Moscow; died 1944 at Neuilly-sur-Seine. Studies law and political economy in Moscow but 1896 goes to Munich to become painter. 1901 founder member of Phalanx group offering exhibitions of contemporary painting. Travels widely, repeatedly staying in Paris where he exhibits in Salon d'Automne. 1908–14 lives in village of Murnau as well as in Munich; contact with other artists in both places. 1909 first president of Munich New Artists' Association; Kandinsky, Marc and others secede 1911. 1912 publication of *Blaue Reiter* almanac, edited by Kandinsky and Marc, and exhibitions mounted under the same name. Publication of major theoretical text, *Concerning the Spiritual in Art*, soon translated into other languages. 1914 returns to Russia and plays leading role in helping to reorganize art institutions in Russia after 1917. 1921 leaves Russia; teaches at Bauhaus 1922 until closure in 1933. Publication 1926 of second treatise, *Point and Line to Plane*. 1933 settles at Neuilly near Paris.

Washton-Long, Rose, *Kandinsky: The Development of an Abstract Style*, Oxford 1980

Lindsay, Kenneth, and Vergo, Peter (ed.), *Kandinsky: Complete Writings on Art*, London 1982

Catalogue, *Kandinsky in Munich, 1896–1914*, Guggenheim Museum, New York 1982

Catalogue, *Kandinsky: Russian and Bauhaus Years, 1915–1933*, Guggenheim Museum, New York 1983

Catalogue, *Kandinsky in Paris, 1934–1944*, Guggenheim Museum, New York 1985

Allan Kaprow

Born 1927 in Atlantic City, New Jersey. First works in painting influenced by Abstract Expressionism, but soon moves into assemblage, introducing element of spectator involvement. Also studies musical composition with John Cage. 1957–9 experiments in environmental installations with audience participation; 1959 *18 Happenings in 6 Parts* at Reuben Gallery, New York.

Kaprow, Allan, *Assemblage, Environments, and Happenings*, New York 1966

Ellsworth Kelly

Born 1923 in Newburgh, New York. Studies art in Boston and at Ecole des Beaux-Arts in Paris. 1954 back in New York, working with ever more succinct forms and radiant colour oppositions. Frequent one-man exhibitions in New York from 1956 on. Full restrospective exhibition 1973 at Museum of Modern Art, New York.

Waldman, Diane, *Ellsworth Kelly*, Greenwich Conn., 1971

Catalogue, *Ellsworth Kelly*, Museum of Modern Art, New York 1973

Catalogue, *Ellsworth Kelly, Paintings and Sculpture, 1966–1979*, Arts Council of Great Britain, London 1980

Catalogue, Ellsworth Kelly, *Sculpture*, Whitney Museum, New York 1983

Anselm Kiefer

Born 1945 in Donaueschingen, West Germany. Studied law and French in Freiburg, then painting in Freiburg and Karlsruhe. 1971–2 in touch with Beuys. 1971 settles in Hornbach in the Odenwald (S. W. Germany), where he still lives. In 1969 already his work is concerned with German culture's relationship to Nazism, symbolically stated in pictorial books and paintings, and recently also sculpture and installations, his theme broadening to deal with the fate of art and of all lore and wisdom. First one-man show 1969; many in Germany and abroad from 1973 on.

Rosenthal, Mark, *Anselm Kiefer*, Chicago and Philadelphia 1987

Ed Kienholz

Born 1927 in Fairfield, Washington. Studies at Washington State College, Pullman; Eastern Washington College of Education, Chetney; Whitworth College, Spokane, Washington, 1945–52. Large variety of occupations in fifties, some of which (e.g. window display designer, mental institution nursing)

are reflected in subsequent work. From wooden relief paintings develops into life-size assembled and sculptured tableaux. Since 1953. living in Los Angeles; first one-man show there 1953 at Café Galleria. Retrospective shows in Boston and Los Angeles 1966; European touring show (Stockholm, Amsterdam, Düsseldorf, Paris, Zurich, London) 1970

Tillim, Sidney, 'The Underground Pre-Raphaelitism of Edward Kienholz' in *Artforum* (New York) April 1966
Catalogue, *Ed Kienholz*, Moderna Museet, Stockholm 1970

Ken **Kiff**

Born 1935 in Essex, England. Studies painting at Hornsey School of Art, London 1955–61. Part-time teaching at Chelsea School of Art and Royal College of Art; lives in London. In group exhibitions 1970 on; first one-man 1979, University of Sussex; first commercial gallery shows London 1980, New York 1981.

Catalogue, *Ken Kiff : New Work* , Fischer Fine Art, London 1988

Ernst Ludwig **Kirchner**

Born 1880 in Aschaffenburg; died 1938 in Davos, Switzerland. 1905 abandons architectural studies to form Dresden *Die Brücke* group with Heckel, Schmidt-Rottluff, and Bleyl and live as professional painter. Moves to Berlin 1911. Murals for an exhibition in Cologne, 1912. 1914 joins German army but after a breakdown in 1916 never completely recovers health and mental stability. Spends most of post-war years in Switzerland. 1937 large number of his paintings removed from German public collections and some of them shown in 'Degenerate Art' exhibition. Commits suicide 1938.

Gordon, Donald E., *Ernst Ludwig Kirchner*, New York 1968
Catalogue, *Ernst Ludwig Kirchner, 1880–1938*, Nationalgalerie, Berlin 1979

R. B. **Kitaj**

Born 1932 in Ohio; studies art at Cooper Union, New York, and Academy of Fine Arts, Vienna. Military service as seaman 1951–5, then further studies at Ruskin College, Oxford, and Royal College of Art, London, until 1961. Becomes known as one of British Pop artists 1961–2, but one-man shows 1963 and after prove a scholarly and political spectrum of references rather than one associated with mass culture.

Ashbery, John, et al., *Kitaj: Paintings, Drawings, Pastels*, London 1983
Livingstone, Marco, *R.B. Kitaj*, Oxford 1985

Paul **Klee**

Born 1879 in Münchenbuchsee near Berne; died 1940 in Muralto, Locarno. The son of musician parents, he too is talented musically but opts to become painter, studying at Munich Academy 1898–1901. Italian tour, then returns to parents in Berne. 1905 first visit to Paris. 1906 marries and settles in Munich; son Felix born 1907. 1910 shows 56 graphic works in Berne, Zurich and Winterthur. 1912 participates in second *Blaue Reiter* exhibition, Munich; second visit to Paris. Group of works shown in Der Sturm Gallery, Berlin. 1914 visit to Tunisia: 'Colour and I are one'. Military service 1916–18. 1921–31 teaching at Bauhaus in Weimar and Dessau; then professor at Düsseldorf Academy until 1933 when he emigrates to Switzerland to get away from Nazi attacks. 1924 lecture 'On modern art' at Jena University; 1925 Bauhaus publishes his *Pedagogical Sketchbook*; 1929 50th-birthday exhibition at Galerie Flechtheim, Berlin (shown 1930 at Museum of Modern Art, New York); another exhibition in Paris. First exhibition in England at Mayor Gallery, London; 1935 retrospective exhibition at Berne Kunsthaus. Ill health. 1940 large exhibition at Zurich Kunsthaus of recent works, shortly before death.

Grohmann, Will, *Paul Klee*, New York 1957
Lynton, Norbert, *Klee*, London 1975
Short, Robert (ed.), *Paul Klee*, London 1979
Lanchner, Carolyn (ed.), *Paul Klee*, New York 1987

Yves **Klein**

Born in Nice 1928; died Paris 1962. No art training, but trains for merchant navy, learns Oriental languages and Judo; lives in Japan 1952–3 and achieves black belt 'fourth dan'. First exhibition in Tokyo 1953. Returns to Europe to be technical director of Spanish Judo Federation in Madrid. 1955 to Paris; monochrome (orange) painting rejected from Salon des Réalités Nouvelles. 1956 exhibits monochrome paintings of various hues and sizes in Paris; 1957 eleven blue paintings shown in Milan; two exhibitions in Paris. 1958 exhibition 'Le Vide' at Galerie Iris Clert, Paris. 1960 demonstrates his *Anthropometries*: impressions made by nude models and blue paint on canvas while orchestra performs his 'Monotone Symphony'. Experiments with works composed of fire, water, wind. 1961 exhibitions at Museum Haus Lange, Krefeld, Germany; Castelli Gallery, New York; Dwan Gallery, Los Angeles; Galleria La Salita, Rome; and Galleria Apollinaire, Milan.

Catalogue, *Yves Klein*, Tate Gallery, London 1974
Restany, Pierre, *Yves Klein*, New York 1982
Catalogue, *Beuys, Klein, Rothko*, Anthony d'Offay Gallery, London 1987

Franz **Kline**

Born 1910 in Wilkes-Barre, Pa.; died 1962 in New York. Trains as painter in Boston and London, returning to New York 1939; abstract and representational paintings. 1949 sees his brush drawings enlarged by

projector; begins to paint in large calligraphic style with six- and eight-inch brushes, black on white. About 1958 reintroduces colour. 1952–4 teaches at Black Mountain College, North Carolina; also in Brooklyn and Philadelphia. 1960 prize at Venice Biennale. One-man shows from 1950 on.

Catalogue, *Franz Kline*, Whitney Museum of American Art, New York 1968

Gaugh, Henry, *The Vital Pressure: Franz Kline*, New York 1985

Oskar **Kokoschka**

Born 1886 in Pöchlarn, Austria. Art training in Vienna 1904 on. Begins to exhibit 1908 and works in Wiener Werkstätte (craft workshops). 1910–11 in Berlin; exhibits in Der Sturm Gallery and contributes drawings to *Der Sturm* journal. Volunteered into Austrian cavalry 1914; critically wounded 1915. 1919–24 teaching at Dresden Academy; then travels around Europe, painting landscapes. 1933 to Vienna, then Prague and London. After second world war settles in Switzerland; for some years runs School of Seeing in Salzburg.

Catalogue, *Oscar Kokoschka*, Künstlerhaus, Bregenz 1976

Catalogue, *Oskar Kokoschka 1886–1980*, Tate Gallery, London 1986

Whitford, Frank, *Oskar Kokoschka—a Life*, London 1986

Käthe **Kollwitz**

Born 1867 in Königsberg, East Prussia; died 1945 in Moritzburg, near Dresden. Studies art from 1880 on, graphics first, then sculpture, in Königsberg, Berlin and Munich. 1901 in Paris at Académie Julian; meets Steinlen and Rodin. Marries a doctor; settles with him in working-class district of Berlin 1901. Graphic works against poverty, injustice and war; major exhibitions from 1917 on. Also occasional sculptures; works on monument for her son, killed in first world war. Professor, Prussian Academy, 1919–1933. Visits Russia by invitation 1928. Large exhibition in Berlin (National Gallery), Moscow and Leningrad, 1932. Her work proscribed by Nazis and shown as 'Degenerate Art' 1937.

Klipstein, A., *The Graphic Work of Kaethe Kollwitz*, New York 1955

Kollwitz, Hans (ed.), *Käthe Kollwitz. Diary and Letters*, Chicago 1955

Schneede, Uwe, *Käthe Kollwitz: das zeichnerische Werk*, Munich 1981

Hinz, Renate, *Käthe Kollwitz: Graphics, Posters, Drawings*, London 1981

Willem de **Kooning**

Born 1904 in Rotterdam. Commercial and fine-art training; also attends classes in Brussels, Antwerp and Rotterdam. 1926 to New York, meets Gorky 1927. Works for Federal Arts Project, for first time painting full-time; abstractions and figurative murals. 1946 one-man show at Egan Gallery, New York. Abstract paintings in black and white establish him as leader among Abstract Expressionists. From 1950 working on *Woman I* series; subsequently figurative and abstract paintings and, in 1970s, sculptures.

Hess, Thomas B., *Willem de Kooning*, New York 1959

Catalogue, *Willem de Kooning*, Museum of Modern Art, New York 1968

Rosenberg, Harold, *De Kooning*, New York 1973

Gaugh, Harry, *Willem de Kooning*, New York 1983

Waldman, Diane, *Willem de Kooning*, New York and London 1988

Joseph **Kosuth**

Born 1945 in Toledo, Ohio. Studies at Toledo Museum School of Design, at Cleveland Art Institute, and at School of Visual Arts, New York, 1955–67; also studies anthropology and philosophy at New School for Social Research, New York, 1971–2. American editor for Art & Language Press, Coventry, England, and New York, from 1969 on; co-editor *The Fox* magazine, New York, from 1975 on. First one-man show at Museum of Normal Art, New York (of which he is founder-director) 1967. One-man shows at Castelli Gallery, New York, 1969 on.

Mikhail **Larionov**

Born 1881 in Tiraspol, Bessarabia, Russia; died 1964 in Fontenay-aux-Roses, France. Studies art 1898–1902 and 1903–8 at College of Painting, Sculpture and Architecture, Moscow. 1906 included in World of Art exhibition, St Petersburg, and in Union of Russian Artists exhibition, Moscow; included by Diaghilev in display of Russian paintings at Salon d'Automne, Paris. Visits Paris and London. 1908 founds 'Golden Fleece' exhibitions, Moscow; shows primitivist works. Organizes and contributes to many exhibitions in following years. 1911–12 invents Rayonnism (or Rayism), an abstract form of painting stimulated by Impressionists' and Futurists' interest in light. Work shown in Roger Fry's Second Post-Impressionist Exhibition, Grafton Galleries, London, 1912, and in mixed autumn exhibition at Sturm Gallery, Berlin, 1913. 1914 visit to France. 1915 invalided out of Russian army; moves to Switzerland and subsequently to France. Decors for Diaghilev's Russian Ballets mostly in collaboration with wife Goncharova: *Chout* 1921, *Le Renard* 1922, *Les Noces* 1923.

George, Waldemar, *Larionov*, Paris 1966

John **Latham**

Born 1921 on Zambesi River, Mozambique. Studies at Chelsea School of Art 1946–50. Honorary Founder Member of Institute for the Study of Mental Images, 1954. First spray paintings 1954; first book sculptures 1958; participates in films and happenings from 1960 on. Founder member of Artists' Placement Group,

1968. First one-man show Kingly Gallery, London, 1948. Major retrospective 1975 at Kunsthalle, Düsseldorf. 1976 show at Tate Gallery, London.

Catalogue, *John Latham*, Kunsthalle, Düsseldorf 1975

Fernand Léger

Born 1881 in Argentan, Normandy; died 1955 in Gif-sur-Yvette. Apprenticed to architect; works as architectural draughtsman. From 1903 studies painting in Paris. From 1909 part of Cubist circle; shows with *Section d'Or*. 1914–17 in army; discharged with gas poisoning. 1922–3 decors for Swedish Ballet, *Skating Rink* and *La Création du Monde*. 1924 film *Ballet Mécanique*. 1925 his paintings shown in Le Corbusier's *Pavillon de L'Esprit Nouveau* at Paris decorative arts exhibition; exhibition in New York, and 1928 in Berlin. 1940 to New York; in America until 1945, teaching and exhibiting. 1945 back to Paris and joins Communist Party. 1955 Grand Prix at São Paulo Bienal.

Catalogue, *Fernand Léger*, Réunion des Musées Nationaux, Paris 1971
Green, Christopher, *Léger and the Avant-Garde*, New Haven 1976
De Francia, Peter, *Fernand Léger*, New Haven and London 1983

Wyndham Lewis

Born 1882 off Nova Scotia of American father and British mother; died 1957 in London. Slade School of Art 1898–1901. Period of travel and additional studies in Paris and Munich. Back in England 1909, but frequent visits to Paris. Meets Ezra Pound; contributes to Camden Town Group exhibitions and Roger Fry's Second Post-Impressionist Exhibition, Grafton Galleries, London, 1912. 1913 joins Fry's Omega Workshops but soon leaves and sets up Rebel Art Centre 1914; also founder-member of London Group. Edits and contributes to two issues of *Blast*, 1914 and 1915. June 1915 organizes Vorticist Exhibition at Doré Galleries; 1917 Vorticist Exhibition in New York. Gunner in army 1916; seconded as war artist, December 1917. 1918 first novel, *Tarr*, published. 1919 one-man show, Goupil Gallery. Continues to paint and also to write novels, political and cultural critiques and books and reviews generally attacking modernist art. Deteriorating eyesight; blind 1951.

Michel, Walter, *Wyndham Lewis*, London 1971
Farrington, Jane, *Wyndham Lewis*, London 1980

Roy Lichtenstein

Born 1923 in New York. Studies at Art Students' League and Ohio State University. First one-man show 1949. 1960 assistant professor at Douglas College, Rutgers University, New Jersey. Through Allan Kaprow meets Oldenburg and other young artists. 1961 begins his Pop paintings; 1962 one-man show at Castelli Gallery, New York. 1967–8 retrospective show at Pasadena Art Museum; Walker Art Center, Minneapolis; Stedelijk Museum, Amsterdam; and Tate Gallery, London. 1969 retrospective exhibitions at Solomon R. Guggenheim Museum, New York, and in Kansas City, Seattle and Chicago.

Waldman, Diane, *Roy Lichtenstein*, London and New York 1971
Coplans, John (ed.), *Roy Lichtenstein*, London 1973
Alloway, Lawrence, *Roy Lichtenstein*, London 1983

El Lissitzky

Born 1890 in Poshinok, Smolensk; died 1941 in Moscow. Architectural studies in Darmstadt 1909–14. Back in Russia works also as illustrator and painter. 1917 designs first Soviet flags. 1919 brought to Vitebsk by Chagall to teach at reformed art academy. Malevich comes to teach and influences Lissitzky, who begins series of *Proun* paintings. 1921 to Moscow, teaches at Vchutemas art workshops, then to Berlin to set up Russian exhibition; publishes magazine *Object* (3 issues 1922–3). 1923 visit to Hanover; Kestner-Gesellschaft there publishes his 'Proun' and *Victory over the Sun* prints. Ill with tuberculosis, goes to Switzerland for treatment; publishes magazine *ABC* (architecture and design) with Mart Stam and others, the book *Die Kunstismen* with Hans Arp, and an issue of *Merz* magazine with Schwitters. 1925 back to Russia. Works as exhibition designer, architect and typographer; continues to visit the West until 1932. Active also in publicizing Russian achievements in architecture through his book *Russia: New Architecture in the World*, Vienna 1930, and through contributions to journal *Russia Building*.

Lissitzky-Küppers, Sophie, *El Lissitzky*, Greenwich, Conn., and London 1980

Richard Lohse

Born 1902 in Zurich; studies at arts and crafts school there. 1937 founder-member of *Allianz* group of progressive painters in Switzerland. 1948–55 editor of journal *Building and Living*. Regular exhibitions 1948 on; Guggenheim International prize 1958.

Richard Long

Born 1945 in Bristol. Studies at Bristol School of Art and at St Martin's School of Art 1962–8. First landscape piece 1967: *Cycling Sculpture*. First one-man show 1968, Galerie Konrad Fischer, Düsseldorf; 1969 one-man show there and in Paris and Milan; 1970 first one-man show in New York, at Dwan Gallery.

Catalogue, Fuchs, Rudi, *Richard Long*, London and New York 1986

Morris Louis

Born 1912 in Baltimore; died 1962 in Washington.

Studies painting at Maryland Institute of Art. 1952 becomes familiar with Pollock's paintings, and meets Kenneth Noland. 1952 visit to New York (with Noland), including Helen Frankenthaler's studio, where he sees stained paintings in acrylic. First New York one-man show at Martha Jackson Gallery 1957.

Fried, Michael, *Morris Louis*, New York 1979
Upright, Diane, *Morris Louis, The Complete Paintings*, New York 1985
Catalogue, *Morris Louis*, Museum of Modern Art, New York 1986

René **Magritte**

Born 1898 at Lessines, Belgium; died 1967 in Brussels. Studies painting at Brussels Academy. 1922 sees de Chirico's *Song of Love*; 1925 turns to Surrealism; 1927 first one-man show, Le Centaure Gallery, Brussels. 1927–30 in Paris, associating with Breton and Surrealists. Visits Dali in Cadaques, Spain 1929. Returns to Brussels 1930.

Soby, James T., *René Magritte*, New York 1966
Gablik, Suzi, *Magritte*, London 1970
Torcyner, Harry (ed.), *Magritte: the True Art of Painting*, London 1979
Calvocoressi, Richard, *Magritte*, Oxford 1984

Kasimir **Malevich**

Born 1878 at Kiev; died 1935 in Leningrad. Exhibits paintings 1898; moves to Moscow to study at School of Painting, Sculpture and Architecture. 1907 shows in Moscow Artists' Association exhibition; 1910 in 'Union of Youth' exhibition, Petersburg; 1911–14 in 'Jack of Diamonds' exhibition, Moscow, and others. 1913 decor for Futurist opera, *Victory over the Sun*, St Petersburg. December 1915 shows Suprematist paintings in Moscow exhibition '0.10'. 1918 given various roles under Soviet Commissariat for Popular Education. 1919 invited by Chagall to teach in Vitebsk; soon after Chagall retires from directorship. End 1919/early 1920 retrospective exhibition in Moscow. 1922 to Petrograd; works mainly on architectural models and theoretical writings. 1927 travels with one-man exhibition to Warsaw and Berlin; sections of his writings published by Bauhaus as *The Non-Objective World*. Returns to Leningrad; teaches and writes theory and art history; paints hieratic figurative images; attacked for his 'formalism'.

Andersen, Troels, *Malevich*, Amsterdam 1970
Douglas, Charlotte, *Swans of Other Worlds*, Ann Arbor 1980
Simmons, W. Sherwin, *Malevich's 'Black Square' and the Genesis of Suprematism*, New York and London 1981
Zhadova, Larissa, *Malevich*, London 1982

Walter de **Maria**

Born 1935 in Albany, California. Studies history and then art at University of California, Berkeley (until 1959). Organizes happenings at Berkeley and San Francisco 1959–60. Works with Velvet Underground as drummer, New York 1965. One-man exhibitions from 1965 on, in New York and elsewhere; 1966 contributes to Primary Structures exhibition at Jewish Museum, New York, and to major international exhibitions in late sixties. Retrospectives at Basle 1972 and Darmstadt 1974.

Catalogue, *Walter de Maria*, Hessisches Landesmuseum, Darmstadt 1974

Agnes **Martin**

Born 1912 in Maklin, Saskatchewan, Canada. Moves to USA 1932; studies art at Columbia University, New York, 1941–54. Associates with Kelly, Rosenquist and other younger artists in New York during later fifties and sixties; since 1967 lives in seclusion in Cuba, New Mexico. Frequent one-man shows and contributions to mixed shows from 1958 on, in Europe as well as USA.

Catalogue, *Agnes Martin*, Philadelphia Museum of Art, Philadelphia, Pa., 1973

Georges **Mathieu**

Born 1921 at Boulogne-sur-Mer. Studies law and philosophy; begins to paint 1942. 1947 to Paris, influenced by Wols; contributes to exhibitions of lyrical abstract painting. 1950 first one-man show, Galerie Drouin; 1952 first show in New York. 1957 in Tokyo where he performs large paintings in public.

Charpentier, Jean, *Georges Mathieu*, Paris 1965

Henri **Matisse**

Born 1869 at Le Cateau-Cambrésis; died 1954 in Vence. Law studies; 1890 begins to study art in Paris, at Académie Julian and under Gustave Moreau. 1897 meets Pissarro and in 1899 meets Derain. Sends to various exhibitions, including Salon des Indépendants from 1901 and Salon d'Automne from 1903; 1904 first one-man show at Vollard's gallery. Spends summers painting in South of France. 1905 and 1906 shows with artists together labelled the Fauves in Salon d'Automne. 1909 commission from Shchukin for large paintings for Moscow house; travels to Italy, Germany, Spain, Morocco, Moscow. Decors for Diaghilev from 1919 on; 1930 commissioned to do mural for Barnes collection, Pennsylvania; decoration of Chapelle du Rosaire, Vence, 1948–51. First prize at Carnegie International Exhibition, Pittsburgh 1927, and Venice Biennale, 1950. Major exhibitions during lifetime include San Francisco, 1936 and 1951; New York 1943 and 1952; large commemorative exhibition Paris 1956; centenary exhibition Paris 1970.

Barr Alfred H., *Matisse: His Art and His Public*, New York 1951

Elderfield, John, *Matisse in the Collection of the Museum of Modern Art*, New York 1968

Catalogue, *Henri Matisse*, Réunion des Musées Nationaux, Paris 1970

Elsen, Albert E., *The Sculpture of Henri Matisse*, New York 1972

Gowing, Lawrence, *Matisse*, London 1979

Watkins, Nicholas, *Matisse*, Oxford 1984

Flam, Jack, *Matisse: the Man and His Art 1869–1918*, New York and London 1986

Joan **Miró**

Born 1893 in Barcelona; died 1983 in Majorca. 1907–10 and 1912–15 art studies; 1918 first one-man show at Dalmau Gallery, Barcelona. 1919 first visit to Paris; meets Picasso. From 1920 to 1940 spends large part of his time in Paris; first one-man show there 1921 at Galerie La Licorne; associates with Surrealists, especially poets; 1926 with Ernst creates decor of Diaghilev ballet *Romeo and Juliet*. First exhibitions in New York 1930, London 1933. 1947 first visit to USA. In mid-1940s and mid-1950s makes ceramics in collaboration with Artigas. Major exhibitions 1956 Amsterdam, Brussels, Basle; 1959 New York and Los Angeles; 1962 Paris; 1964 London and Zurich.

Dupin, Jacques, *Miró*, London and New York 1962

Lassaigne, Jacques, *Miró*, Lausanne 1963

Rowell, Margit (ed.), *Miró: selected writings and interviews*, London 1986

Catala Roca, Francese, *Miró: Ninety Years*, London 1986

Laszlo **Moholy-Nagy**

Born 1895 in Bacsbarsod, Hungary; died 1946 in Chicago. Studies law but associating with writers and musicians. 1914–18 in Hungarian army, wounded; makes drawings; with others organizes artists' group *MA* (Today). 1919 influenced by new Russian art; moves to Vienna, starts to experiment with photograms. 1920 moves to Berlin. 1921 meets El Lissitzky in Düsseldorf; visit to Paris. 1922 first one-man show, at Sturm Gallery; meets Gropius, who invites him to join Bauhaus faculty; 1923–8 teaching at Bauhaus in Weimar and Dessau. 1928 to Berlin; stage designs for Piscator and others; designs exhibitions and experiments with film. 1934 to Amsterdam; retrospective show at Stedelijk Museum. 1935 to London; layout and poster design, exhibitions, books, films; 1936 special effects for Korda's film *The Shape of Things to Come*. 1937 to USA; director of short-lived New Bauhaus in Chicago; opens own School of Design, Chicago, 1938. Influential books: *Painting, Photography, Film* and *The New Vision: from Material to Architecture* originally published by Bauhaus 1925 and 1929 (English edition of second published New York 1932); *Vision in Motion*, Chicago 1947.

Kostelanetz, Richard, *Moholy-Nagy*, New York 1970

Catalogue, *Laszlo Moholy-Nagy*, Arts Council of Great Britain, London 1980

Passuth, Krisztina, *Laszlo Moholy-Nagy*, London 1985

Piet **Mondrian**

Born 1872 in Amersfoort, Holland; died 1944 New York. Largely self-taught; also evening classes in drawing and 1892–4 studies painting at Amsterdam Academy. First exhibition in Amsterdam. Works in Amsterdam; exhibits at Stedelijk Museum 1909, with Spoor and Sluyters. 1909 joins Theosophical Society. End of 1911 or early 1912 to Paris; sends to Salon des Indépendants. Returns to Netherlands August 1914; prevented by war from returning to Paris; forms friendship with Theosophist Dr Schoenmaekers. 1915 meets van Doesburg; 1916–17 with van der Leck they form *De Stijl* group. Mondrian writes theoretical articles for *De Stijl* magazine, 1917 on. 1919 returns to Paris. Collected essays published as *Le Néo-plasticisme* by Galérie Léonce Rosenberg 1920, and by Bauhaus 1925. Contributes to exhibitions in Paris and Hanover; 1922 50th-birthday exhibition in Amsterdam. 1925 leaves *De Stijl* group over van Doesburg's *Counter-Compositions*. Included in exhibitions in Paris, Amsterdam, The Hague, New York. Moves to London 1938, and to New York 1940. 1942 one-man show at Dudensing Gallery, New York.

Jaffé H. L. C., *Piet Mondrian*, New York and London 1970

Catalogue, *Piet Mondrian*, Solomon R. Guggenheim Museum, New York 1971

Champa, Kermit, *Mondrian Studies*, London and Chicago 1985

Holtzman, Harry, and Martin, James (ed.), *The New Art—The New Life: the Collected Writings of Piet Mondrian*, London 1986

Claude **Monet**

Born 1840 in Paris; died 1926 in Giverny. Begins to paint in Normandy; studies at Académie Suisse and Ecole des Beaux-Arts, Paris. Meets Pissarro, Renoir, Sisley and Bazille; meets Manet and Courbet. Visit to London 1870–1; visits to Holland 1871 and 1872. Paints in Paris and its suburbs. 1874 first Impressionist Exhibition; Monet contributes to this and subsequent exhibitions until 1882. From 1880s on works further afield – Rouen, South of France, Italy, London. 1889 well-received joint exhibition with Rodin, Georges Petit Gallery, Paris. 1890 buys and subsequently develops property at Giverny; water-lily paintings series begins 1899; 1914 on works on large cycle of such paintings. 1921 group of paintings accepted by State and Orangerie reconstructed to house them. Repeated eye troubles; partial sight from 1923 on; worked on until death. Major exhibitions in Paris 1931, Zurich 1952, London 1957 and New York 1960.

Seitz, William C., *Claude Monet*, New York 1960

Gordon, Robert, and Forge, Andrew, *Monet*, New York 1983

Rewald, John, and Weitzenhoffer, Frances (ed.), *Aspects of Monet: a Symposium on the Artists's Life and Times*, New York 1984

Henry **Moore**

Born 1898 at Castleford, Yorkshire; died 1986 at Much Hadham, Hertfordshire. Studies 1919–25 at Leeds College of Art and Royal College of Art, London. Joins staff of RCA, then teaches Chelsea School of Art 1931–9. War artist 1940–2 (shelter drawings). 1923 on frequent visits to Paris; extensive tour of Italy 1925. First one-man exhibition, Warren Gallery, London; from 1931 on one-man shows at Leicester Galleries, London. 1933 member of Unit 1; 1936 founder-member of English Surrealist group. First retrospective exhibition, Temple Newsam, Leeds, 1941. 1943 first exhibition abroad, Buchholz Gallery, New York. 1956 commissioned to make sculpture for UNESCO building in Paris; begun near Carrara quarries, finished on site. Many other commissions for public sculpture throughout the world. 1963 awarded highest British distinction, the Order of Merit. Large retrospective exhibitions at Tate Gallery, London, 1951 and 1968 and Royal Academy, London 1988.

Catalogue, *Henry Moore*, Arts Council of Great Britain 1968

Bowness, Alan (ed.), *Henry Moore: Complete Sculpture*, 6 vols., London and New York 1944–88

Henry Moore at the British Museum, British Museum, London 1981

Berthoud, Roger, *The Life of Henry Moore*, London 1987

Catalogue, *Henry Moore*, Royal Academy of Arts, London 1988

Giorgio **Morandi**

Born 1890 in Bologna; died 1964 at Grizzana. Studies at Bologna Academy 1907–13. Attracted by Early Renaissance painting and by Futurism. Brief military service, followed by illness. 1918 associates with *Valori Plastici* group led by Carrà; exhibits with the group 1921 and 1922. 1930–56 professor of engraving at Bologna Academy. 1945 one-man exhibition at Galleria Il Fiore, Florence. From now on increasing reputation, prizes. 1957 Grand Prize for Painting at São Paulo Bienal.

Vitali, Lamberto, *Giorgio Morandi*, Milan 1970

Catalogue, *Giorgio Morandi*, Arts Council of Great Britain, London 1970

Malcolm **Morley**

Born 1931 in London. Studies at Royal College of Art 1954–7. Moves to New York 1964. Works with Barnett Newman 1964–5. One-man shows Kornblee Gallery, New York, 1964, 1967 and 1969; in group shows 1955 on, in Europe and America.

Calas, Nicolas and Elena, *Icons and Images of the Sixties*, New York 1971

Catalogue, *Malcolm Morley: Paintings 1965–1982*, Whitechapel Art Gallery, London 1983

Robert **Morris**

Born 1931 in Kansas City, Mo. Studies engineering, then art at Kansas City Art Institute; California School of Fine Arts, San Francisco; and Reed College, Oregon. Works in improvisatory theatre, film and painting. First sculptures 1961. Studies art history at Hunter College, New York, 1962–3 (dissertation on Brancusi). First one-man show of sculpture Green Gallery, New York, 1963. Essays on sculpture published in *Artforum*, February 1966 on. 1969–70 series of large museum shows, Washington, Detroit, New York; some works made specifically for the shows; New York show at Whitney Museum closed by order of the artist when USA invaded Cambodia. Part retrospective, part new work show at Tate Gallery, London, 1971.

Catalogue, *Robert Morris*, Tate Gallery, London 1971

Catalogue, *The Drawings of Robert Morris*, Williams Collection of Art, Mass., 1982

Robert **Motherwell**

Born 1915 in Aberdeen, Washington. Studies art at Otis Art Institute, Los Angeles, and Stanford University, where he changes to philosophy; further studies in aesthetics at Harvard and art history at Columbia. Contact with European Surrealists in New York. 1944 first one-man show at Art of this Century Gallery, New York; 1948 co-founder of Subjects of the Artist school, New York, with Rothko and Still. Active as writer and editor of writings on art.

Catalogue, *Robert Motherwell*, Museum of Modern Art, New York 1967

Arnason, H. H., *Robert Motherwell*, New York 1982

Paul **Nash**

Born London 1889; died 1946 at Boscombe, near Bournemouth. Studies art at Chelsea School of Art, Bolt Court School and Slade School of Art; first exhibition in Oxford 1912. 1914 army; 1917 official war artist. 1921–5 lives at Dymchurch, Kent; 1925–30 at Iden, Sussex. 1928 exhibition at Leicester Galleries, London. Innate 'love of the monstrous and the magical' confirmed by influence of de Chirico and then Surrealism. 1933 organizes Unit 1 group. 1936 committee member of International Surrealist Exhibition, New Burlington Galleries, London. 1940 again appointed official war artist.

Nash, Paul, *Outline. An Autobiography and other Writings*, London 1949

Bertram, Anthony, *Paul Nash: The Portrait of an Artist*, London 1955

Causey, Andrew, *Paul Nash*, Oxford 1980

King, James, *Interior Landscapes: a Life of Paul Nash*, London 1987

Barnett Newman

Born 1905 in New York; died there 1970. Studies painting at Boston University and in London. 1947–8 associate editor of art journal *Tiger's Eye*; teaches at Subjects of the Artist school. One-man shows in New York from 1950 on; retrospective 1969 at Solomon R. Guggenheim Museum, New York, and in Amsterdam, London and Paris 1972.

Hess, Thomas B., *Barnett Newman*, New York 1969
Catalogue, *Hommage à Barnett Newman*, National-galerie, Berlin 1982

Ben Nicholson

Born 1894 at Denham, Buckinghamshire; died 1982 in London. Son of painters. Short period at Slade School, 1910–11; some months in France and Italy. First one-man show 1922, Adelphi Gallery, London. In twenties lives mainly in Cumberland. Frequent visits to Paris. 1933 member of English Unit 1 group and of French *Abstraction-Création*. 1936 co-editor of *Circle, International Survey of Constructive Art*. 1939–58 lives in St Ives, Cornwall, 1944 retrospective exhibition, Leeds City Art Gallery; 1949 first USA show at Durlacher Gallery, New York; 1952 first prize for painting at Carnegie International; 1954 retrospective at Venice Biennale, Ulisse award; 1957 First Prize for Painting at São Paulo Bienal. 1968 Order of Merit. 1958 to 1971 living in the Ticino, then in Cambridge and London. 1974 Rembrandt Prize awarded by Goethe Foundation.

Read, Herbert, *Ben Nicholson*, London 1948
Read, Herbert, *Ben Nicholson: Work since 1947*, London 1956
Russell, John, *Ben Nicholson*, London 1969

Kenneth Noland

Born 1924 in Ashville, North Carolina. Studies art at Black Mountain College, North Carolina 1946–8 and 1948–9 in Paris with Zadkine. First one-man show 1949 at Galerie Creuze, Paris. Settles in Washington, meets Morris Louis 1952 and with him visits Helen Frankenthaler's studio 1953. First of frequent one-man exhibitions at New York 1957, at Tibor de Nagy Gallery. 1964 shown at Venice Biennale; that year begins shaped canvas paintings. 1977 retrospective at Solomon R. Guggenheim Museum, New York.

Moffet, Kenworth, *Kenneth Noland*, New York 1977
Catalogue, *Kenneth Noland: Recent Paintings*, Waddington Galleries, London 1979

Emil Nolde

Pseudonym of Emil Hansen, born 1867 in Nolde, Schleswig; died 1956 in Seebüll. Trains in furniture-making and design. Some months studying painting under Hölzel in Dachau, near Munich (1899) and in Paris at Académie Julian (1900). 1906–7 member of *Die Brücke* group. Series of intense paintings on biblical themes 1909–11. Lives mostly in Schleswig; frequent periods in Berlin. Welcomes rise of Nazis as emergence of Nordic and nationalist force; Nazis forbid him to paint and seize over a thousand of his works from public collections, showing some (including *Life of Christ* polyptych) in 'Degenerate Art' exhibition 1937.

Haftmann, Werner, *Emil Nolde*, London and New York 1960

Georgia O'Keeffe

Born 1887 in Sun Prairie, Wisconsin; died 1986 in Santa Fe, New Mexico. Art training, mainly at Chicago Art Institute, 1905–6, and Art Students' League, New York 1907–8. 1908–12 works in commercial art. 1912 art classes at University of Virginia, and 1914–15 at Teachers College, Columbia. 1916 works exhibited at Alfred Stieglitz's '291' Gallery, New York. 1918 she settles in New York at Stieglitz's suggestion; 1923 he arranges exhibition of her paintings at Anderson Galleries, New York; 1924 they marry. 1927 retrospective exhibition at Brooklyn Museum. 1929 trip to New Mexico: subsequently summers often in New Mexico. 1943 full retrospective at Chicago Art Institute; and in 1946 at Museum of Modern Art, New York.

Goodrich, Lloyd, and Bry, Doris, *Georgia O'Keeffe*, New York 1970
Castro, Jan, *The Art and Life of Georgia O'Keeffe*, London 1986

Claes Oldenburg

Born 1929 in Stockholm, Sweden. Early periods in USA with diplomat father. Chicago Art Institute 1953–4. Around 1958 contact with Allan Kaprow and others: Happenings and environmental pieces. 1961 opens 'The Store', selling replicas of food; soon creating widening range of metamorphosed items from everyday life, and, from 1965 on, drawings and models of colossal monuments. 1962 one-man show at Green Gallery, New York; 1964 at Sidney Janis Gallery, New York, and Galerie Ileana Sonnabend, Paris. 1966 one-man show at Moderna Museet, Stockholm. 1970 retrospective shows in Amsterdam, Düsseldorf and London.

Rose, Barbara, *Claes Oldenburg*, New York 1970
Oldenburg, Claes, and Bruggen, Coosje van, *Claes Oldenburg. Large-Scale Projects*, New York 1980

Jules Olitski

Born 1922 in Gomel, Russia. Studies art in New York and Paris 1939–42 and 1949–50. Thick paintings of 1950s, influenced by Hofmann, succeeded in 1960 by stained canvases and, from 1963 on, by sprayed paint-

ings without linear boundaries. 1973 retrospective at Whitney Museum, New York. Since 1970 also making sculpture, and since about 1973, thickly textured paintings.

Moffet, Kenworth, *Jules Olitski*, New York 1981

Dennis **Oppenheim**
Born 1938 in Mason City, Washington. Studies at California College of Arts and Crafts and Stanford University 1959–65. Some years working as construction labourer in Hawaii. First one-man show 1968 at John Gibson Gallery, New York; 1969 shows in Paris, Milan, and exhibition entitled 'A Report: Two Ocean Projects' at Museum of Modern Art, New York. 1975 retrospective exhibition Brussels and Rotterdam.

Catalogue, *Dennis Oppenheim*, Musée d'Art Moderne de la Ville de Paris, Paris 1979

Meret **Oppenheim**
Born 1913 in Berlin; grows up in Germany and Switzerland. To Paris 1932; meets Giacometti, Arp and other associates of Surrealism and exhibits with them in thirties. Studies at Basle Kunstgewerbeschule 1938–40; paints and lives from picture restoring. Frequent one-man shows around Europe from 1959 on.

Rotzler, Willy, *Objekt-Kunst von Duchamp bis Kienholz*, Cologne 1972
Catalogue, *Meret Oppenheim et ses Jeux d'Etet*, Galerie Armand Zerbib, Paris 1974
Catalogue, *Meret Oppenheim*, Musée d'Art Moderne de la Ville de Paris, Paris 1984

José Clemente **Orozco**
Born 1883 in Zapotlán, Mexico; died 1949 in Mexico City. Studies at San Carlos Academy, Mexico City, 1908–14. Committed to social revolution; from 1922 on paints murals promoting democratic society; murals in USA during 1929–34, then returns to Mexico. Mural in Museum of Modern Art, New York, 1940.

Helm, MacKinley, *Man of Fire: José Clemente Orozco*, Westport, Conn., 1953
Reed, Alma, *Orozco*, New York 1956
Catalogue, *Orozco, 1883–1949*, Museum of Modern Art, Oxford 1980

Victor **Pasmore**
Born 1908 in Chelsham, England. Studies art at Central School, London; co-founder 1937 of Euston Road School; from 1938 full-time painter. 1947–8 turns to abstract painting and, from 1951, reliefs. Director of Urban Architectural Design for part of Peterlee New Town, County Durham 1955–7. One-man exhibitions from 1940 on. Major retrospectives

at Venice Biennale 1960, Hanover 1962, London 1965. 1964 awarded international prize for painting at Pittsburgh International.

Catalogue, *Victor Pasmore*, Tate Gallery, London 1965
Bowness, Alan, *Victor Pasmore*, London 1980

Francis **Picabia**
Born 1879 in Paris; died there 1953. Studies at Ecole des Beaux-Arts and Ecole des Arts Décoratifs. 1905 first one-man show. 1909–10 meets Duchamp and his brothers; 1911 founder-member of *Section d'Or* group. 1912 abstract paintings. 1913 to New York; contact with Stieglitz. War years travelling between America and Europe, linking up Dada Activities in several places and publishing Dada Journals. 1919 back in Paris, promoting Dada events and subsequently contributing to Surrealist exhibitions.

Catalogue, *Francis Picabia*, Musée National d'Art Moderne, Paris 1976
Salle, David, *Francis Picabia*, Munich 1983
Camfield, William, *Francis Picabia: His Art, Life and Times*, Princeton University Press 1979

Pablo **Picasso**
Born 1881 in Malaga; died 1973 in Antibes. Son of art teacher. From 1895 living in Barcelona, part of avant-garde group with Symbolist leanings. Yearly visits to Paris 1900–3; settles in Paris 1904. 1907 *Demoiselles d'Avignon*. 1909–12 close contact with Braque; 1912 first collages and constructions. 1917 to Rome to work on ballet *Parade*. 1919 to London to work on ballet *The Three-Cornered Hat*. 1920–5 his 'neo-classical' period. 1925 *The Dance*. Large retrospective exhibition 1932 in Paris, Galerie Georges Petit, and Zurich. 1937 *Guernica*. Major retrospective at Museum of Modern Art, New York. Picasso/Matisse exhibition in London, Victoria and Albert Museum, and Brussels, 1945. 1946 paints murals in Palais Grimaldi, Antibes. 1947 begins to produce ceramics. 1953 retrospectives at Lyon, Rome, Milan, and São Paulo. 1954 variations on Delacroix's *Algerian Women*; 1957 variations of Velázquez' *Las Meninas*. 1958 mural for UNESCO building, Paris. Major exhibitions in London 1960 and New York 1962. 1966 exhibitions everywhere to celebrate 85th birthday. Major retrospective exhibition in Paris 1979 and New York 1980

Penrose, Roland, *Picasso*, London and New York 1971
Ashton, Dore, *Picasso on Art*, London 1972
Rubin, William *Picasso* in the 'Collection of the Museum of Modern Art', New York 1972
Spies, Werner, *Sculpture*, London and New York 1972
Penrose, Roland, and Golding, John (eds.) *Picasso 1881–1973*, London and New Hampshire 1973
Daix, Pierre, *Picasso: the Cubist Years, 1907–1916*, London 1979
Measham, Terry, *Picasso and his World*, London 1980

Rubin, William (ed.), *Pablo Picasso: a Retrospective*, New York and London 1980

McCully, Marilyn, *A Picasso Anthology*, London 1981

Michelangelo **Pistoletto**

Born 1933 in Biella, Italy; grows up in Turin, works with father as picture restorer. Begins painting in 1956; also does sculpture in mid-sixties and Happenings 1970 on. First one-man shows (Galleria Galatea, Turin) 1960 and 1963; soon thereafter exhibitions also in other European centres and in Minneapolis, Detroit, Buffalo and New York (all before 1968); many one-man and group shows on both sides of Atlantic.

Catalogue, *Michelangelo Pistoletto*, Kestner-Gesellschaft, Hanover 1973

Catalogue, *Pistoletto (prima parte)*, Stedelijk Van Abbe Museum, Eindhoven 1986

Carl **Plackman**

Born 1943 in Huddersfield, England. After apprenticeship in architecture studies art at West of England College of Art, Bristol, and at Royal College of Art, London, 1962–70. One-man shows at Serpentine Gallery, London, 1972 and at Arnolfini Gallery, Bristol, 1978; included in many exhibitions in Britain and in Paris, Frankfurt, Cologne, Milan, Vienna, and Sydney.

Jackson **Pollock**

Born 1912 in Cody, Wyoming; died 1956 in East Hampton. Grows up in California and has first art training there. 1931–3 attends Art Students' League, New York, to study painting and sculpture. Contact with Rivera and Siqueiros. From 1937 intermittent Jungian psychoanalysis. 1943 first one-man show at Art of the Century Gallery, New York. 1946–51 annual one-man shows, Betty Parsons Gallery, New York (two in 1949). 1950 shows in Venice and Milan; 1952 Paris, 1953 Zurich. 1952 on one-man shows at Sidney Janis Gallery, New York. Retrospective memorial exhibition at Museum of Modern Art, New York December 1956–February 1957, and in São Paulo Bienal 1957, and subsequently 1958–9 in Rome, Basle, Amsterdam, Hamburg, Berlin, London, and Paris.

O'Connor, Francis V., *Jackson Pollock*, New York 1967

Friedman, B. H., *Jackson Pollock, Energy Made Visible*, London and New York 1972

Catalogue, *Jackson Pollock*, Centre Georges Pompidou, Paris 1982

Potter, Jeffrey (ed.), *To a Violent Grave: an oral biography of Jackson Pollock*, New York 1985

Lyubov **Popova**

Born 1889 in Moscow province; died 1924 in Moscow. Studies painting privately. Travels in Italy 1910 and spends some months in Paris 1912, with Le Fauconnier and Metzinger. 1914–16 contributes to avant-garde exhibitions in Moscow and St Petersburg. 1917 makes posters and street decorations for Revolution. 1920 with husband Alexander Vesnin designs decorations for Red Square and model for vast open-air performance. 'The End of Capitalism'. Participates 1923 in '5 × 5 = 25' exhibition; ceases to paint, devotes herself to Productivist work and teaching. Designs productions for Meyerhold 1922–3; 1922–4 works on textile designs with Stepanova, also poster and book design.

Gray, Camilla, *The Great Experiment: Russian Art 1863–1922*, London 1962

Robert **Rauschenberg**

Born 1925 at Port Arthur, Texas. Studies at Kansas City Art Institute; Académie Julian, Paris; Black Mountain College, North Carolina; Art Students' League, New York. 1951 first one-man show, Betty Parsons Gallery, New York; frequent exhibitions thereafter, including, from 1953 on, in Italy, in Düsseldorf 1959, Paris 1961. Major exhibitions in Jewish Museum, New York, 1963, Whitechapel Art Gallery, London, 1964. Designs and performs in dances of Merce Cunningham Dance Company.

Forge, Andrew, *Robert Rauschenberg*, Amsterdam and New York 1968

Catalogue, *Robert Rauschenberg: Werke 1950–1980*, Staatliche Kunsthalle, Berlin 1980

Man **Ray**

Born 1890 in Philadelphia; died 1976 in Paris. Drawing classes at Ferrer Center, New York. 1913 strongly influenced by European modernism at Armory Show. 1915 first one-man show, Daniel Gallery, New York; friendship with Duchamp; begins experimental photography. 1918 spray gun paintings. 1921 to Paris, associates with Dadaists. 1922 contributes to *Salon Dada*; publishes suite of photographs *Les Champs Délicieux*; 1923 begins to make films. Associates with Surrealists: from 1921 on paints and makes disquieting objects out of found materials; publishes photographs and 'rayographs' (photograms), often with texts by Surrealist writers. 1940 back to America; 1951 returns to Paris.

Penrose, Roland, *Man Ray*, Greenwich, Conn., and London 1975

Martin, Jean-Hubert, *Man Ray: Photographs*, London 1982

Ray, Man, *Self-Portrait*, London 1988

Martial **Raysse**

Born 1936 in Golfe-Juan, Nice. Associated with Tinguely, Arman and Klein in Nouveaux Réalistes group. Produces, from 1960 on, assemblages of manufactured goods and photographs, sometimes in association with time-honoured art images: 'I wanted my works to possess the serene self-evidence of mass-

produced refrigerators.' Stage decor work, including 1967 Royal Ballet production *Paradise Lost*, Covent Garden, London.

Catalogue, *Martial Raysse*, Dwan Gallery, Los Angeles 1967
Catalogue, *Martial Raysse*, Centre Georges Pompidou, Paris 1981

Ad **Reinhardt**
Born 1913 in Buffalo, New York; died New York 1967, 1931–5 studies under Meyer Schapiro at Columbia University and 1936–7 at National Academy of Design, New York. Joins American Abstract Artists group. First one-man show 1944, Artists' Gallery, New York; 1944–5 works as photographer for US Army marines. 1945–51 further studies at Institute of Fine Arts, New York. 1946 on one-man shows at Betty Parsons Gallery, New York; retrospective there 1960. 1953–4 eradicates asymmetries and colour from his paintings. Major retrospective at Jewish Museum, New York. 1972–3 touring retrospective Düsseldorf, Eindhoven, Zurich, Vienna.

Lippard, Lucy, *Ad Reinhardt*, New York 1981

Germaine **Richier**
Born 1904 in Grans, near Arles; died 1959 in Montpellier. Trains in Montpellier and under Bourdelle in Paris (1925–9). First one-man show 1934 at Galerie Kaganovitsch, Paris. 1939–45 in Switzerland and South of France: 1945 returns to Paris. 1951 sculpture prize at São Paulo Bienal.

Crispolti, Enrico, *Germaine Richier*, Milan 1968
Catalogue, *Germaine Richier, a retrospective*, London 1973

Hans **Richter**
Born 1888 in Berlin; died 1976 in Locarno. Art studies in Berlin and Weimar; contact with modernism through Sturm Gallery. 1915 works for activist journal *Die Aktion* (special Richter issue 1916). In army 1915–16; invalided. 1916 to Zurich, joins Dada circle; 1918 meets Eggeling in Zurich, returns with him to Berlin where both work on scroll paintings. 1920 first essays in film. 1923–6 edits journal *G* (= Gestalt) with Mies van der Rohe and others. To America 1940. Collaborates on films such as *Dreams that Money Can Buy* with Arp, Duchamp, Ernst, Léger, Man Ray, etc., 1944–7. Author of books on film (1929, 1935, 1941) and Dada (1961, 1964).

Richter, Hans, *Hans Richter*, London 1971
Catalogue, *Hans Richter, 1888–1976*, Städtische Galerie im Lenbachhaus, Munich 1982

Bridget **Riley**
Born 1931 in London. Studies art at Goldsmith's College and Royal College of Art, London 1949–55. First

one-man show Gallery One, London, 1962. First New York show, Richard Feigen Gallery, 1965. 1970–1 retrospective tours Hanover, Berne, Düsseldorf, Turin, London, and Prague. 1978–80 retrospective tours Buffalo, Dallas, Sydney, Perth, Tokyo. Her first 'Op' paintings are in black and white; via greys and blues she moves, *c.*1967, into full colour, subtly bunched to deliver ever-varying optical and thence emotional sensations.

De Sausmarez, Maurice, *Bridget Riley*, London 1970
Catalogue, *Bridget Riley*, Arts Council of Great Britain, London 1971
Catalogue, *Bridget Riley*, British Council, London 1978
Catalogue, *Working with Colour: recent paintings and studies*, Arts Council of Great Britain, London 1984

Diego **Rivera**
Born 1886 in Guanajuato, Mexico; died 1957 in Mexico City. Art studies in Mexico and Madrid; then travels in Europe. 1911 settles in Paris; contact with Picasso and Cubists. 1921 back to Mexico; member of artists' commune and active in revolutionary movement. From 1923 on paints didactic murals on political and historical themes in public buildings in Mexico; in 1930s also in USA; frescos for Rockefeller Center, New York, 1933.

Evans, Ernestine, *The Frescoes of Diego Rivera*, New York 1929
Secker, Hans F., *Diego Rivera*, Dresden 1957
Gual, E. F., *Diego Rivera*, Buenos Aires 1966
Catalogue, *Diego Rivera: a retrospective*, Institute of Arts, Detroit, and Arts Council of Great Britain, London 1986

William **Roberts**
Born 1895 in London; died there 1980. Works on posters and advertising and attends evening classes at St Martin's School of Art. 1910–13 Slade School of Art on scholarship. 1913 travels in France and Italy; influenced by Cubism. 1914 meets Wyndham Lewis; co-signatory of *BLAST* manifesto. 1915 contributes to *BLAST No. 2*. 1916–18 in France as gunner; 1918 official war artist. In Group X exhibition, Mansard Gallery, London, 1920; first one-man show Chenil Galleries 1923. Continues to paint popular subjects in monumental style. 1948 begins to exhibit regularly at Royal Academy; is made Royal Academician 1966.

Catalogue, *William Roberts*, Arts Council of Great Britain, London 1965
Catalogue, *William Roberts 1895–1980: an artist and his family*, National Portrait Gallery, London 1984

Alexander **Rodchenko**
Born 1891 in St Petersburg; died 1956 in Moscow. Studies at Kazan School of Fine Arts; much

influenced by Futurist performance in 1914. 1915 to Moscow to study at Stroganov School; influenced by Cubo-Futurism, makes first abstract drawings. 1916 invited by Tatlin to show in 'The Store' exhibition. 1917 contributes to decoration of Café Pittoresque, with Tatlin, Yakulov and others; appointed secretary of Left Federation of Artists within new Union of Painters. 1918 helps organize Museum of Artistic Culture and becomes its first director. One-man show, Left Federation, Moscow; 'black on black' paintings as challenge to Suprematism; first space constructions. 1919 line drawings and paintings, collages and photomontages; co-director of Industrial Art section of Moscow workshops. 1920 shows 57 works including 25 architectural designs, in State Exhibition; professor in metalwork department of Vkhutemas. 1921 shows constructions in exhibition of Society of Young Artists; in exhibition '5 × 5 = 25' shows red, blue and yellow monochrome canvases, 'the last paintings'. 1922 typographical experiments and other utilitarian designs; titles for Vertov's 'Kino-Pravda' newsreels. 1923 posters and advertisements, often in collaboration with Mayakovsky covers and layout for *Lef* journal, founded by Mayakovsky, and photomontages for Mayakovsky book of poems *About This*; experimental photography. 1924 on increasingly active as photographer. 1925 makes designs for Russian display at Paris decorative Arts exhibition; visits Paris to install 'Workers' Club' (his only journey abroad). 1927–8 covers, layout, illustrations and articles for *Novy Lef*. 1929 stage design for Mayakovsky's *Bed Bug* and other plays. 1930–1 attacks on Rodchenko on grounds of formalism. From 1933 on designs issues of periodical *USSR in Construction*. 1935 begins to paint again, figurative studies; typographical and photographic work; from 1940 on also lyrical abstract paintings.

Weiss, E. (ed.), *Alexander Rodchenko Fotografien 1920–1938*, Cologne 1978
Catalogue, *Alexander Rodchenko*, Museum of Modern Art, Oxford 1979
Khan-Magomedov, Selim, *Rodchenko*, London 1986

August **Rodin**

Born 1840 in Paris; died 1917 in Meudon. Dominant sculptor in late nineteenth-century and early twentieth-century France, primarily through modelled work replacing traditional idealism and naturalism with expressive and dynamic forms and surfaces. Main works: *Gates of Hell* 1880 onwards; *Burghers of Calais* 1884–9 (unveiled 1895); *Monument to Balzac* 1891–8. His plaster figure of the latter is rejected by the State commissioning committee, but cast after Rodin's death and set up 1939.

Elsen, Albert E., *Rodin*, New York 1963
Elsen, Albert E. (ed.), *Rodin, Readings on his Life and Work*, New Jersey 1965
Jianou, Ionel, and Goldscheider, Cécile, *Rodin*, Paris 1969

Catherine Lampert, *Auguste Rodin, Sculpture and Drawings*, London 1986

James **Rosenquist**

Born 1933 in Grand Forks, North Dakota. Studies art at University of Minnesota, Minneapolis, and Art Students' League, New York; additional study with Jack Youngerman and Robert Indiana. Works as display artist 1952–4 and 1959. First one-man show Green Gallery, New York, 1962; one-man shows frequently thereafter, also in mixed shows in USA and Europe 1962 on.

Catalogue, *James Rosenquist*, Whitney Museum of American Art, New York 1972

Mark **Rothko**

Born 1903 in Dvinsk, Russia; died 1970 in New York. To USA 1913. Studies at Yale University and at Art Students' League, New York, 1921–5. Researches into colour, also mythology, and Jungian theory. First one-man show 1933 at Contemporary Arts Gallery, New York. Founds group 'The Ten' with Adolf Gottlieb. 1942–7 surrealistic, biomorphic paintings; one-man show 1945 at Art of this Century Gallery, New York. 1947–50 transitional paintings, moving towards large floating rectangles of colour; 1948 co-founds Subjects of the Artist painting school. Major retrospective 1961–2 shown in New York, London, Amsterdam, Brussels, Basle, and Paris; another 1971–2 Zurich, Berlin, Düsseldorf, Rotterdam, and London. 1958 commissioned to do paintings for Seagram Building, New York (architect Mies van der Rohe with Philip Johnston); withdraws paintings when use of room changes, from conference hall to restaurant (some of them now in Tate Gallery, London). 1965–7 set of paintings for de Menil family, to hang in chapel of Institute for Religion and Human Development, Houston, Texas.

Waldman, Diane, *Mark Rothko*, London and New York 1978
Ashton, Dore, *About Rothko*, New York 1983
Catalogue, *Mark Rothko*, Tate Gallery, London 1987

Georges **Rouault**

Born 1871 in Paris; died there 1958. Apprenticed to stained-glass artist; also art studies at Ecole des Arts Décoratifs, and at Ecole des Beaux-Arts under Gustave Moreau; fellow pupils include Matisse and other future Fauves with whom he is associated in 1905–6. Large body of prints 1917–27, including suites such as *Miserere*; 1918 onwards also oil paintings of great intensity, often on religious themes. Retrospective at Petit Palais, Paris, 1937. Large retrospectives 1945 New York, 1948 Zurich; internationally touring retrospective 1952–4.

Courthion, Pierre, *Georges Rouault*, London and New York 1962

Henri **Rousseau**

Known also as the 'Douanier' Rousseau. Born 1844 in Laval; died 1910 in Paris. After army service he is gatekeeper for a customs-house, retiring in 1885. Begins to send paintings to Salon des Indépendants in 1885, gradually attracting interest of avant-garde artists and critics. 1905 a group of his paintings displayed at Salon d'Automne. 1906 contact with Picasso, Apollinaire, and others; 1908 guest of honour at banquet given by Picasso.

Rich, Daniel Catton, *Henri Rousseau*, New York 1946
Le Pichon, Yann, *The World of Henri Rousseau*, Oxford 1982
Catalogue, *Henri Rousseau*, Museum of Modern Art, New York 1985

Morton **Schamberg**

Born 1881 in Philadelphia; died there 1918. Studies architecture at University of Pennsylvania and painting at Pennsylvania Academy of Fine Arts. Close friend of Charles Sheeler. Spends time with Sheeler in Europe, especially Paris, 1905–10. Helped by Stieglitz; becomes photographer. Through Sheeler meets Duchamp 1916. Dies in Spanish influenza epidemic.

Catalogue, *The Modern Spirit: American Painting 1908–1935*, Arts Council of Great Britain, London 1977

Oskar **Schlemmer**

Born 1888 in Stuttgart; died 1943 at Baden-Baden. Studies at Stuttgart Academy under Hölzel. 1921–9 teaching at Bauhaus; 1929–32 teaching at Breslau Academy. 1933 his first retrospective, ready to open in Stuttgart, is vetoed by Nazis and Schlemmer dismissed from recently acquired teaching post in Berlin. 1937 works confiscated and shown in 'Degenerate Art' exhibition in Munich. 1922 first full production of *Triadic Ballet* in Stuttgart. At Bauhaus Schlemmer at various times runs sculpture workshops, collaborates with students on murals in entrance and staircase of the Weimar school, runs stage workshop, and teaches course on Man.

Maur, Karin von, *Oskar Schlemmer*, Munich 1979
Maur, Karin von, *Oskar Schlemmer: Monographie und Oeuvrekatalog*, Munich 1982
Catalogue, *Oskar Schlemmer 1888–1943, Man and Abstraction in the 20s and 30s*, Stedelijk Museum, Amsterdam 1987

Julian **Schnabel**

Born 1951 in New York. Studies at the University of Houston 1969–72 and on Whitney Museum Study Program 1973. First one-man show Houston 1976, Düsseldorf 1978, New York 1979, followed by many more in USA and abroad.

Catalogue, *Julian Schnabel*, Tate Gallery, London 1982

Catalogue, *Julian Schnabel, Paintings 1975–1986*, Whitechapel Art Gallery, London 1986

Georg **Schrimpf**

Born 1889 in Munich; died 1938 in Berlin. Self-taught painter; first exhibits at Der Sturm Gallery, Berlin, 1920. Visits to Switzerland and Italy. 1926–33 teaching at School of Applied Art in Munich and then at Berlin-Schöneberg art school.

Pförtner, M., *Georg Schrimpf*, Berlin 1940

Kurt **Schwitters**

Born 1887 in Hanover; died 1948 in Ambleside, England. 1909 studies at Dresden art academy. Expressionist paintings, exhibits at Der Sturm Gallery, Berlin, 1918. Conceives *Merz* art: shows first *Merz* paintings and publishes *Merz* poems 1919, in Der Sturm Gallery and *Der Sturm* magazine. 1920 begins *Merz* environment in his house in Hanover; refused admission into Berlin Dada group. 1922 travels with van Doesburg in Holland to promote Dada. 1923 starts publishing *Merz* magazine. 1925 exhibition at Der Sturm Gallery, shown in part subsequently in Moscow, Dresden, and Hanover. 1936 work included in two Museum of Modern Art exhibitions, New York. 1937 work included in 'Degenerate Art' show, Munich and tour. Settles in Norway. Work included 1938 in London show of German art. 1940 to England; internment, then lives 1942–5 in London and later at Ambleside.

Schmalenbach, Werner, *Kurt Schwitters*, New York and London 1970
Elderfield, John, *Kurt Schwitters*, London 1985

Arthur **Segal**

Born 1875 in Jassy, Rumania; died 1944 in London. Art studies in Berlin, Munich (partly under Hölzel), Paris and Italy. 1904 settles in Berlin; exhibits with Secession. 1910 founder-member of New Secession. 1914–20 in Switzerland; friendship with Arp and Dada circle; contributes two woodcuts to *Dada* No. 3 (December 1918). 1920 returns to Berlin; director of Novembergruppe, with whom he exhibits regularly. One-man exhibitions in Berlin, Rotterdam, The Hague. 1933 to Spain; 1936 to London. Runs school for professionals and amateurs in London and Oxford. Memorial exhibition London 1945.

Catalogue, *Arthur Segal*, Fischer Fine Art, London 1978
Catalogue, *Arthur Segal 1875–1944*, Kölnischer Kunstverein, Cologne 1987

Franz Wilhelm **Seiwert**

Born 1894 in Cologne; died there 1933. Applied art studies; then works for architect. Suffers most of his life from ultimately terminal X-ray burns on his head.

1919 active in Cologne Dada group but finds its activities too bourgeois. 1920 with Hoerle and others founds Association of Progressive Artists; 1929 founds and edits journal *a–z* (last issue February 1933).

Jatho, Karl Oskar, *Franz Wilhelm Seiwert*, Recklinghausen 1964

Victor **Servranckx**

Born 1897 in Diegem, Belgium; died 1965 in Vilvoorde. Brussels Academy 1913–17. 1917 first one-man show: abstract paintings. 1918 and after contact with van Doesburg, Léger and other Elementarist and Purist artists. In 1920s makes sculptures as well as formal abstract paintings; 1925 designs interior and furniture for Paris international decorative arts exhibition. Late twenties abandons abstraction. 1947 and 1965 retrospective exhibitions in Brussels.

Bilcke, M., *Servranckx*, Brussels 1964

Georges **Seurat**

Born 1859 in Paris; died there 1891. Trains at Ecole des Beaux-Arts in Ingres tradition; influenced by Delacroix, Puvis and Barbizon painters. By 1883 aware of Impressionism, and embarking on scientific investigation of colour and composition as structure and communication. Series of large masterpieces begins with *Bathers at Asnières* 1884 (London, National Gallery); concurrent small paintings, mostly landscapes. One-man show Paris 1888; memorial exhibitions in Brussels and Paris 1892; major retrospective Paris 1905. His ideas on painting publicized by painter Paul Signac in *From Delacroix to Neo-Impressionism*, Paris 1899.

Homer, William Innes, *Seurat and the Science of Painting*, Cambridge, Mass., 1964
Russell, John, *Seurat*, London and New York 1965
Thomson, Richard, *Seurat*, Oxford 1985

Charles **Sheeler**

Born 1883 in Philadelphia; died 1965 in Dobbs Ferry, New York. Studies at Philadelphia School of Industrial Arts and at Pennsylvania Academy 1900–6; period in Europe and subsequent visits. Experiments with photography from 1912 on; exhibits in Armory Show 1913. Active as photographer as well as painter, and bases paintings at times on own photographs, including double exposure images.

Catalogue, *Charles Sheeler*, Smithsonian Institution, Washington 1968
Catalogue, *Charles Sheeler: a concentration of works from the permanent collection of the Whitney Museum of American Art*, Whitney Museum, New York 1980

David **Siqueiros**

Born 1896 in Chihuahua, Mexico; died 1974 in Mexico City. Studies art at Academy of San Carlos and Mexican Academy. Joins revolutionary army 1914; promoted to general staff; 1919–22 in Europe as military attaché to Madrid Embassy. Returns to Mexico and collaborates with Rivera on murals. 1925–30 stops painting for political work; otherwise combines political activity with mural painting in Mexico and USA, later in Chile and Cuba.

Tibel, R., *David Alfaro Siqueiros*, Buenos Aires 1966
Folgarait, Leonard, and Siqueiros, David, *March of Humanity on Earth and towards the Cosmos*, Cambridge 1987

David **Smith**

Born 1906 in Decatur, Indiana; died at Bennington, Vermont 1965. Brief periods of study – drawing, poetry – and employment. 1926–9 evening studies at Art Students' League, New York: mainly painting. Begins to weld sculptures 1933; 1935–6 in Europe. First one-man show 1938 at East River Gallery, New York. 1942 works for American Locomotive Company. Work praised by Clement Greenberg. 1947 touring retrospective exhibition in USA; 1957 retrospective at Museum of Modern Art. First major European show 1966, Tate Gallery, London.

Fry, Edward F., *David Smith*, New York 1969
McCoy, Garnett (ed.), *David Smith*, London and New York 1973
Marcus, Stanley, *David Smith: the sculptor and his work*, Ithaca 1983

Richard **Smith**

Born 1931 in Letchworth, England. Studies at Luton and St Albans Schools of Art and at Royal College of Art. 1960–1 in USA on Harkness Fellowship. Contributes to several exhibitions in London; 1961 first one-man show, at Green Gallery, New York; frequent shows thereafter. 1967 Grand Prize at São Paulo Bienal. 1970 shown in British Pavilion at Venice Biennale. Large retrospective exhibition Tate Gallery, London, 1975.

Catalogue, *Richard Smith*, Tate Gallery, London 1975
Catalogue, *Richard Smith, neue Arbeiten*, Ulm 1980

Robert **Smithson**

Born 1938 in Passaic, New Jersey; died 1973 in plane crash at Amarillo, Texas. Studies at Art Students' League, New York. Exhibits 1966 in Primary Structures exhibition at Jewish Museum, New York, and subsequent minimal art shows. First one-man show at Artists' Gallery, New York, 1959; series of one-man shows at Dwan Gallery, New York, 1966–70.

Holt, Nancy (ed.), *The Writings of Robert Smithson*, New York 1979
Catalogue, *Robert Smithson Sculpture*, Ithaca 1980

Jésus-Rafaël **Soto**

Born 1923 in Ciudad Bolivar, Venezuela. Studies art

at Caracas Academy. 1942–7 director of art school at Maracaibo. Turns from painting to making kinetic reliefs and environments with marked optical effects. 1950 settles in Paris and exhibits frequently; from late 1950s on wide international renown.

Catalogue, *Soto*, Kestner-Gesellschaft, Hanover 1968
Catalogue, *Soto, œuvres actuelles*, Centre Georges Pompidou, Paris 1979

Pierre Soulages

Born 1919 in Rodez. Serves in French Army 1939–41. Self-taught; begins to show in Paris exhibitions in 1946. 1957–8 visit to USA, Japan and India.

Juin, H., *Pierre Soulages*, Paris 1959

Stanley Spencer

Born 1891 at Cookham, Berkshire, England; died 1959 at Cliveden. 1908–12 studies at Slade School. 1912 included in Second Post-Impressionist Exhibition, Grafton Galleries, London. 1915–18 army service. Lived mostly outside London, in southern England. 1927 first one-man show, at Goupil Gallery, London. Mural decoration of Memorial Chapel, Burghclere. One-man show in British Pavilion at Venice Biennale 1938. 1940–4 shipyard paintings, commissioned by War Artists' Advisory Commission. Retrospective exhibitions at Temple Newsam House, Leeds, 1947, and at Tate Gallery, London, 1955.

Newton, Eric, *Stanley Spencer*, Harmondsworth 1947
Spencer, Gilbert, *Stanley Spencer*, London 1961
Catalogue, *Stanley Spencer*, Arts Council of Great Britain, London 1976
Rothenstein, John (ed.), *Stanley Spencer the man, correspondence and reminiscences*, London 1979
Robinson, Duncan, *Stanley Spencer: visions from a Berkshire Village*, Oxford 1979

Nicolas de Staël

Born 1914 in St Petersburg; died 1955 at Antibes. Aristocratic family, exiled 1919. Grows up in Brussels: art studies at Royal Academy there begun 1933, but soon leaves to travel and settles in Paris 1938. Joins Foreign Legion 1939–40. Returns to Paris 1943; included in exhibition of abstract painters. One-man show at Galerie Bucher 1945: fast-growing reputation as abstract painter. Exhibitions New York 1950 and London 1952. Figuration again evident in works of last years.

Cooper, Douglas, *Nicolas de Staël*, London 1961
Catalogue, *Nicolas de Staël*, Tate Gallery, London 1981

Frank Stella

Born 1936 in Malden, Mass. Studies painting at Princeton University 1954–8. Lives in New York. First one-man show of shaped canvases and stripes in aluminium paint, Castelli Gallery, New York, 1960. Contributes to important New York shows of abstract and geometric painting throughout sixties; one-man shows in London from 1964 on. In 1970s turns to making relief structures in various materials and with bright colours and patterns. 1983–4 gives Charles Eliot Norton Lectures at Harvard University, published 1986 as *Working Space*.

Rubin, William, *Frank Stella*, New York 1970
Rosenblum, Robert, *Frank Stella*, Harmondsworth and Baltimore 1971
Meier, Richard, *Shards*, New York 1982

Clyfford Still

Born 1904 in Grandin, North Dakota. Art training at Spokane and Washington State University. 1941–3 war service and part-time painting; 1943 first one-man show, San Francisco Museum of Art. 1945 contributes to exhibition at Art of this Century Gallery, New York; 1947 one-man show at Betty Parsons Gallery, New York. 1948 settles in New York; paints on large scale; co-founder of Subjects of the Artist school. 1959 major retrospective at Albright Art Gallery, Buffalo, New York. 1961 moves to Westminster, Maryland.

Sharpless, Ti-Grace, *Clyfford Still: Thirty-three Paintings in the Albright-Knox Art Gallery*, Buffalo 1966
O'Neill, John, *Clyfford Still*, New York 1979

Paul Strand

Born 1890 in New York; died there 1976. Studies at Ethical Culture School: interest in photographing people. After visit to Armory Show and Stieglitz's gallery, becomes interested also in abstract forms: one-man show at Stieglitz's '291' Gallery, 1916. Makes film *Manahatta* with Charles Sheeler 1921. 1932–4 in Mexico as Chief of Photography and Cinematography in Secretariat of Education. Retrospective exhibition at Museum of Modern Art, New York, 1945. Periods working in Europe and Africa. Publishes sets of photographs as books.

Tomkins, Calvin, *Paul Strand: 60 Years of Photographs*, New York 1976

Antoni Tàpies

Born 1923 in Barcelona. 1946 abandons law studies for art; already painting with thick impasto and incorporating objects. 1950 first one-man show at Galerias Layetanas, Barcelona; government award gives him year in Paris. 1953 one-man show at Martha Jackson Gallery, New York; 1955 one-man show at Galerie Stadler, Paris. 1957 Premio Lissone, Milan. Show with Venice Biennale 1958: UNESCO Prize. Other prizes follow. Retrospectives in Hanover 1962; Vienna, Hamburg, and Cologne 1968; Paris and Geneva 1973; Berlin and London 1974.

Penrose, Roland, *Antoni Tàpies*, New York 1977 and London 1978
Permanyer, L., *Tàpies and the new Culture*, New York 1986

Vladimir **Tatlin**

Born 1885 in Moscow; died 1953 in Moscow. Brief art studies at Moscow School of Architecture, Sculpture and Painting. Exhibits with Union of Youth, St Petersburg, 1911, and thereafter in other avant-garde shows in St Petersburg and Moscow. 1913 visit to Paris via Berlin; visits Picasso's studio and sees Cubist constructions. 1913–14 makes first 'painting reliefs'; 1915 exhibits metal constructions, including 'counter reliefs'; quarrel with Malevich. Works with Yakulov on decoration of Café Pittoresque, Moscow, 1917. After Revolution several leading posts in art education and on Commissariat committees. 1919–20 designs and makes model for Monument to Third International (the Tatlin Tower). 1923 designs for Khlebnikov's dramatic poem *Zangezi*. Increasingly concerned with practical application of artistic understanding of materials and form: he and his students (in Petrograd and, after 1927, in Moscow) design winter clothes for workers, domestic stoves, furniture, etc., 1929–31 developing a one-man aeroplane. In 1930s several decors for theatre; also paintings, mostly of still life and nudes.

Catalogue, *Vladimir Tatlin*, Moderna Museet, Stockholm 1968
Milner, John, *Vladimir Tatlin and the Russian Avant-Garde*, New Haven and London 1983
Zhadova, Larissa (ed.), *Tatlin*, London 1988

Jean **Tinguely**

Born 1925 in Fribourg. Intermittent studies at Basle Art and Design School; paints abstract pictures, then turns to metal constructions with, in later 1950s, built-in mechanical motion. 1959 exhibits a painting machine (employing felt pens and paper). 1960 *Hommage to New York* destroys itself in the garden of the Museum of Modern Art; 1961 *Hommage to Dali* set up in Figueras. 1966 collaborates with Niki de Saint-Phalle and Per-Oluf Ultveldt on gigantic reclining woman, *Hon*, large enough to be walked around in.

Ammann, J. C., 'Jean Tinguely' in *Werk* (Zurich), March 1966
Bischofsberger, Christina, *Jean Tinguely: catalogue raisonné of sculptures and reliefs 1954–1968*, Küssnacht 1982
Catalogue, *Tinguely*, Tate Gallery, London 1982

Mark **Tobey**

Born 1890 in Centerville, Wisconsin; died 1976 in Basle. Some classes at Chicago Art Institute; otherwise self-taught. 1911 to New York; success as portrait painter. 1922 to Seattle; becomes interested in Oriental

painting and in Buddhism. 1930–7 teaching at Dartington Hall, England. One-man shows of mature paintings from 1944 (Willard Gallery, New York) and after. 1961–2 large retrospective exhibition shown Paris, London, Cleveland and Chicago.

Schmied, Wieland, *Mark Tobey*, New York 1966
Dahl, Arthur, et al., *Mark Tobey: art and belief*, Oxford 1984

William **Tucker**

Born 1935 in Cairo, Egypt, of British parents. Studies history at Oxford 1955–8, then sculpture at Central School of Art and Crafts 1959–60. First one-man exhibition, London 1962; first abroad (New York) 1965. In milestone London sculpture exhibition 'The New Generation' at Whitechapel Art Gallery 1965. 1972 represents Britain at Venice Biennale. 1977 to Canada; now lives in New York. Retrospective exhibition at Storm King, New York 1988.

Tucker, William, *The Language of Sculpture*, London 1974; catalogue, *The Condition of Sculpture*, Arts Council of Great Britain, London 1975
Catalogue, *William Tucker, Sculpture 1970–1973*, Arts Council of Great Britain, London 1973
Catalogue, *William Tucker, Sculptures*, Arts Council of Great Britain, London 1977
Catalogue, *William Tucker, Gods: Five Recent Sculptures*, Tate Gallery, London 1987
Catalogue, *William Tucker, Storm King*, New York 1988

Georges **Vantongerloo**

Born 1886 in Antwerp; died 1965 in Paris. Studies art and architecture at Antwerp and Brussels Academies. Wounded on military service 1914, invalided out; goes to Holland and meets van Doesburg. Member of *De Stijl* group 1917–21. 1924 publishes book *Art and its Future* and makes first sculptures embodying mathematical formulae. 1927 moves to Paris. 1931 Vice-President of *Abstraction-Création* group.

Vantongerloo, Georges, *Paintings, Sculptures, Reflections*, New York 1948
Catalogue, *Georges Vantongerloo*, Kunsthaus, Zurich 1981

Victor **Vasarely**

Born 1908 at Pécs, Hungary. Studies medicine and then art at Budapest Academy and under Alexander Bortnyk. 1930 moves to Paris. Works first as commercial artist and on personal graphics; 1944 turns to painting and soon begins to exhibit regularly at Denise René Gallery. From 1947 exclusively working on constructive geometrical art, prefabricating coloured forms for variable assemblage to produce cheap, multipliable art. In later fifties and sixties wins many

international prizes. 1970 opens Vasarely Didactic Museum at Gordes, southern France.

Hahn, Otto, *Vasarely*, Paris 1970
Weikert, Hans, *Victor Vasarely*, Munich 1971

Dziga **Vertov**

Pseudonym of Denis Arkadevich Kaufman, born 1896 in Bialystok (Russian Poland); died 1954 in Moscow. Studies medicine in St Petersburg; photo and film reporter during war. 1917 onwards edits 42 issues of newsreels (*Kino-Nedelya*). 1922 founds Kinocki Group; 1922–5 produces 23 issues of *Kino-Pravda* documentaries. 1924 begins *Kino-Glas* series: further development in constructive use of documentary material, culminating in *The Man with the Movie Camera* (1920). *Donbas Symphony* (1931) and *Three Songs of Lenin* (1934) use sound as constructive element. 1944–54 produces 55 issues of *News of the Day*.

Michelson, Annette, *The Writings of Dziga Vertov*, London and Sydney 1984
Petrić, Vlada, *Constructivism in Film: the Man with the Movie-Camera, a cinematic analysis*, Cambridge and New York 1987

Maurice de **Vlaminck**

Born 1876 in Paris; died 1958 in Rueil-le-Gadelière. Racing cyclist, self-taught painter. 1900 meets Derain who encourages him to concentrate on painting. 1901 impressed by van Gogh exhibition; meets Matisse. Contributes to Fauve displays at Salon d'Automne 1905 and 1906. Work included in *Blaue Reiter* exhibition, Munich, and in Second Post-Impressionist Exhibition, London, both 1912. Increasingly interested in Cézanne.

Cabanne, Pierre, *Vlaminck*, Paris 1966

John **Walker**

Born 1939 in Birmingham, England. Studies at Birmingham College of Art 1955–60; some months at Académie de la Grande Chaumière, Paris, 1961. First one-man show, Axiom Gallery, London, 1967. Gregory Fellow in Painting, Leeds University 1967–9; 1969–71 in USA on Harkness Fellowship. 1972 exhibition in British Pavilion at Venice Biennale.

Andy **Warhol**

Born 1928 in Philadelphia; died 1987 in New York. Studies at Carnegie Institute of Technology in Pittsburgh and works as advertising illustrator in New York: wins Art Directors' Club Medal 1957. Becomes known as Pop artist in 1962 with stencilled images of soup cans, dollar bills and Marilyn Monroe. From mid-sixties on increasing range of activities: films, stage decor, managing rock music group, etc.

Catalogue, *Warhol*, Tate Gallery, London 1971
Ratcliff, Carter, *Andy Warhol*, New York 1983
Andy Warhol: A Picture Show by the Artist, New York 1987

Tom **Wesselmann**

Born 1931 in Cincinnati, Ohio. Studies psychology, then art at Art Institute of Cincinnati and Cooper Union, New York. First one-man show New York, Tanager Gallery, 1961; regular shows thereafter. 1962 included in Museum of Modern Art exhibition 'Recent Painting USA: The Figure'. Contributes to Pop exhibitions in America and Europe 1962–4.

Tom Wesselman/Slim Stealingworth, New York 1980

Wols

Pseudonym of Wolfgang Schulze, born 1913 in Berlin; died 1951 in Paris. Self-taught in art; to Paris 1932, lives from photography and from teaching German, also doing drawings and watercolours and is in touch with Surrealists. Interned 1939–40; then lives in South of France, in extreme poverty. 1945 back to Paris, begins to paint with oils on canvas: first one-man show at Galerie Drouais, 1945.

Haftmann, Werner, *Wols-Aufzeichnungen*, Cologne 1963

Bibliography

Useful and recommended texts available in English

General

Ades, Dawn, *Photomontage*, London 1976
Arnason, H. H., *A History of Modern Art*, New York 1976 and London 1977
Ashton, Dore, *A Reading of Modern Art*, Cleveland and London 1969
Banham, Reyner, *Theory and Design in the First Machine Age*, London 1972
Bowness, Alan, *Modern Sculpture*, London 1965
Burnham, Jack, *Beyond Modern Sculpture*, London 1968
Catalogue, *Abstraction: Towards a New Art. Painting 1910–1920*, Tate Gallery, London 1980
Catalogue, *Film as Film: formal experiment in film 1910–1975*, Arts Council of Great Britain, London 1979
Chipp, Herschel B., *Theories of Modern Art*, Berkeley and Los Angeles 1968
Egbert, Donald D., *Social Radicalism and the Arts*, London 1970
Elsen, Albert E., *The Origins of Modern Sculpture*, New York 1974 and London 1978
Elsen, Albert E., *Modern European Sculpture 1918–1945*, New York 1979
Goldwater, Robert, *Primitivism in Modern Art*, New York 1967
Haftmann, Werner, *Painting in the Twentieth Century*, London 1968
Hamilton, George H., *Painting and Sculpture in Europe 1880–1940*, Harmondsworth 1972
Hammacher, A. M., *The Evolution of Modern Sculpture*, London 1969
Herbert, Robert L., *Modern Artists on Art*, Englewood Cliffs 1964
Higgins, I. (ed.), *Literature and the Plastic Arts*, Edinburgh and London 1973
Hoffmann, Werner, *Turning Points in Twentieth-Century Art*, London 1969
Hughes, Robert, *The Shock of the New*, London 1980
Janis, Harriet, and Blesh, Rudi, *Collage*, New York and London 1967
Kozloff, Max, *Renderings in Art*, London 1970
Krauss, Rosalind E., *Passages in Modern Sculpture*, London and New York 1977
Lippard, Lucy R., *Changing*, New York 1971

Popper, Frank, *Origins and Development of Kinetic Art*, Greenwich, Conn., 1968
Read, Herbert, *A Concise History of Modern Sculpture*, London and New York 1964
Richardson, Tony, and Stangos, Nikos (eds.), *Concepts of Modern Art*, Harmondsworth and New York 1974
Rickey, George, *Constructivism: origins and evolution*, New York 1967
Rubin, William (ed.), *Primitivism in Twentieth Century Art*, 2 vols., Museum of Modern Art, New York 1984
Russell, John, *The Meanings of Modern Art*, New York and London 1981
Schapiro, Meyer, *Modern Art*, London and New York 1978
Scharf, Aaron, *Art and Photography*, London 1968
Selz, Peter, *Art in Our Time, A Pictorial History 1890–1980*, New York 1981
Shapiro, Theda, *Painters and Politics*, New York 1976
Steinberg, Leo, *Other Criteria*, New York 1972
Towards a New Art, *The Background to Abstract Art, 1910–1920*, Tate Gallery, London 1980
Tucker, William, *The Language of Sculpture*, London 1974

Fauvism and Expressionism

Catalogue, *Expressionism: a German Intuition, 1905–1920*, Guggenheim Museum, New York 1980
Crespelle, Jean-Paul, *The Fauves*, Greenwich, Conn., 1962 and London n.d.
Diehl, Gaston, *Fauvism*, New York 1975
Dube, Wolf Dieter, *The Expressionists*, London 1972
Elderfield, John, *Fauvism and its Affinities*, New York 1976
Giry, Marcel, *Fauvism, Origins and Development*, New York 1981
Gordon, Donald, *Expressionism. Art and Idea*, New Haven and London 1987
Lankheit, Klaus (ed.), *The Blaue Reiter Almanac*, London 1969
Muller, J. E., *Fauvism*, London 1967
Myers, Bernard, *Expressionism: a generation in revolt*, London 1963
Roethel, Hans K., *The Blue Rider*, New York 1971

Roters, Eberhard, *Painters of the Bauhaus*, London 1965

Selz, Peter, *German Expressionist Painting*, Berkeley 1957

Whitfield, Sarah, *Fauvism*, London 1988

Whitford, Frank, *Expressionist Painting*, London 1987

Whitford, Frank, *Expressionism*, London 1970

Cubism

Cooper, Douglas, *The Cubist Epoch*, London 1970

Daix, Pierre, *Cubists and Cubism*, London 1983

Fry, Edward F., *Cubism*, London 1965

Golding, John, *Cubism, a history and an analysis*, London 1971

Green, Christopher, *Cubism and its Enemies: Modern Movements and Reaction in French Art, 1916–1928*, New Haven and London 1987

Habasque, Guy, *Cubism*, Lausanne 1959

Rosenblum, Robert, *Cubism and Twentieth Century Art*, London and New York 1960

Roskill, Mark, *The Interpretation of Cubism*, Philadelphia 1985

Schwartz, Paul Waldo, *The Cubists*, London 1971

Wadley, Nicholas, *Cubism*, London 1970

Futurism

Apollonio, Umbro, *Futurist Manifestos*, London 1973

Futurism and the International Avant-Garde, Philadelphia 1980

Kirby, Michael, *Futurist Performance*, New York 1971

Martin, Marianne W., *Futurist Art and Theory*, Oxford 1969

Rye, Jane, *Futurism*, London 1972

Taylor, Christina, *Futurism: Politics, Painting and Performance*, Ann Arbor 1979

Taylor, Joshua C., *Futurism*, New York 1961

Tisdall, Caroline, and Bozzola, Angelo, *Futurism*, London 1977

Dada and Surrealism

Ades, Dawn, *Dada and Surrealism Reviewed*, London 1978

Breton, André, *What is Surrealism?*, New York 1973 and London 1978

Cardinal, Roger, and Short, Robert S., *Surrealism, Permanent Revelation*, London 1970

Carrà, Massimo (ed.), *Metaphysical Art*, London 1971

Chadwick, Whitney, *Myth in Surrealist Painting 1919–1939*, Ann Arbor 1980

Chadwick, Whitney, *Women Artists and the Surrealist Movement*, London 1985

Erickson, John, *Dada Performance, Poetry and Art*, Boston 1984

Finkelstein, *Surrealism and the Crisis of the Object*, Ann Arbor, 1979

Gershman, Herbert S., *The Surrealist Revolution in France*, Ann Arbor 1969

Greenberg, Allan, *Artists and Revolution: Dada and the Bauhaus*, Ann Arbor 1975

Leavens, I., *From '291' to Zurich: the Birth of Dada*, Ann Arbor 1983

Lippard, Lucy (ed.), *Dadas on Art*, Englewood Cliffs 1971

Lippard, Lucy (ed.), *Surrealists on Art*, Englewood Cliffs 1974

Motherwell, Robert (ed.), *The Dada Poets and Painters*, New York 1951

Picon, Gaetan, *Surrealism 1919–1939*, London 1977

Richter, Hans, *Dada*, London 1965

Rosemont, Franklin, *André Breton and the First Principles of Surrealism*, London 1978

Rubin, William S., *Dada and Surrealist Art*, New York and London 1969

Schneede, Uwe, *Surrealism*, New York 1974

Sheppard, Richard (ed.), *New Studies in Dada: Essays and Documents*, Driffield 1981

Verkauf, Willy (ed.), *Dada*, London 1975

Waldberg, Patrick, *Surrealism,*, London 1966

De Stijl, Elementarism, Purism

Barr, Alfred H., *De Stijl 1917–1928*, New York 1961

Blotkamp, Carel, et al., *De Stijl, the Fomative Years*, Cambridge (Mass.) and London 1986

Catalogue, *Léger and Purist Paris*, Tate Gallery, London 1970

Jaffé, Hans, et al., *De Stijl, 1917–1931: Visions of Utopia*, New York and Oxford 1982

Jaffé, H. L. C., *De Stijl 1917–1931*, London 1956

Mansbach, Steven, *Visions of Totality: Laszlo Moholy-Nagy, Theo van Doesburg and El Lissitzky*, Ann Arbor, 1980

Overy, Paul, *De Stijl*, London 1969

Ozenfant, Amedée, *The Foundations of Modern Art*, New York 1952

Rotzler, Willy, *Constructive Concepts*, Zurich 1977

Whitford, Frank, *Bauhaus*, London 1984

Wingler, Hans M., *The Bauhaus*, Cambridge, Mass., 1969

Post-1945: general

Battcock, Gregory (ed.), *The New Art*, New York 1966

Catalogue, *Art of Our Time: The Saatchi Collection*, 4 volumes, London 1984

Catalogue, *New Art*, Tate Gallery, London 1983

Catalogue, *Zeitgeist, International Art Exhibition*, Martin-Gropius-Bau, Berlin 1982

Davies, Douglas, *Art and the Future*, London 1973

Godfrey, Tony, *The New Image: Painting in the 1980s*, Oxford 1986

Gottlieb, Carla, *Beyond Modern Art*, New York 1976

Haskell, Barbara, *BLAM! The Explosion of Pop, Minimalism and Performance 1958–1964*, New York 1984

Honnef, Klaus, *Contemporary Art*, 1988

Kultermann, Udo, *The New Painting*, Boulder 1976

Kultermann, Udo, *The New Sculpture*, London 1968

Kultermann, Udo, *New Realism*, New York 1972

Lippard, Lucy, *Overlay: Contemporary Art and the Art of Prehistory*, New York 1983

Lucie-Smith, Edward, *Movements in Art since 1945*, London 1975

McShine, Kynaston L. (ed.), *Information*, New York 1970

Müller, Grégoire, *The New Avant-Garde*, New York 1972

Nairne, Sandy, *State of the Art: Ideas and Images in the 1980s*, London 1987

O'Doherty, Brian, *Object and Idea*, New York 1967

Oliva, A. B., *Europe/America, the different Avant-Gardes*, 1976

Seitz, William C., *The Responsive Eye*, New York 1965

Schneider, Ira, and Korot, Beryl (eds.), *Video Art*, New York and London 1976

Tomkins, Calvin, *The Bride and the Bachelors*, New York 1968 (also published as *Ahead of the Game*, London 1968)

Walker, John A., *Art since Pop*, London 1975

Post-1945: main tendencies

POP ART

Alloway, Lawrence, *American Pop Art*, New York 1974

Amaya, Mario, *Pop as Art*, London 1965

Catalogue, *Pop Art in England*, Hamburg 1976

Compton, Michael, *Pop Art*, London 1970

Finch, Christopher, *Pop Art*, London 1968

Lippard, Lucy, *Pop Art*, New York 1968

Russell, John, and Gablik, Suzi, *Pop Art Redefined*, London and New York 1969

HAPPENINGS, PERFORMANCE ETC.

Beardsley, John, *Earthworks and Beyond*, New York 1984

Goldberg, Rose Lee, *Performance, Live Art 1909 to the Present*, New York and London 1979

Hansen, Al, *A Primer of Happenings and Time/Space Art*, New York 1965

Henri, Adrian, *Environments and Happenings*, London 1974

Kaprow, Allan, *Assemblage, Environments and Happenings*, New York 1965

Kirby, Michael, *Happenings*, New York 1966

Kostelanetz, Richard, *The Theatre of Mixed Means*, London 1970

Kultermann, Udo, *Art-Events and Happenings*, London 1972

Nuttall, Jeff, *Performance Art*, London 1979

OTHERS

Barrett, Cyril, *Op Art*, London 1970

Battcock, Gregory (ed.), *Minimal Art*, New York 1968

Battcock, Gregory (ed.), *Idea Art*, New York 1973

Battcock, Gregory (ed.), *Super Realism: a Critical Anthology*, New York 1975

Catalogue, *The New Art*, Arts Council of Great Britain, London 1972

Catalogue, *When Attitudes Become Form*, Institute of Contemporary Arts, London 1969

Celant, Germano (ed.), *Art Povera: Conceptual, Actual or Impossible Art?*, London 1969

Lindey, Christine, *Superrealist Painting and Sculpture*, London 1980

Lippard, Lucy, *Six Years: The Dematerialization of the Art Object*, London 1973

Meisel, Louis, *Photorealism*, New York 1980

Meyer, Ursula, *Conceptual Art*, New York 1972

Individual Countries

FRANCE

Breunig, Leroy C., *Apollinaire on Art*, London 1972

Hunter, Sam, *Modern French Painting, 1855–1956*, New York 1956

Marchiori, G., *Modern French Sculpture*, New York 1963

Shattuck, Roger, *The Banquet Years*, London 1969

Soby, James T., *After Picasso*, Hartford, Conn., and New York 1935

Spate, Virginia, *The Evolution of Non-Figurative Painting in Paris 1910–1914*, Oxford 1979

GERMANY AND AUSTRIA

Catalogue, *German Art in the 20th Century*, Royal Academy of Arts, London 1985

Catalogue, *Berlinart 1961–1987*, Museum of Modern Art, New York 1987

Händler, G., *German Painting in Our Time*, Berlin 1956

Hinz, Berthold, *Art in the Third Reich*, Oxford 1980

Paret, Peter, *The Berlin Secession. Modernism and its Enemies in Imperial Germany*, London 1980

Ritchie, Andrew C. (ed.), *German Art of the Twentieth Century*, New York 1957

Roh, Franz, *German Art in the 20th Century*, Greenwich, Conn., 1968

Röthel, Hans K., *Modern German Painting*, New York 1957

Sotriffer, K., *Modern Austrian Art*, New York 1965

GREAT BRITAIN

Bertram, Anthony, *A Century of British Painting 1851–1951*, London 1951

Bowness, Alan, *Contemporary British Painting*, London 1968

Catalogue, *Arte inglese oggi 1960–76*, Commune di Milano, Milan 1976

Catalogue, *British Art in the Twentieth Century*, Royal Academy of Arts, London and Munich 1986

Catalogue, *British Sculpture in the Twentieth Century*, Whitechapel Art Gallery, London 1981

Catalogue, *St Ives 1939–64: Twenty Five Years of Painting, Sculpture and Pottery*, Tate Gallery, London 1985

Catalogue, *Vorticism and its Allies*, Arts Council of Great Britain, London 1974

Cork, Richard, *Vorticism and Abstract Art in the First Machine Age*, London 1976

Farr, Dennis, *English Art 1870–1940*, Oxford 1978

Finch, Christopher, *Image as Language*, Harmondsworth 1969

Hammacher, A. M., *Modern English Sculpture*, New York 1968

Harrison, Charles, *English Art and Modernism*, London 1981

Neff, Terry (ed.), *A Quiet Revolution: British Sculpture since 1965*, London 1987

Ray, Paul C., *The Surrealist Movement in England*, Ithaca and London 1971

Shone, Richard, *The Century of Change*, Oxford 1977

Watney, Simon, *English Post-Impressionism*, London 1980

ITALY

Ballo, Guido, *Modern Italian Painting from Futurism to the Present Day*, New York 1958

Carrieri, Raffaele, *Avant-garde Painting and Sculpture (1890–1955) in Italy*, Milan 1955

Salvini, R., *Modern Italian Sculpture*, New York 1962

Soby, James T., and Barr, Alfred H., *Twentieth-Century Italian Art*, New York 1949

MEXICO

Charlot, Jean, *The Mexican Mural Renaissance 1920–1925*, New York and London 1963

Rodriguez, Antonio, *A History of Mexican Mural Painting*, London 1969

RUSSIA

Bowlt, John (ed.), *Russian Art of the Avant-Garde: Theory and Criticism 1902–1934*, New York 1976; revised and enlarged, London 1988

Barron, Stephanie, and Tuchman, Maurice, *The Avant-Garde in Russia, 1910–1930*, Cambridge (Mass.) and London 1980

Compton, Susan P., *The World Backwards*, London 1978

Elliot, David, *New Worlds: Russian Art and Society 1900–1937*, London 1986

Gibian, George, and Tjalsma, H. W. (eds.), *Russian Modernism*, Ithaca and London 1976

Gray, Camilla, and Burleigh-Motley, Marian, *The Russian Experiment in Art, 1863–1922*, London 1986

Lodder, Christina, *Russian Constructivism*, New Haven and London 1983

Markov, Vladimir, *Russian Futurism*, London 1969

Rudenstine, Angelica, *Russian Avant-Garde Art: the George Costakis Collection*, London 1981

Williams, Robert C., *Artists in Revolution*, Indiana 1977 and London 1978

U.S.A.

Ashton, Dore, *The Unknown Shore*, Boston 1962

Ashton, Dore, *The New York School*, New York 1973

Auping, Michael (ed.), *Abstract Expressionism: the Critical Development*, London 1987

Catalogue, *11 Los Angeles Artists*, Arts Council of Great Britain, London 1971

Cox, Annette, *Art as Politics: the Abstract Expressionist Avant-Garde and Society*, Ann Arbor 1982

Crane, Diana, *The Transformation of the Avantgarde: the New York Art World 1940–1985*, Chicago and London 1987

Davidson, Abraham, *Early American Modernist Painting*, New York 1981

Doezema, Marianne, *American Realism and the Industrial Age*, Cleveland 1980

Friedman, Martin, *The Precisionist View in American Art*, Minneapolis 1960

Geldzahler, Henry, *New York Painting and Sculpture 1940–1970*, New York 1970

Goodrich, Lloyd, *Pioneers of Modern Art in America*, New York 1963

Homer, William, *Alfred Stieglitz and the American Avant-Garde*, London 1977

Levin, Gail, *Synchromism and American Color Abstraction, 1910–1925*, New York 1978

Levin, Gail, and Carleton Hobbs, Robert, *Abstract Expressionism: the Formative Years*, Ithaca 1978

Lucie-Smith, Edward, *American Art Now*, Oxford 1985

O'Connor, Francis V. (ed.), *W.P.A.: Art for the Millions*, New York 1973

Rose, Barbara, *American Art since 1900*, New York 1967

Rose, Barbara, *Readings in American Art since 1900*, New York 1968

Sandler, Irving, *The Triumph of American Painting*, New York 1975

Tuchman, Maurice (ed.), *The New York School*, London 1970

Acknowledgements

The publishers wish to thank all private owners, museums, galleries, libraries and other institutions for permission to reproduce works in their collections; they should also like to acknowledge the help of many photographers and photographic agencies in supplying pictures. Further acknowledgement is made to the following:

(Figs. 4, 25, 47, 163, 226) Giraudon, Paris; (Fig. 5) Museum of Fine Arts, Boston (gift of Misses Aimée and Rosamund Lamb in memory of Mr and Mrs Horatio A. Lamb); (Fig. 23) Ralph Kleinhempel; (Fig. 30) Barry Donahue; (Figs. 32, 33, 111, 112, 129, 161, 171) Gordon Roberton; (Fig. 39) Scientific and Encylopaedic Publishing House, Bucharest; (Fig. 50) courtesy Musées Nationaux; (Fig. 79) Arts Council of Great Britain; (Fig. 96) lithograph reproduced in *El Lissitzky*, monograph published by VEB Verlag der Kunst, Dresden; (Fig. 103) Photo: Carmelo Guadagno; (Fig. 106) Copyright Nina Williams; (Figs. 107, 108) reproduced by kind permission of Nina Williams; (Fig. 109) courtesy Marlborough Fine Art Ltd. London; (Fig. 110) from a collection of 70 woodcuts by Arthur Segal, published by Richard Nathanson; (Fig. 120) Miles Spackman, courtesy Museum of Modern Art, Oxford; (Fig. 125) Etienne Bertrand Weill; (Fig. 127) courtesy Kunstmuseum Hanover mit Sammlung Sprengel; (Fig. 130) courtesy Acquavella Galleries, Inc., New York; (Fig. 134) Galerie Brockstedt; (Fig. 140) © The Oskar Schlemmer Family Estate, Badenweiler, West Germany; (Fig. 143) ©1971 by the estate of Paul Strand (as published in *Paul Strand: A Retrospective Monograph 1915–1916*; (Fig. 152) *La Femme 100 Têtes*, published by Editions du Carrefour, 1926. Photograph by Jacqueline Hyde; (Fig. 153 *Une Semaine de bonté*, published by Editions Jeanne Bucher, 1934; (Fig. 176) © Henry Moore Foundation 1989. Reproduced by kind permission of the Henry Moore Foundation;

(Fig. 178) Photo: Bibliothèque Nationale, Paris; (Fig. 184) *Poésie de Stéphane Mallarmé*, published by Albert Skira, 1932; (Figs. 190, 191) John Webb; (Fig. 217) Marc Shuman; (Figs. 218, 248, 249, 257, 258, 262) courtesy Leo Castelli; (Fig. 221) Robert Cerney, Minnesota; (Fig. 233) Walter Dräyer, Zurich; (Fig. 235) courtesy Norbert Lynton; (Figs. 244, 245) courtesy Floyd Picture Library; (Figs. 252a,b) © David Hockney; (Fig. 260) courtesy Connaisance des Arts, Paris; (Fig. 263) courtesy Tate Gallery, London; (Fig. 267) Ann Münchow; (Fig. 277) courtesy Nigel Greenwood, London; (Fig. 281) courtesy Brian Marsh; (Fig. 287) © Harry Shunk 1969; (Fig. 297) Photo: M. Knoedler & Co. Inc., New York; (Fig. 298) courtesy David McKee Gallery, Photo: Sarah Wells; (Fig. 299) Photo: J. Littkeman; (Fig. 305) Photo: courtesy Fischer Fine Art, London, Ltd; (Fig. 306) Photo: courtesy Lisson Gallery, London.

The works of Beckmann, Beuys, Carrà, Chia, de Chirico, Ernst, Fautrier, Flavin, Genovés, Grosz, Heartfield, Judd, Kelly, Kollwitz, Léger, Lichtenstein, Mondrian, Morris, Motherwell, Noland, Olitski, Picasso, Rauschenberg, Rosenquist, David Smith, Vasarely, de Vlaminck and Wesselmann are © DACS 1989. Those of Adami, Bonnard, Brancusi, Braque, Chagall, Delaunay, Derain, Dubuffet, Duchamp, Giacometti, Kandinsky, Klein, Larionov, Magritte, Miró, Picabia, Ray, Raysse, Richier, Richter, Rouault, Servranckx, Soulages, de Staël, Tàpies and Tobey are © ADAGP, Paris/DACS, London 1989 and the works of Albers, Arp, Bissier, Klee, Kokoschka and Schwitters are © COSMOPRESS, Geneva/DACS, London, 1989. The work of Dali is © DEMART PRO ARTE BV/DACS, 1989 and that of Hilton is © Estate of Roger Hilton, All Rights Reserved/DACS, 1989. The works of Matisse are © Succession Henri Matisse/DACS, 1989.

Index

398